I Do...

100 YEARS OF WEDDING FASHION

First published in the United States in 2002 by

Watson-Guptill Publications

a division of VNU Business Media, Inc.

770 Broadway, New York, New York 10003

www.watsonguptill.com

Created by Co & Bear Productions (UK) Ltd.

Copyright © 2002 Co & Bear Productions (UK) Ltd.

Text copyright © Co & Bear Productions (UK) Ltd.

Photographs and illustrations copyright © Various (see p.314)

Co & Bear Productions (UK) Ltd. identify Caroline Cox as author of the work.

Library of Congress Control Number: 2001094959

ISBN: 0-8230-2511-X

Manufactured in Italy

1 2 3 4 5 6 / 07 06 05 04 03 02

I Do...

100 YEARS OF WEDDING FASHION

WRITTEN BY CAROLINE COX

Watson-Guptill Publications /New York

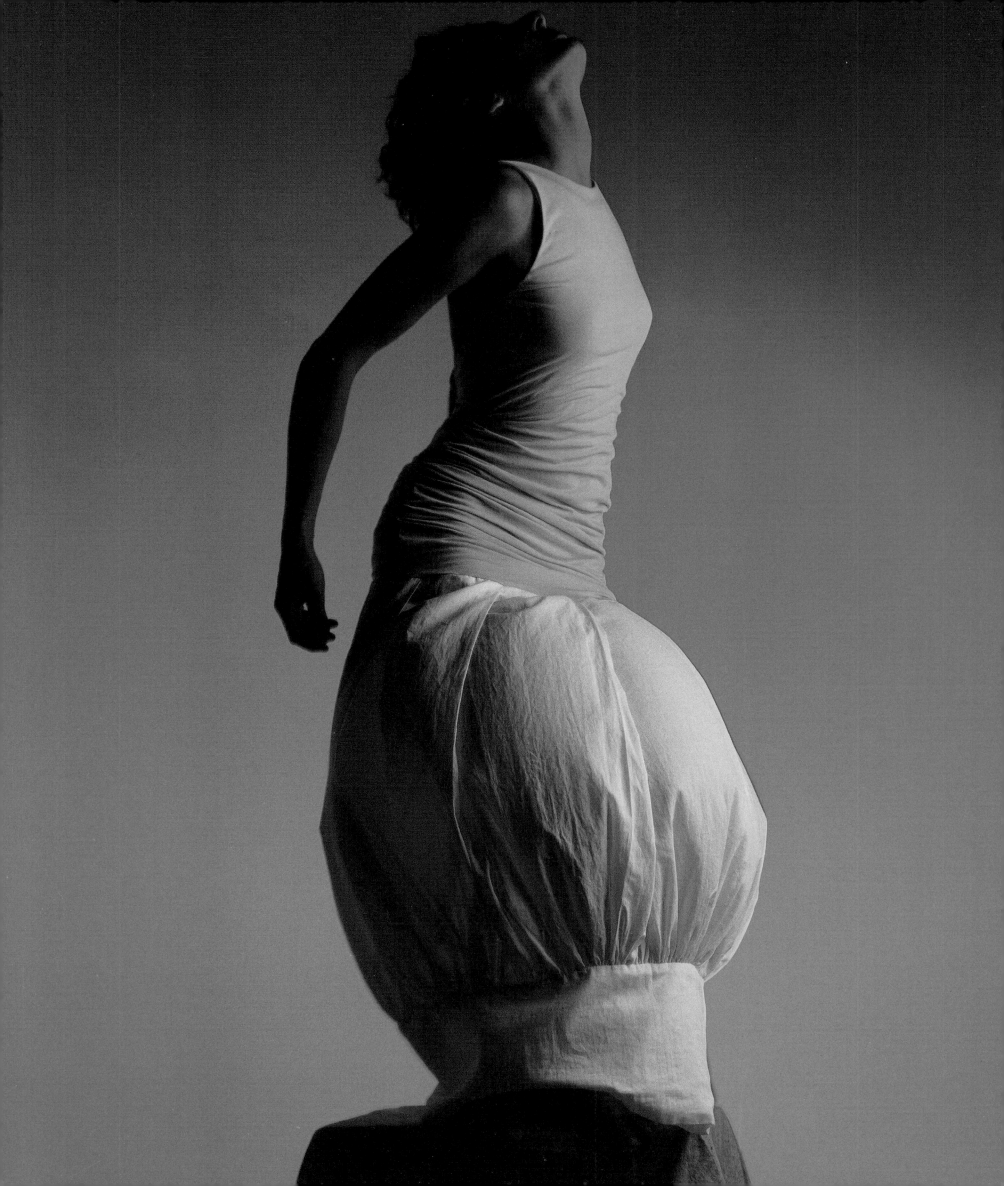

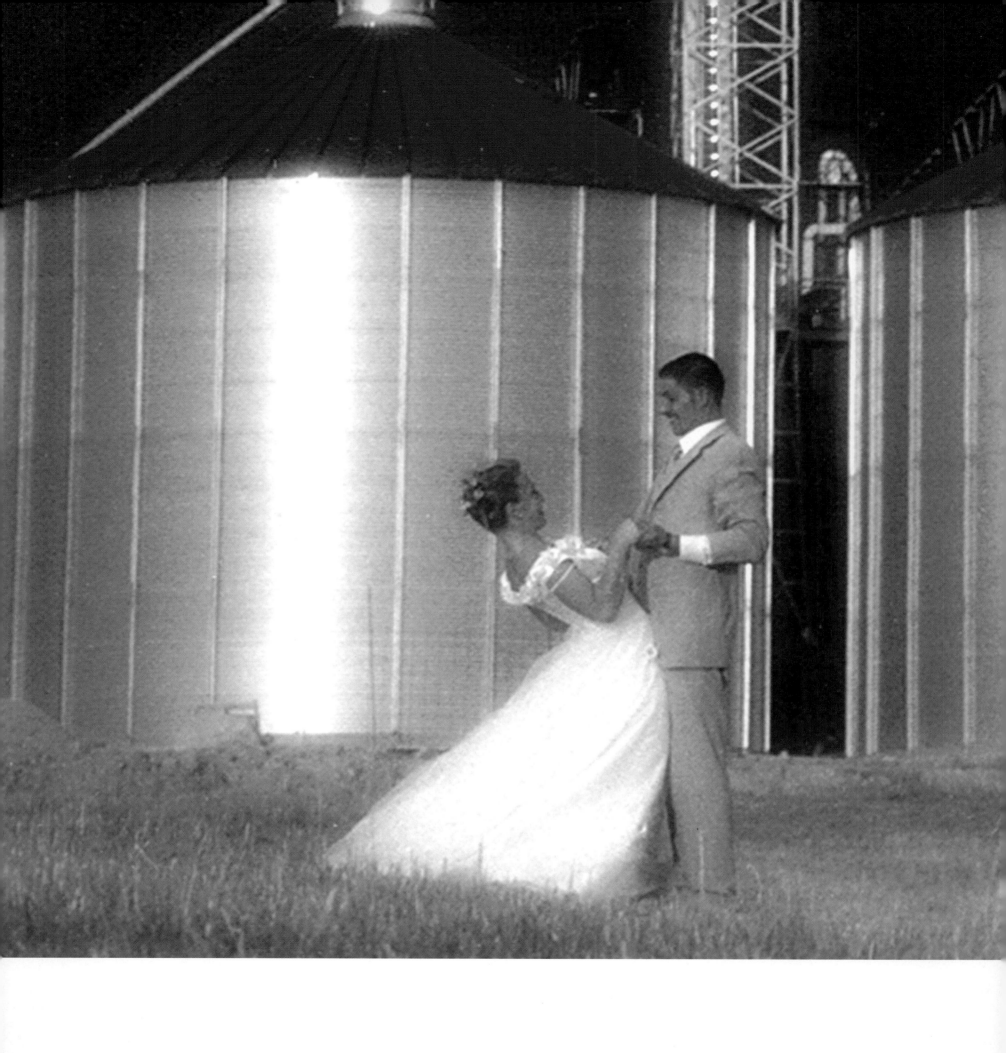

'[She] was dressed in rich materials – satins, and lace and silks – all of white. Her shoes were white.
And she had a long white veil dependent from her hair, and she had bridal flowers in her hair, but her hair was white.'[1]

Miss Havisham, the jilted bride, in Charles Dickens' *Great Expectations* (1861)

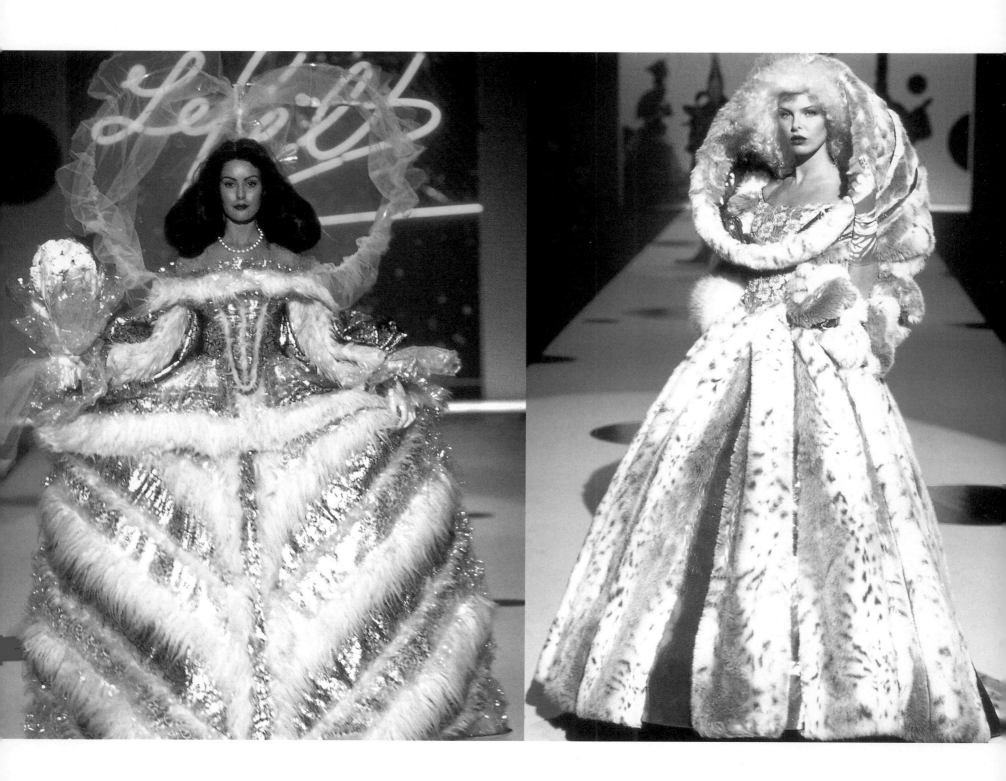

Introduction

The white wedding dress embodies all our dreams of perfect love, a sartorial symbol of romance and happiness – 'till death do us part,' or, as in the ghostly Miss Havisham's case, a grotesque reminder of what might have been. Miss Havisham, frozen at the moment when she heard the news of her rejection, has become a waxwork of a woman garbed in decaying bridal attire. Surrounded by rotting food and cobwebbed candlesticks, she provides a salutary reminder of the woman who never weds, the one who has been 'left on the shelf,' failing to fulfill society's expectations of femininity.

In global culture the wedding dress has become the ultimate spectacle. It is the most expensive piece of clothing most women will ever buy, insuring an enraptured gaze from an invited audience in a sacred setting. Wedding fashion makes all sorts of sartorial statements, yet little has been written about its meaning. In *The Importance of Wearing Clothes* (1959), the historian Lawrence Langner attempted some form of deconstruction, stating that 'The ability of clothes to create an emotional effect is nowhere better illustrated than at weddings in Western society, where the symbolism of pagan times continues to be observed in the wearing of the gayest party clothes by all the relatives and friends. If the bride is marrying for the first time, she wears a white wedding gown to symbolise her virginity. If, however, she is marrying for the second, third or fourth time, a condition none too rare in these United States, her lack of a white wedding gown tells her friend and the world at large what they already know – without putting it into embarrassing words. If she wears a veil, it is interesting to remember that these were first used to keep evil spirits away from the bride, while her orange blossoms symbolise the fertility that is hoped for. The bridesmaids usually wear a uniform, which not only adds to the beauty of the ceremony, but informs the group present that they too are virgins available for marriage. The bridegroom also dons a special suit, which varies in different countries, but since his own virginity does not come into question, it is seldom white. It is usually the same black suit which we associate with funerals. To show that this is apt to be a happier affair, he will wear a light tie and a light vest, and sport a light flower in his lapel.'[2]

The sociologist Chrys Ingraham is more scathing in her interpretation of weddings, stressing that 'What the white wedding keeps in place is nothing short of a racist, classist, and heterosexist social order.'[3] In fact, it seems that whenever institutionalized heterosexuality is under siege – through feminism or the visibility of gay rights, for example – the glamorous, ostentatious, extravagant white wedding becomes incredibly popular.

OPPOSITE Two elaborate wedding gowns, by 102 Dalmatians. (Left) A highly formal wedding dress based on an eighteenth-century manteau, the hoop skirt flattened and widened to achieve an exaggerated shape. (Right) A stiffened cowl neck is married with a nineteenth-century bell-shaped skirt.

As the radical philosopher Guy Debord put it, 'The spectacle appears at once as society itself, as a part of society and as a means of communication. As a part of society, it is that sector where all attention, all consciousness converges.'[4] And the spectacle of the white wedding has completely permeated global culture. The word 'wedding' is of Anglo-Saxon origin. To 'wed' was to take part in a betrothal ceremony, and being betrothed constituted an initial entry into a married state and meant that the couple would marry in the future but could have sex in the meantime. Marriage, therefore, did not necessarily begin with a wedding and brides did not have to be in a virginal state – these are all modern notions. Professor Adrian Thatcher makes the point when he writes: 'Who says marriage begins with a wedding? This is a modern and misleading assumption. In holding that marriages begin with weddings, Christendom is actually suffering from collective amnesia.'[5] He goes on to explain how for centuries the Church supported both betrothal and wedding ceremonies. As betrothal was generally assumed to initiate the state of marriage, by the time many brides had a wedding they were no longer in a virginal condition.

In the eighteenth century, almost half of all brides in Britain and North America were pregnant at the altar. Even in the supposedly sexually repressed nineteenth century there was far less shame attached to being a pregnant bride. In the countryside she was a cause for celebration as proof of her fertility and contribution to a future work force. Thus, early weddings could be overtly sexual, bawdy events. A description of one in 1597 runs: 'The bride attired in a gown of sheep's russet and a kirtle of fine worsted … was led to church between two sweet boys with rosemary tied about their silken sleeves … the ceremony ended in a riotous manner; the young men tore ribbons, garters, and bridal laces from the bride as souvenirs, later the crown raucously escorted the bridal couple to their bedchambers.'[6]

By contast, in the nineteenth century the pregnant bride became a social and sexual taboo. Another major change that had taken place by the nineteenth century was the merging of the two ceremonies – betrothal and wedding. Thus the important transitional stage from singleness to marriage – previously marked by betrothal – disappeared. Although the Church still resists this transitional phase and sees sexual relationships as only permissible within marriage, the notion of unmarried couples living together is now socially acceptable, a contemporary equivalent of the betrothal ceremony.

Marrying for love is another relatively new concept. Before the nineteenth century, marriages tended to be of convenience, to join together two powerful families or to increase estates. According to an old German saying, 'It is not a man that marries maid, but field marries field, vineyard marries vineyard, cattle marry cattle.' Very few women were under the illusion that they could marry who they wanted; it was a duty arranged by the family to enhance their wealth and status wherever possible. There also tended to be a disparity between the ages of the bride and the groom, with the latter being considerably older. The philosopher Aristotle described the ideal marriage as between a bride of 18 and a groom of 37, mirroring the paternal and authoritative role of the groom and the wifely subordination of the younger woman. This age discrepancy also reflected the more distressing reality that many young women died in childbirth, so leaving men free to marry several times over.

OPPOSITE The flamboyant Southern belle has inspired numerous wedding dresses, including this 'Louisiana' gown of 2000 by Catherine Davighi, which incorporates three-quarter-length sleeves with a heart-shaped, crinoline skirt.

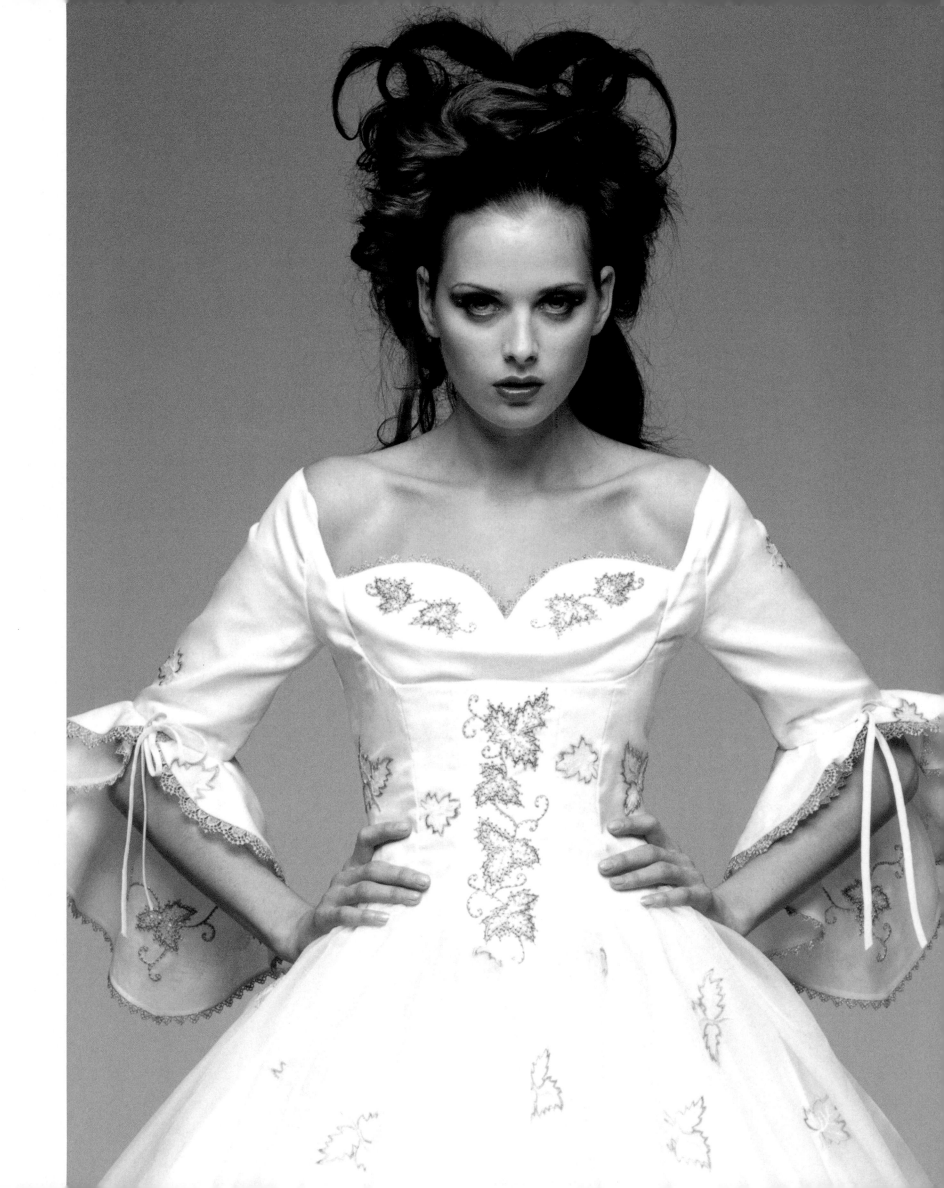

Because most marriages were in essence matches made with money, the appearance of the bride assumed great importance. She stood for the family's reputation. Thus, this pivotal day in a woman's life became burdened by ritual, charms, and superstition, including customs such as pealing the church bells as the couple left the church, to drive away all evil spirits. Bridesmaids were also originally dressed in the same kind of gown as the bride, in order to confuse any demons that were likely to spirit the bride away. It wasn't until the more secularized climate of the late nineteenth century that bridesmaids began dressing to differentiate themselves from the woman getting married. On perhaps the most important day of their lives, women also had to abide by exhortations to wear 'something old, something new, something borrowed, something blue.'

Most significantly, the wedding ceremony symbolized the end of girlhood and the initiation of a woman into her new responsibilities and status as wife. The historian Margaret Visser has stressed this aspect of the wedding, stating that 'weddings are initiatory ceremonies in all cultures; even in our own the traditional elements remain. Examples include the wearing of extraordinary clothes expressing purity and fertility; the swearing of oaths administered by official Elders; acceptance of rings as symbols of irrevo-cability; the flinging of many small objects at the newly professed; a momentous "honeymoon" journey and so on. People who go through initiations are transformed thereby; they leave a lower status for a higher. They learn a new thing, usually how to play a new role, and having passed through the ordeal there is no going back. One dresses differently during the ritual, and may receive the right to wear picturesque robes thereafter. Very often one is given a new name or a new title; in many societies the initiate's body itself is symbolically marked, sometimes for life.'[7]

The exchange of rings between partners was an ancient act of binding and a symbol of eternity within an agreement. Putting a ring on the third finger of the left hand was believed to have a physiological effect by connecting the vein that led directly from hand to heart. The diamond became a betrothal stone in the fifteenth century, although the expense of such a rare stone meant that it was out of most people's reach. By the 1970s, however, a massive eighty percent of engagement rings worn contained a diamond or two, and the cultural notion of diamonds being a girl's best friend had taken a firm hold. The use of a bridal veil also has a long legacy, with its origins in the flammeum, a yellow-colored veil used to enfold the bride at

RIGHT John Galliano for Christian Dior grand finale of the Haute Couture collection Spring-Summer 1999. A flamenco inspired crinoline skirt and three quarter length bodice for the bride with Spanish flair.

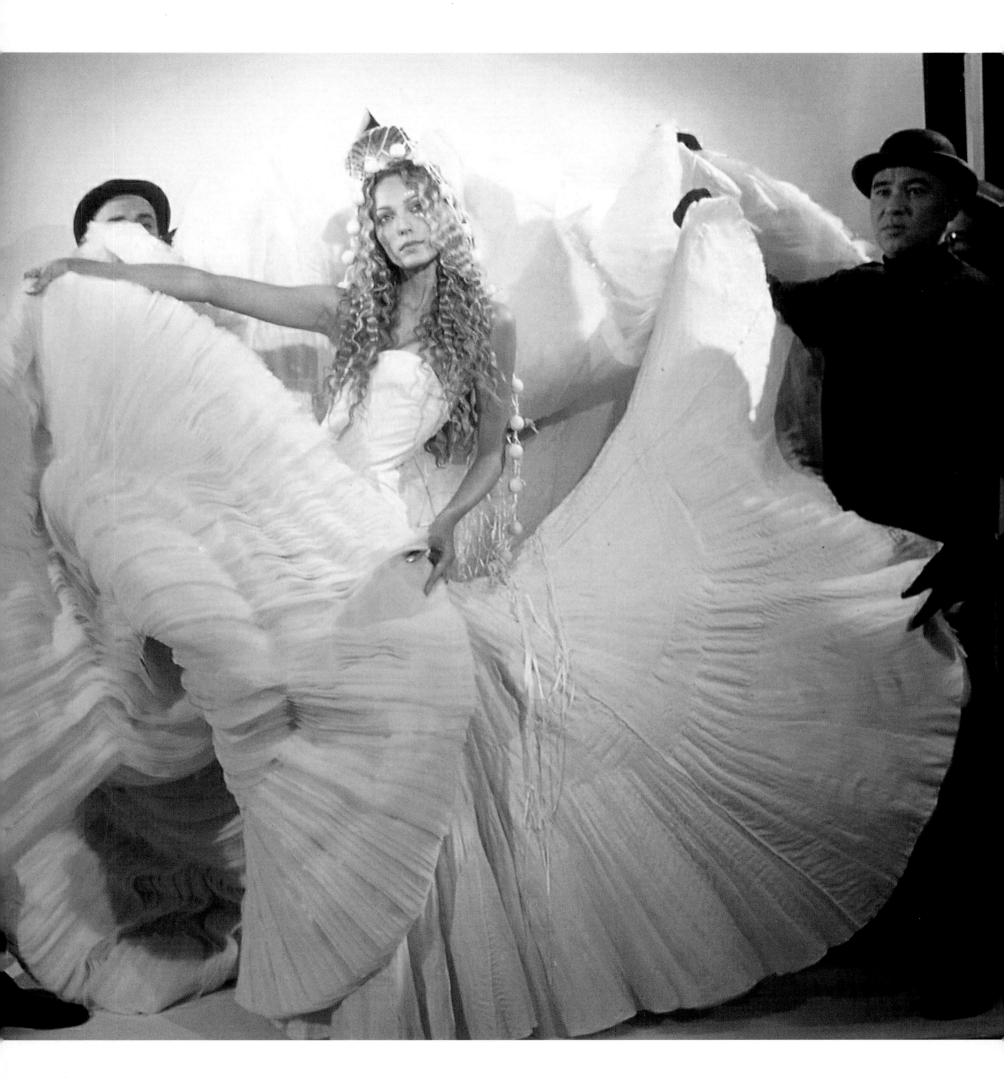

Roman weddings. This veil was a symbol of modesty devoted to Hymen, the goddess of marriage, and the lifting of the veil at the end of modern ceremonies signifies the breaking of the hymen on the forthcoming wedding night. Bridal bouquets are eighteenth century in origin, although it was the Victorians who invented a language of flowers, with red roses meaning an intensely passionate love and the ubiquitous orange blossom, saying 'your purity equals your loveliness.'

In fact, however 'fixed' wedding rituals appear today, most of them are a product of Victorian times. It was in the nineteenth century that 'traditional' concepts like the honeymoon, bridesmaids, the best man, and the white wedding cake were invented. The honeymoon was, according to W.T. Marchant, author of *Betrothals and Bridals* (1879), originally 'derived from the Teutonic custom which prevailed of drinking a concoction of honey for thirty days, or a moon's age, after a wedding feast. Attila the Hun is said to have celebrated his nuptials in such a glorious manner, of the beverage Hydromel, that he drank himself to death on the wedding night.[8] It was in the nineteenth century that the concept of a holiday or 'wedding tour' was invented, the first honeymoons taking place in the spa towns of England such as Buxton, Bath, and Cheltenham.

But perhaps the most pervasive legacy of Victorian Britain was the white wedding dress. Up to that era, brides had not always worn white. Roman brides wore yellow, and the dress was of lesser importance than the veil, girdle, and sandals. In the sixteenth and seventeenth centuries, pale green was a popular choice because of its associations with fertility, but more usually brides wore their best clothes whatever the color. Wedding historian Anthea Jarvis gives a succinct history: 'Throughout the Middle Ages and until the seventeenth century there was no customary bridal colour, the bride wore the best dress she could afford, and her status as a bride was proclaimed by her hair worn flowing loose and crowned with a wreath of flowers. Following the suppression of almost all sort of religious ceremonial under the Puritans, late seventeenth- and eighteenth-century weddings were generally extremely quiet, unostentatious affairs, and it was not until the beginning of the nineteenth that brides began to wear white dresses and veils over their heads, thus starting the tradition that many brides still follow.'[9]

By the early nineteenth century it had become the custom for women to wear white at most formal occasions, including presentations at court and eventually weddings, as a result of the fad for Neoclassical dress in Europe. The fashionable woman sported diaphanous high-waisted white and gold muslin gowns *à l'antique* with matching veils. Wearing white was not just fashionable; it was a prime indicator of wealth and thus social status. White showed the dirt, so to look good it had to be freshly laundered. This was a great expense in the days before constant hot running water and detergents, and a family had to be truly rich to clothe a daughter in an elaborate white wedding gown that would only be worn once. The color white also symbolized purity, befitting the supposed virgin state of the perfect bride.

However, the idea of a white wedding permeated all social classes and took over from other marital rituals, perhaps in its most unsettling form in the nineteenth-century custom of American slaves marrying in white, at the behest of their slave masters. These events revealed, as the historians Shane and Graham White argue, 'the complex relationships between white and black cultures … [as] a surprising number of slaves not

OPPOSITE Medieval fantasies of Queen Guineivere, King Arthur, and Camelot have provided endless inspiration for wedding attire and remain a potent force in the twenty-first century. The model Kirsty Hume chose this style to marry Donovan Leitch in 1997.

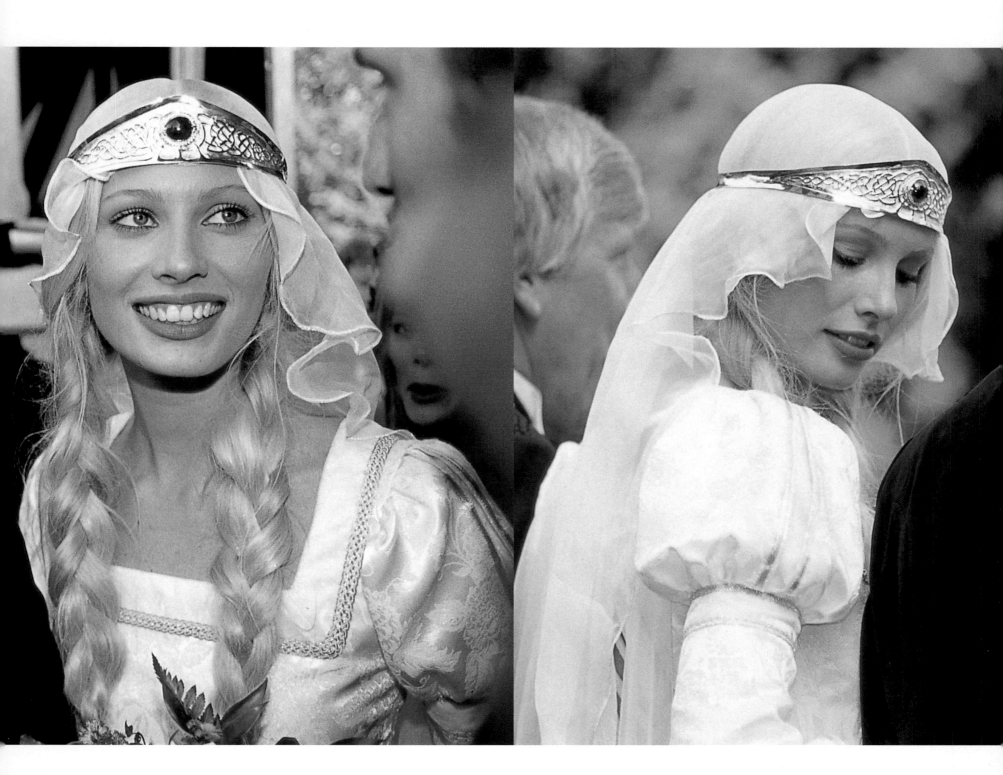

only were married by a preacher but also wore the type of apparel whites associated with weddings.'[10] Even so, slaves' dress 'still manifested the small but significant differences that generally characterised African-American clothing,' illustrated by the example of the slave Harriet Jones, who wore 'one of my Mistis [mistress's] desses wid a long train, hit is a white dress an I wear a red sash an, a big bow n de back, den I has on red stockings an a pair of bran new shoes, an a big wide brim hat.'[11] The red stockings and sash were a subversion of white wedding attire by Jones, introducing the traditional bright colors of African dress.

In Europe, the wedding of Queen Victoria to Prince Albert of Saxe-Coburg Gotha at St. James's Palace, London on February 10, 1840 firmly set the fashion for white, although the actual 'whiteness' of the gown compared to contemporary wedding dresses is relative. Most 'white' wedding dresses in the nineteenth century were actually cream. Wedding historian Elizabeth Laverack describes 'from top-of-the-milk to a Devon clotted cream colour ... silk rarely bleaches to white by natural means ... and it is only when drastic chemical bleaching has been used (such as in the 1950s and the 1960s) that one finds genuinely white wedding dresses. Unfortunately this also means that the silk has been damaged beyond repair.'[12] Thus Victoria wore a gown of creamy white satin with a long, pointed bodice and elbow-length, double-puffed sleeves, and full skirt with a train that was edged with sprays of orange blossom. The skirt had a deep bertha (or panel) of Honiton lace at the front, chosen by Victoria to support the declining lace trade. She sported a coronet of orange blossoms from which her veil was suspended.

Queen Victoria's use of orange blossom was a significant choice. The flower originated in China, where it was an emblem of purity, innocence, and chastity. In the Mediterranean, it became a pagan symbol of fertility because the orange blossom plant was a prolific bearer of fruit. For that reason some nineteenth-century moralists saw it as a vulgar fashion for a bride because of the obvious associations with sexual reproduction. But Victoria really set the nineteenth-century fashion for the flower, and brides following her example who couldn't afford the real thing when the flower was out of season simply wore wax copies.

Unlike Queen Victoria's, most weddings in the nineteenth century were family affairs with no particular publicity. According to Anthea Jarvis, 'Though mid-nineteenth century wedding dresses were often elaborate and costly, the wedding ceremony itself was, except in Court or high society circles, invariably a quiet family occasion, shared only with close relatives or a few friends, and with no publicity.

RIGHT The extravagant ceremony of Queen Victoria and Prince Albert in 1840 has become the archetype of the 'traditional' wedding of today. Victoria inspired generations of women to wear white on their special day.

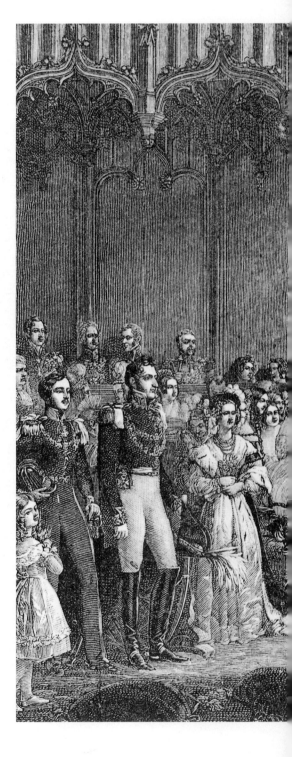

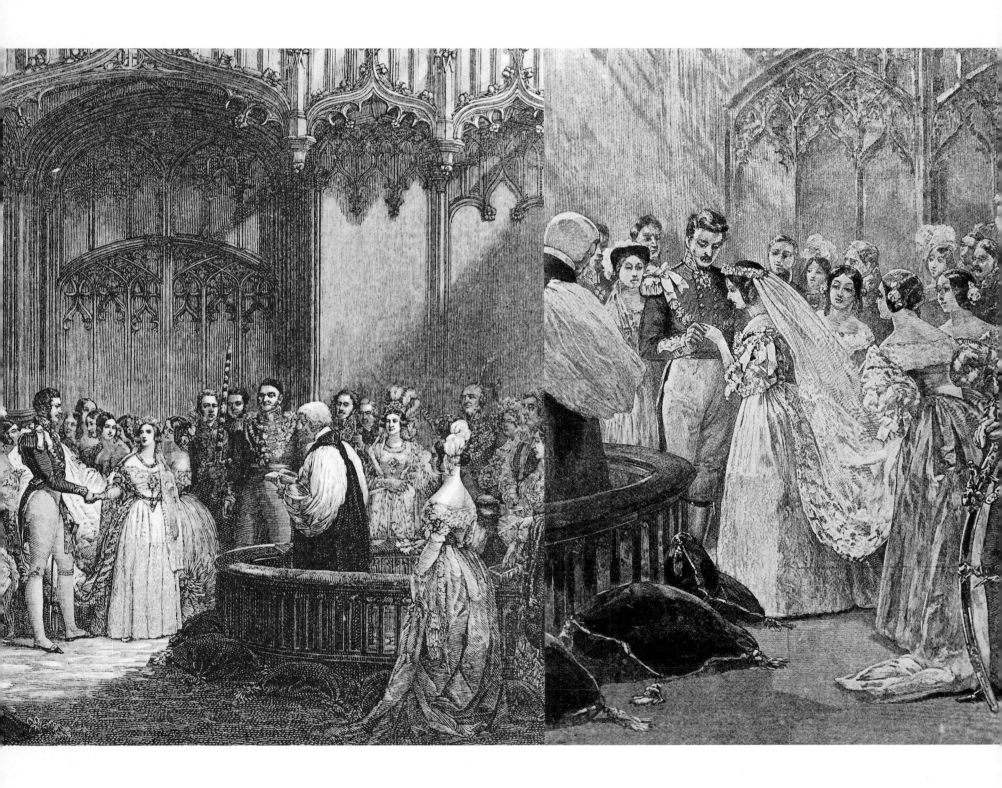

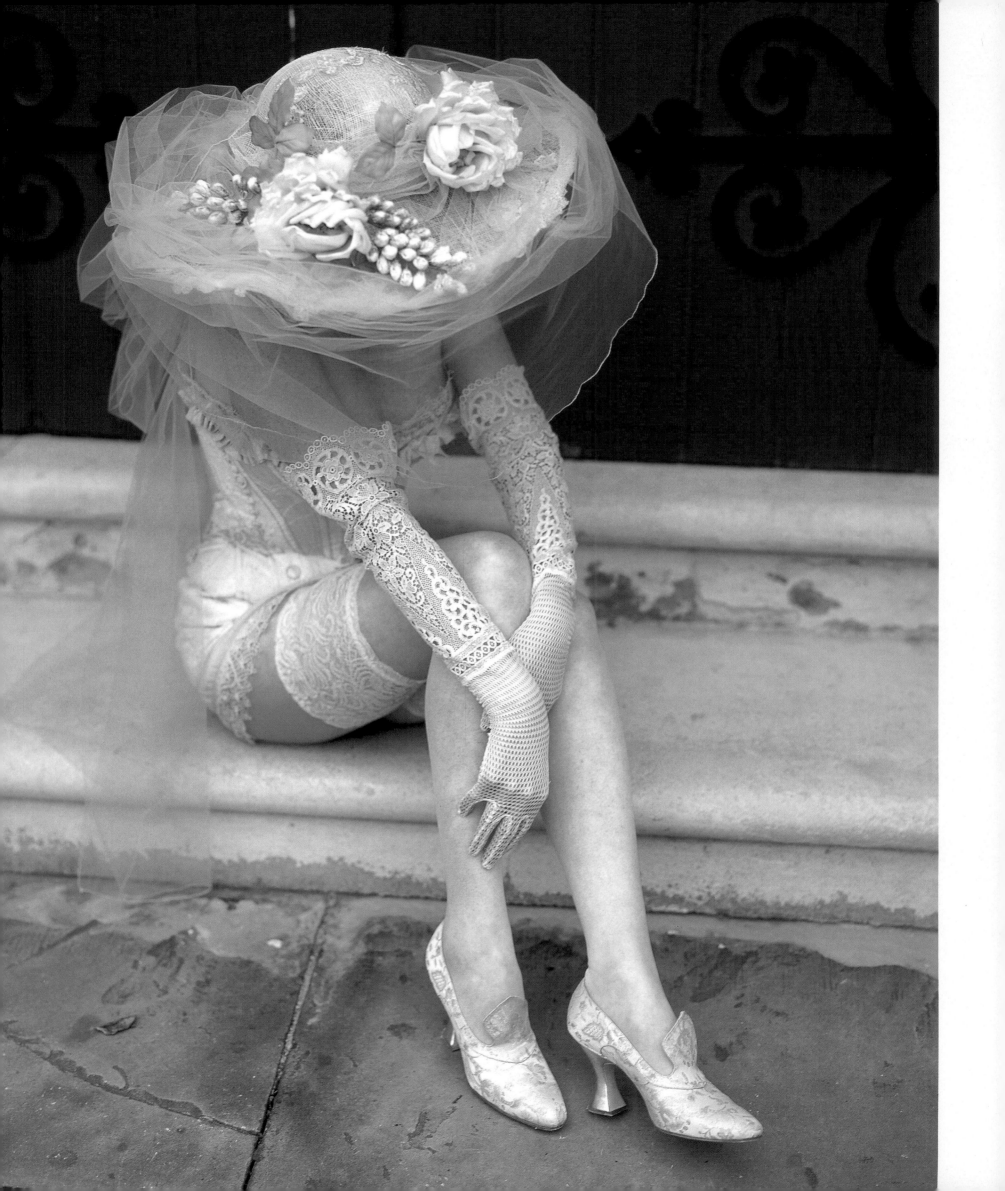

The legal hours for solemnising marriages in the Church of England were from 8 a.m. until noon, so this would often entail making an early start for those wishing to make elaborate toilettes. The entertainment afterwards, known as the Wedding Breakfast, could indeed be a breakfast, or a luncheon party, but often the bride and groom drove away from the church door to their new home or on the first stage of their wedding tour, and there were no celebrations at all.'[13] Even after Victoria's marriage, which had given the royal seal of approval to the white wedding, most ceremonies were quick and quiet. Economy and practicality were watchwords for the modest bride, who wore fashionable day outfits that could be worn again and again rather than just the once, and then to be hung in mothballs in the closet.

In 1886 wholesale changes began to occur to the wedding ceremony in Britain, when the enactment of a parliamentary bill extended the number of hours in the day when weddings could take place. With the advent of the early-afternoon wedding came more ostentation, as the celebrations could easily continue into the evening. The extravagance of some brides became a cause for complaint. An 1877 edition of *Tatler* magazine cautioned: 'Propound to her the question of marriage and you will speedily arrive at the truth of the fact. You will find she has not a single article of attire from a night cap to a shoe lace but must first be replaced and then reduplicated; and the trousseau with all its horrors rises before you as the first female bar to matrimony. True, you will (probably) not have to pay for it yourself but it will be the first shadow of a fearful burden you must bear all the rest of your life and its monstrous proportions indicate a Giant Horror from which you will shrink back appalled. Why a girl cannot be married "all standing" has ever been a mystery to us but as a matter of fact she will not go to church without an entirely new rigout and as she is on her wedding day so you will be expected to keep her henceforth and forever.'[14]

The author above was complaining about the trousseau, an invented tradition of the nineteenth century derived from the accepted practice in many ancient cultures of a bride being expected to provide a certain number of household goods for her new home, such as linen, clothing, and kitchen utensils. Victorian trousseaux were a collection of new clothes, linen, and (most importantly) an adequate supply of underwear, also known as the 'bottom drawer.' But, as chapter one of this book reveals, by the Edwardian era the trousseau had become a conspicuous display of wealth, and royal and aristocratic brides went so far as to have the contents of their trousseau described and illustrated in the popular press. When one of Queen Victoria's daughters, Princess May, married Prince George, Duke of York, in 1893, her fabulous trousseau included forty outdoor suits, fifteen ball gowns, five afternoon gowns, and numerous accessories.

As the bride's clothes became more varied in style, the groom's became more static. An 1877 manual, *Courtship and Matrimony*, advised the groom to wear 'a black dress coat and trousers, white waistcoat, either silk or other good material – not satin – with white necktie and white gloves.' Compare this to the 1554 wedding clothes of Philip of Spain, who had 'spent hugely at his tailors. There were suits of crimson velvet, grey satin and white silk decorated with a profusion of jewels … One jacket in particular was described as covered in gold chain and silver braid while some of his clothes were so encrusted with precious stones that it was not possible to see the cloth beneath.'[15] For the marriage itself, he wore a white doublet and knee-breeches, with a matching gold mantle lined with red velvet and decorated with gold thistles and pearls.

OPPOSITE In a moment of contemplation, the bride allows a glimpse of the luxurious eroticism of her wedding lingerie and picture hat by Basia Zarzycka.

As government intervention helped to make weddings more extravagant affairs, any activism against marriage as an institution was quashed. The sociologist Chrys Ingraham describes how, 'As activists in the nineteenth century discovered, to critically examine heterosexuality's rules and norms was to encounter either legal or social sanction. For example, marriage reform activists were often censored and jailed under the Comstock Act of 1872. As part of the free thinker movement, activists dedicated themselves to the elimination of church and state control over marriage, arguing that under these rules marriage was a form of "sexual slavery." When these marriage reformers attempted to distribute their ideas, they were frequently arrested, indicted and convicted for mailing "obscene" materials through the U.S. Postal Service. To mail writings on "sex education, birth control, or abortion" was deemed by the U.S. Postal Code 1461 – the Comstock Act – as the dissemination of obscenity and a federal offence.'[16] However, as chapter one shows, the increasing puritanism of the late nineteenth century, and early twentieth, obliterated many traditional attitudes to weddings as the Victorian ritualized version won through.

Chapter two discusses how attitudes to courtship and marriage started to change in the 1920s and 1930s, and so did the shape and style of wedding dresses. Dramatic changes occurred when the sleeker, 'flapper' style began to rid wedding dresses of extraneous decoration to achieve a slimline bias-cut silhouette derived from Parisian couture, and in particular the work of Madeleine Vionnet. However, chapter three shows how, after the strictures of World War II, when brides 'made do and mended' using the most incongruous materials to create a white wedding gown, the 1950s were dominated by the traditional crinoline shape in the form of the New Look, or Sweetheart line as it was dubbed in America. Weddings once again became huge, costly affairs, to be denied only by the late 1960s with the combined efforts of hippie culture and radical feminism, as chapter four illustrates. Women were renegotiating their status and position within patriarchy and it wasn't until the 1980s that they felt secure enough in their position in culture to indulge again in the 'ritual' of the wedding.

Chapter five discusses the most expensive celebration we will undertake – if we are still prepared to undertake it – in the twenty-first century. The wedding industry is now massive: the British market is worth £4.5 billion, with an average spend of £14,500. Weddings are marketed in magazines, at exhibitions, and on Web sites. There is more interest than ever before, as the public is increasingly influenced not by traditional moral values but by high-profile celebrity bashes as featured in the glossy magazines. Looking at weddings over the past hundred years, the changes are clear. Many brides now wear dresses completely unrelated to fashion, but instead don 'historical' styles – unlike the Victorian bride, who wanted to fit in with the mainstream trends of the day. Victorian brides also expected to wear their expensive wedding dresses after the ceremony at other functions, whereas now they tend to be worn only on the wedding day itself.

Bridal clothes today have become conventionally formalized, incorporating many elements of the nineteenth-century wedding gown: a fitted bodice; a small waist with full crinoline skirt made of organdy, silk, lace, or gauze (or the less expensive polyester); and a matching veil made from similar fabrics. Even though most wedding dresses incorporate these elements, the basic idea that the choice of gown reflects some personal choice

OPPOSITE Two contrasting wedding gowns. On the left, a gown by French couturier Christian Lacroix displays his trademark eclectic use of color and texture. Peter Langner takes a more minimalist approach, concentrating on a bold back detail derived from the Japanese kimono.

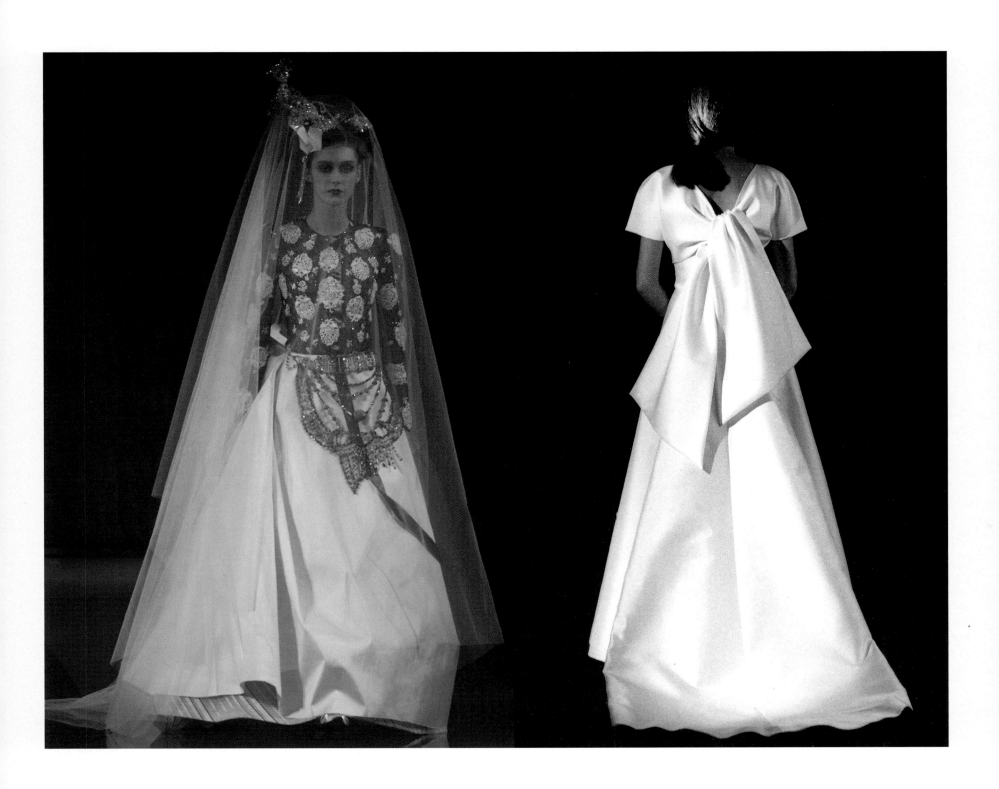

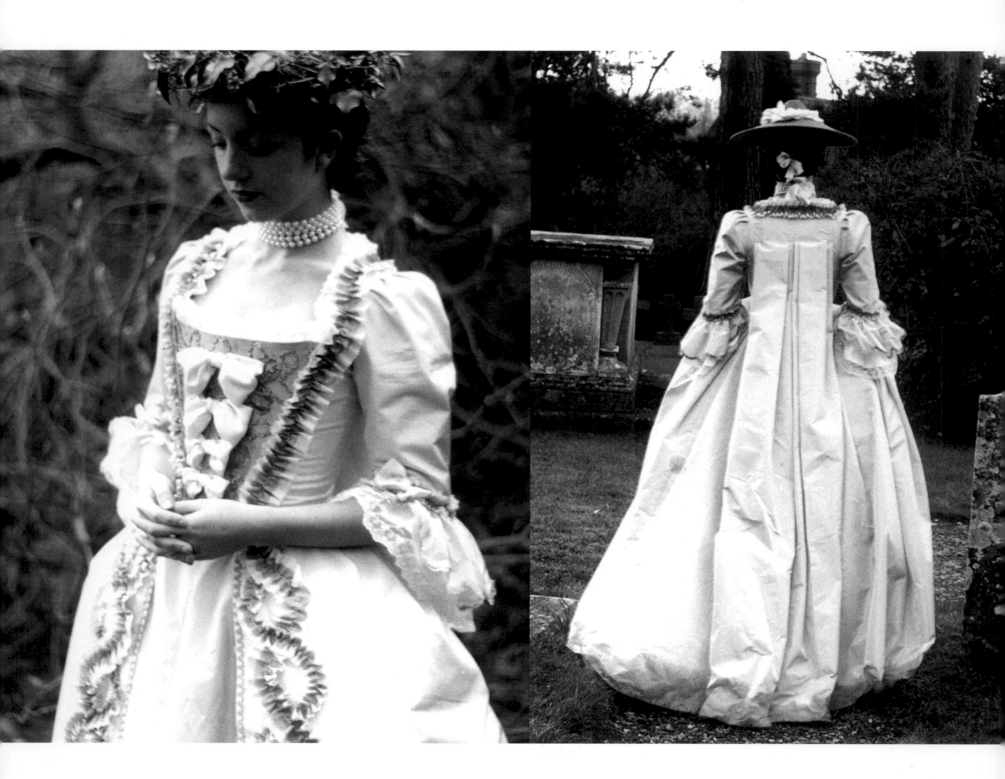

on the part of the bride still pervades. It is, in fact, the least likely example of a woman's personal style, for most of the time completely unrelated to anything else she has in her closet. According to the cultural historian Simon R. Charsley, 'choosing a dress is not therefore the normal process of choice, guided by some balance of taste, fashion, the sense of self-presentation, the need to fit items together to make an outfit, and expectations and limits as regards cost. As with all other items of wedding expenditure, people here are almost always moving beyond the zone in which they normally operate and make judgements on the basis of their own experience. Buying a wedding dress is something quite different.'[17]

The dress is about a woman's image of herself as a bride rather than the image of herself as herself. Even the feminist Naomi Wolf, famed for her vituperative comments about the pressures women have to face in fashion and beauty culture, was seduced by the idea of herself as a bride in the 1990s. She writes: 'To my astonishment as the date grew nearer, I found myself poring over the pages of the bridal magazines. Even though, as a feminist, I had "deconstructed" the institution of marriage and knew perfectly well that a white wedding derives from traditions that value women's virginity as a form of currency and that transfer the woman herself as property from one man to another, still I returned again and again to the visions of white. I began dreaming about a veil, about a garter, a rose, a ring. But the centrepiece of what I began half-ruefully to think of as "Brideland," this new country of gratified material desire, is of course the dress.'[18]

This formal white wedding gown, known colloquially as a 'meringue' because of its frothy whiteness and implied sugary sweetness, is now a sartorial record of one of life's most important social events. Wedding ceremonies all over the world now include these similar characteristics: the bride and groom are distinguished by special forms of dress; there is a feast for family and friends; and gifts are given. Fruit, rice, nuts, flowers, or confetti are thrown to symbolize the blessing of children to come. Chrys Ingraham succinctly captures the current appeal of the white wedding when she declares: 'In a high-tech, Internet-permeated, media-based, and alienated commodity culture where goods replace human interaction and shopping anaesthetises us to the realities of life, romance and its pinnacle, the white wedding, become compulsory and necessary for survival. Under these conditions, the white wedding as packaged and sold … is both homogeneous and the site for the simulation of social relations that we hope will take care of our utopian desires for love, community, belonging and meaningful labour.'[19]

OPPOSITE Two gowns by Ninya Mikhaila. (Left) The picturesque qualities of eighteenth-century rococo fashions are evoked in this open-front gown with beribboned stomacher. (Right) A 'contouche' or sack dress with Watteau back pleats which would not have looked out of place in the eighteenth century.

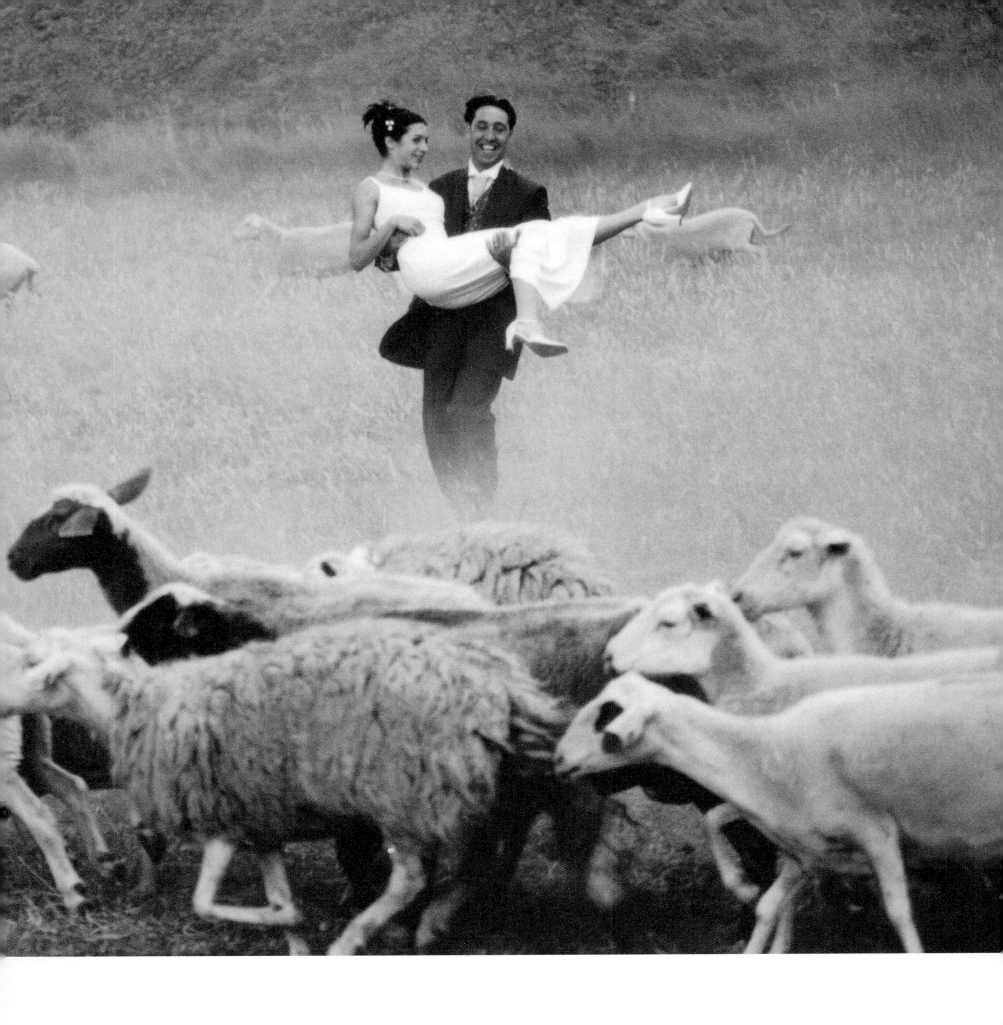

'BRIDE, n. A woman with a fine prospect of happiness behind her.'[1] Ambrose Bierce (1911)

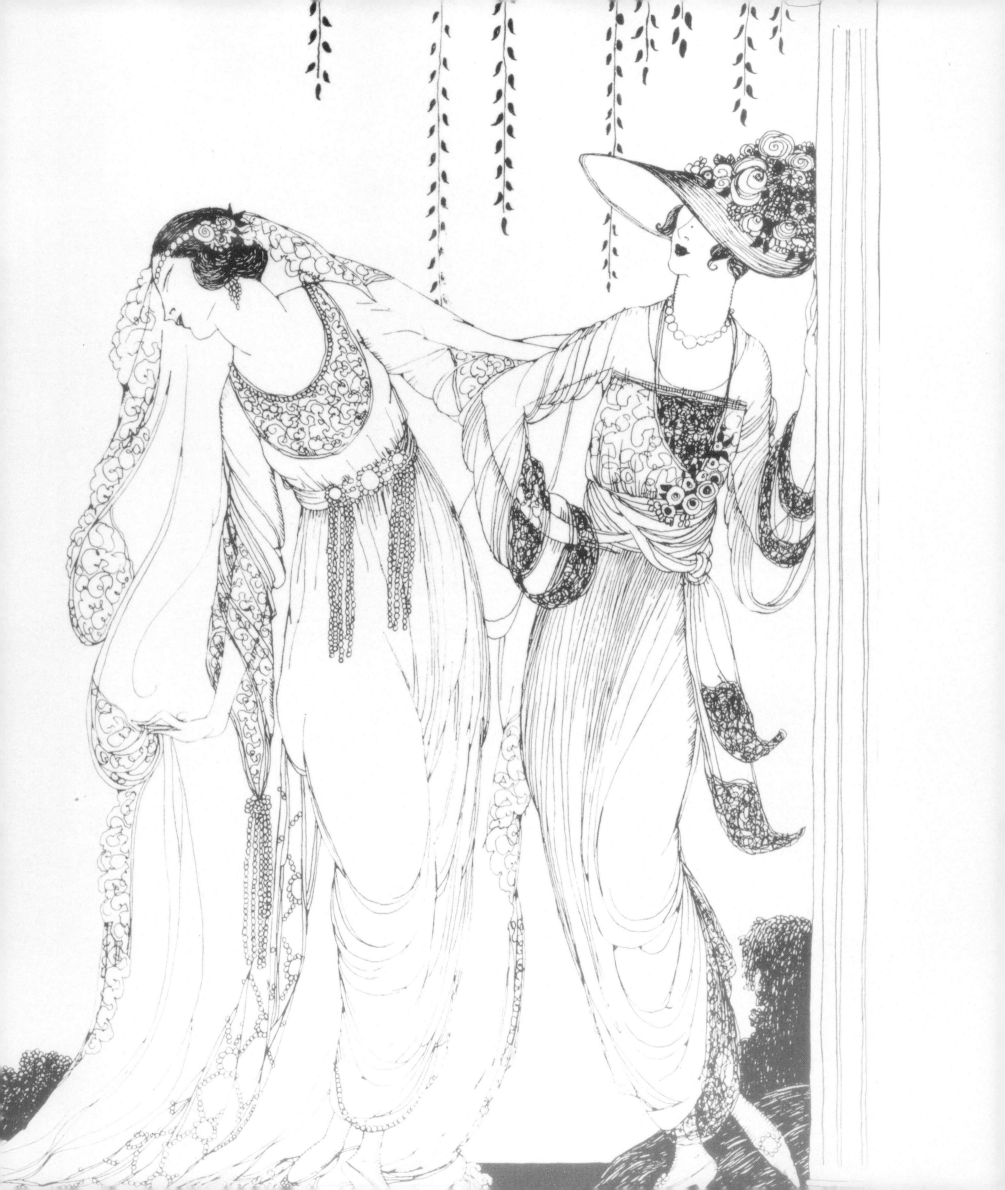

Edwardian extravagance

The words 'Edwardian era' conjure up a nostalgic golden age of British tea parties and picture hats, the click of croquet balls on a manicured lawn, and evenings spent at the pianola – a world where both the classes and sexes knew their place. The elaborate clothes worn by women of fashion signified their wealth and social position, for feminine dress was all 'froufrou,' frills, and lace, a product of days of skilled needlework and, thus, great expense. An extravagantly feminine look was popular in the early years of the twentieth century, comprising lacy blouses with puffed sleeves, and heavy, floor-length skirts or gowns covered with applied decoration of every sort, from cascades of lace to fur or feather trimmings. Immense hairdos, padded out with false hairpieces to add to their bulk, were worn topped with extravagantly decorated Gainsborough hats. The whole was a mark of conspicuous consumption, which showed through its decorative complexity that the lady was a woman of leisure rather than physical labor. The ideal figure was positively Junoesque by contemporary standards – one designer refused to use models weighing less than 154 pounds, and 'big girls with fine figures were the ideal of beauty.' Rigid undergarments, in particular the corset, created the fashionably curvaceous figure, which had a prominent monobosom (giving rise to what was dubbed the 'pouter pigeon' look) balanced by the shape of the hips and buttocks, which stuck out behind to create an S-shaped silhouette. But the writer Alison Lurie observes, 'As photographs show, in this costume the mature beauty looked glorious. Younger and slimmer women, however, often appeared awkward and cluttered with decoration; thinner women seemed gaunt; and the pocket Venus was reduced to an untidy bundle of expensive washing.'

A fashionable luxury pervaded wedding fashions at this time, too. The heavy, stiff-satin, full-skirted dresses popular in the nineteenth century were replaced with cream and ivory narrow-skirted styles, which were softer and lighter, being made mainly of fabrics such as chiffon, crepe de Chine, soft taffeta, and velvet. Such gowns were worn draped over S-shaped corsets, with skirts gored to flow over the hips and with high necklines buttoned at the back (reflecting the fashionable look of the time). The typical Edwardian high neckline as used on wedding gowns was dubbed the 'wedding band collar.' The American magazine *Ladies' Home Journal*, seeing the style as suitably modest for a bride, gave the following advice: 'It should always be remembered that no matter how beautiful the neck and arms of a bride are, she is sinning against good form who does not have a high neck and long-sleeved bodice, for it must be remembered that she is not going to a dance or reception, but to a religious ceremony.'[2]

Headwear was varied at Edwardian weddings. Waist-length veils were worn held on the head with a wreath of flowers, although by this time hats were popular, in mainstream as well as wedding fashion, and were sported by women of all classes. On wedding days the bride, bridesmaids,

OPPOSITE The elaborate understructure of the early twentieth-century wedding gown has been disavowed in this 1919 illustration for British *Vogue* by Helen Dryden. Simple girdled belts delineate the waist, and the soft flowing lines of the garments owe much to the work of the British designer Lucile.

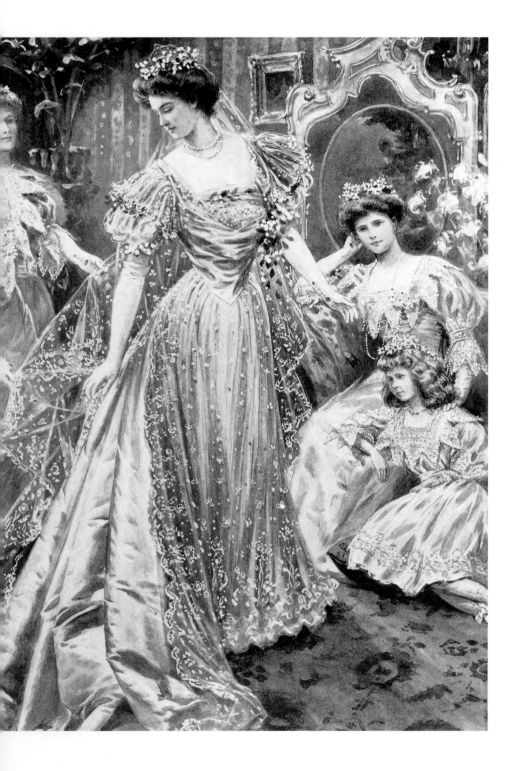

and female guests seemed to be in competition to see who could wear the largest and most heavily decorated hat. A true 'society' bride in England showed her status, however, by wearing a gown with a full-length train copied from those worn at court presentations and thus an established part of court dress. In the late nineteenth century, it had become the custom for a young aristocratic bride and her groom to be presented at court after marriage, a type of upper-class networking where titled families paraded in front of royal eyes displaying their taste, wealth, and finery. Wedding gowns could be reused on these occasions by removing the sleeves and lowering the neckline. Wedding historian Anthea Jarvis contends that wedding dresses were designed with this in view and that 'most were in fact made with a removable yoke or "chemisette" of lace, chiffon or other semi-transparent fabric, which made this a very simple transformation to effect.'[3]

As the strictures of royal etiquette demanded a full-length court train, the wearing of an ostentatious train for the wedding ceremony implied that a meeting with royalty was imminent. A long train also demanded several attendants to look after it and therefore hinted again at the healthy finances of the bride's family. Ostentatious weddings were also popular in America, where 'weddings like race meetings and Sunday church, were the occasions when the plantation-owner's wife and the women on cattle ranches or farms could get together and show off their latest finery.'[4]

Weddings of royal and aristocratic couples first began to be reported in the press in the late 1870s and, the more public the

LEFT Late nineteenth-century weddings popularized the practice of having several similarly dressed bridesmaids who could be easily distinguished from the bride. Here, at the wedding of Princess Beatrice in 1885, the bridesmaids' dresses are shorter with less décolletage than the royal bride's.

ceremony, the more elaborate it became – any excuse for the declaring of a family's wealth and fashionability on a national stage. Reports of society weddings featuring prominent members of English and American society were popular fuel for the mass of new women readers of publications such as *The Queen* and *Lady's Realm.* Extravagant society bashes were lavishly documented and avidly consumed in the same way that we read about the latest celebrity nuptials in *OK*, or *Hello*, or *People* magazines nowadays. Wedding historian Pauline Stevenson comments that in the 1900s, for the first time, 'Weddings are reported in the minutest detail, with illustrations not only of the bride in her dress and with her bouquet and veil, and of her going-away outfit, her bridesmaids large and small, and pages if any, but also of her mother's dress and quite often the toilettes of fashionable members of society who attended the ceremony. There is a plentiful and rather superfluous scattering of French terms throughout, photographs of the couple before marriage, descriptions of the flowers and music at the church, the presents – invariably described as costly or valuable – the reception and how and where the honeymoon was to be spent.'[5]

As more and more women wanted the appropriately 'fashionable look' for their wedding, they began to model their own nuptials on the dominant representations of femininity that were becoming more widely available in the popular press, from society beauties to stars of the music hall. They followed the advice laid down for them in magazines such as the American *Myra's Journal* or

RIGHT Such was the public interest in weddings during the Edwardian era that this elaborate royal gown of white satin and Carrickmacross lace, worn by Princess Margaret of Connaught in 1905, made the front page of *The Illustrated London News.*

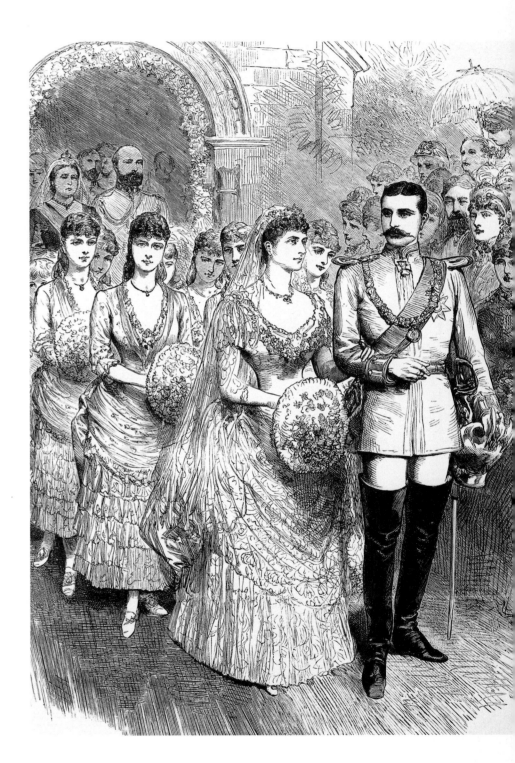

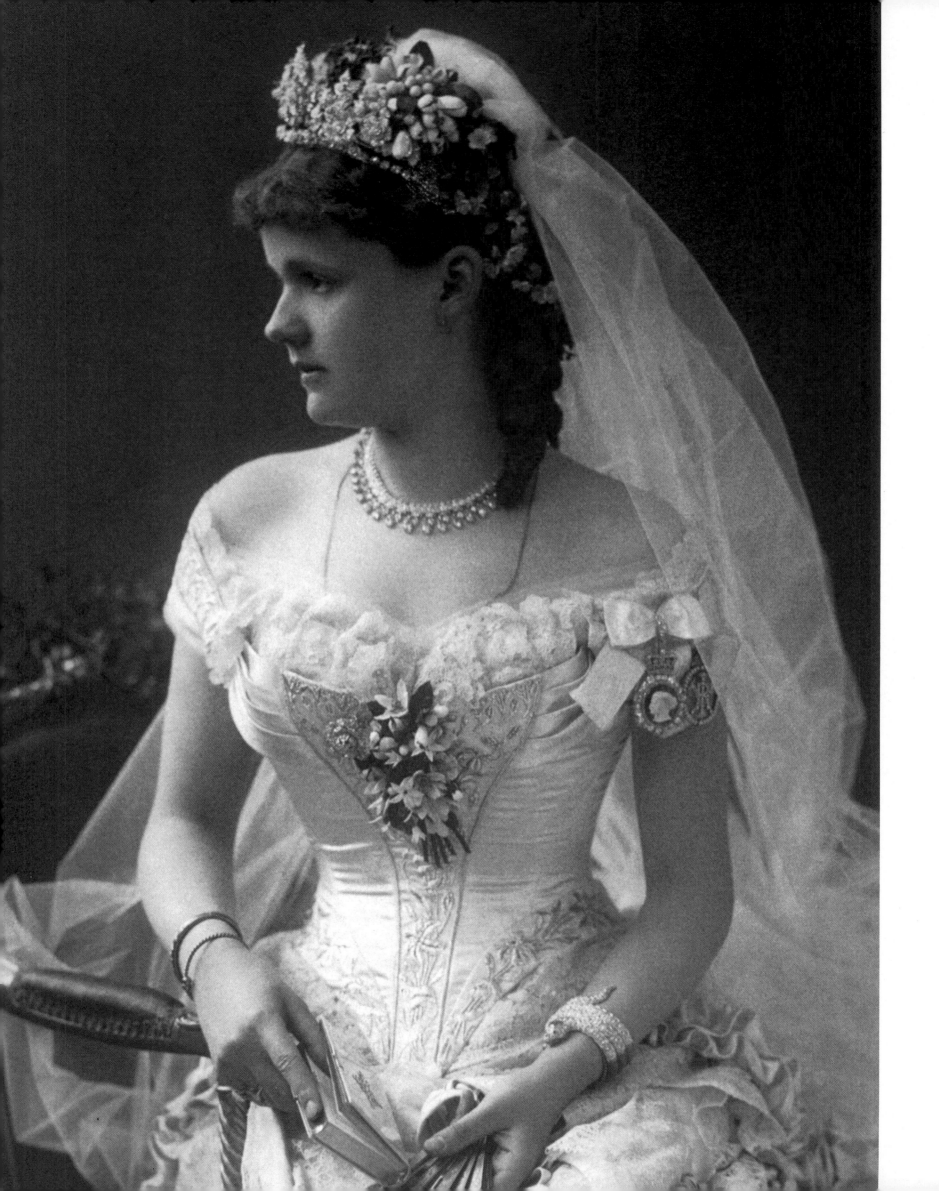

Godey's Lady's Book, 'the arbiter of middle-class women's culture.'[6] A unique phenomenon also began to be charted in the popular press. Emancipated American heiresses, whose wealth derived from the new railway, oil, and steel industries, were invading Europe hoping to obtain a title from one of the impoverished aristocratic dynasties. They were dubbed 'buccaneers' by the American author Edith Wharton. As one writer put it, 'any title was thought to be deliciously exotic. But the most avid title seekers were those eligible young American women who flocked to Europe on what were ostensibly educational trips, but who in private, one feels, were cherishing visions of notepaper and embroidered sheets decked with coronets, and of being addressed as "Your Grace", "My Lady", "Duchess" or "Countess".'[7] Successful matches included Jennie Jerome to Lord Randolph Churchill; May Goelet, daughter of a New York real-estate tycoon, to the ninth Duke of Roxburghe; and Maude Burke from San Francisco, who married Sir Bache Cunard, the shipping magnate. The wedding of 'Mrs. Turnure,' an American widow, to Lord Monson at the British Embassy in Paris was described in the American press as having 'pink flowers and palms decorating the altar and entrance of the church,' and the bride looking 'very handsome in white crepe-de-chine. Beautiful white lace and Irish guipure were encrusted in undulating fashion around the skirt, headed by mousseline roses. A white tulle hat, garnished with white plumes completed an effective ensemble.'[8]

Whether in Europe or America, any self-respecting wealthy bride wanted her gown to be created by Charles Frederick Worth of the House of Worth in Paris, an atelier particularly popular amongst heiresses from the plutocratic dynasties of the New World. As the English bridal magazine *Orange Blossoms* put it, 'Was ever an American girl who could afford it married in a gown built by any other man?'[9]

Charles Frederick Worth had been responsible for the look of one of the great society weddings of the late nineteenth century. Dubbed the 'Match of the Century,' the pairing of the fabulously rich American Consuelo Vanderbilt and the English aristocrat, the Duke of Marlborough, at St. Thomas Church, New York in 1895, was the perfect alliance of the new American dollar and the ancient aristocratic title. There had been a press frenzy, and the Vanderbilts were rumored to have employed a press agent to create much of the furore. As historians Gail MacColl and Carol Wallace point out, 'Some of the columns bore the stamp of a publicist. *The New York Times*, discussing the wedding preparations, noted that "the pews were to be decorated with floral torches that would recall the flambeaux on the old residences in London" – hardly an image to leap to the mind of the average New York journalist.' However, the press agent failed to prevent details (which were quite clearly wrong) of Vanderbilt's trousseau appearing in *The Times* newspaper, and Consuelo complained, 'I read to my stupefaction that my garters had gold clasps studded with diamonds and wondered how I should live down such vulgarities.'[10]

On the day, 300 police were needed to hold back the thousands of onlookers who thronged the streets hoping to glimpse the bride dressed in a satin and lace number by Worth, with the requisite fifteen-foot train. In a church bedecked with roses and lily of the valley, and to the strains of a 500-piece orchestra and sixty-voice choir, the ceremony should have heralded the union of two powerful families. But, as the bride started up the aisle, two things were immediately obvious: her face was tear-stained and the groom was considerably shorter – a good six inches, in fact.

OPPOSITE Ostentation was the hallmark of the aristocratic Edwardian wedding. The bride's highly structured and richly decorated gown presents her as a privileged object of conspicuous consumption displaying her family's wealth and social status.

RIGHT... This 1894 French fashion illustration depicts a bride surrounded by her attendants in a gown by Fourcillon. Her tiny waist, an obviously idealized image, has been 'achieved' by the corsetry of Madame Emma Guëlle.

Paris Journal des Demoiselle

Robes et Confections de Mesdames FORCILLON sœurs, rue Saint-

Parfums de la Maison GUERLAIN, 15

1er Oc'obre 1894.

et Petit Courrier des Dames réunis 14, rue Drouot

é, 165 (place du Théâtre-Français). — Corsets de Madame Emma GUELLE, 3, place du Théâtre-Français.

de la Paix. — TEINTURERIE EUROPÉENNE, boulevard Poissonnière, 26.

MacColl and Wallace see the Duke's height as 'a metaphor for the whole ugly phenomenon; an effete member of a dissolute family, coldly marrying a fresh, innocent American girl for her dollars rather than her charm.' By 1906 they were separated; they eventually divorced in 1920.

The success of the House of Worth meant that, even if a bride couldn't afford to go to the master himself, she had to have an appropriately 'French' wedding dress, and women's magazines in the 1890s and 1900s gave advice on how best to achieve it. The journalist Isabel A. Mallon, writing in the American *Ladies' Home Journal*, stated firmly that, 'Of all the people in the world the French are the ones who most positively combine sentiment and frocks,' and suggested that to evoke a typical Gallic flavor the bride had to wear a gown of 'white satin, heavy and lustrous' with 'a white tulle veil and orange blossoms.'[11] There were successful American bridal designers or 'modistes,' too. One of the most celebrated was a Mrs. Connelly, whose name frequently graces the pages of *Harper's Bazaar* in the late nineteenth century and who was responsible for designs such as a gown with 'an empress train and corsage of the richest brocaded white satin, with an apron of plain satin nearly covered with lace, pearl passementerie and bouquets of orange blossoms.'[12]

An alternative to the rather orthodox French style of wedding fashion was becoming available, though, created by the English dressmakers Lucile, Lady Duff Gordon and her contemporary, Ada Wolf, who were based in the East End of London. Lucile had originally made her name with luxurious lingerie designs, which she described as 'delicate as cobwebs and as beautifully tinted as flowers',[13] and she transferred this erotic aesthetic to wedding fashion, for the most part creating intimate underclothes for the bride's trousseau. Her first wedding-gown design was for her sister, the celebrated novelist Elinor Glyn, for her marriage to Clayton Glyn, a member of the Essex gentry, at the fashionable church of St. George's in Hanover Square, London. (Their honeymoon started with a romantic touch – Clayton rented the public baths in Brighton so his new wife could swim alone, wearing nothing except her long red hair.)

By the early 1900s, Lucile had become a renowned exponent of a style popularly dubbed 'Neoclassical.' The gowns shown at her salon in Hanover Square were sensuously draped and highly decorative, worn with matching white satin wedding corsets and incorporating embroidered panels with historical or natural references. Violet, Lady Hardy, describes the thrill of wearing a bridesmaid's dress designed by Lucile in the 1900s, 'made of the softest gauze net with innumerable frills of narrow lace, like a baby's robe crowned by the lightest of burnt straw picture hats with one lovely pink rose, ties with black velvet ribbon.'[14] This particular genre of wedding fashion was inspired in part by the flowing 'art gowns' that had been produced for Liberty's department store in London at the turn of the century in Arcadian (Greek-reproduction), 'medieval,' or Celtic modes covered in lace, appliqué and art nouveau embroidery. Arthur Lasenby Liberty had founded his store in 1875 as a showcase for imported Oriental goods, and his customers included the artistic and aesthetic elite. By the end of the nineteenth century he had branched out into production – most famously textiles but also 'artistic' furniture, jewelry, and fashion influenced by not only his travels in the East but the Arts and Crafts movement back home in Britain. Liberty wedding gowns were popular in the 1900s and featured embroidery influenced by the work of Scottish artist Anne

OPPOSITE Bessie Wallis (later the infamous Wallis Simpson) in 1916 on her first wedding day. She was to marry twice more. King Edward VIII – her last husband – was forced to abdicate the British throne for her.

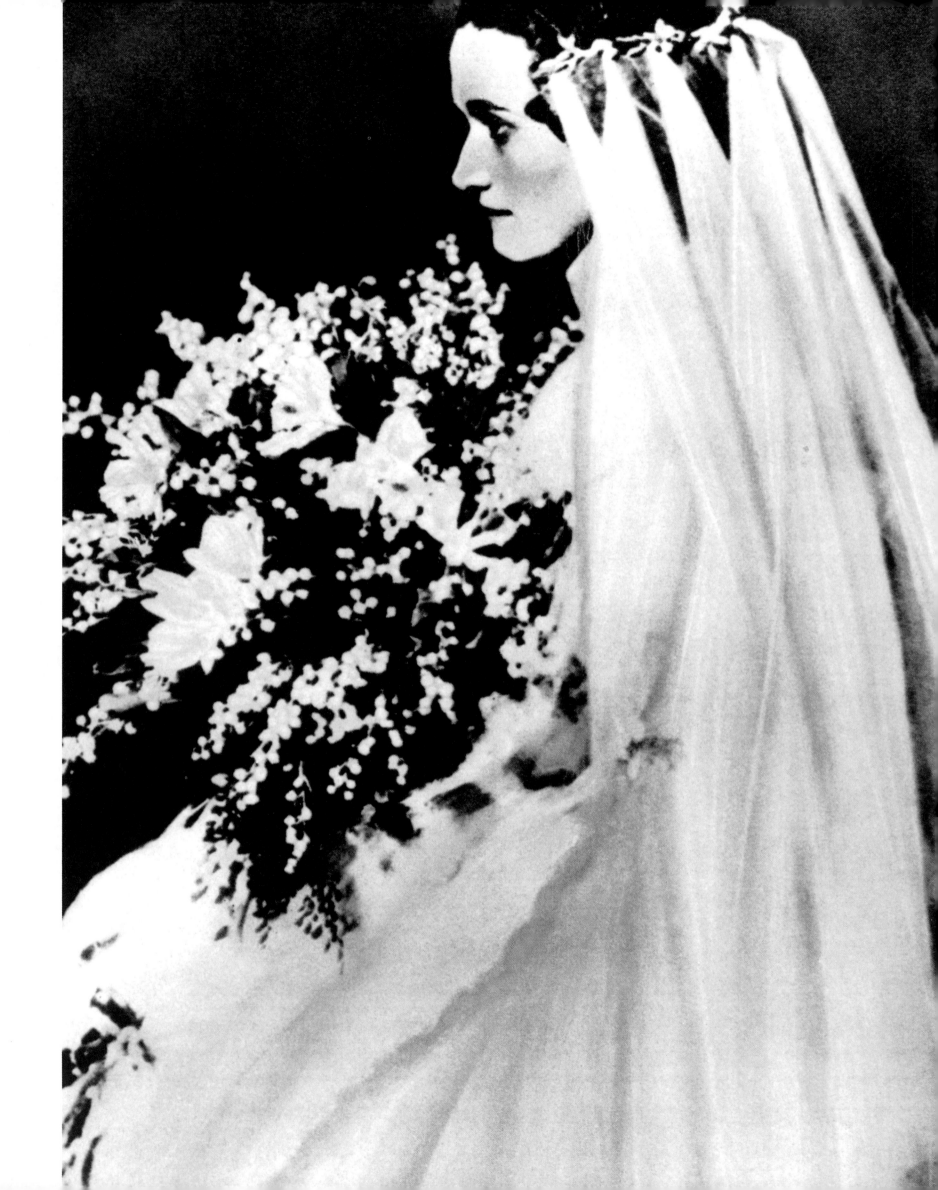

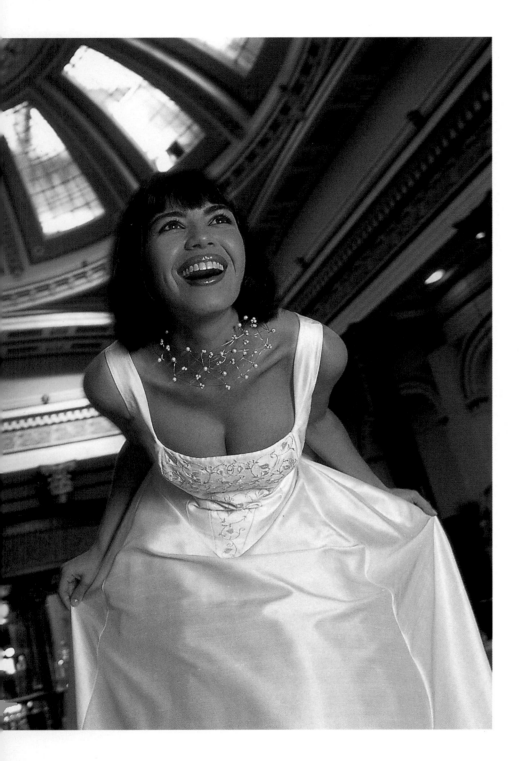

Macbeth, who designed loosely draped 'aesthetic' fashions of linen and cotton that were then embroidered with her characteristic Celtic motifs. Her colleague Jessie Newbery designed her own wedding gown, which was described in the Glasgow press as a 'robe de style' or 'picture gown.' The gown does not survive, but a similar dress, which she made after her marriage, was 'of fine, green corded silk, with white chiffon slashed inserts in the sleeves and a square neck edged with black pearls, the whole dress lined with alpaca.'[15] A key feature of a Newbery gown was to do away with waistbands. Instead, skirts were suspended from the bodice, which had no tailoring darts, giving the whole dress a loose, comfortable fit that was at odds with the trussed-up look of mainstream fashion.

Typical features of a more mainstream 'artistic' wedding gown included medieval-inspired flowing sleeves that covered most of the hand, high waistlines juxtaposed with low hip-belts, plenty of beaded braid, and (most evocatively) nun-like veils that covered most of the head and neck, leaving only the face itself to glance out shyly as befitted the timorous virgin bride. Fashion historian Madeleine Ginsburg describes a typical Ada Wolf design of 1914 worn just after the declaration of the Great War of 1914–18. The ivory silk lace gown is 'elaborate, escapist and consciously picturesque; a fashionable short jewel edged tunic mounted over heavy lace, the train lined with a ruche of pink tulle and edged with a waterfall of frills.'[16]

The vogue for wearing an 'artistic' wedding dress continued until well into the 1920s and the most photographed and illustrated of

LEFT The tightly encasing bodice with nipped-in waist was a popular look in Edwardian times. Modern fabrics and patterns now make such gowns far more comfortable, as shown by this carefree, laughing bride dressed by Edinburgh-based designer Lorraine Weselby.

this type was the gown worn on November 26, 1923 by Lady Elizabeth Bowes-Lyon (now known as the Queen Mother), daughter of the Earl of Strathmore, on her marriage to the Duke of York, later to be crowned George VI. Designed by Madame Hanley Seymour and described as 'medieval Italian in influence,'[17] the gown was made from ivory chiffon moiré with silver lamé bands ornamented with seed pearls, with shoulder and waist trains. The bride teamed it with a veil of *point de Flanders* lace, which had been provided by Queen Mary. Nigel Arch and Joanna Marschner, curators of the Court Dress Collection at Kensington Palace, consider this gown as a simple one by royal standards: 'The dress had a deep, square neckline with a narrow piped edge. The sleeves were similarly trimmed. The bodice was cut straight to the waist, with no darts, and the back extended to a separate train. At the front, the skirt was gently pleated into the waist seam. Down the front of the dress was an appliquéd bar of silver lamé' with horizontal bars arranged over the bodice to form the appearance of a stomacher; each bar was decorated and edged with gold embroidery and pearl and paste beads. The train at the back, integral to the dress, extended some ten inches beyond the hem and spread eighty inches wide. Over this was worn the train of antique lace by Queen Mary. The veil, of similar lace, was secured by a simple wreath of orange blossom.'[18]

Thus, early twentieth-century wedding dresses tended towards the elaborate, even though, as fashion historian Madeleine Ginsburg comments, 'etiquette books might moralise about ostentation and recommend a pure simplicity. On the whole their advice was disregarded except by the poorest or the most thrifty. Brides wanted a special dress, usually elaborate and above all fashionable, for the crowning day of their girlhood – their wedding day.'[19] At the same time, in an era of conspicuous consumption, the more highly crafted the gown the better, and yards of handmade or, better still, antique 'family' lace took precedence over the obviously cheaper machine-made – in fact, weight for weight handmade lace was more expensive than gold.

Lace – that is, the intricate interlacing and braiding of fine cotton threads – had been regarded as an art form since the seventeenth century and because of the painstaking hours of handwork which went into the production of the best quality was phenomenally expensive. Thus it became the fashion up to the nineteenth century for both men and women to use great quantities of lace in their clothes as a display of wealth and sophistication, particularly Brussels or *point d'Angleterre* lace, which was of exceptionally high quality and used primarily in royal courts. Gradually, the tradition grew of handing fine lace down as an heirloom from generation to generation, and by the Edwardian era it was given to a bride to be incorporated into her apparel, either in the form of a veil or as a decorative part of the wedding gown. The effect was one of enhanced femininity, for by the early twentieth century lace was only used in female fashion. It also, of course, displayed a family's affluence – weddings were used as an excuse to 'get out' the family lace.

Together with lace, a myriad of decorative detailing such as narrow tucks and silver or gold thread-work was used to give the impression of what one bride of the time described as 'overpowering finery,'[20] shown in this description of a 'richly trimmed bridal dress' of 1911: 'Miss Rawson's dress was of lily white satin, with a drapery of fine old Brussels lace forming a crossed fichu bodice. The vest and collar band were also of old lace and ruffles foamed at the elbow in quite a Louis Seize fashion, while the undersleeves were also of lace cut from a deep flounce.'[21] The tradition of the wedding gown as an expensive 'one of a kind' was being set firmly in place.

Fashionable wedding-dress designs were extremely labor-intensive, resulting from days of skilled handwork, cutting, fitting, and finishing by poorer women. According to the historians Jane Beckett and Deborah Cherry, 'The power, therefore, of middle and upper-class women to signify by their dress their social position, wealth and class and their construction in femininity was based on the labour and expertise of working-class women.'[22] When Lady Violet Manners was preparing to marry the Duke of Rutland in 1911, she suddenly decided a few days before the wedding to have her and her groom's family crests embroidered into her gold tissue train – we can well imagine the sleepless nights of the poor needlewoman obliged to conform to her demands.

The bride and her attendants underwent hardships, too, but for the sake of fashion rather than economy. Wedding hairstyles, for instance, could be incredibly complex, as the feminine ideal at the time called for enormous hairdos, padded out with false pieces called 'transformations' and requiring the frequent attentions of a maid. Lady Violet Hardy wrote of 'Enormous hats often poised on a pyramid of hair, which if not possessed was supplied … Pads under the hair were universal and made heads unnaturally big. This entailed innumerable hairpins.'[23] Before a wedding, the demand for the services of a particular hairdresser could be so great that many wedding guests had their hair dressed from up to two days in advance and had to spend an uncomfortable couple of nights sitting upright in a chair in order not to ruin the effect.

As the domestic space was seen as the appropriate sphere for women – despite the increasingly militant protestations of the suffragette movement – marriage and the wedding ceremony sanctified this traditional notion of femininity. The ritual of the wedding stressed that a woman's place was as wife and mother rather than outside of the home as a single, independent woman, and it is no great coincidence, at a time of increasing objections to the domiciled and subjugated state of women by feminists in Europe and America, that weddings became more ostentatious, formal, and fixed in their rituals. Women were being reminded of their place within culture – as blushing brides. Some women were prepared to resist, though. One writer suggested that 'Marriage which looked at in anticipation presents itself as a way out, but proves often but a second underpaid employment added to the first,'[24] and the actress and suffragette Cicely Hamilton argued, in her book *Marriage as a Trade* (1909), that marriage was predicated on the economic, sexual, and social subjugation of women. This was perhaps unconsciously symbolized in a short-lived fashion in wedding headdresses where the flowers on the wreath that swathed the head were twisted onto wire stalks, which caused them to tremble as the bride made her way up the aisle, thus symbolizing her internal trepidation at what she was letting herself into.

The Edwardian era was therefore a time when women were debating the validity of marriage as an institution. In her classic book *Love and Marriage* (1911), the Swedish feminist Ellen Key wrote that women should 'regard men merely as a means to a child.'[25] The historian Sheila Rowbotham cites a 'rebellious minority' who 'set out to defy convention by opposing marriage in their own lives. They included anarchist women like Rose Witcop, from the East London Jewish community, who lived in a free union with the anarchist Guy Aldred, and the witty socialist feminist writer Rebecca West, who was to have a child with H.G. Wells.'[26] Rowbotham describes vociferous groups of women with 'advanced views' who

OPPOSITE Ian Stuart's bride seems to have stepped out of a nineteenth-century painting by Winterhalter, the extravagance of her gown intensified by the use of the color red. The theatricality of the design aesthetic makes it clear that today's wedding dresses are for one day and one day only.

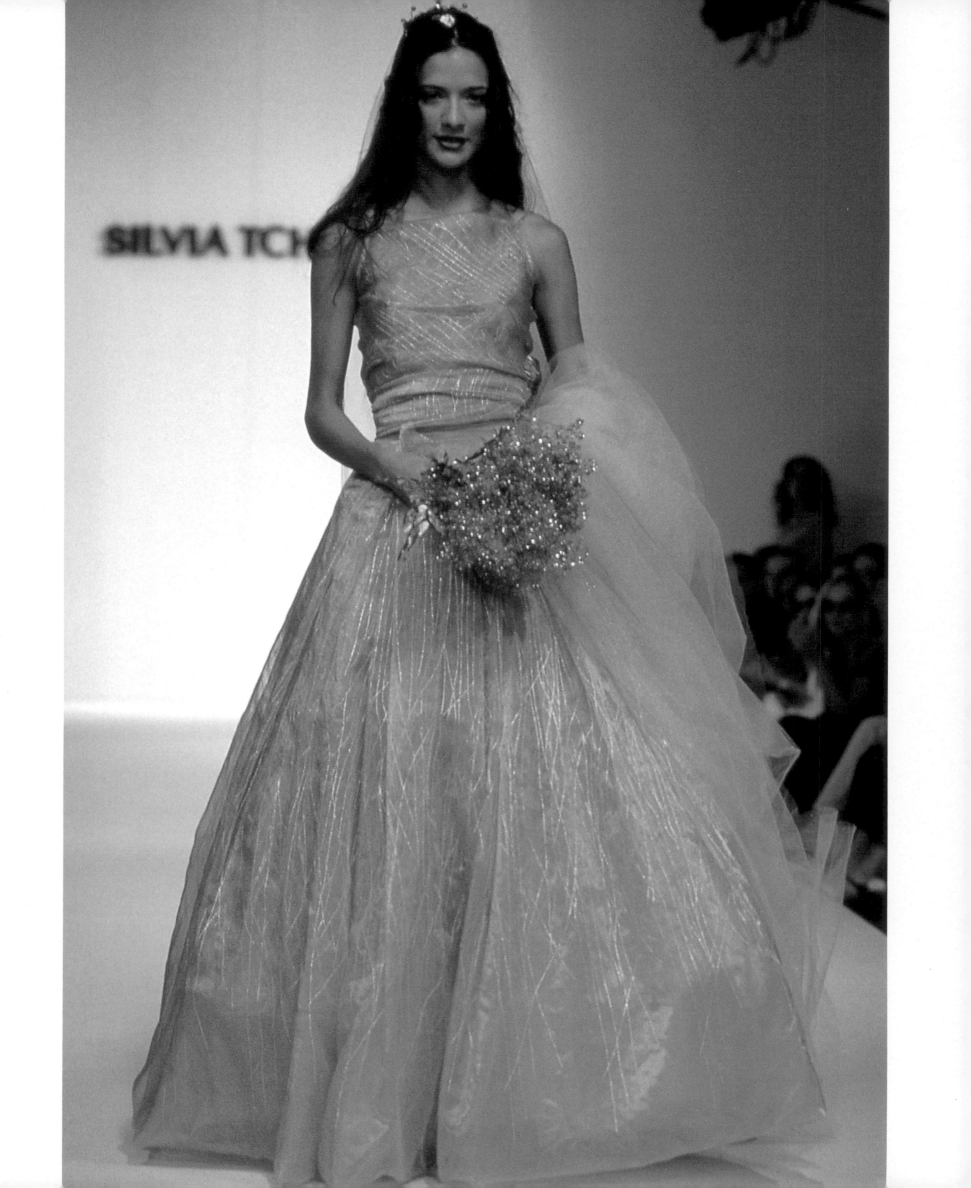

'were to be found debating marriage and free love, adopting short hair and artistic styles of house decoration and clothing in provincial cities and small towns' – a radical culture allied to both the suffragette and socialist movement.

It is significant that, amid radicalism and calls for social change, the wedding ceremony became even more of a significant event in the Edwardian age. Instead of the typical Victorian ceremonies, which took place without publicity (as befitted a modest bride), illustrations and photographs documented the event, wedding cakes became monstrous confections of sugary icing, and some customs were quite simply invented, such as the giving of jewelry to the bride and bridesmaids by the groom and the giving of money instead of gifts.

This increasingly formal attitude to love and marriage reached into all sectors of society, banishing the rituals of courtship that had been in place for generations. In the past, sexual relations between men and women who intended to marry was usually tolerated (particularly in working-class families and in rural areas as part of the traditional betrothal system). However, change was afoot and, as the historian Steve Humphries writes, 'under the influence of Victorian sexual taboos, the first half of the twentieth century was to be a period of intense sexual self-restraint and sexual guilt among very young people who were "going steady".'[27] However, this did not mean that sex was now off the agenda – it now became a guilty, hidden affair and relationships between unmarried couples began to follow a strict etiquette of 'do's and don'ts,' which were regulated by parents. Thus, long periods of engagement were in, sex before marriage was out of the question and the average age of marriage for men and women was the highest it had ever been: 24 for the bride and 27 for the groom. Law required parental permission before anyone under the age of 21 could marry (and this was rarely granted).

Edwardian courtship was controlled and regulated by parents, who would have a say in the initial choice of partner. Any suitor would then have to ask formal permission to take a girl out for the evening, sometimes in the form of a letter to her father. Prospective boyfriends would be vetted over Sunday tea and, if all went well, a lengthy period of courting and engagement would ensue, where sexual self-restraint had to be practiced at all times. After all this, the wedding achieved an importance it had never had before and became, as Steve Humphries suggests, 'an increasingly elaborate marriage ceremony which celebrated the virgin bride ... the product of a new sexual conformity and uniformity.'[28] He continues: 'Increasing state intervention which included compulsory schooling in urban and rural areas and the growth of the media industries which popularised middle-class ideology led to the disappearance of "the informal" and "immoral" sexual customs which had originated in the countryside. Common law marriage or "living tally" as it was known; "besom" weddings, a secular right that allowed self-marriage and self-divorce; bundling and night visiting where courting couples slept together before marriage; and the old rural tradition of pre-bridal pregnancy, a test of fertility; all these traditions and others, quite common among the poorer classes, were little more than memories in most areas. By Edwardian time the values of sexual purity and sexual respectability, championed by the church, the state and the middle classes had penetrated all but the very lowest and very high echelons of society.'[29]

OPPOSITE Radiant in a shimmering gown of golden silk, the bride as dressed by designer Silvia Tcherassi looks at once contemporary and romantic. Tcherassi takes on tradition by using gold instead of the more traditional white.

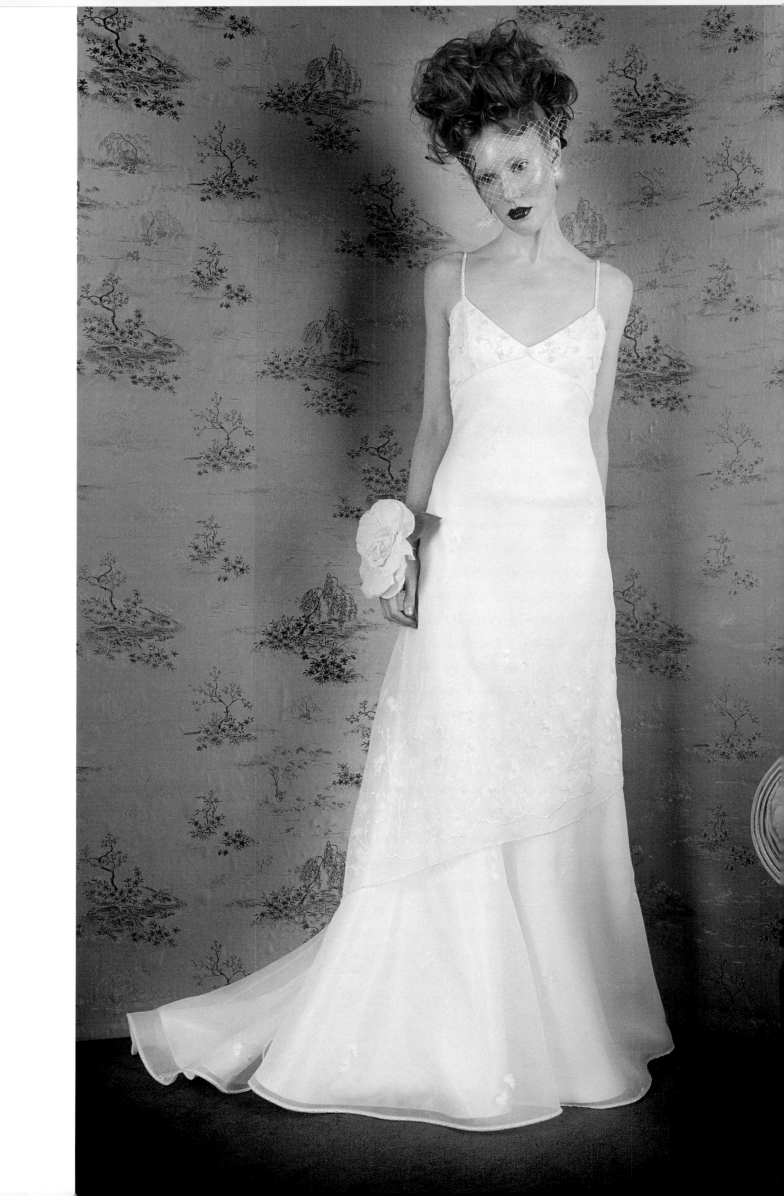

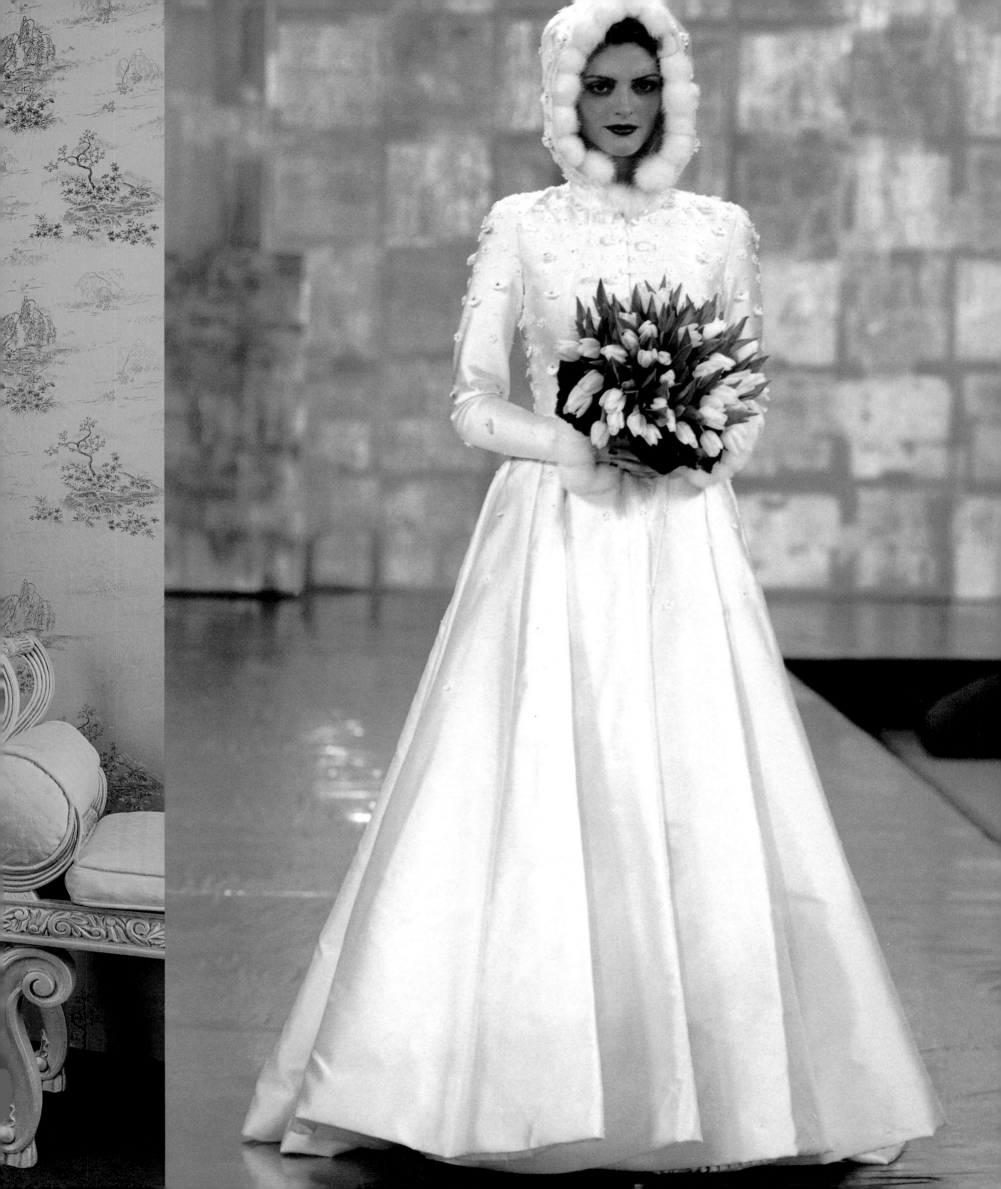

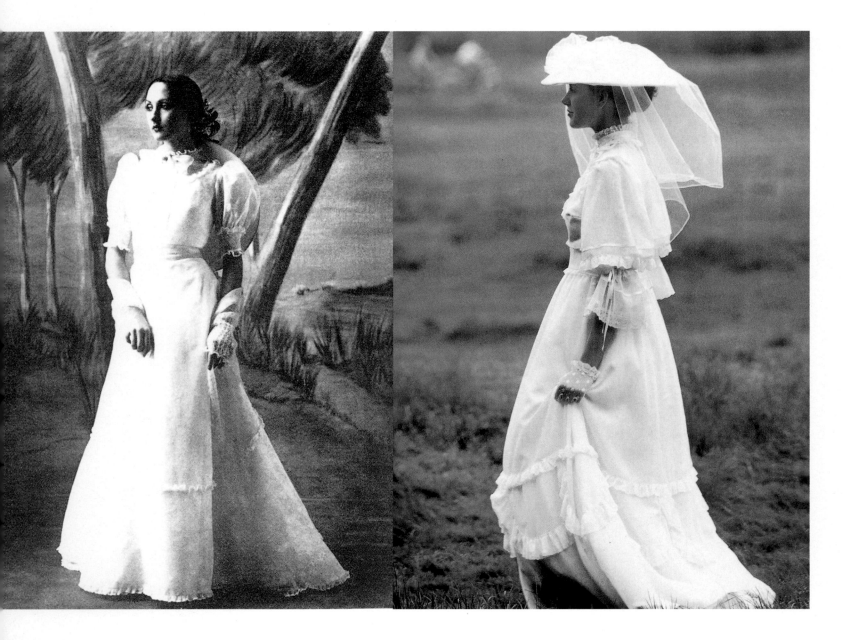

PREVIOUS PAGE... (Left) With her softly piled hair and demure look, this bridal image (by Cocoe Voci) displays the perennial fascination with all things Edwardian. (Right) In the tradition of haute couture, British designer Tomasz Starzewski ends with a bride in the finale to his show. She sports a full organza skirt with a fitted bodice, from which embroidered flowers stand in three-dimensional relief. The fur-trimmed hood and cuffs recreate a romantic image of nineteenth-century ice-skating outfits – a perfect look for a winter bride.

ABOVE & OPPOSITE... In the 1970s, British designer Laura Ashley tapped into hippie nostalgia for a lost Arcadian rural past to produce an immensely successful series of Edwardian-inspired gowns that typify that decade's look. Based on the informal tea gown rather than the early twentieth-century wedding gown itself, Ashley's dresses were worn at all sorts of formal functions.

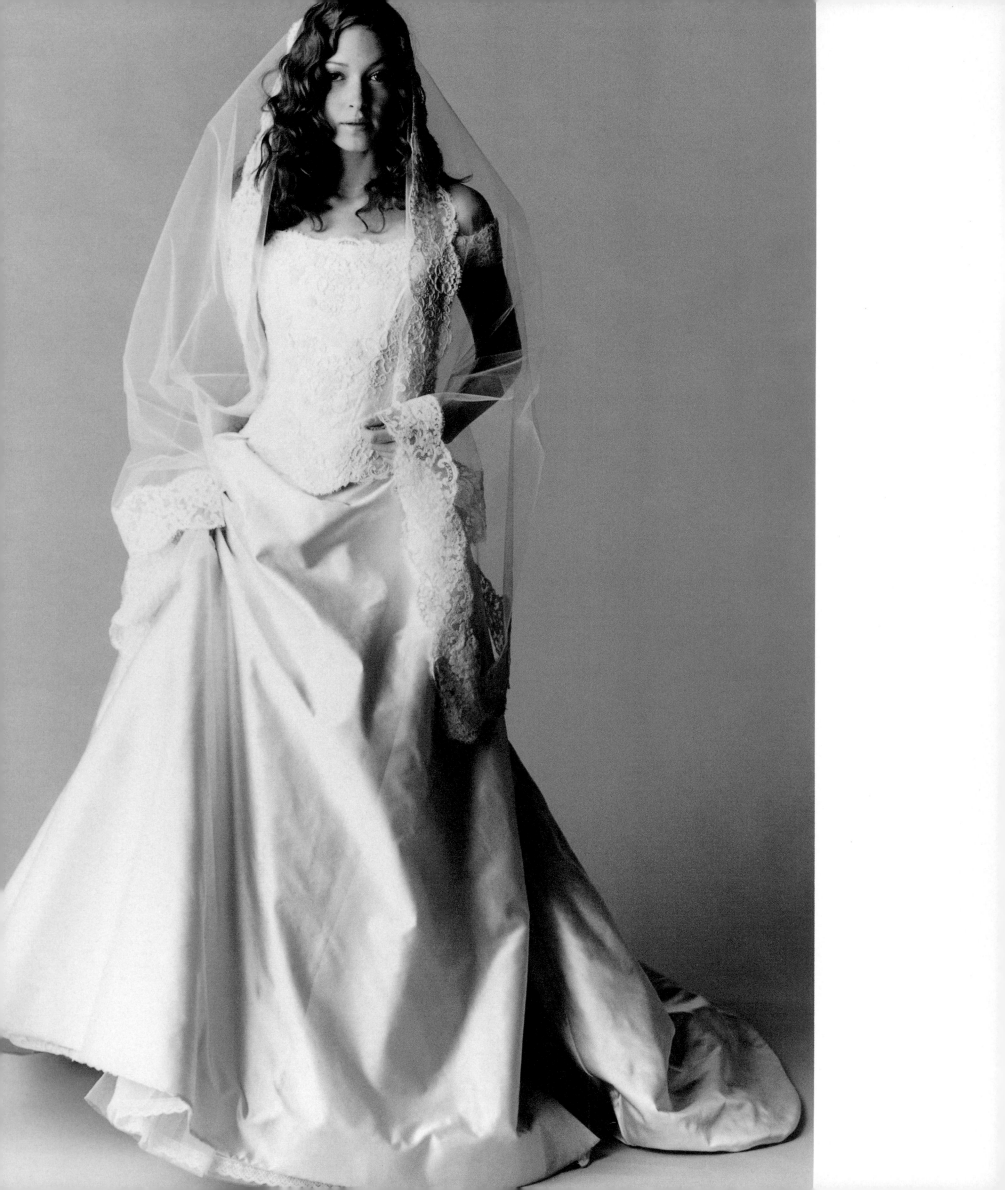

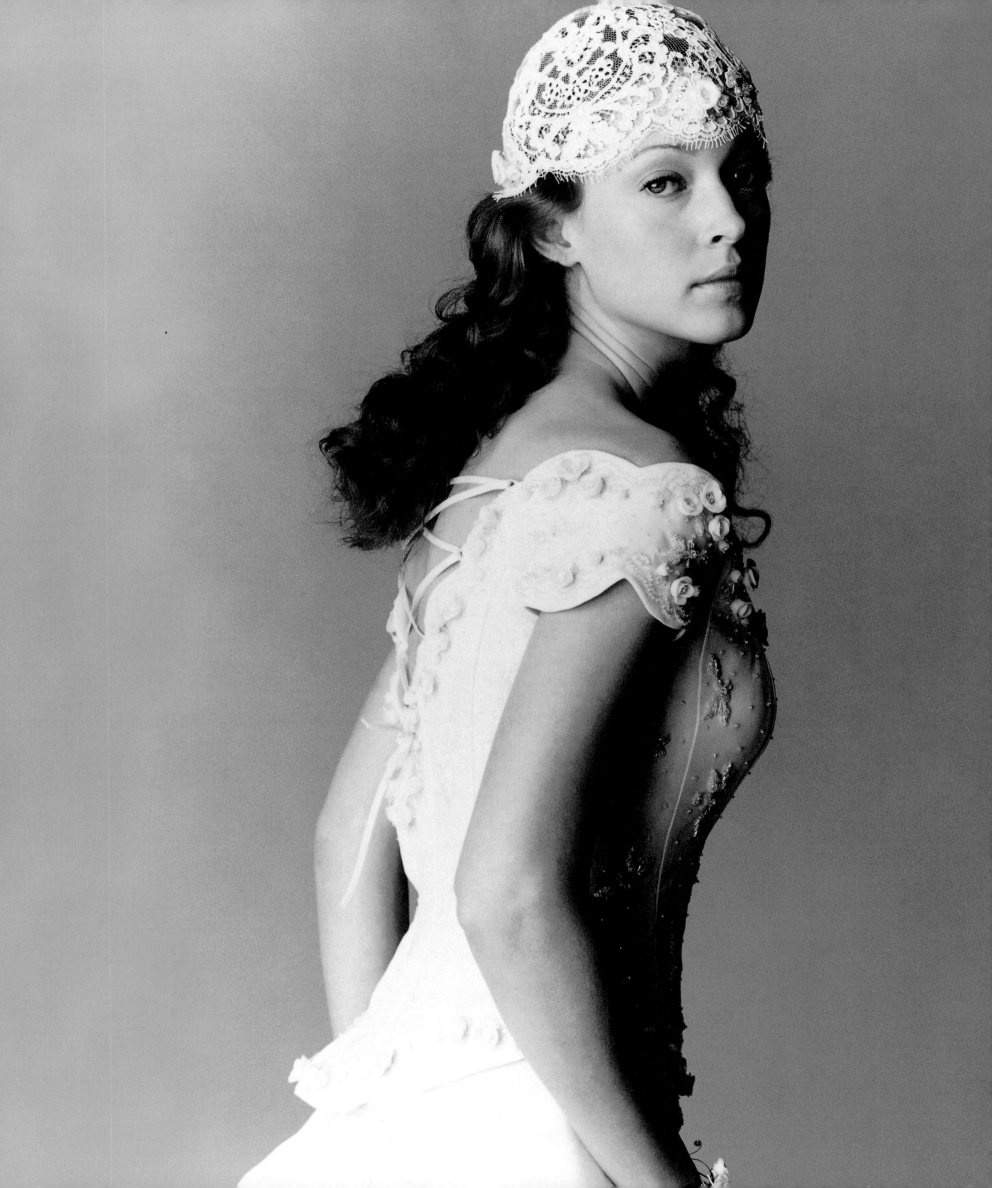

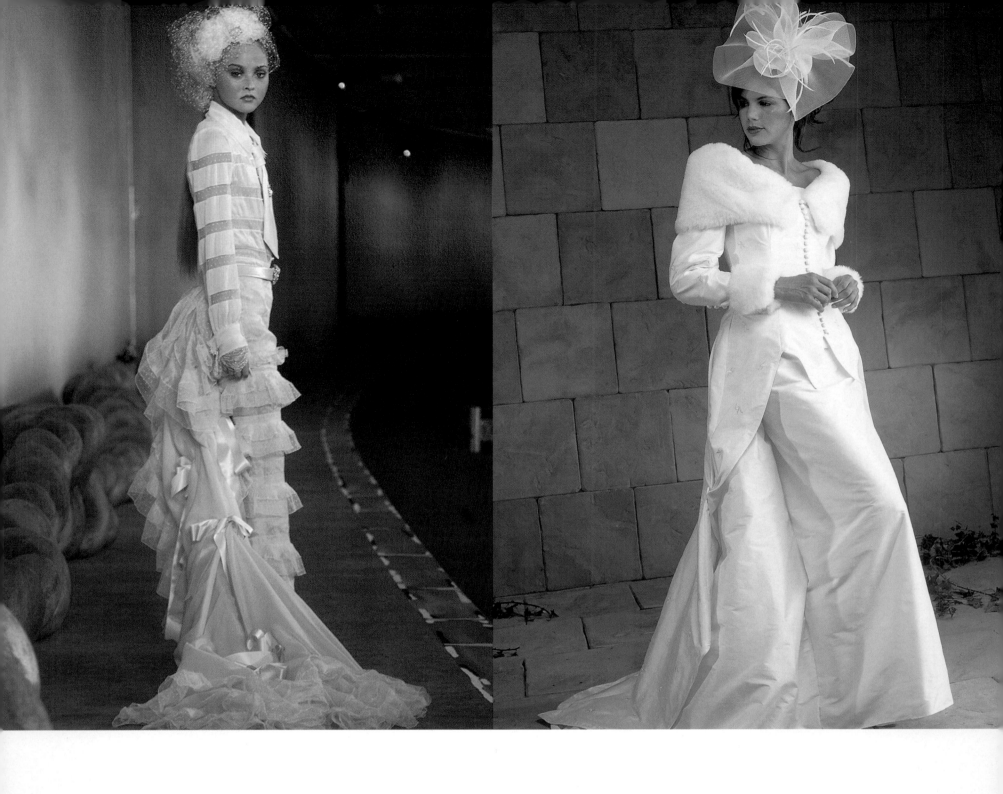

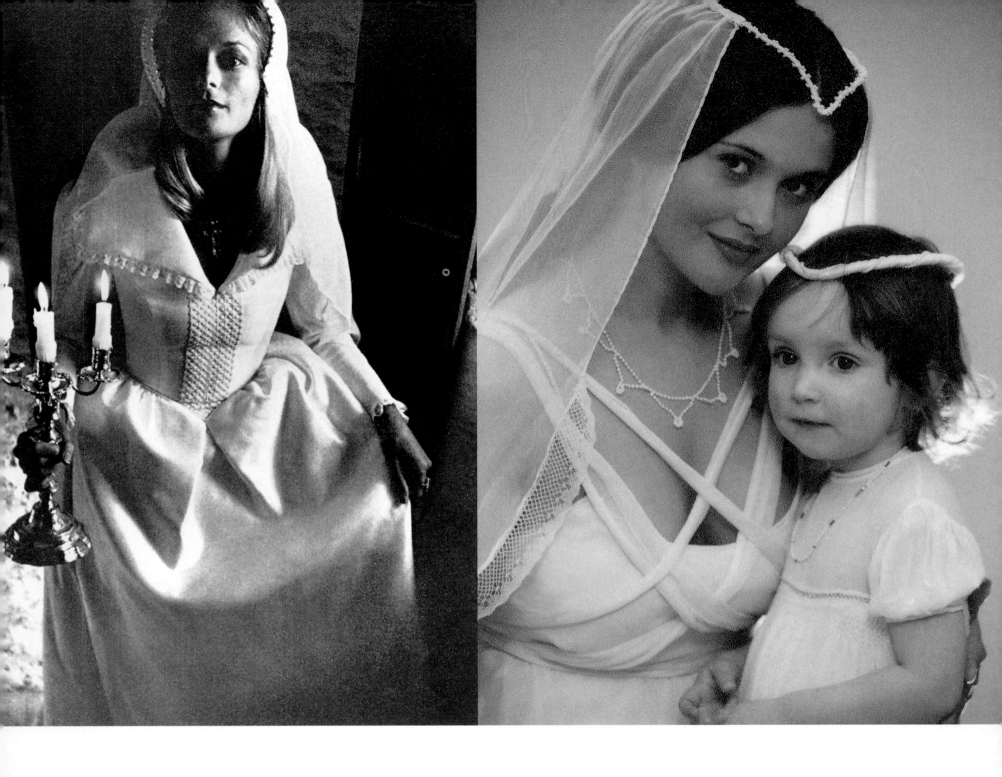

PREVIOUS PAGE... Two traditional designs by Atelier Aimée using historical references for fairy-tale effect. The bell-shaped skirts with integral trains find inspiration from the early twentieth century and provide a contemporary version of the Edwardian silhouette.

OPPOSITE & ABOVE... Four contrasting brides who display the many historical references used by designers. From left to right: An example of Chanel haute couture incorporating a nineteenth-century bustle; Donna Salado subverts the male frock coat to glamorous effect an image of Mary Queen of Scots is suggested in this 1971 image photographed for *Vogue* by Dick Zimmerman; pearls by Coleman Douglas have been used as an alternative to the wedding tiara.

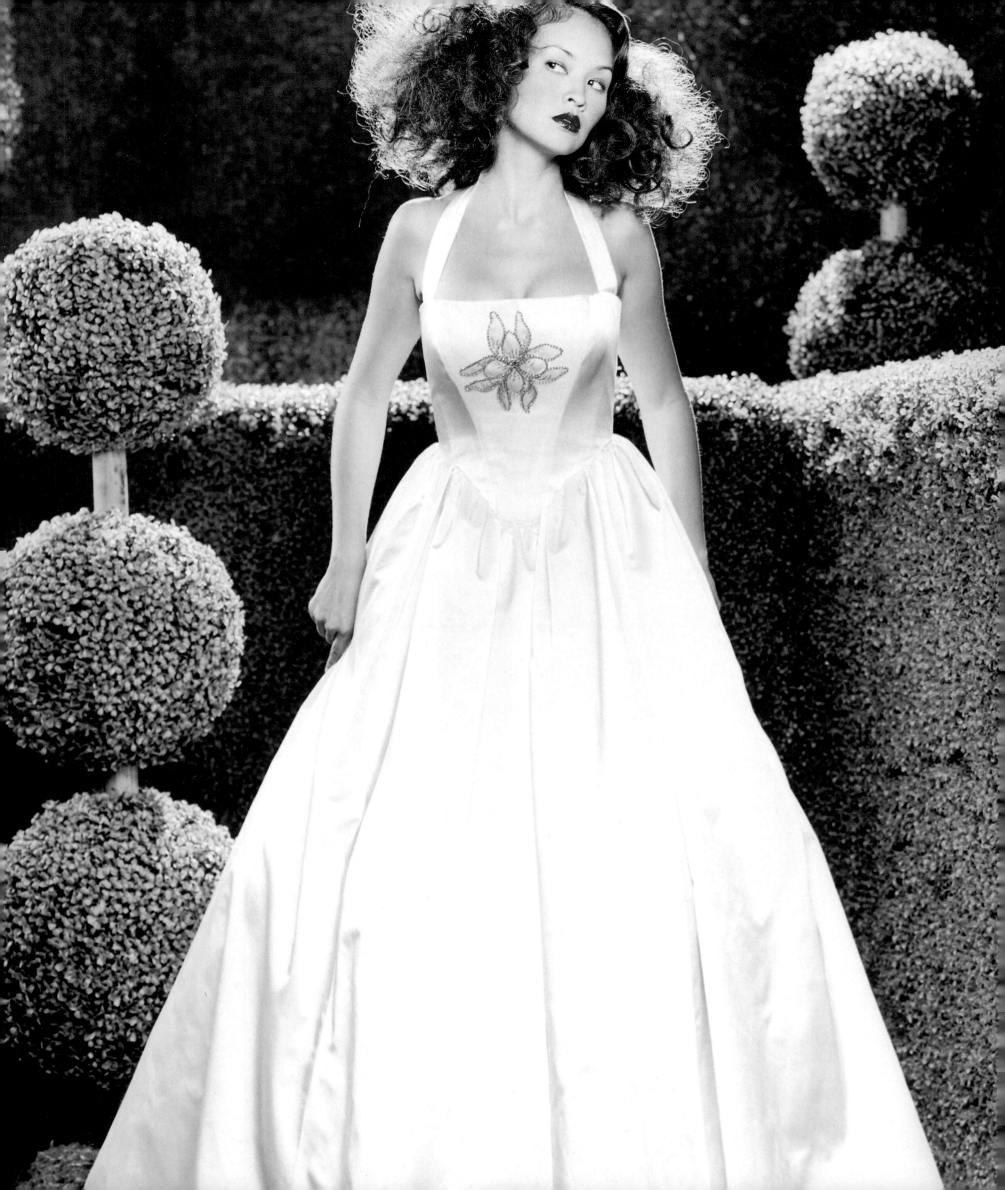

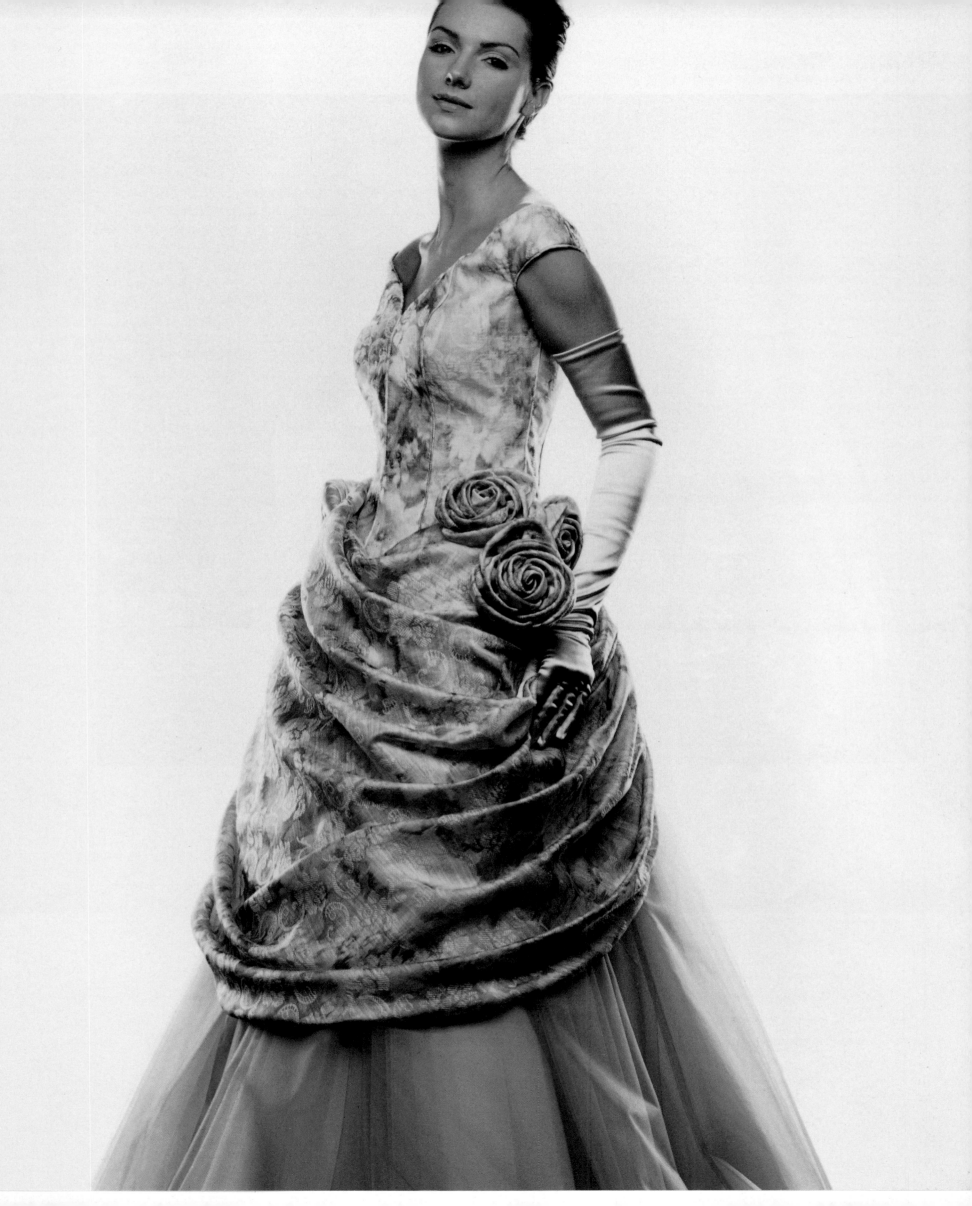

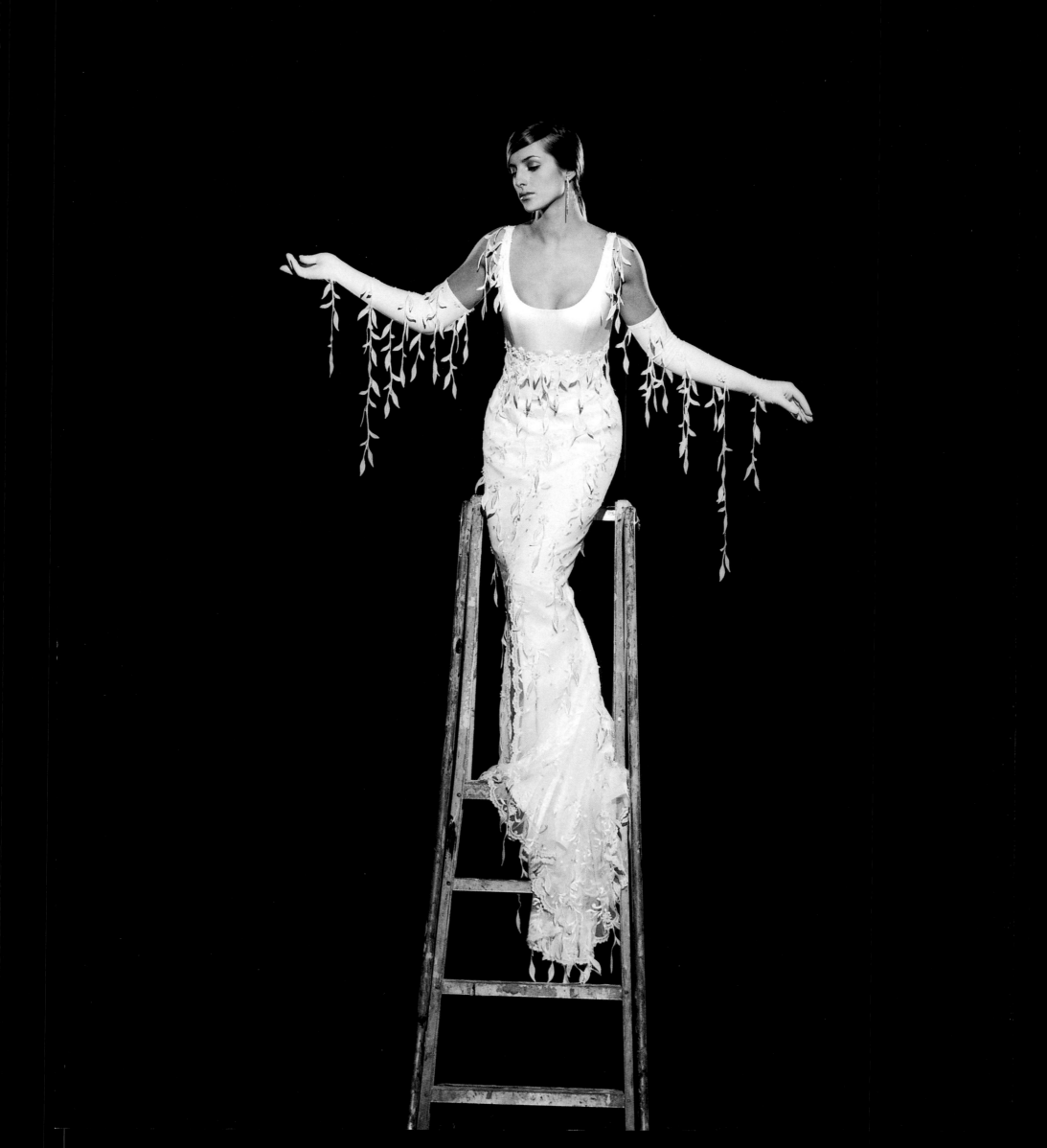

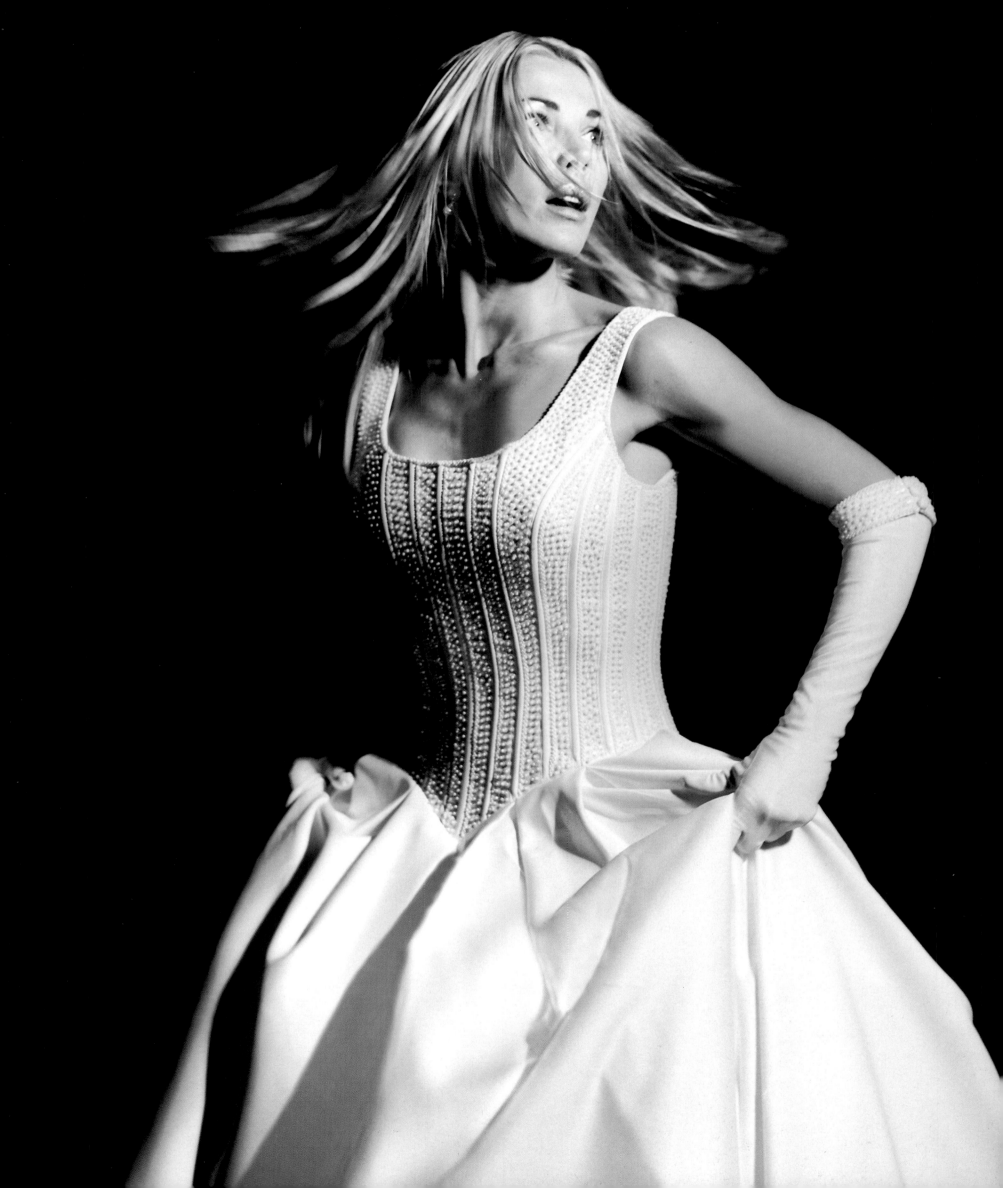

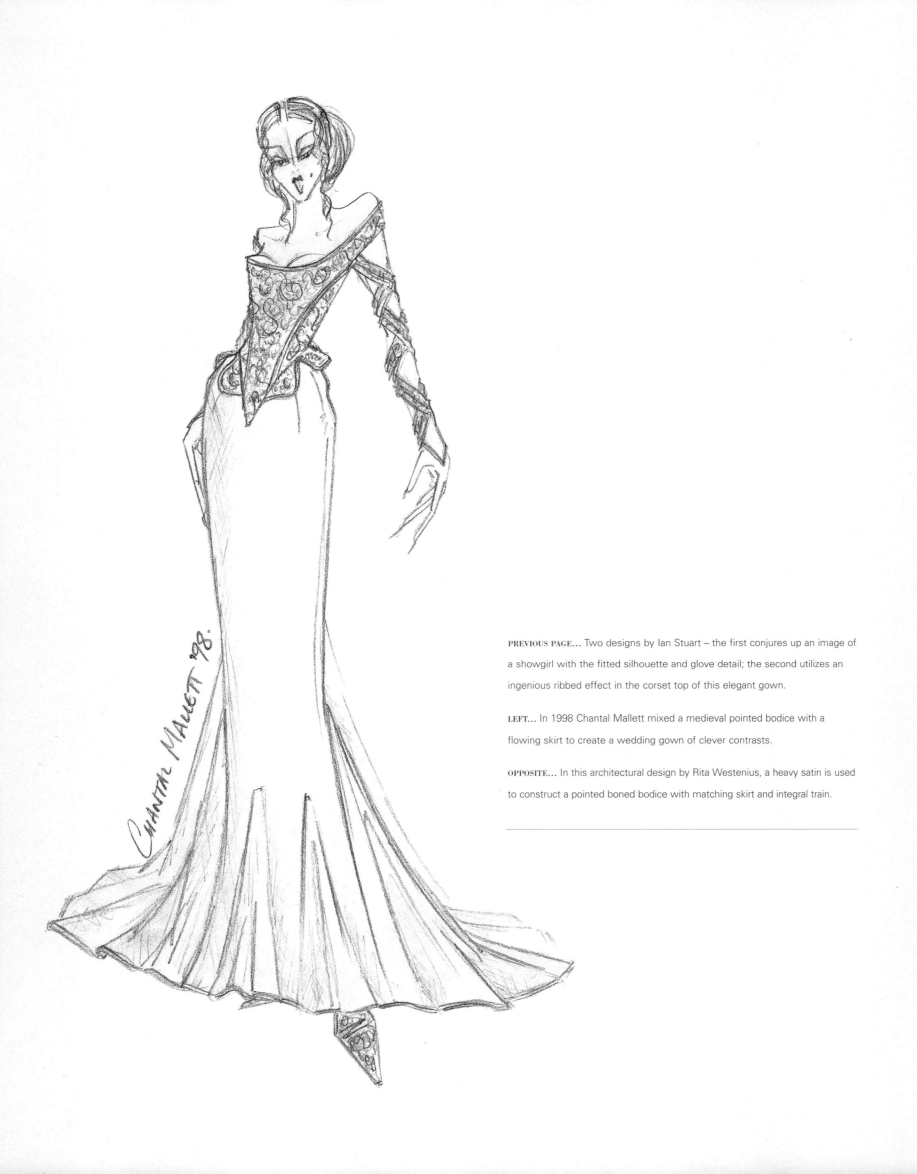

Chantal Mallett '98.

PREVIOUS PAGE... Two designs by Ian Stuart – the first conjures up an image of a showgirl with the fitted silhouette and glove detail; the second utilizes an ingenious ribbed effect in the corset top of this elegant gown.

LEFT... In 1998 Chantal Mallett mixed a medieval pointed bodice with a flowing skirt to create a wedding gown of clever contrasts.

OPPOSITE... In this architectural design by Rita Westenius, a heavy satin is used to construct a pointed boned bodice with matching skirt and integral train.

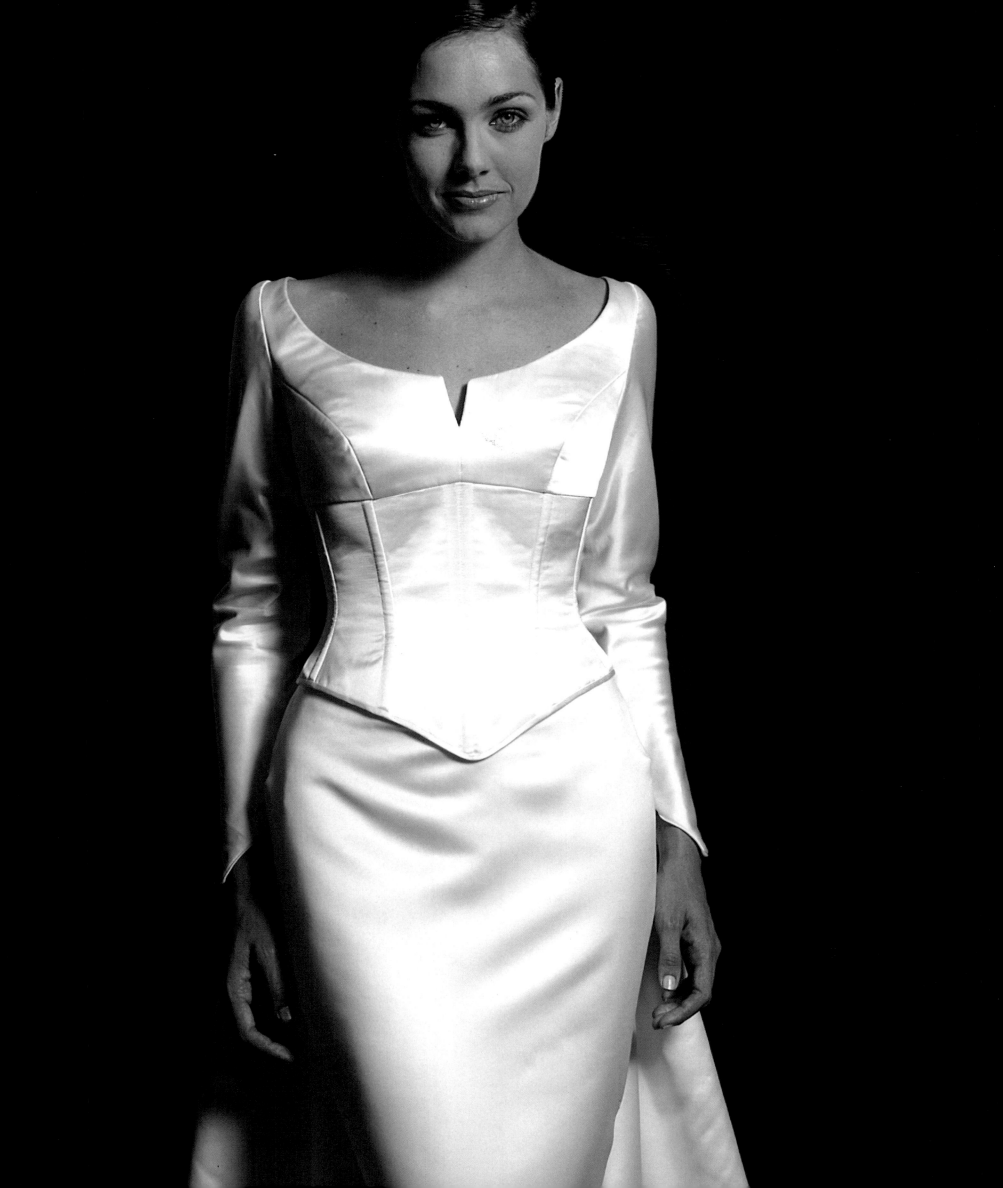

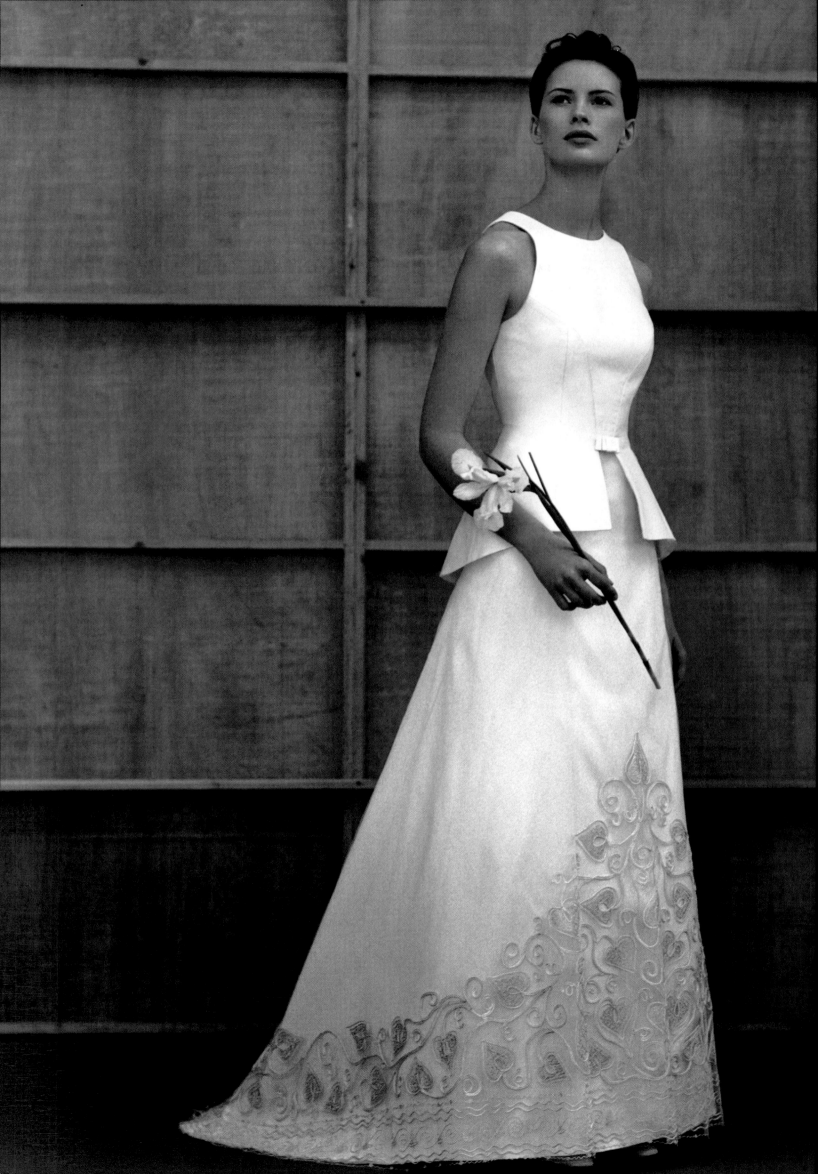

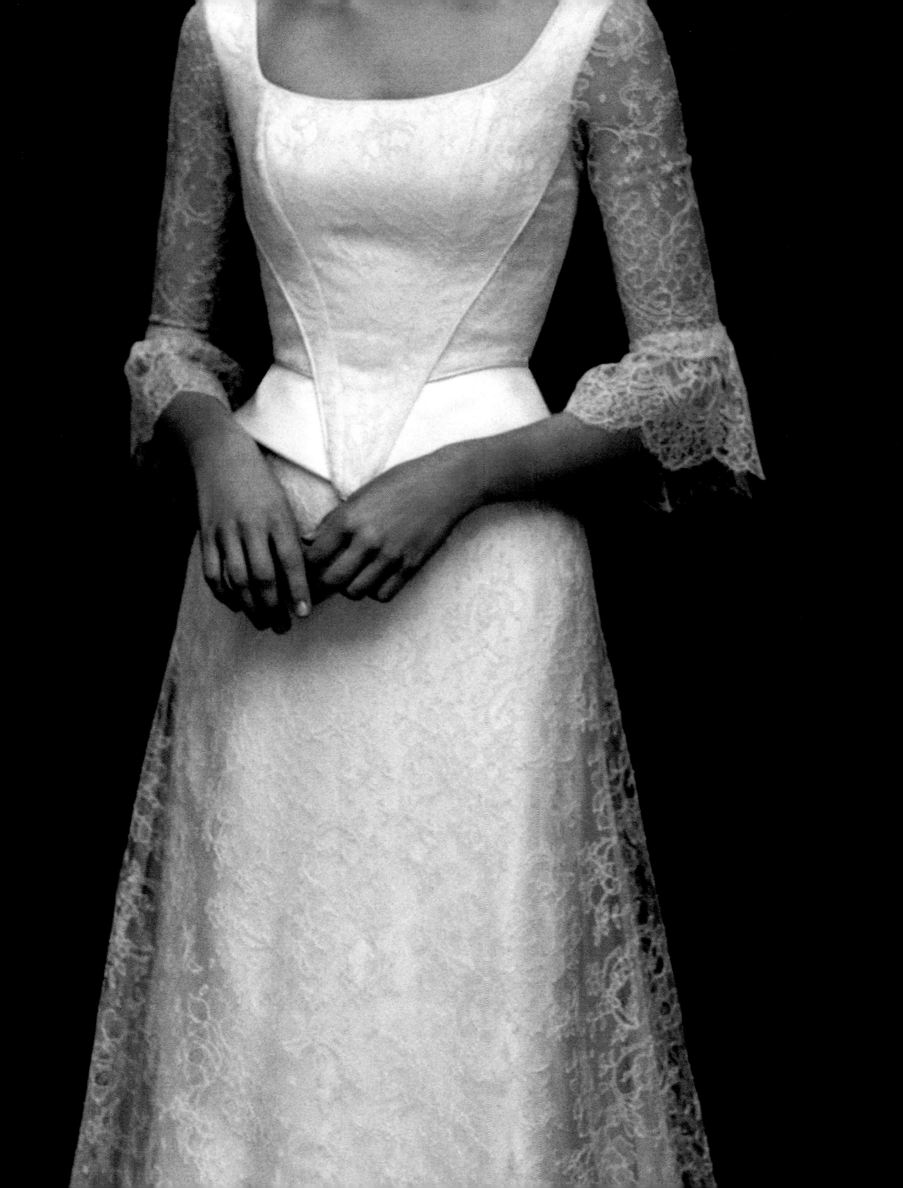

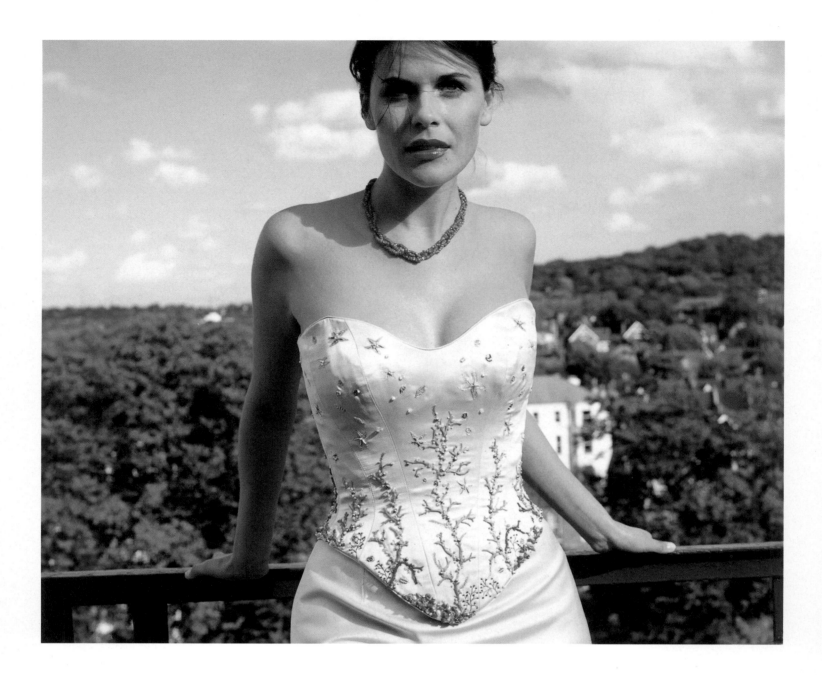

PREVIOUS PAGE... (Left) A Jesus Peiro design of 1999 in which the bodice and skirt are made from two separate pieces of dupion silk. The simple bodice with peplum and front detail creates an effect akin to body armor, but the look is softened by the fleur-de-lis embroidered detailing on the skirt. (Right) In this evocative bridal gown, Peiro uses a combination of Elizabethan-style bodice and nineteenth-century peplum with eighteenth-century elbow-length lace sleeves. A transparent look is achieved with the use of a simple silk skirt overlaid with lace – except for the arms, where the bride's flesh is made visible.

ABOVE... The simple shape of this bodice and skirt by Allison Blake is given a luxurious finish with the intricately embroidered motifs taken from nature.

OPPOSITE... Contrasting starkly with the architectural modernity of Sydney Opera House, this wedding dress by Maggie Sottero is steeped in nostalgia.

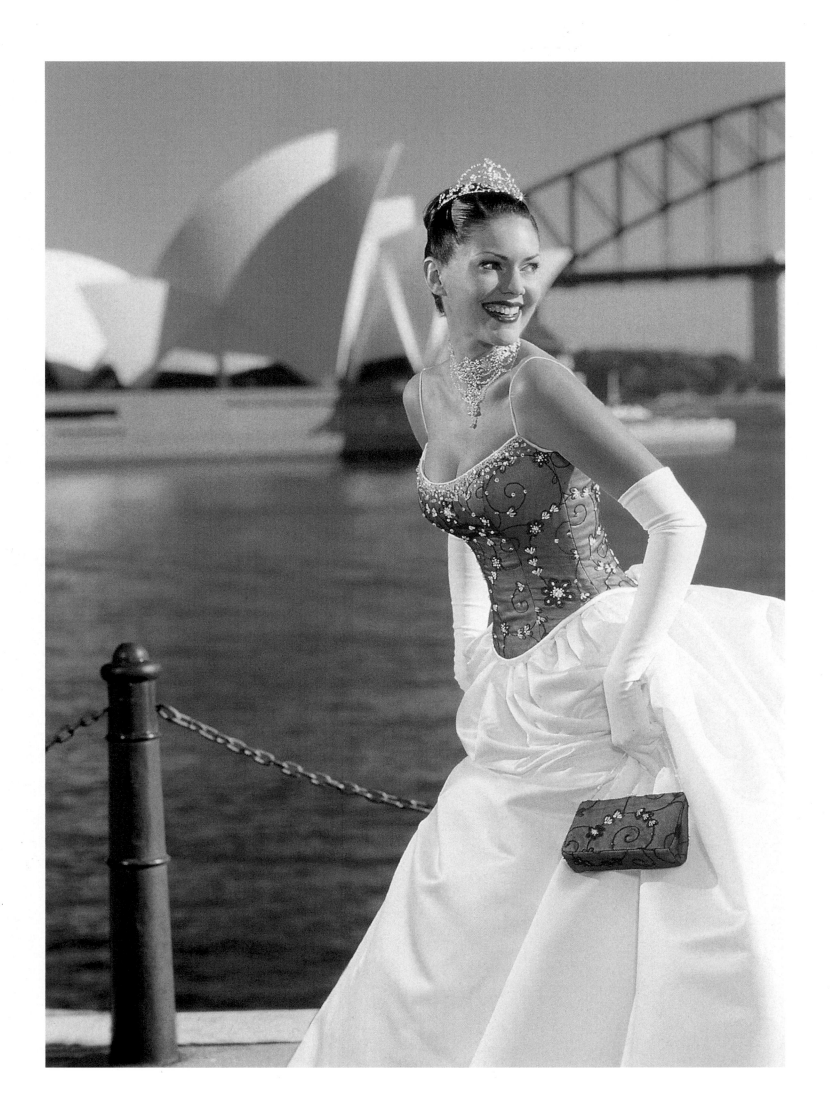

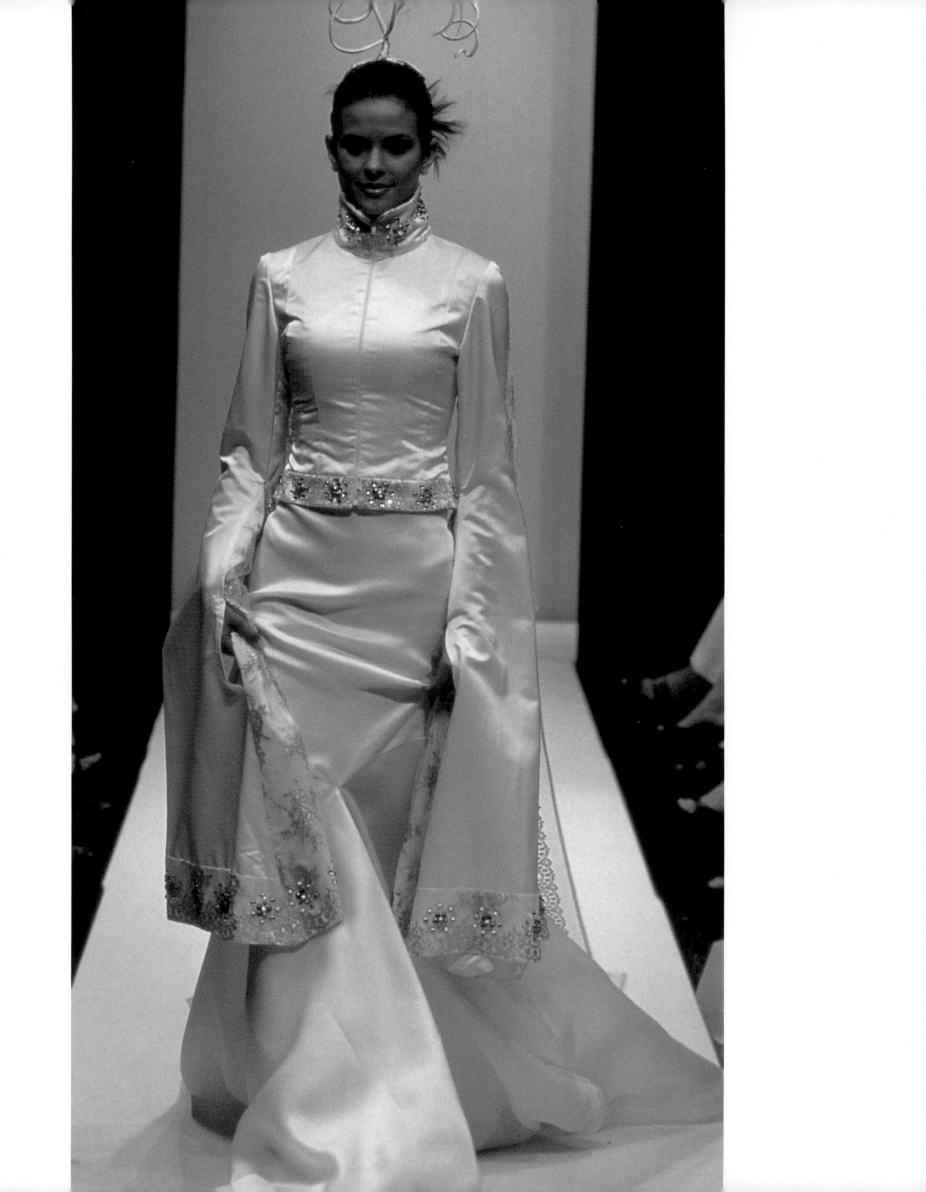

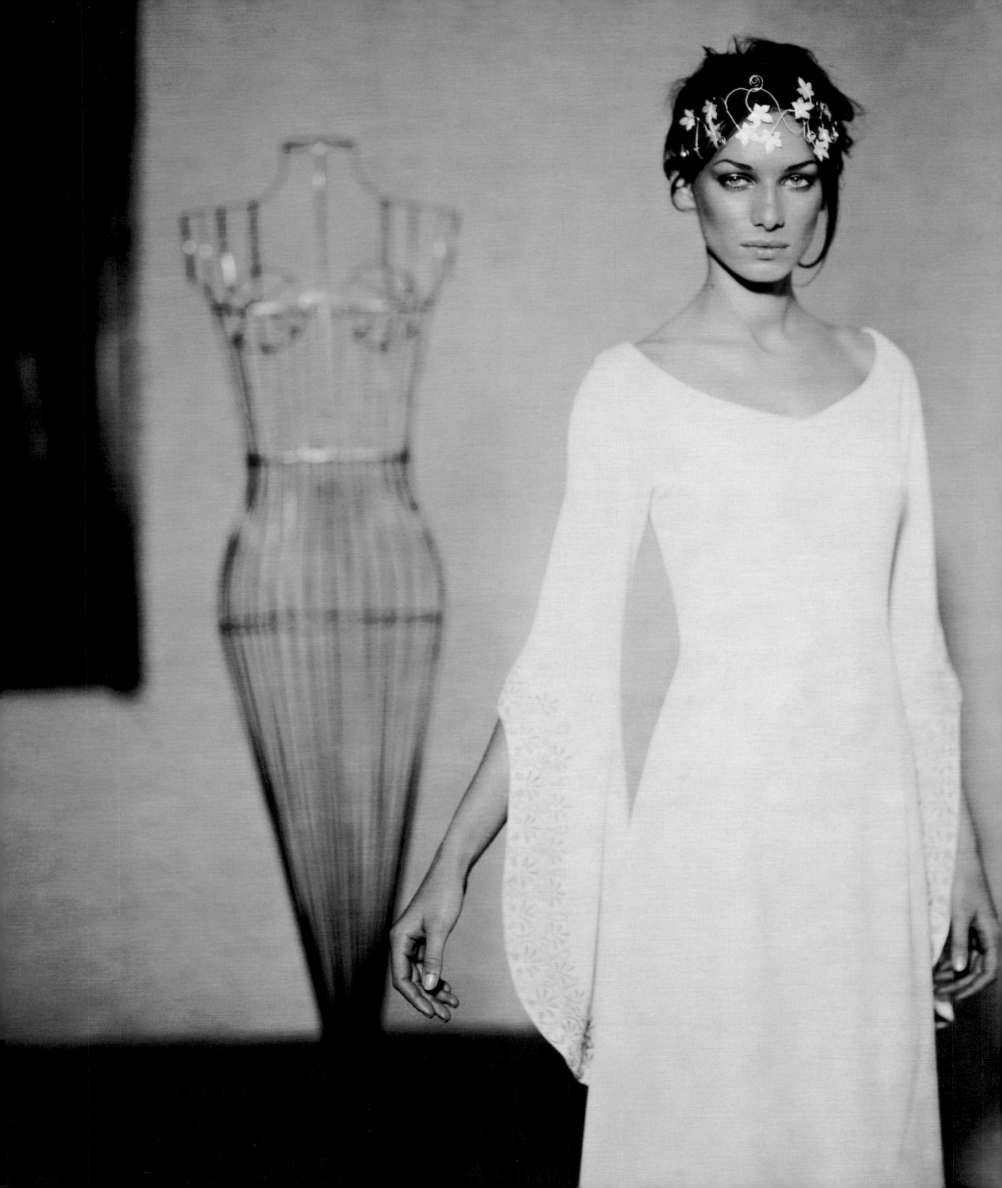

PREVIOUS PAGE... (Left) Ani Alvarez Caldéron uses as a starting point the traditional cheongsam to fuse together East and West in this innovative design. (Right) For 2000, Jesus Peiro chose a silk crepe for its hanging quality to create a deceptively simple design with medieval sleeves, accessorized with a Pre-Raphaelite-influenced headpiece of trailing ivy.

RIGHT... A contemporary Italian bride wears a gown featuring nineteenth-century design details reworked for nostalgic effect.

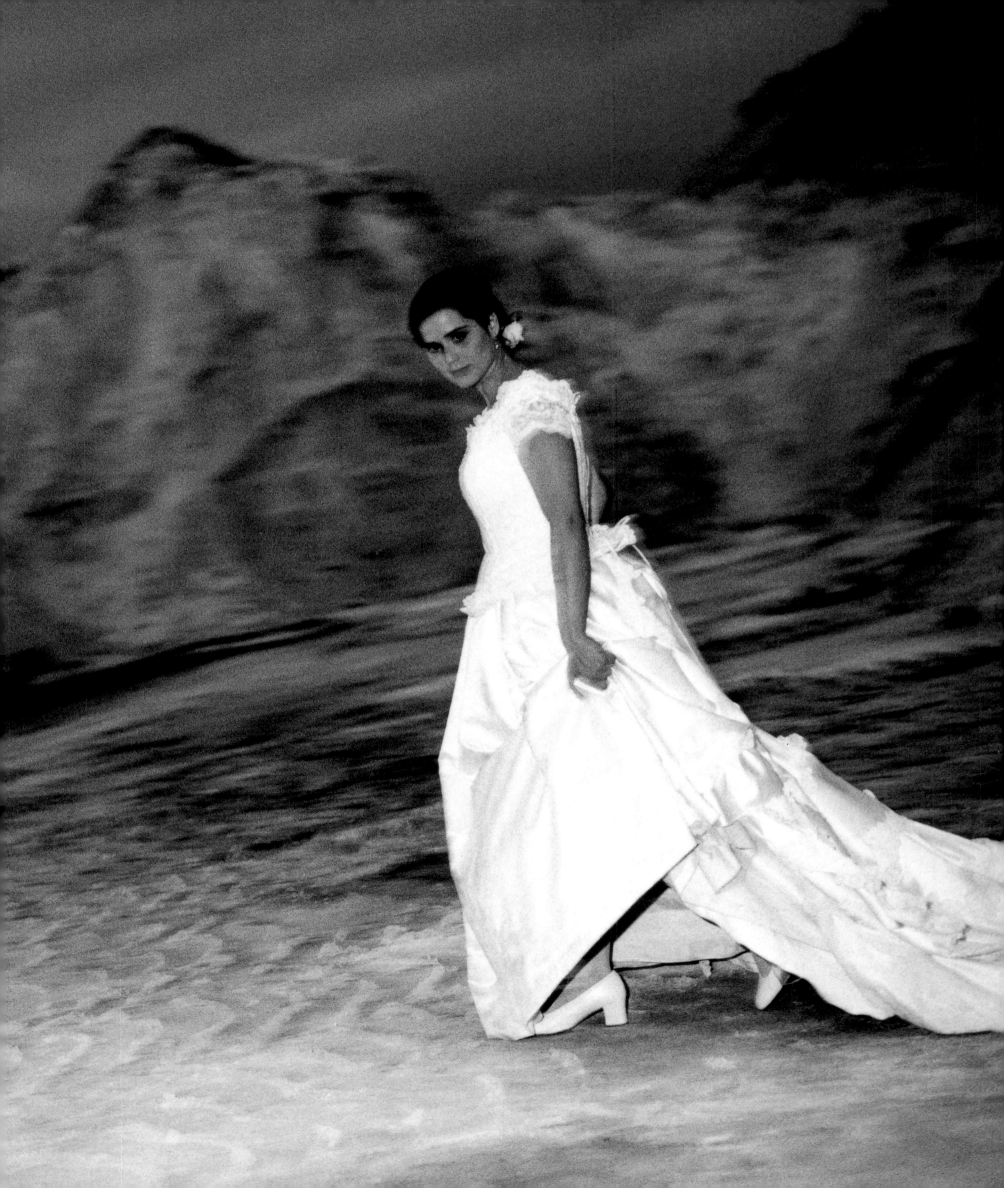

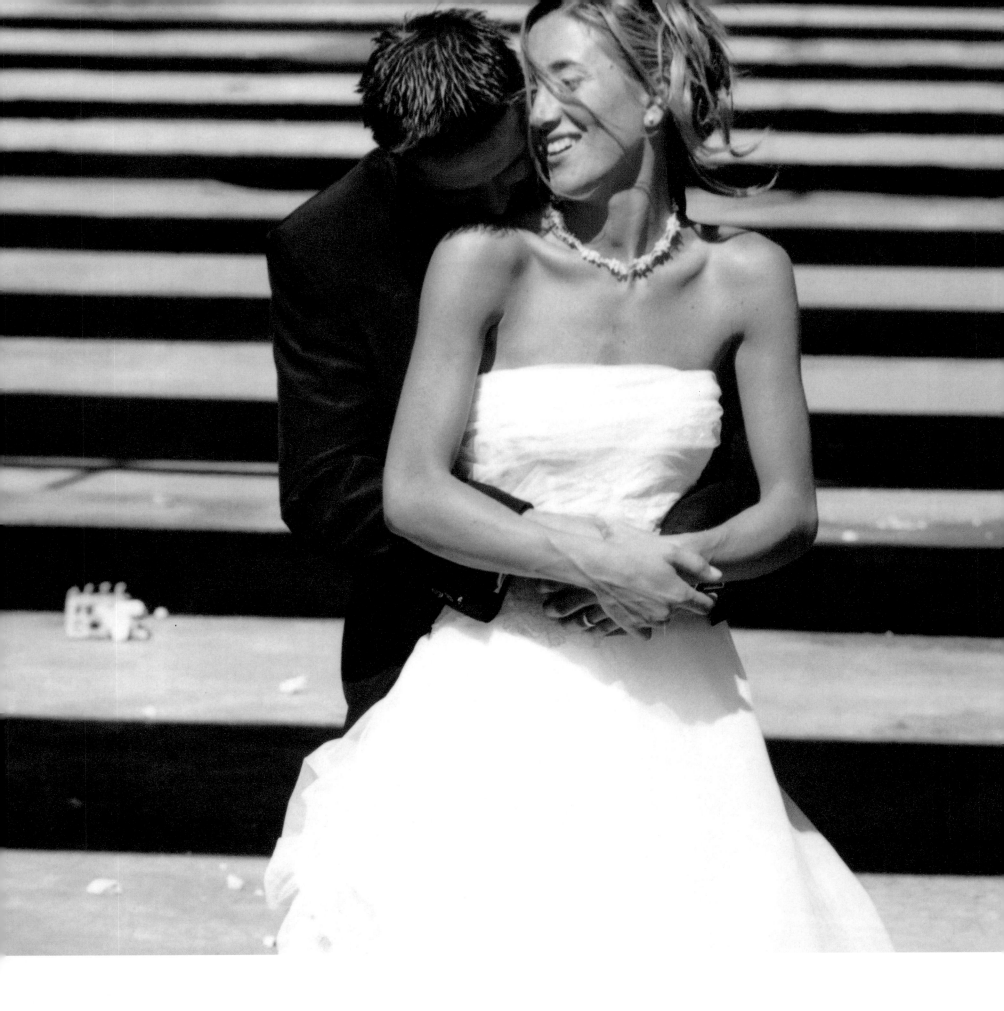

'Wantons go in bright brocade; Brides in organdie; Gingham's for the plighted maid; Satin's for the free!'[1]

Dorothy Parker (1928)

changes, too. Women gained the vote; had more of a voice in divorce and child custody cases; but had yet to achieve equal pay. By 1934 the feminist Winifred Holtby felt able to say: 'A few minor anomalies remain … but the whole legal position of men and women has been revolutionised.'[8]

Despite this cultural shift, attitudes towards courtship and marriage remained firmly entrenched in tradition, and most women saw marriage as their rightful destiny. The formality of the Edwardian era still dominated relationships, finding a mate, falling in love – in fact the whole business of courtship was still a very formal affair, because it 'touched on key concerns of the working-class community like family pride, the fear of illegitimacy and economic well-being or survival. In many families the parents' efforts to control the courtship and delay the marriage of their sons and daughters – especially daughters – was born out of economic necessity or a desire to maintain a slightly higher standard of living. Valuable breadwinners were lost when children married and this economic value was especially important in single parent families.'[9]

In the 1920s, the height of a young couple's ambition was to have a white wedding and a decent home to live in once married, and this meant years of 'saving' – saving money, saving for the 'bottom drawer' and 'saving yourself' for marriage. Historian Steve Humphries comments that 'one dream, dear to the heart of many couples, was of a perfect wedding, above reproach. This meant, more than anything else, that the bride should be chaste and virginal, or, more important, that she should appear to be so to family and friends. The big church wedding gained enormously in popularity in the first half of the century … The wedding, and especially the white wedding, had become an immensely important rite of passage into adulthood for young people. It was also a major public statement of a family's status and respectability. The most damaging thing that could happen which could bring shame on a family was for the bride to be pregnant, or at least for it to be known that she was pregnant.'[10]

In the early 1920s, as Elizabeth Wilson and Lou Taylor explain, 'the elite still dominated the social scene in the sense that the popular imagery of a desirable way of life was based on the way this elite lived.'[11] This is borne out in wedding fashion. Influences still 'trickled down' from the top and style influences tended to emanate from royal or aristocratic weddings, which were still firmly entrenched in 'Edwardiana.' Pseudo 'medieval' styles continued to be *de rigueur*, particularly the romantic low-waisted style accentuated with girdled belts. This look can be clearly seen in the 1922 wedding of Henry, Viscount Lascelles, to Princess Mary (daughter of King George V), who wore a double rope of pearls low on the waist of her sumptuous gown. Prewar in essence and, like most royal weddings of the twentieth century, dominated by invented tradition, this ceremony was modern in one important aspect – the level of media access. The amount of information given to the press was unprecedented for royalty. Intimate details of the royal wedding trousseau were published in *The Times*, as were sketches and descriptions of the gown made by Reville, a firm of court dressmakers founded in 1906 who, unlike Paris couturiers, catered to a very small and select aristocratic elite. Tidbits of information regarding presents and the future domestic arrangements of the bride and groom were made freely available by the happy couple, paving the way for the media obsession with royal brides today and the careful maintenance of a flattering public image. The public was gently reminded of the bride and groom's war work, with a sentimental picture of the bride in her Voluntary Aid Detachment uniform caring for sick children, for instance.

OPPOSITE (Left) In 1934 Princess Marina's gown caught the mood of Paris couture. (Right) In contrast, Elizabeth Bowes-Lyon, on marrying the future George VI in 1923, chose a rather safe medieval-influenced design by court dressmaker Madame Hanley-Seymour.

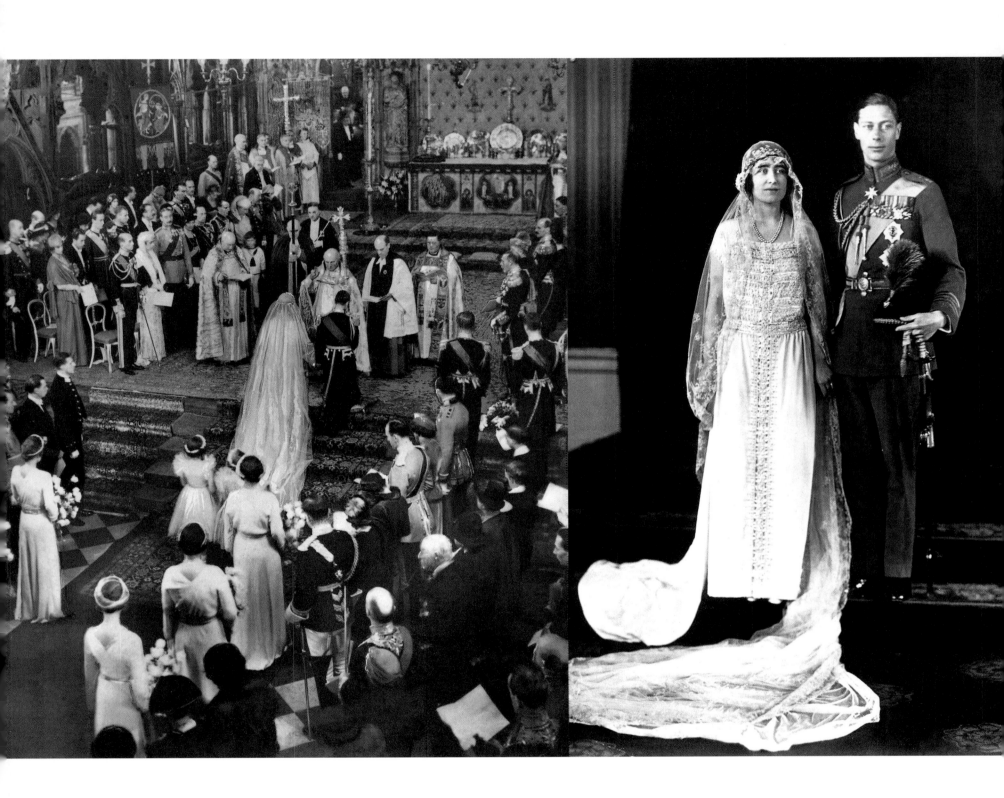

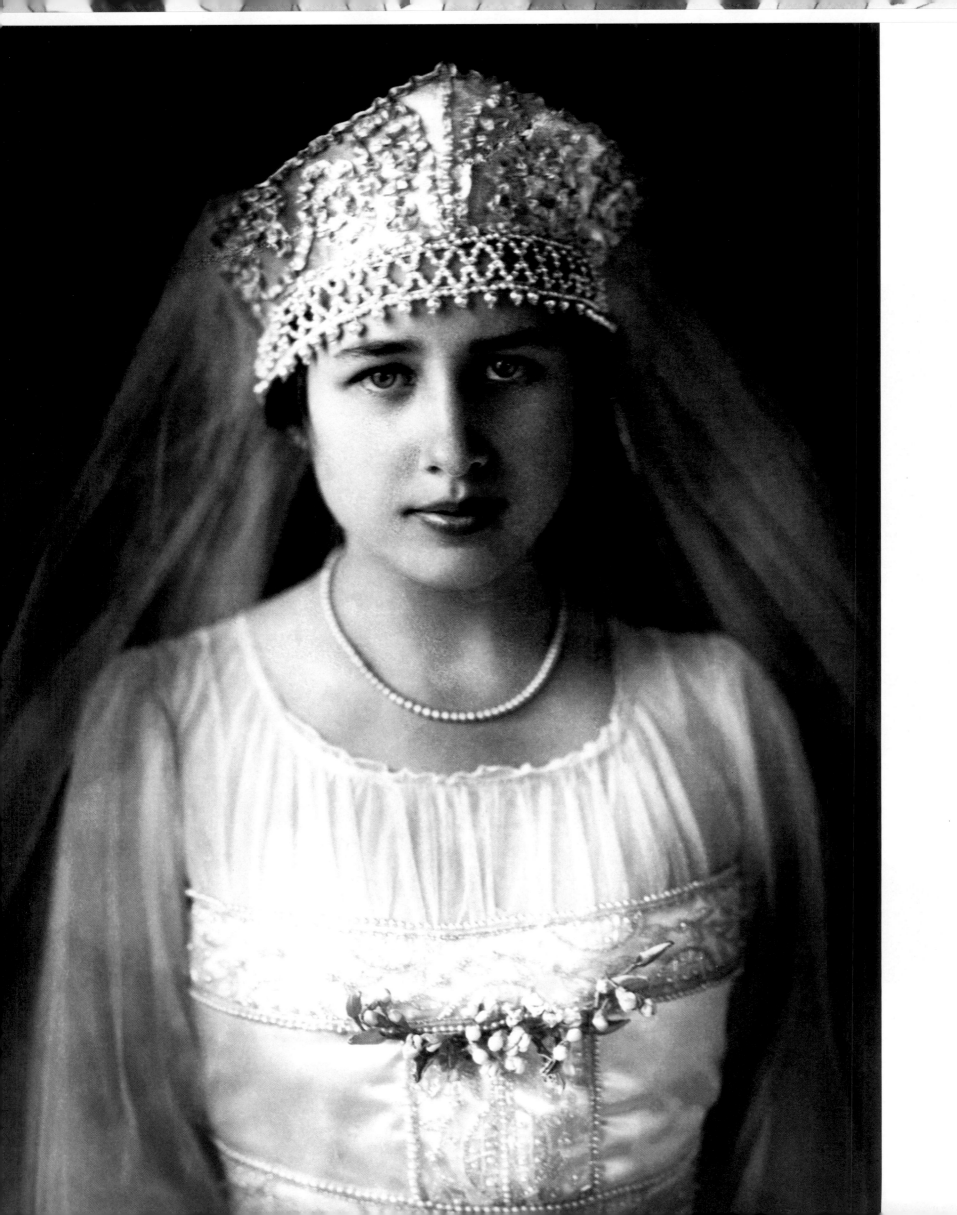

used in many ways, to make halter necks, cowl necks, petal skirts or handkerchief dresses … Often asymmetrical, they were designed to show the beauty of the body in motion.'[22]

Vionnet's bias-cut dresses were widely copied, as they suited women's increasing interest in health, diet, and exercise in the 1930s. The body beautiful was there to be attained through sport and dancing, together with lashings of makeup from the newly burgeoning beauty industries and with the help of tips from your favorite movie star. The moving pictures were drawing enormous audiences by the 1930s, and movie magazines catered to every working girl's fantasy of film-star living. The author J.B. Priestley described the *Zeitgeist* of 'filling stations and factories that look like exhibition buildings, of giant cinemas and dance-halls and cafes, bungalows with tiny garages, cocktail bars, Woolworth's, motor-coaches, wireless, hiking, factory girls looking like actresses … periodicals about film stars.'[23] *Filmfair* magazine of 1934 suggested that 'it should be every woman's aim to pick out a star personality resembling her own face, figure or temperament, and be inspired by it. Choosing clothes will then become an easy and fascinating business.'[24] Thus a copy of a heavy satin white bias-cut dress as worn by the incandescently blonde Jean Harlow, and designed by Adrian, was a fantasy that could be made flesh, for fashion was a key element of the new consumer culture of the 1930s. It played an important part in creating the illusion, if not the reality, of freedom and opportunity.

The wedding of Princess Marina of Greece to the Duke of Kent, at Westminster Abbey in 1934, reflected the changes being wrought by both Paris couture and Hollywood costume design. Having lived in Paris for some time, Princess Marina was obsessed with fashion. According to one writer, 'her taste ran to simple lines, allied with the use of the best available fabrics. Her attention to detail – which had her sending back dresses that her eye told her exhibited crooked seams or hems – cast her as the prototype of the royal model.'[25] She was the first royal fashion icon. On learning of the impending nuptials, the English press was rapturous. *The Lady* stated that 'England is lucky indeed to acquire a new Princess whose taste in clothes is so perfect,' and described the essence of her style as 'plain, plain, plain.'[26] From the moment Princess Marina set foot in England, reporters were in hot pursuit, finally cornering her in London. Marina alighted from a train wearing a perfect crepe cloqué dress in the newly fashionable color of beige, together with a three-quarter-length coat trimmed with fox and a matching beige hat with plumes of ostrich feathers. She flashed her engagement ring to the awaiting photographers – an impressive square-cut Kashmiri sapphire set in platinum and flanked by two baton diamonds. For both the press and public, she was the embodiment of continental style and sophistication.

Accordingly, British *Vogue* devoted an entire edition to the first royal bride to wear couture, and the *Illustrated London News* devoted page after page to drawings and descriptions of her wedding outfits. Its columnist compared Marina's eye to 'that of a trained artist [for she] appreciated the beauty of simple unbroken lines and her originality of outlook is reflected in her choice of accessories and details.'[27] Her fabulous trousseau contained such pieces as 'a high-necked evening dress of black cloqué satin, the skirt slit to reveal a stripe of silver lamé,'[28] and pigskin gloves lined with black velvet. In all, there were three morning outfits, five afternoon dresses, six evening gowns, and two coats.

OPPOSITE This bridal headdress is typical of the prewar period and reflects developments in fashionable millinery; in particular, the cloche hat, which was customarily worn fitted close to the head and low on the brow. Hairstyles were also smarter and sleeker, the sharp bob being particularly in vogue.

It was the wedding gown that had perfectly caught the mood of Paris couture, as by the early 1930s cut rather than ornamentation had become paramount. There had been initial problems in the choice of designer. Marina favored Jean Patou, with whom she already had a working relationship (she publicized his house through wearing his clothes, which she acquired at a discount). However, it was regarded as more suitable for an English bride to be dressed for the occasion by an English couture house, and Molyneux stepped in (luckily having premises in both London and Paris). His design of a long, white and silver Lyon brocade gown, complete with a motif of English roses, was to become one of the most-copied wedding fashions of the twentieth century. A closefitting sheath dress with a high neckline and long, loose sleeves, it was one of the most understated wedding gowns a royal bride had ever worn. The obligatory court train hung from the shoulders, and her veil of family lace was exaggerated with yards of added tulle, achieving a width of ten feet at the base, and fixed firmly on her head with a diamond tiara. Even the eight-foot wedding cake by Messrs. McVitie and Price, the biscuit manufacturers, was described in extravagant tones as 'a brilliant and delicate sugar edifice, eight feet high, surrounded by white heather, roses and lily of the valley. Concealed in the first wedge to be cut at the wedding breakfast were seven charms of solid gold representing a wedding ring, a thimble, a bachelor's button, a horseshoe, a dove, a donkey, and a threepenny bit.'[29]

For many women, Princess Marina's wedding was the ultimate fairy tale, and if they couldn't afford the real thing they wanted to allude to it in some small way. Marina tiaras with upstanding points like the rays of the sun became the rage, and took over from flower wreaths and orange blossom. Marina may have had diamonds, but artificial pearls and rhinestones could be a glamorous substitute if the bride was on a tight budget.

Not all women followed the fashionable norm. Some chose to take a more bohemian route to the altar. The celebrated French novelist Colette married for the third time in 1935. Her first marriage had been in 1893 to Henri Gauthier-Villars, a famed roué and writer. As a young, provincial bride Colette had worn a white muslin dress, a corsage of red carnations and a wide satin bandeau around her forehead. As her biographer Judith Thurman relates: 'In the interval between the formalities the bride slipped off into the garden; "Could it be that there, with the tomato seedlings and the calico cat, I glimpsed for a moment the mistake I had made and reassured myself as to my courage?" After a wedding meal of sea pike in a sauce mousseline washed down with champagne the bride retired to be met in the morning by her mother in the kitchen making morning chocolate "with an expression of unutterable sadness".'[30] Indifferent to bourgeois convention, Colette had married on two previous occasions: in 1912, while pregnant, to Baron Jouvenel (a political journalist), in a simple civil ceremony; and in 1935, to journalist Maurice Gondeket. This seventeen-minute ceremony took place in the town hall of the eighth arrondissement in Paris. It featured a short, stocky 62-year-old bride with frizzed hennaed hair, thickly applied kohl and lipstick, and a 45-year-old groom. Later that afternoon the couple and their wedding party feasted on pork knuckles and pancakes at a country inn. 'The afternoon was seasonably warm, but on the way home, there was a spring snowstorm. Colette asked her "old friend and new husband", to stop the car so she could "hear" the flakes which were falling "like a burst eiderdown." Their sound – "the quiet praying of a

OPPOSITE Two elaborate brides. (Left) The typical girdled belt of the 1920s delineates the waist with no emphasis on the traditional accentuation points of the female body. (Right) Princess Patricia of Connaught wore a Venetian-style dress for her wedding in 1919. The dress was made of white panne with a train of silver cloth. The heirloom veil, worn originally by Queen Charlotte, was secured with a wreath of myrtle leaves.

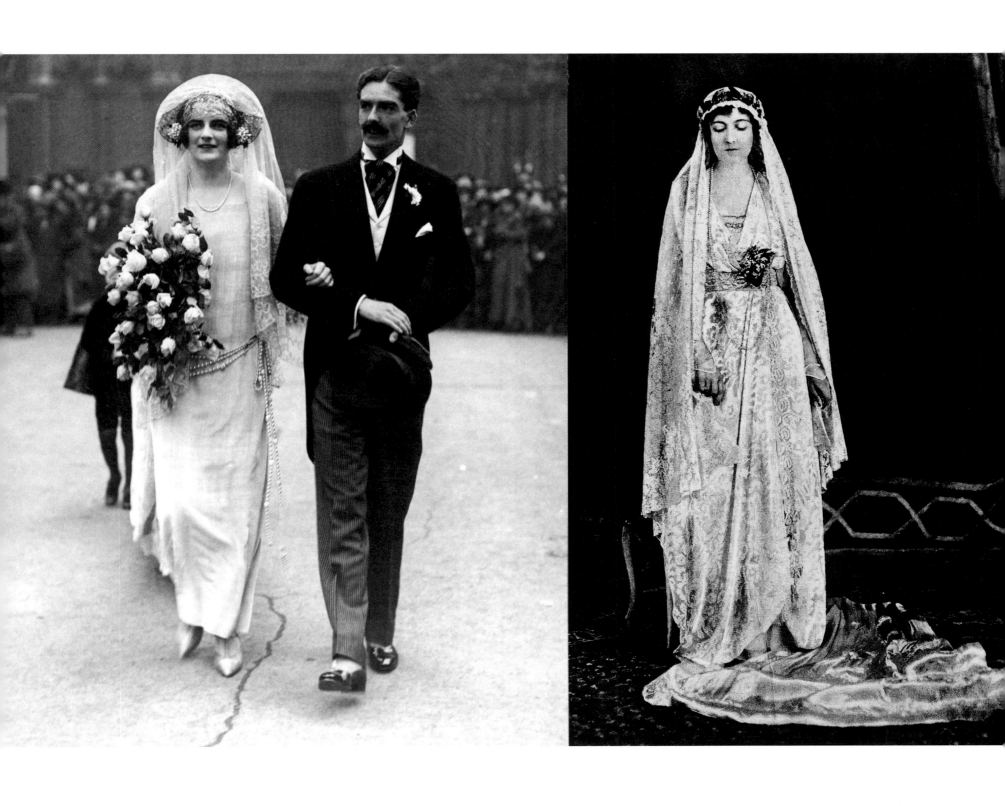

RIGHT & OPPOSITE... Vera Wang recreates the
high-octane Hollywood look of 1930s designer
Adrian in this series of strapless, shoelace-
strapped, and halter-necked wedding gowns.
Only for the very svelte, her bias-cutting molds
the figure, the weight of the fabric causing it to
fall gracefully in floor-length folds.

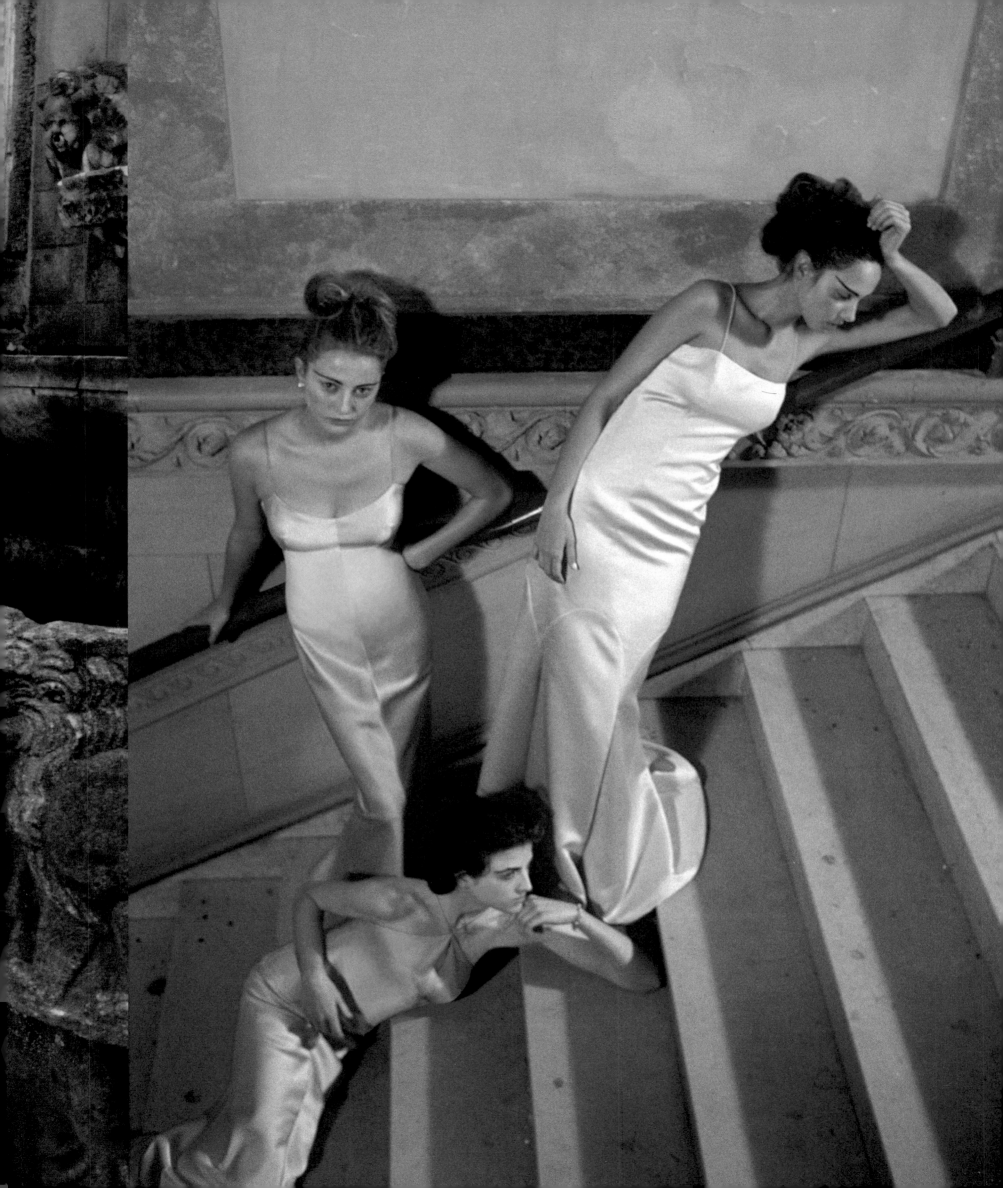

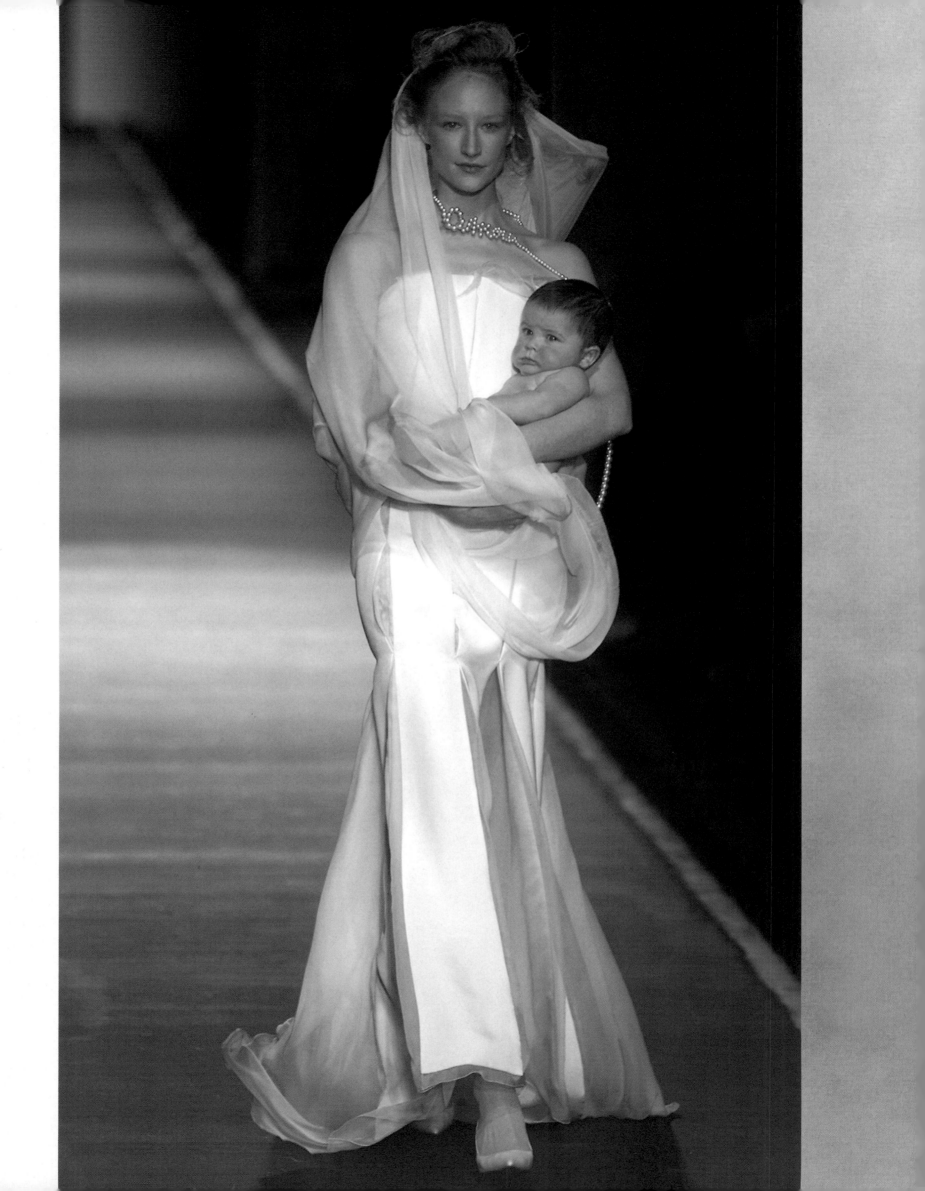

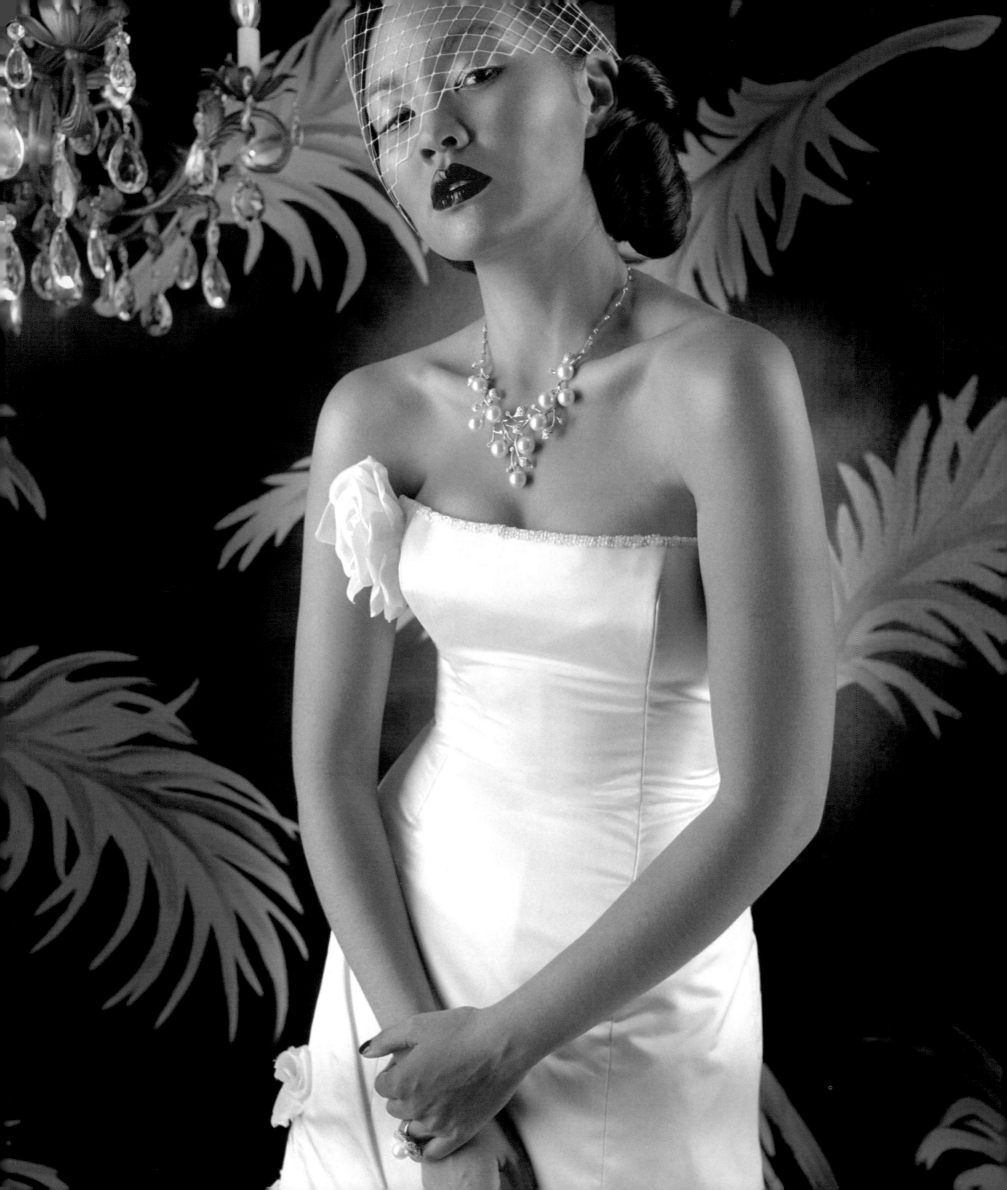

PREVIOUS PAGE... (Left) A contemporary runway bride by Jean-Paul Gaultier displays his wicked sense of humor and play with sexual stereotypes. Here the white wedding dress no longer symbolizes the virgin bride, but a proud mother carrying her baby down the runway. (Right) A simple short-sleeved gown by Giorgio Armani in typically minimalist style, a reaction against the overblown vulgarity of many wedding dresses. A comparison can be drawn with 1920s wedding fashions, when many women freed themselves from the excesses of the Edwardian era.

OPPOSITE... Cocoe Voci evokes the eroticism of 1930s Hollywood in the presentation and style of this strapless and heavily boned evening gown.

RIGHT... The Art Deco bride in a 1928 illustration (by Claire Avery) for British *Vogue* becomes a symbol of modernity from the tip of her bobbed head to her simple shoes. Elegance has been achieved through streamlined simplicity.

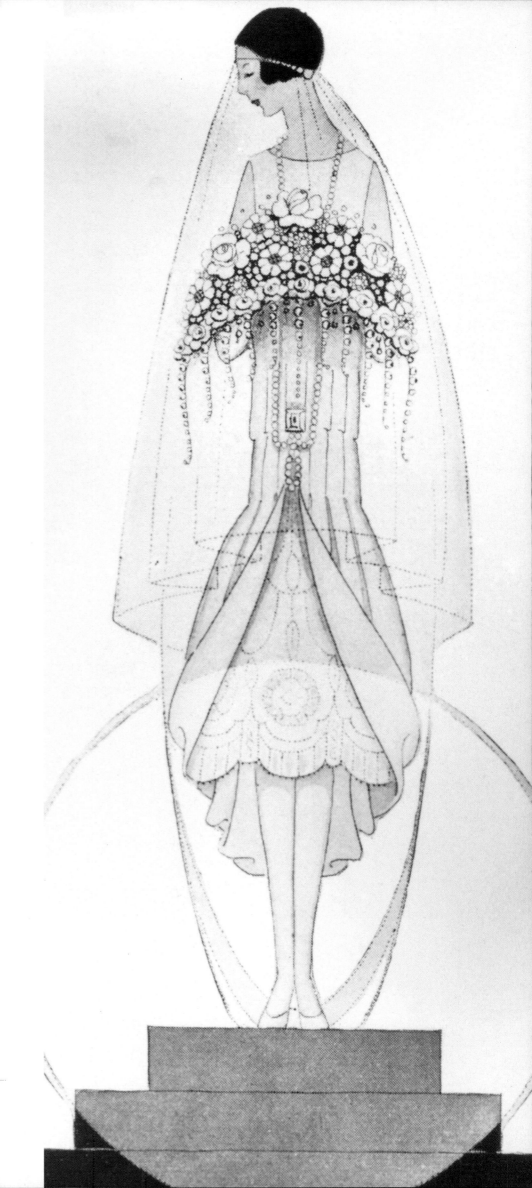

PREVIOUS PAGE... Transparency is used to atmospheric effect in this gown by Beccaria. The androgynous figure of the model lends an innocence to what could have been an overtly erotic image of a bride-to-be and clearly recalls the shape of the 1920s flapper.

OPPOSITE... An Empire line wedding dress by Eternity Bride which plays with the transparent qualities of layered organza. It recalls the Neoclassical fashions of the late eighteenth century, themselves derived from classical sculpture.

RIGHT... An illustration by designer Sharon Cunningham that sums up in a few strokes of the pen the perfect minimalist bride-to-be of 1999. 'Less is more' was the maxim of many late twentieth-century designers.

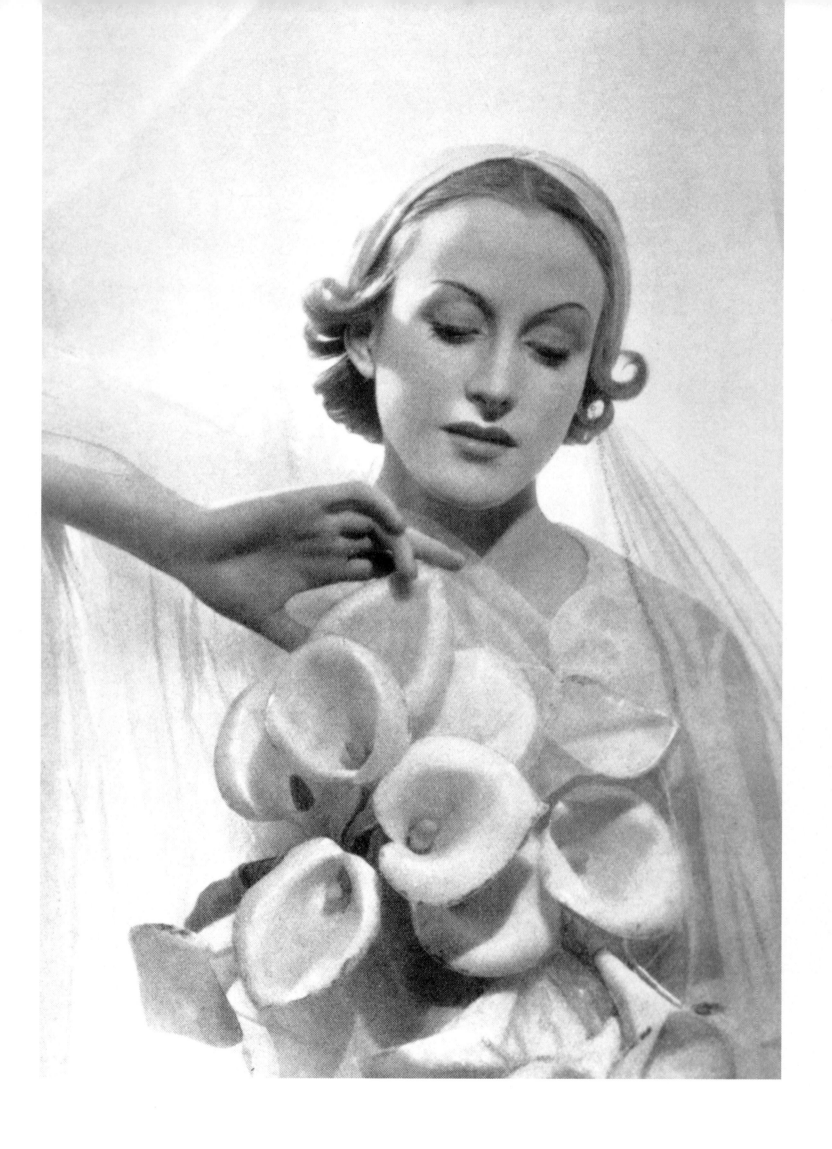

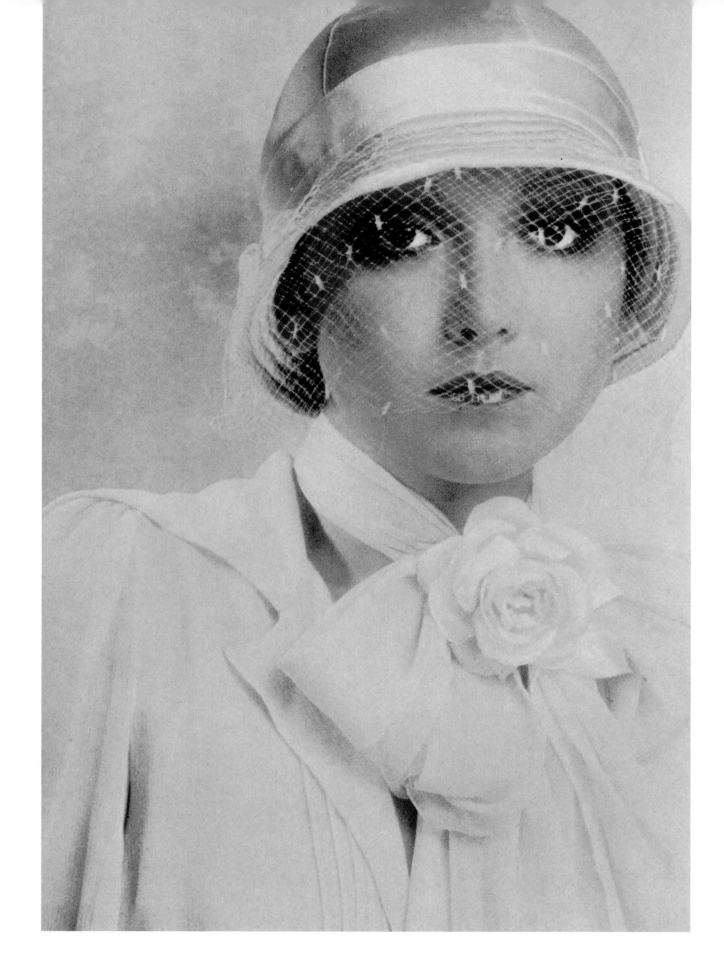

OPPOSITE... Cecil Beaton's photograph for British *Vogue* in 1935 depicts a graceful bride with a curled bob typical of the era and a simple bouquet of arum lilies.

ABOVE... 1970s fashion was dependent on retro looks for its inspiration, as shown in this 1920s-style bridal image by photographer Richard Dunkley for *Brides* magazine.

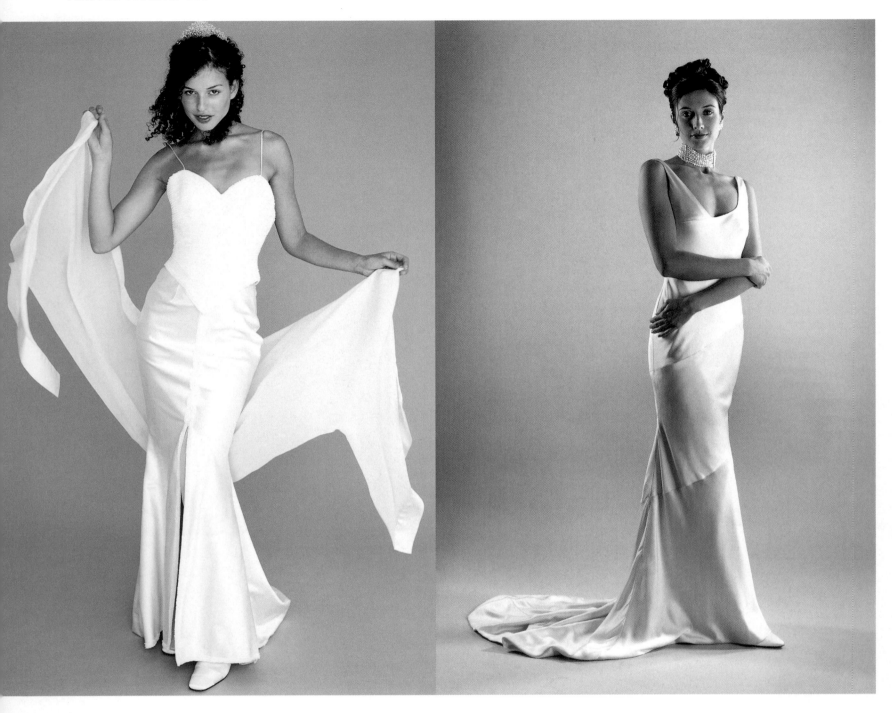

ABOVE LEFT... A contemporary design by Stephane Allin that fuses a shoelace-strapped bodice with a deep front-pleated satin skirt and matching organza wrap.

ABOVE RIGHT & OPPOSITE... Bias-cutting techniques invented by the 1930s couturier Madeleine Vionnet add interest to a graceful gown by Caroline Holmes. Another dress by Holmes, featuring a cowl-neckline, reflects the move toward simplicity in contemporary bridal fashion. All extraneous detail is stripped away to display the body.

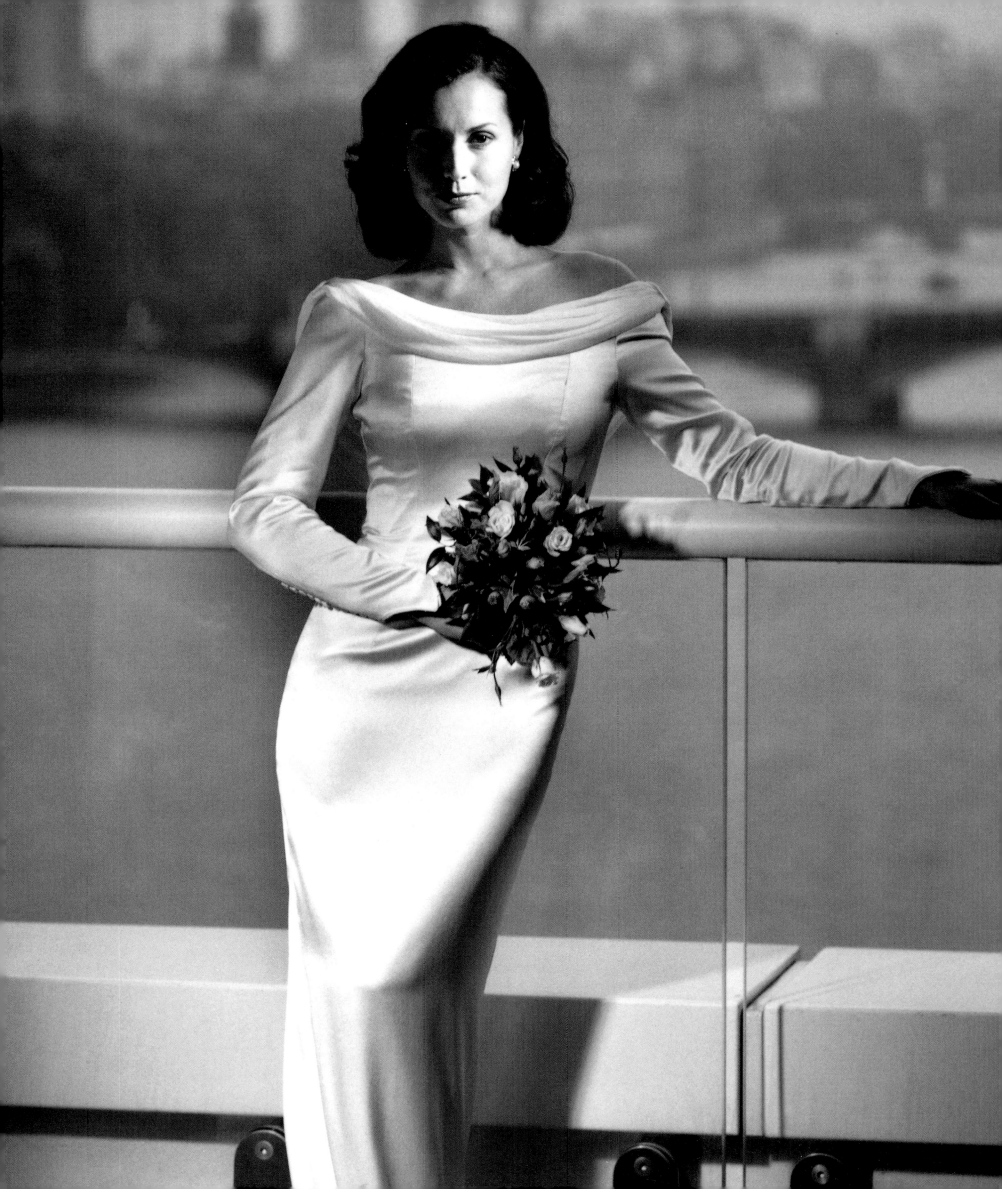

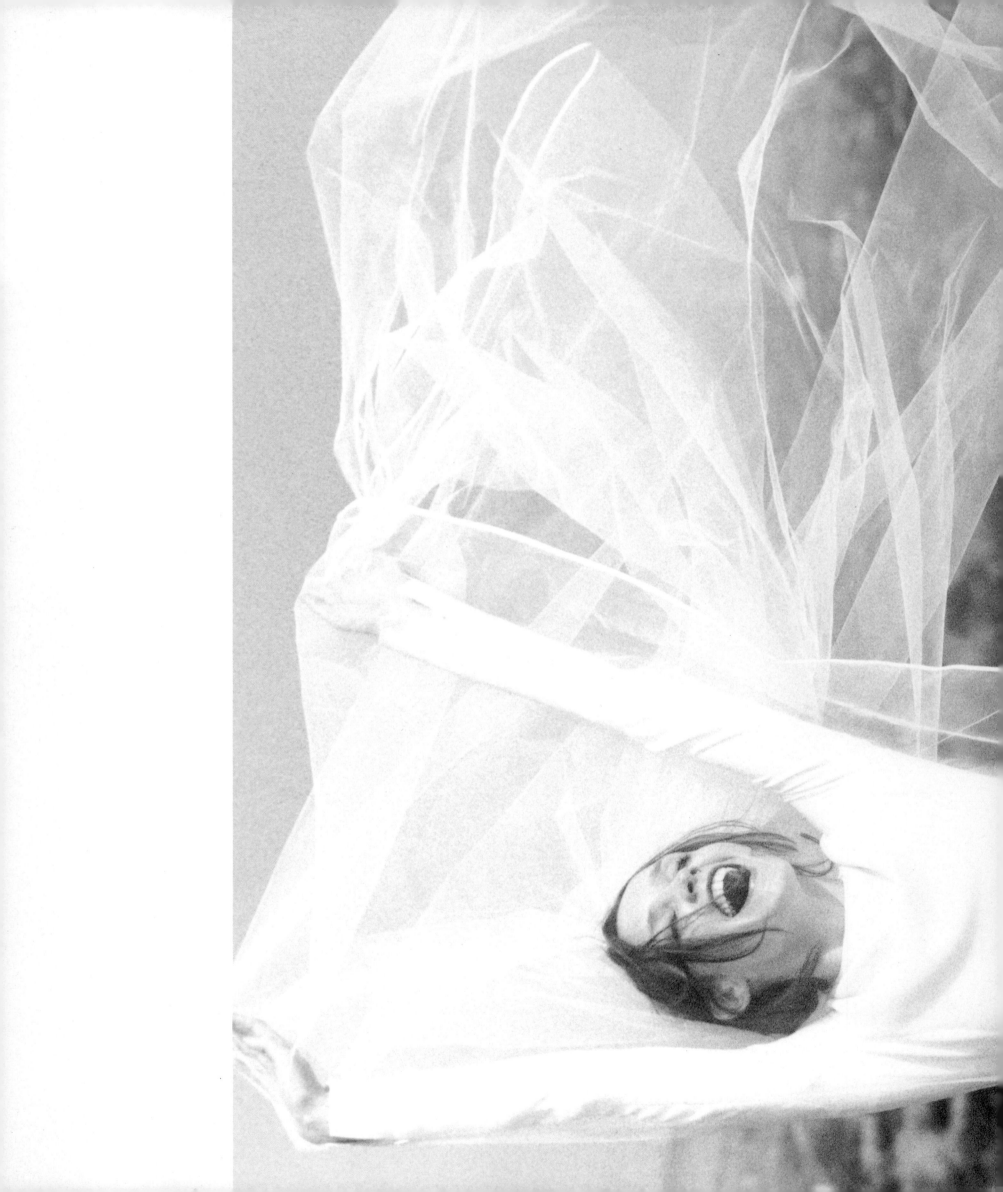

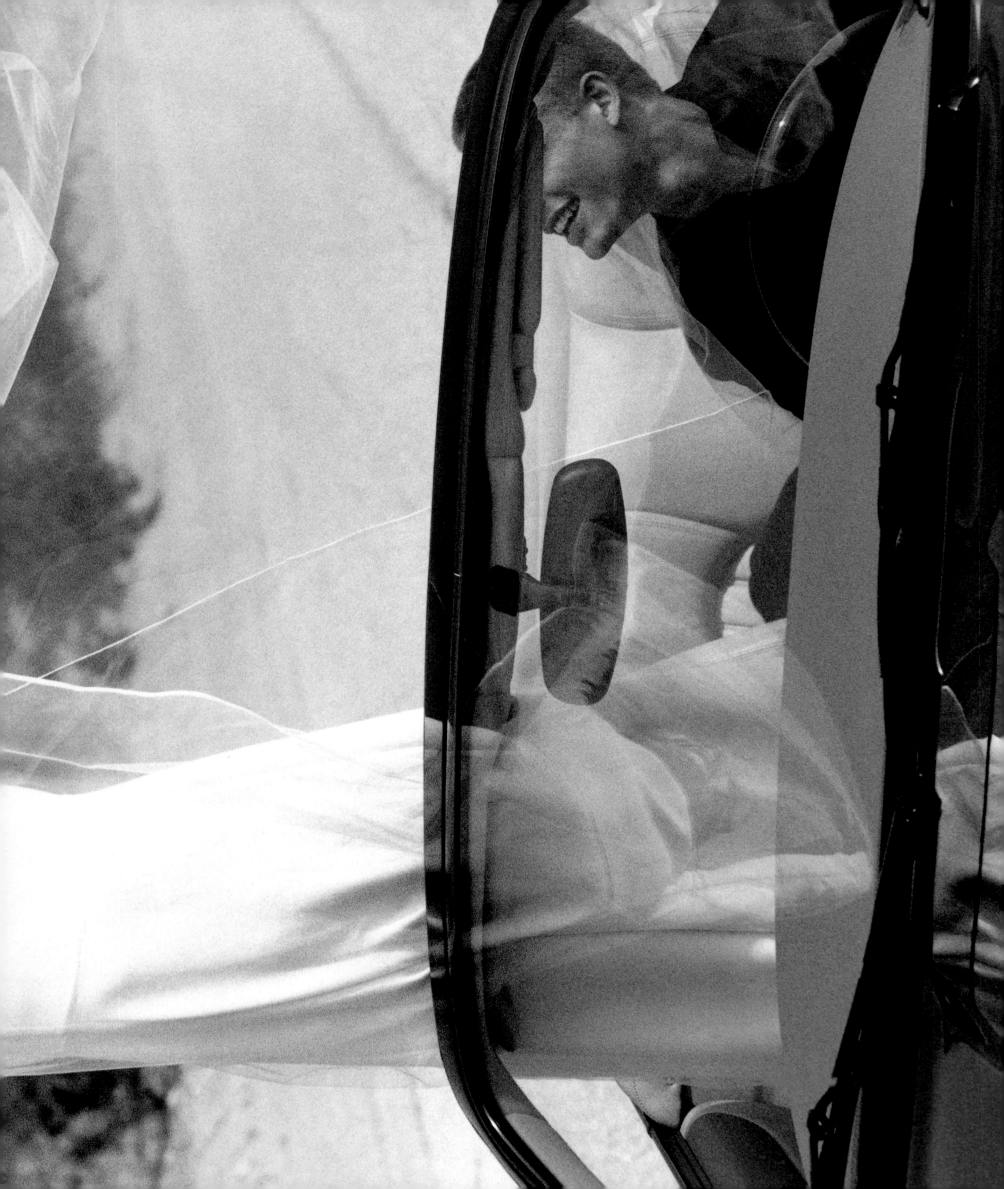

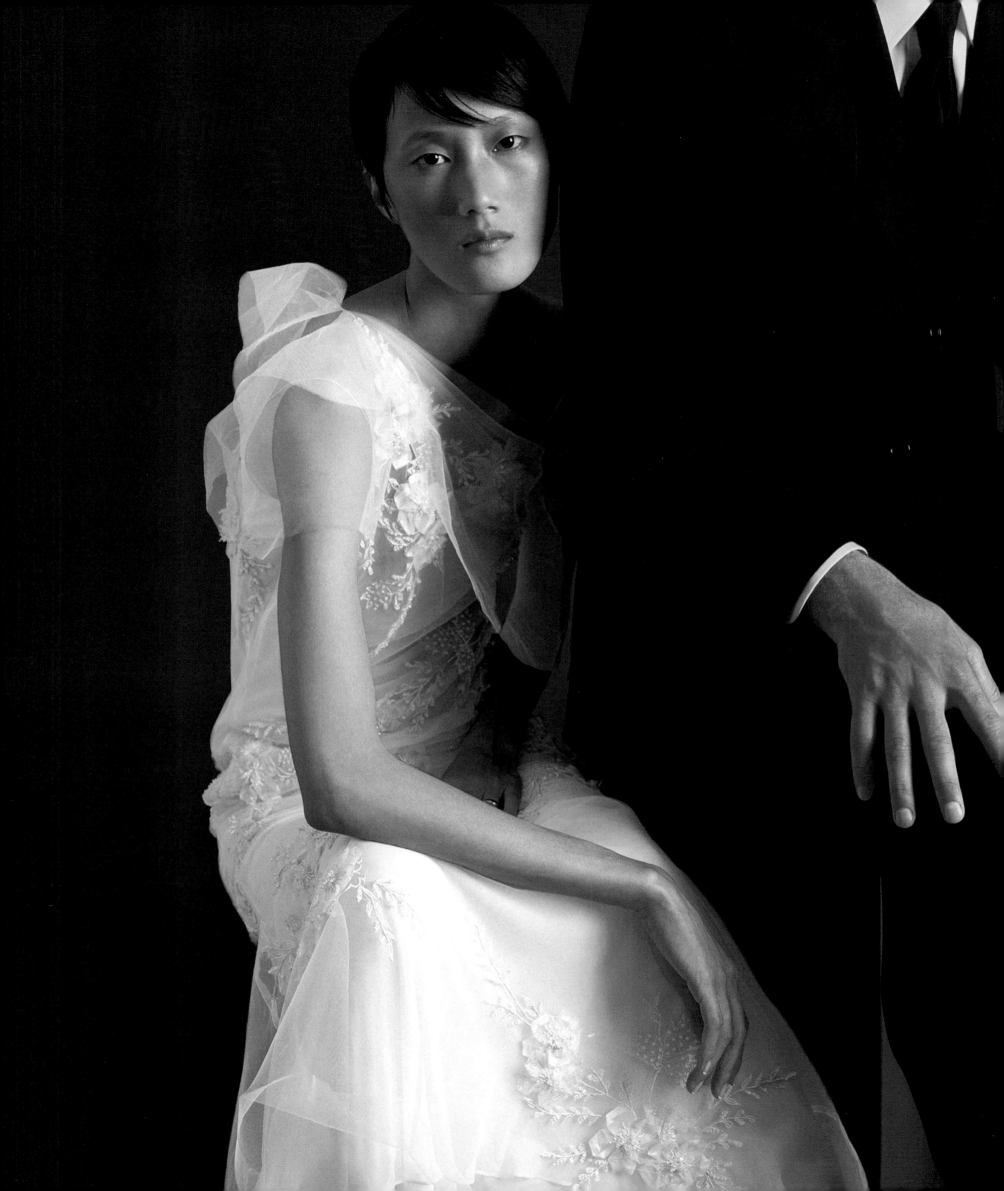

PREVIOUS PAGE... For the modern bride, marriage can give a sense of freedom rather than being a source of subjugation (as in the past) – at least, in this optimistic representation by Giorgio Armani it is, as she shouts for joy amid twirling tulle.

LEFT... A bridal designer of global significance, Vera Wang shows the classic gender divide when it comes to wedding fashion. The bride seems as fragile as her lace-overlay gown and the groom is sober, dignified, and anonymous, as befits his secondary status in wedding fashion.

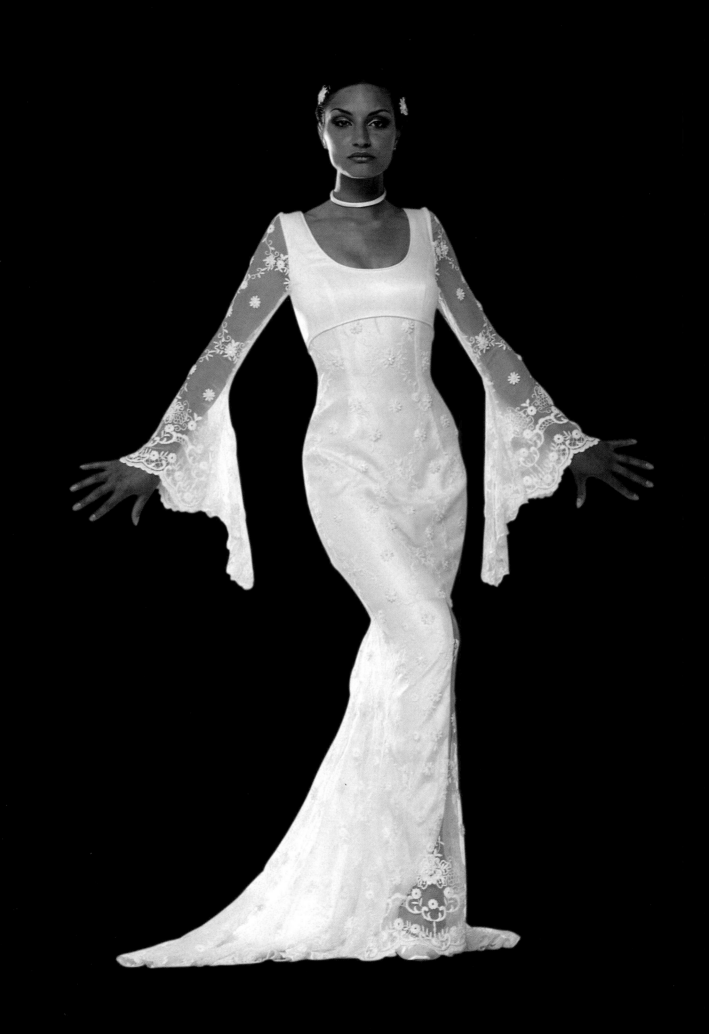

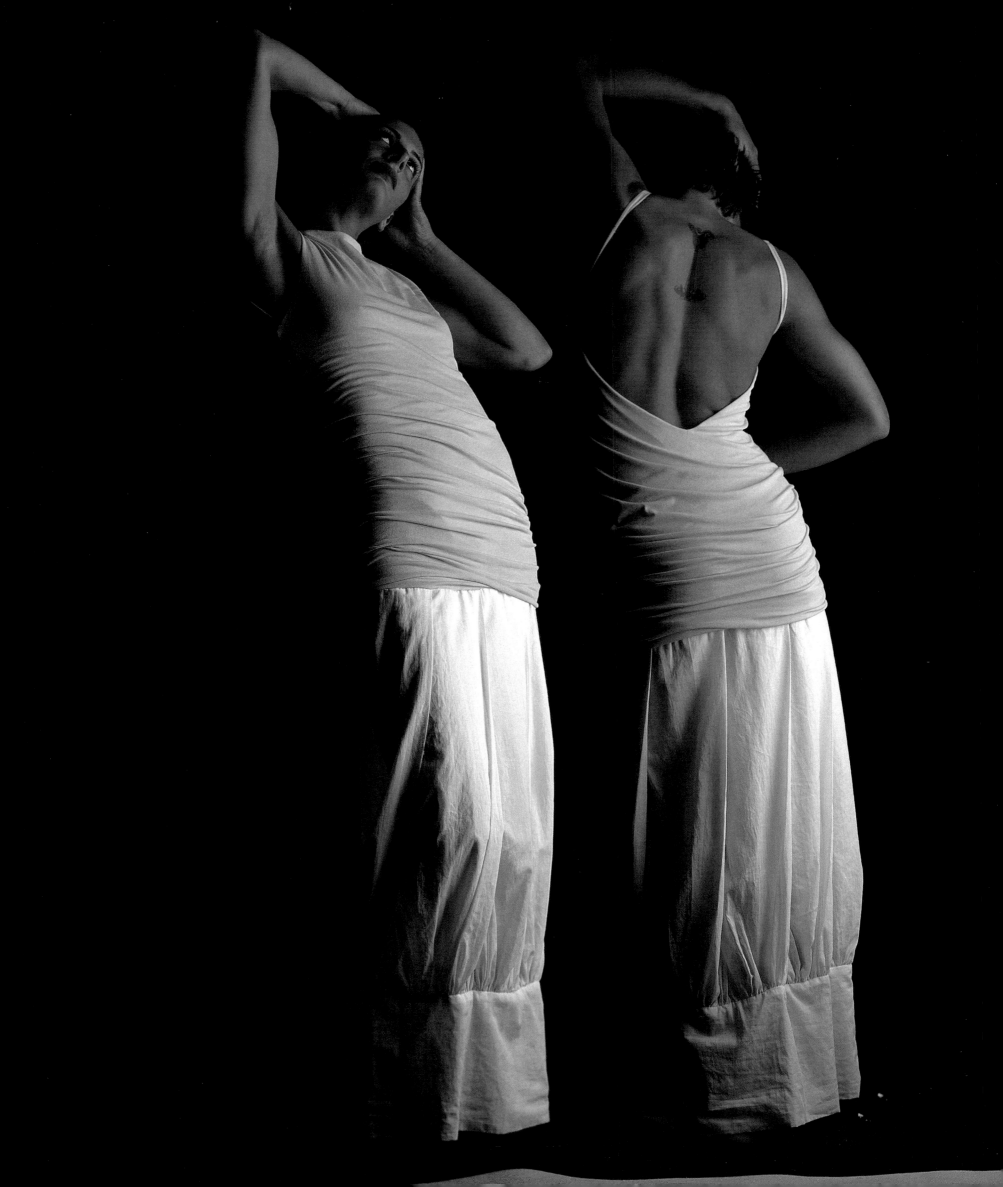

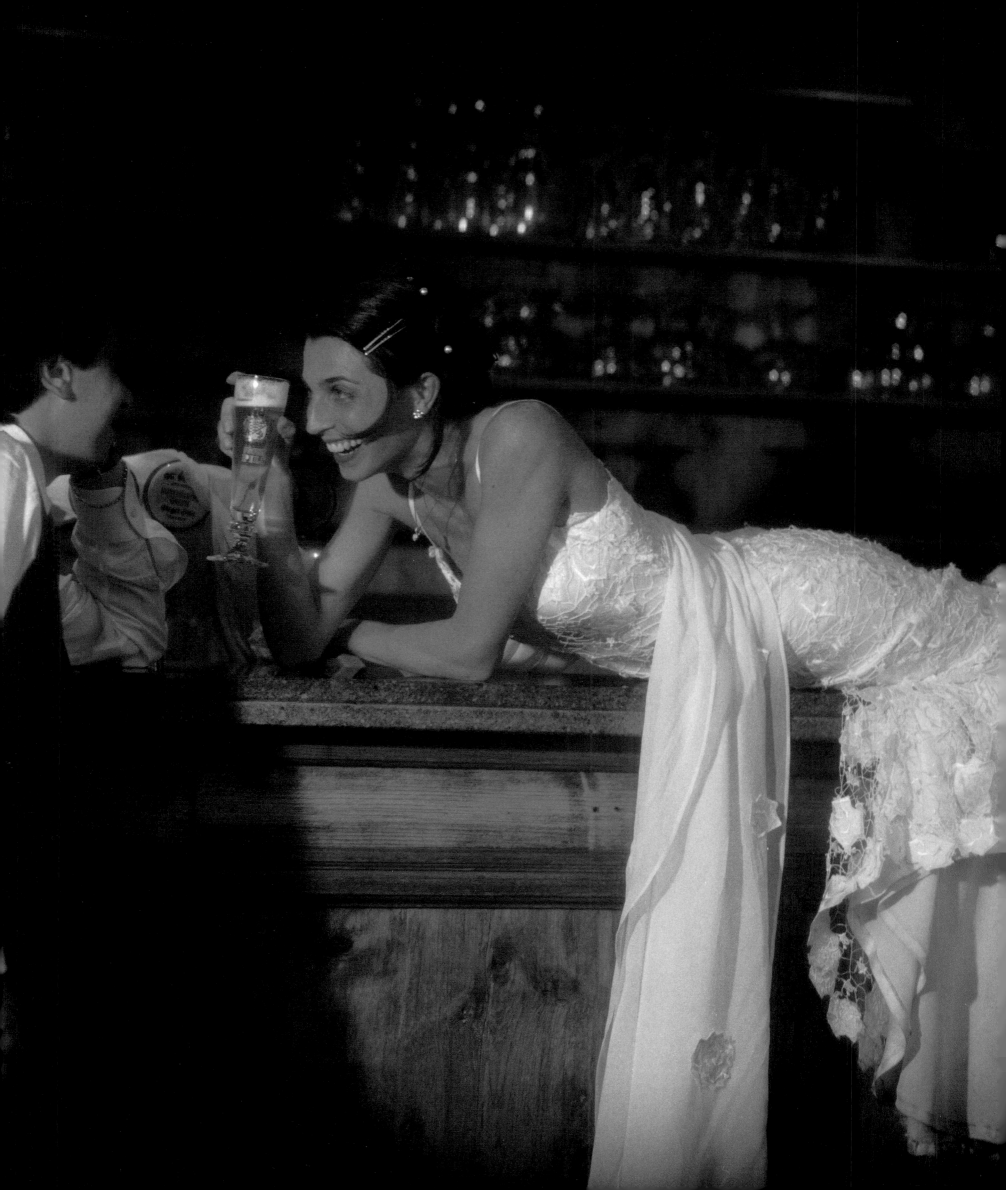

PREVIOUS PAGE... (Left) The uncomplicated lines of this design by Ian Stuart are texturized with a sheer lace overlay, which gives an elegant waterfall effect at the wrist and ankles. (Right) Wrapping the body rather than revealing it in more conventional ways reflects experiments in womenswear by the Japanese designer Rei Kawakubo in the 1980s. Here, Giuseppe Bertolucci's photograph exposes the back as an area of erotic interest, recalling 1930s evening ensembles.

LEFT... A mix of Spanish flamenco and 1930s evening wear photographed by Giuseppe Bertolucci, whose fun-loving bride celebrates after the event in a body-conscious dress. The simple straps and bodice are offset by the more complicated structure of the integral train and flounced skirt.

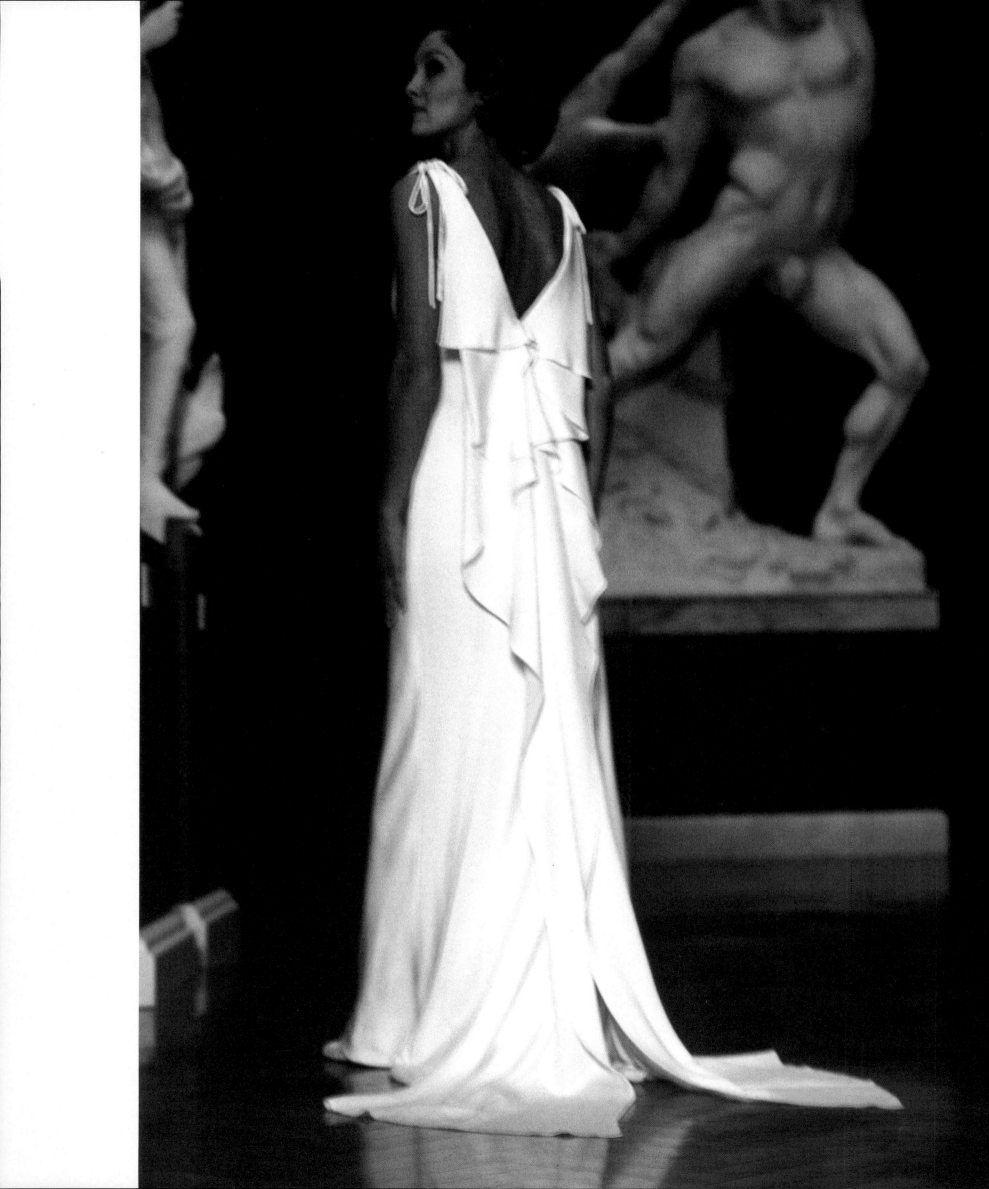

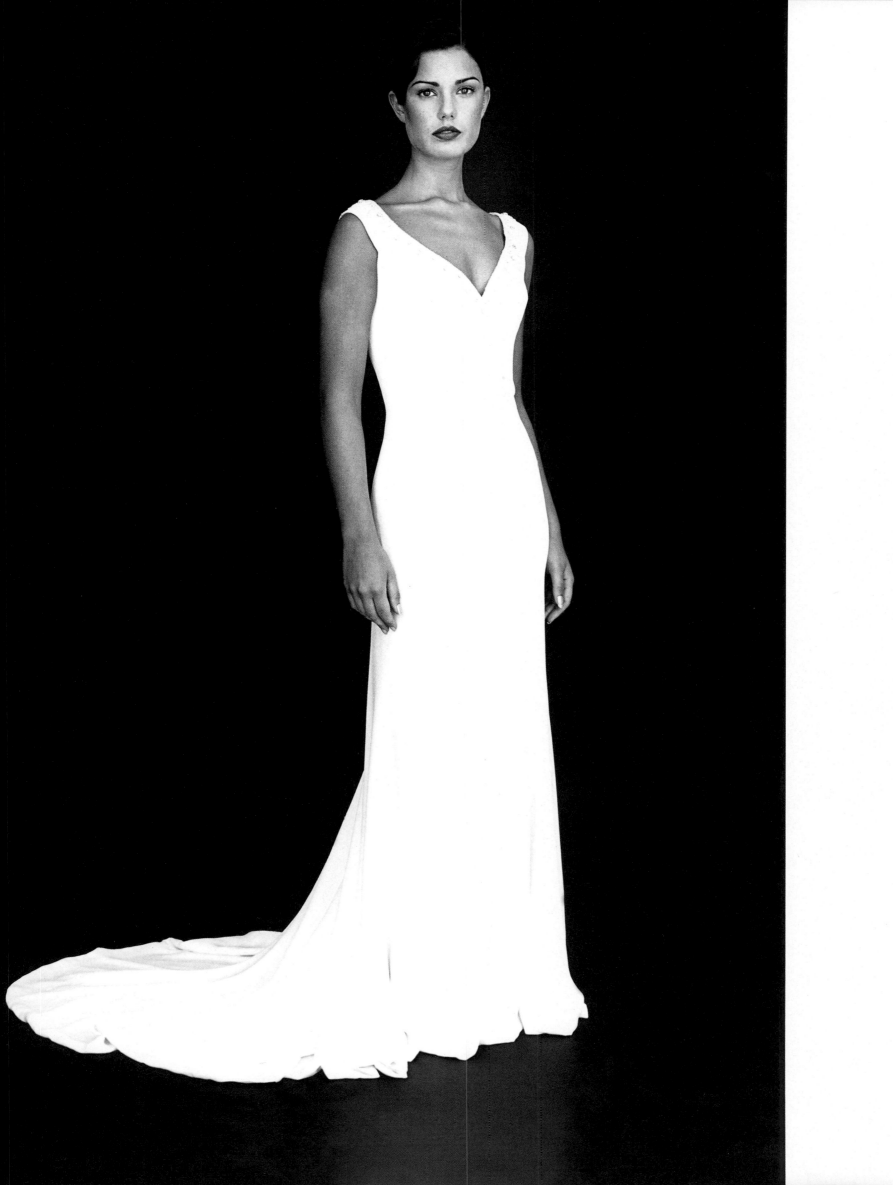

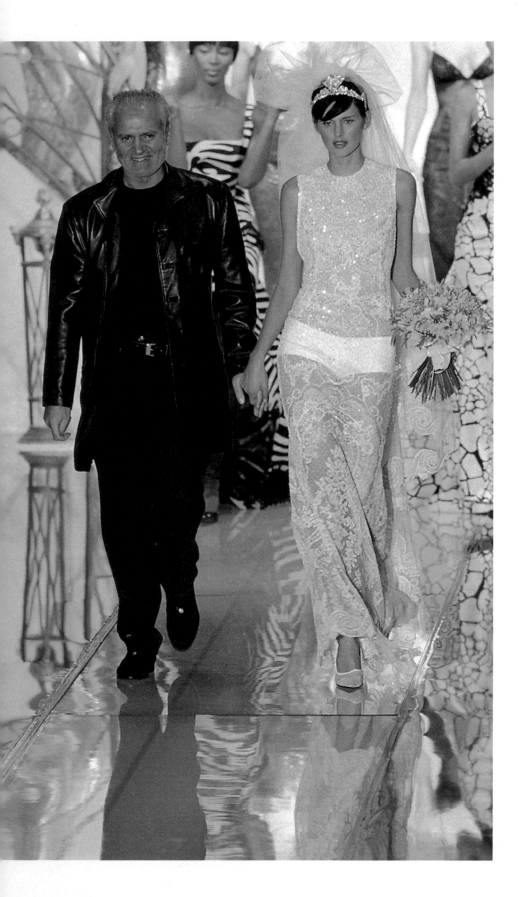

PREVIOUS PAGE... (Left) Peter Langner opened his own atelier in Rome in 1991 and has since been creating (from the highest-quality materials) simple, elegant gowns that use retro detailing to modern effect. This flowing gown with a waterfall effect of drapery at the back has elegant rouleau ties at the shoulders, translating the language of classical statuary into wedding fashion. (Right) A perfect example of how the weight, and therefore hanging qualities, of an expensive bolt of cloth can create as much visual interest as decorative detailing. In Sharon Cunningham's design, elegance emanates from the folds of the pooled train and cutting techniques.

LEFT & OPPOSITE... The late designer Gianni Versace ends his 1996 runway show with the model Stella Tennant sporting a 1930s-inspired bridal gown. One of many high-fashion designers of the 1990s, Versace experimented with see-through materials for evening wear, and here Tennant wears the obligatory 'big knickers,' which resist any hint of vulgarity. The look becomes one of subversion for the late twentieth-century bride.

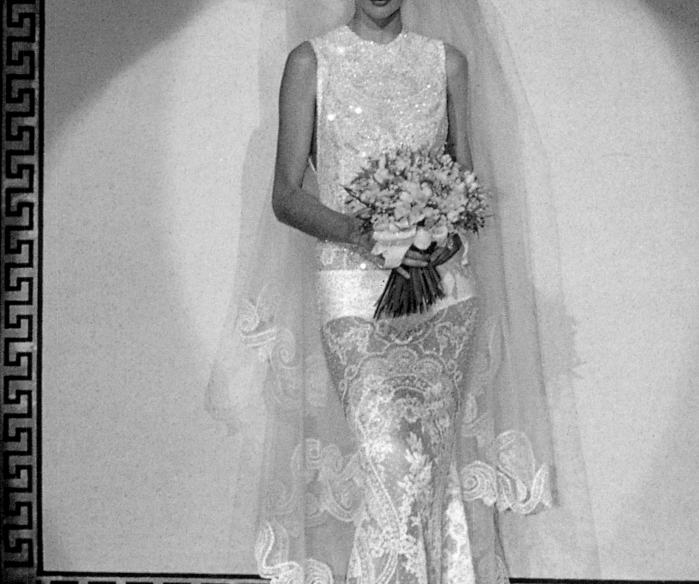

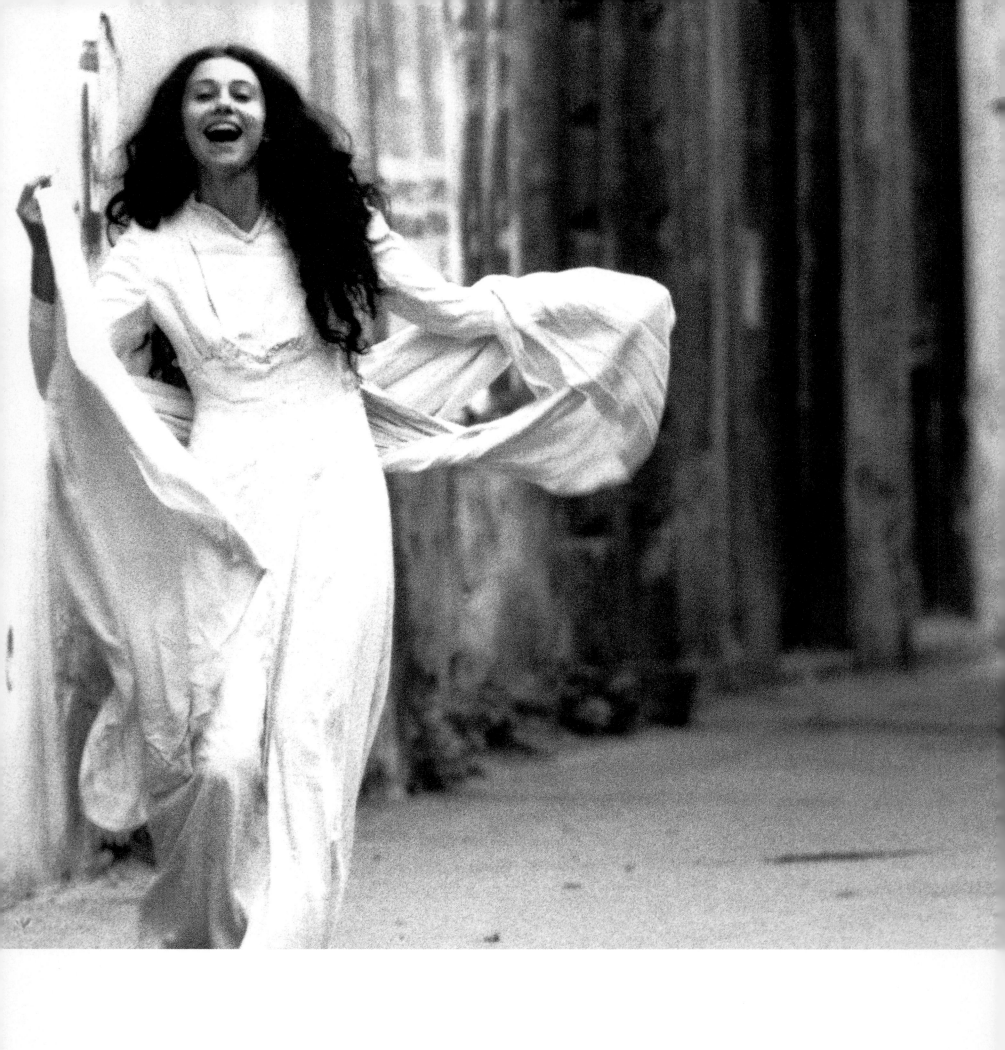

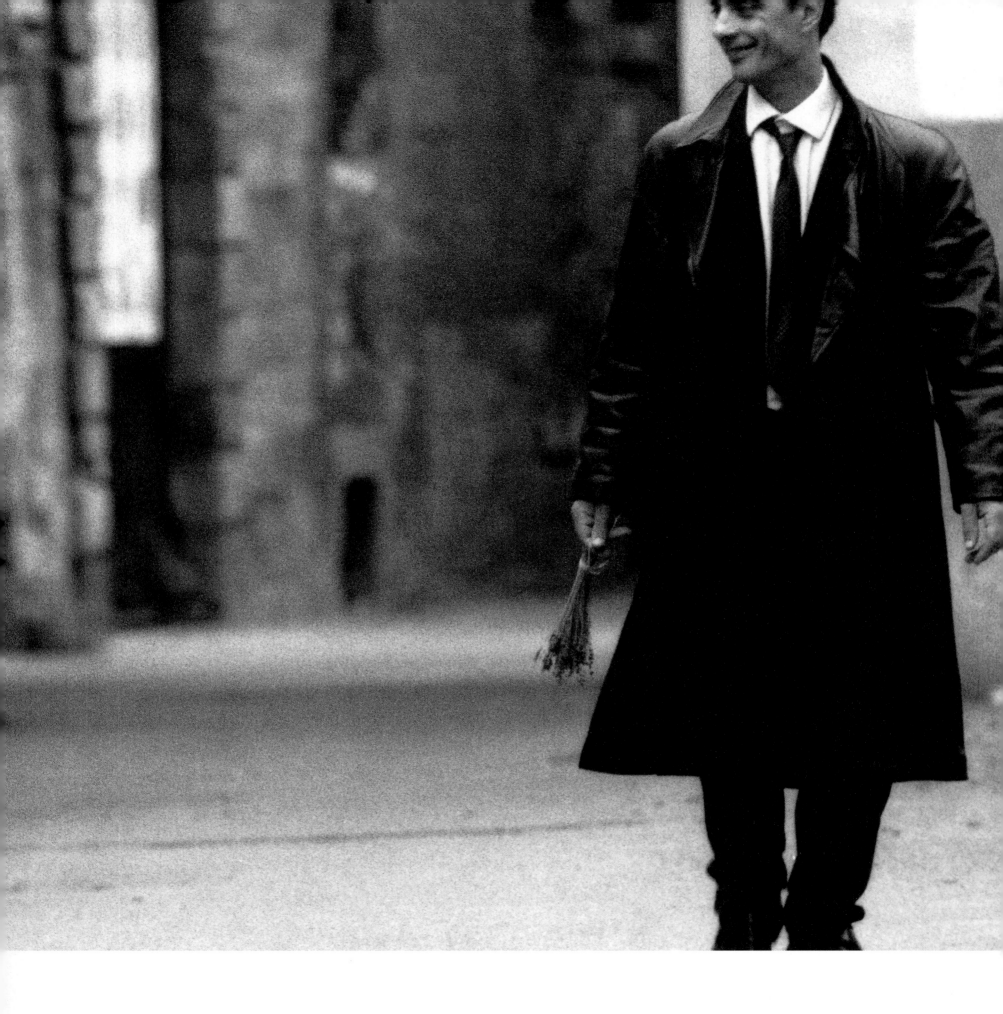

'Your heart knows when you meet the right man. There is no doubt that Nicky is the one I want to spend my life with.' [1]

Elizabeth Taylor on her marriage to Conrad Nicholson Hilton (May 6, 1950)

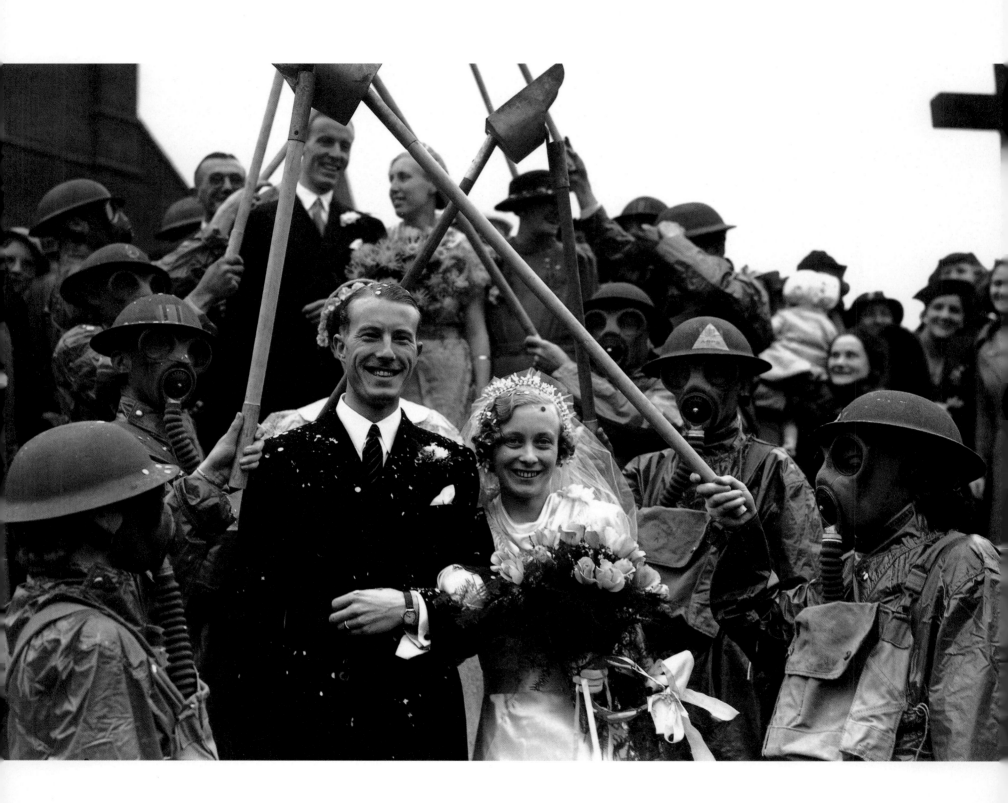

Forties restraint, fifties froth

Wedding culture in the 1940s was profoundly affected by World War II. The war was a powerful catalyst of moral change, and caused many to rethink their attitudes toward love, sex, and marriage. The mood was summed up by one woman, who said: 'Moral taboos had not been banished, but their pride of place was gone. The sex code was a permissive one, allowing chastity or promiscuity, frowning only on prudery and prurience.'[2] Rushed marriages were rife as soldiers demanded emotional security before leaving to fight. 'Last fling fever, ceremonies were hastily arranged by couples who had just met and felt that, as a partner's death might be imminent, they must enjoy the moment. As one American soldier commented, 'By most people's standards we were immoral but we were young and could die tomorrow.'[3] The traditions of long courtship were abandoned and, in the weeks after the Japanese attack on Pearl Harbor, American couples were marrying at the fantastic rate of 1000 per day, a twenty percent rise in the national rate.

Despite such dramatic changes, 'a formal ceremony, with as many trimmings as ration books permitted' was still regarded as *de rigueur* for solemnizing matrimony,'[4] although one army professional asserted that 'Hasty war marriages, on embarkation leave, sometimes between comparative strangers, with a few days or weeks of married life, have left both parties with little sense of responsibility or obligation towards one another.'[5] In a regular wartime column entitled 'Marrying in Haste, Accelerated Wedding Plans,' American *Vogue* wrote that 'weddings nowadays hang not on the bride's whim, but on the decision of the groom's commanding officer. He names the day – when he grants that unexpected furlough … The 1942 schedule may run something like this: engagement announced, if it hasn't already been announced, on Monday, invitations sent out by telegraph on Wednesday, the last handful of rice and rose petals flung on Saturday.'[6]

It is popularly believed that fashion came to a standstill during the war of 1939–45. Paris was under Nazi occupation by June 1940, resulting in the closure of showrooms of some important couture houses, including Balenciaga and Molyneux. However, many designers continued, albeit without the important foreign buyers who had contributed to their prewar success. The concentration on the war effort in the rest of Europe and America meant restrictions on materials and labor for fashion. A rigorous system of clothes rationing was introduced, with an emphasis on practicality in clothing above all other concerns. The result, in the words of historian Maureen Turim, was a 'tailored look which harmonised with the uniforms women were wearing in newly acquired wartime industrial jobs and in the military, and was in keeping with a program of … economy aimed at the consumer on the home front.'[7]

OPPOSITE An ARP (air raid precautions) wedding of 1941, with the bride and groom leaving under an archway of incendiary-bomb scoops held by a guard of honor in gas masks and steel helmets.

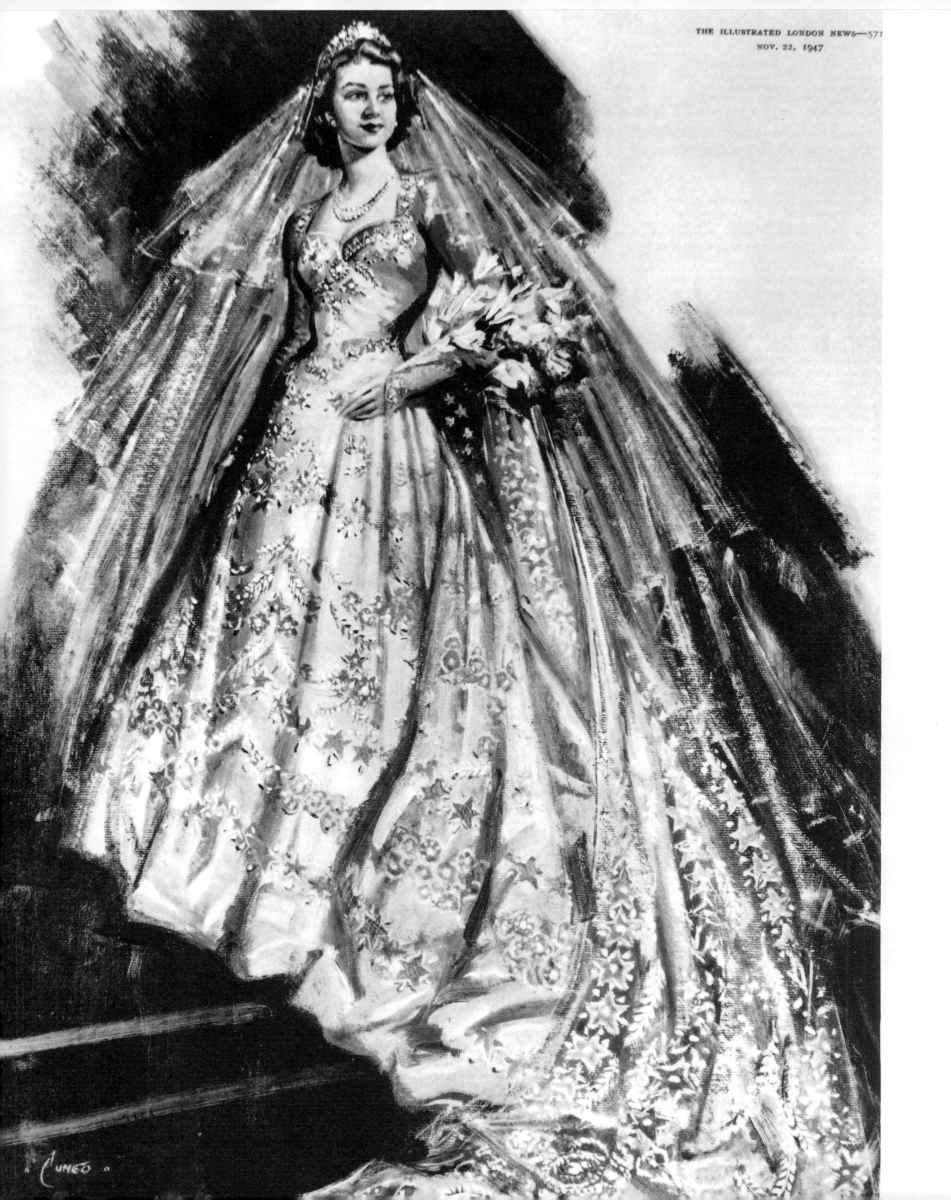

after that that things began to appear from the [army] camp up the road, such as dried fruit and butter, and two airmen came back from leave with some eggs! So with a bit of this and a bit of that, we conjured up a large wedding cake. I had borrowed a wedding dress and veil for the bride and Ruth, the bridesmaid was in uniform.'[12]

Some weddings started well, but long wartime separations caused difficulties. 'Tom arranged the wedding for 1 May 1943. I borrowed my wedding dress of white velvet, long veil and tiara of artificial orange blossom. My friend Muriel bought a second-hand pale-blue, long dress, short blue veil, Juliet cap and gloves to match. There were no church bells. Church bells meant invasion. There was no confetti either. The reception was held in the oak room of the local picture-house-cum-restaurant. We had ham salad, trifle, white wine (one glass only for the toast), a two tier cake covered with iced cardboard, which was removed to reveal a fruit cake underneath, but it looked authentic in the photographs.'[13] Afterwards the groom went back to the front ... When he came back, 'the first few weeks were difficult. He'd been away for three years and there was a lot of friction and squabbles.'

In times of war, morning dress seemed out of place and most men wore their uniforms for the wedding ceremony. In fact, with increasing numbers of women entering the services, both bride and groom were often in uniform. Civilian brides wore utility suits accessorized with a small veiled hat. As it was difficult enough to deck out a bride successfully, bridesmaids were out of the question. Even by 1947, restrictions in Britain still abounded, and firms such as Moss Bros., which had been renting out men's formal clothes since the 1890s, branched into wedding dresses as well. There was still a stigma attached to hired dress though – regarded as the province of the poor – and Noël Coward vividly describes the thrill of an own-bought suit: 'The days of twirling anxiously before Moss Bros's looking glass were over. No more hitching of the armpits to prevent sleeves from enveloping the hands altogether. No more bracing of outgrown trousers to their lowest, with the consciousness that the slightest movement of the arms would display a mortifying expanse of shirt between waistcoat and flies. All that belonged to the past.'[14]

If not dressed by Moss Bros., men tended to wear 'demob' suits (government-issue jackets and pants given to troops when they were demobilized, that is, sent home after the war). Usually poor-fitting, they became a signifier of working-class or bohemian life in the 1950s, and the butt of many jokes. The poet Ted Hughes wore his demob clothes on his wedding to Sylvia Plath, who wore the 'pink wool knitted dress' of the poem's title, ignoring convention and the drab utility styles offered up to her:

> In your pink wool knitted dress
> Before anything had smudged anything
> You stood at the altar. Bloomsday.
> Rain – so that a just-bought umbrella
> Was the only furnishing about me

OPPOSITE Princess Elizabeth's ivory satin wedding gown designed by Norman Hartnell, with pearl and crystal embroidery and Sweetheart neckline – a fairy-tale fantasy in the midst of postwar rationing and deprivation.

Newer than three years inured.
My tie – sole, drab, veteran RAF black
Was the used-up symbol of a tie.
My cord jacket – thrice dyed black,
Exhausted. Just hanging on to itself.
I was a post-war Utility son-in-law![15]

In 1945, as the war was declared to be at an end, one fashion journalist wrote: 'this year begins a new era and it follows as the peace the war, that men want women beautiful, romantic ... birds of paradise instead of hurrying brown hens.'[16] Even so, the dominant high-fashion silhouette up to 1947 was one made up of a broad-shouldered, boxy jacket, a blouse and a straight-cut skirt with a knee-length hemline. Changes came in 1947 with the New Look, which was 'given enormous play in fashion journals anxious to leave behind their wartime sobriety. [It] was characterised by a soft shoulder, a "wasp waist," and a full skirt. It was simple and tailored for daytime wear, with the fullness supplied by draping, and extravagantly full for evening.'[17] The New Look was deliberately promoted by Paris in a successful attempt to regain the fashion position lost during the Occupation. In September 1947, Dior's Corolle line was shown to the assembled press, an event that has entered the annals of fashion as a defining moment.

Perhaps it was the glitz of Dior's show in the aftermath of war that so appealed to the press and foreign buyers. Whatever the reason, as the collection was paraded down the postwar runway, 'The long frothy skirts of Dior's collection were so full that they brushed against the cheeks of the assembled crowd as the models swished. The audience was shocked, enraptured and captivated. Seasoned fashion journalists to this day remember that show as one of the most magical moments of their lives. Perhaps the huge quantity of Dior perfume that was sprayed over each member of the audience as he or she struggled to gain entrance to the little showrooms made everyone a little light-headed.'[18]

Not all were lightheaded, though, and some saw the New Look as a retrogressive form of dressing for women, a return to an almost Edwardian physical restriction and fussiness after the functionalism of 1940s dress. Dior himself made it clear he was breaking with the look that had dominated the last few years, saying, 'we were emerging from a period of war, of uniforms, of women-soldiers built like boxers. I drew women-flowers, soft shoulders, flowing busts, fine waists like liana and wide skirts like corolla.'[19] But such profligate use of material at a time of grim austerity inevitably provoked a reaction in Britain. Journalist Marjorie Beckett wrote of fashions that were being 'launched upon a world which has not the material to copy them, and whose women have neither the money to buy, the leisure to copy, nor in some designs even the strength to support, these masses of elaborate material. We are back to the days when fashion was the prerogative of the leisured wealthy woman and not the everyday concern of the typist, saleswoman or housewife.'[20] However, wedding gowns were not everyday dressing and the tightened waist, fitted bodice, padded hips, and long bouffant skirt of the New Look were embraced by both the bridal industry and home dressmakers alike.

OPPOSITE The 1947 wedding of Princess Elizabeth of Great Britain and Prince Philip of Greece was one of the most publicized of the twentieth century, a beacon of hope for the future after the rigors of wartime, and a renaissance for traditionally styled gowns.

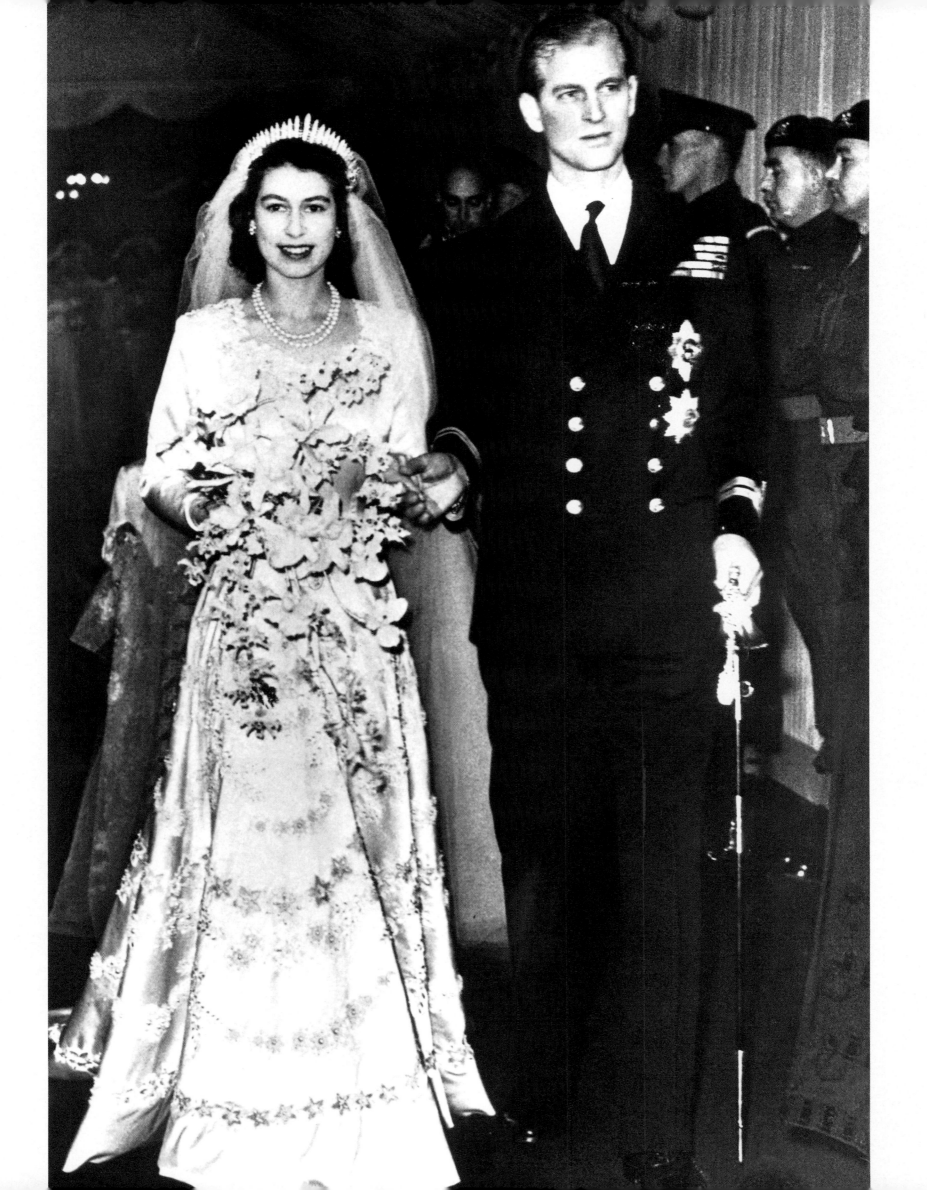

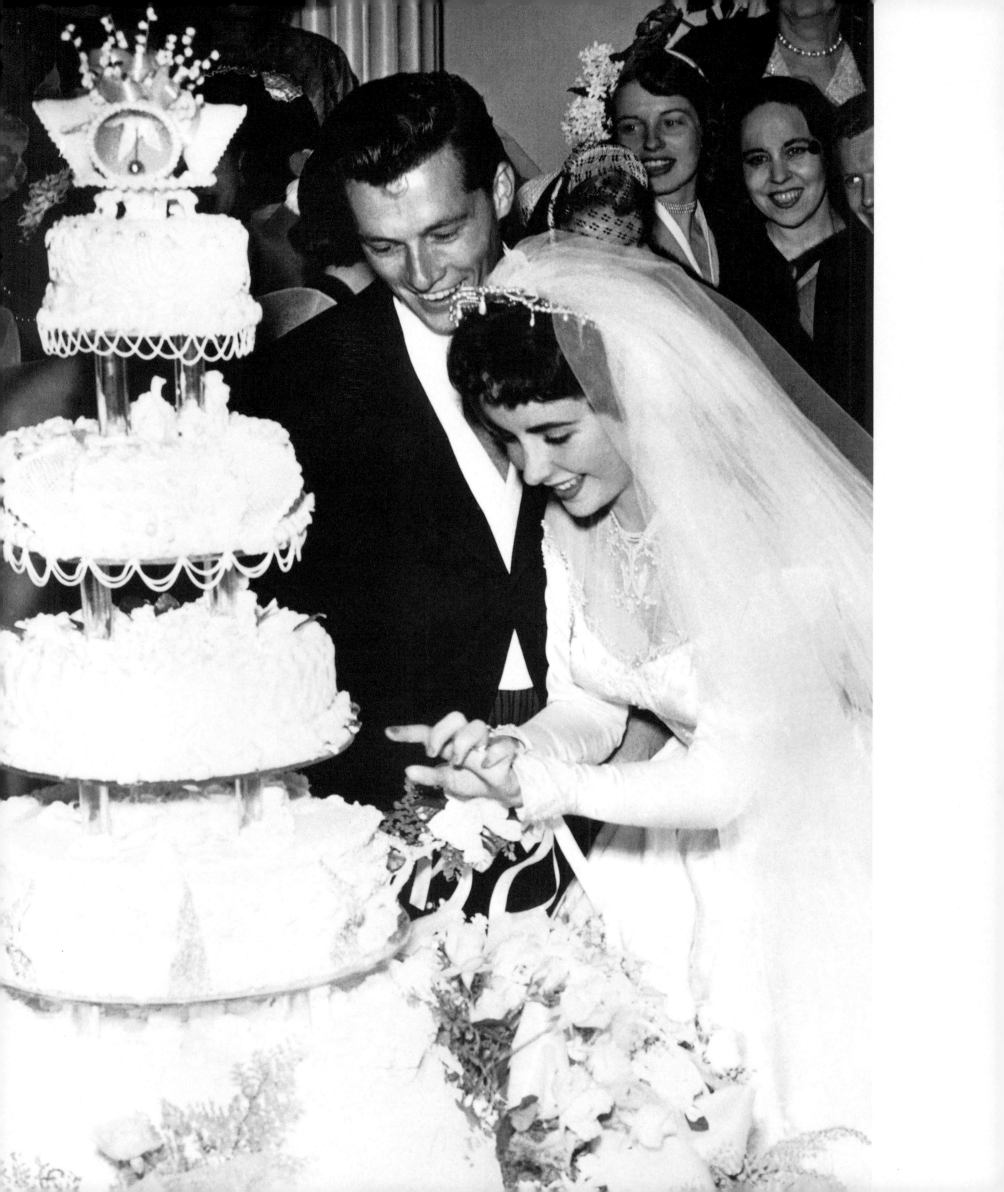

Two important, much-publicized weddings show how the immediate postwar years affected wedding fashion: in Britain, the wedding of Princess Elizabeth and Prince Philip of Greece in 1947; and, in the U.S., the wedding of the film star Elizabeth Taylor and Conrad Hilton in 1950. Helped by a special allowance of clothing coupons, the royal Elizabeth wore a dress of ivory satin, embroidered in pearl and crystal with a motif of roses, starflowers, and orange blossom. It had a Sweetheart neckline and a fifteen-foot court train that (according to mythology) contained one hundred miles of thread. Commonwealth countries lapped up the wedding after the rigors of war, and presents were sent from all corners of the Empire: a diamond necklace from India; a beaver coat from Canada; and, in a typically English gesture, the town of Leamington Spa sent a washing machine. One child in the U.S., worried that rationing would ruin the wedding feast, sent the princess a live turkey in time for the nuptials.

Norman Hartnell was chosen to design the royal gown and, sworn to secrecy, covered up all his workroom windows to combat any spying from the press. The design was based on the painting *Primavera*, by Botticelli, which Hartnell had seen in a London art gallery. As Nigel Arch and Joanna Marschner put it, 'this figure – with its trailing garlands of jasmine, smilax, syringa and rose-like blossoms – was derived from the classical goddess of flowers, Flora, and its floral attributes suggested to him the promise of growth and new beginnings after the drabness of war and the post-war era.'[21] Postwar rationing caused a few hiccups in the construction of such a sumptuous gown, though. Hartnell's manager flew to the U.S. to find the 10,000 pearls used in the decoration of the dress, and silk was quickly obtained from China instead of the more usual silks from Italy or Japan (with whom the Allies had been at war).

The dress was considered a triumph. Arch and Marschner describe it as 'a one-piece Princess style with a fitted bodice, the neckline having a deep-scalloped edge. The front bodice was cut in three panels, with additional waist and bust darts, and the back was cut in four, fastening down the centre back with buttons and loops. The wrist-length, tight-fitting sleeves ended in embroidered cuffs. From the low-pointed waist, the skirt, cut on the cross … extended to a deep circular train.'[22] *Vogue* described it as 'a bridal dress in the great tradition: ivory satin starred, with Botticelli-like delicacy and richness, with pearl and crystal roses, wheat, orange blossom.'[23] Worn with an heirloom diamond tiara given by Queen Mary (who had worn it to her own wedding in 1893), and a double tulle veil, Elizabeth walked down the aisle of Westminster Abbey accompanied by two pages and eight bridesmaids, all dressed by Hartnell, while a patriotic public listened to the ceremony on the radio. By royal standards the wedding could be construed as understated, but the invited guests were determined to show off their wealth. The Danish ambassador's daughter described 'the jewellery at that wedding [as] staggering. I was breathless and gaping at the stupendous display. It was pre-war dimension. Everyone had gone to the bank to get their jewels out of the vault. The former Duchess of Rutland had her entire head wrapped in diamonds. She said it was her grandmother's belt. A woman wearing a turban made of pearls the size of cherries passed another lady weighted down with bunches of cabochon emeralds cascading down her shoulders like grapes on a vine. The Indians wore breastplates of rubies and diamonds and wrapped their arms from wrist to shoulders in sapphires.'[24]

OPPOSITE A radiant 19-year-old Elizabeth Taylor marries Nicky Hilton (the first of her many marriages) in 1950 in a dress by Helen Rose. Rose insisted on the transparent white chiffon, to cover Taylor's revealing décolletage.

ABOVE & OPPOSITE... Farah Diba becomes Queen Farah Pahlevi, the third wife of the Shah of Persia, in a sumptuous ceremony in 1959. Tradition was combined with the best of 1950s' haute couture in Diba's pearl-encrusted gown and bouffant veil.

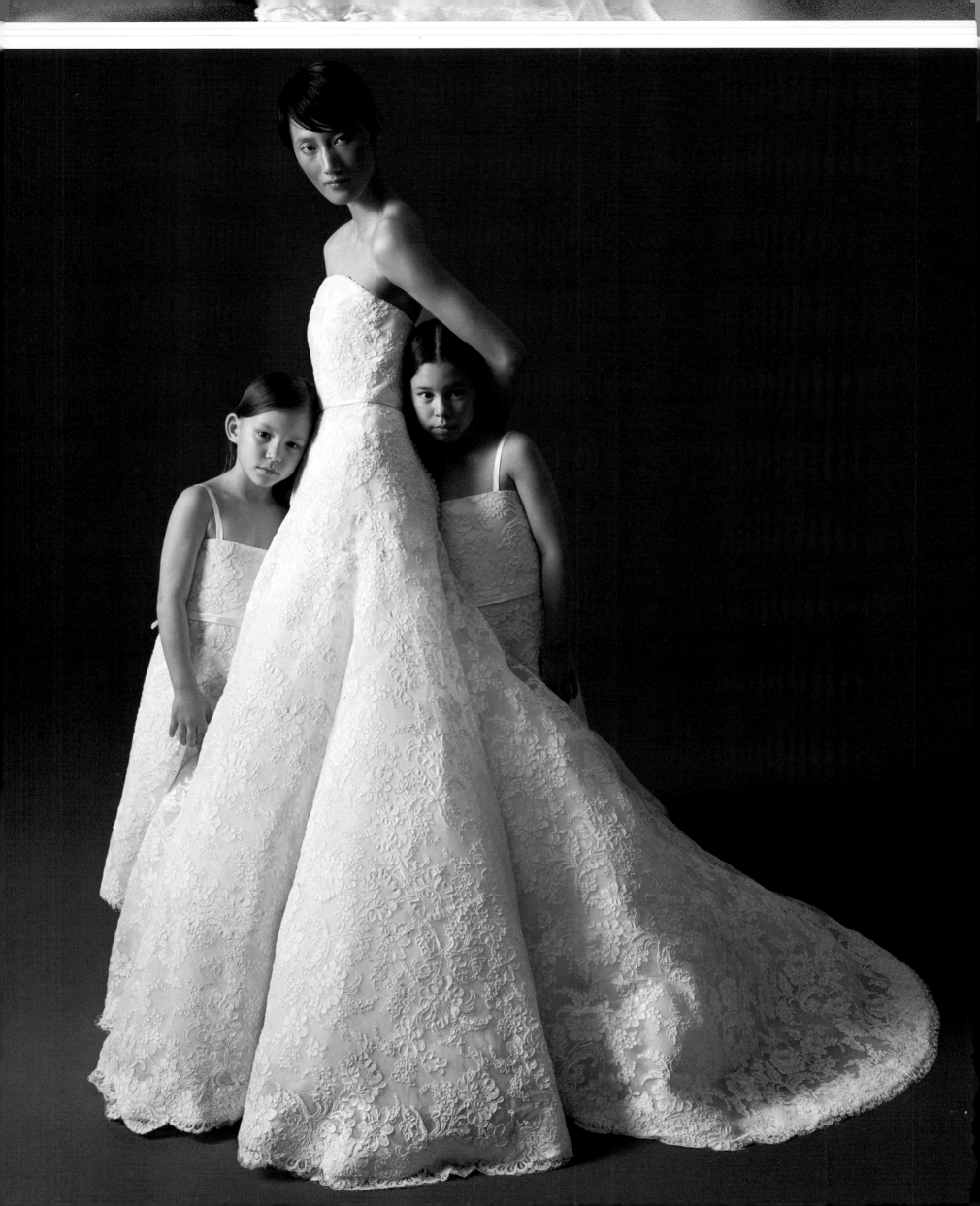

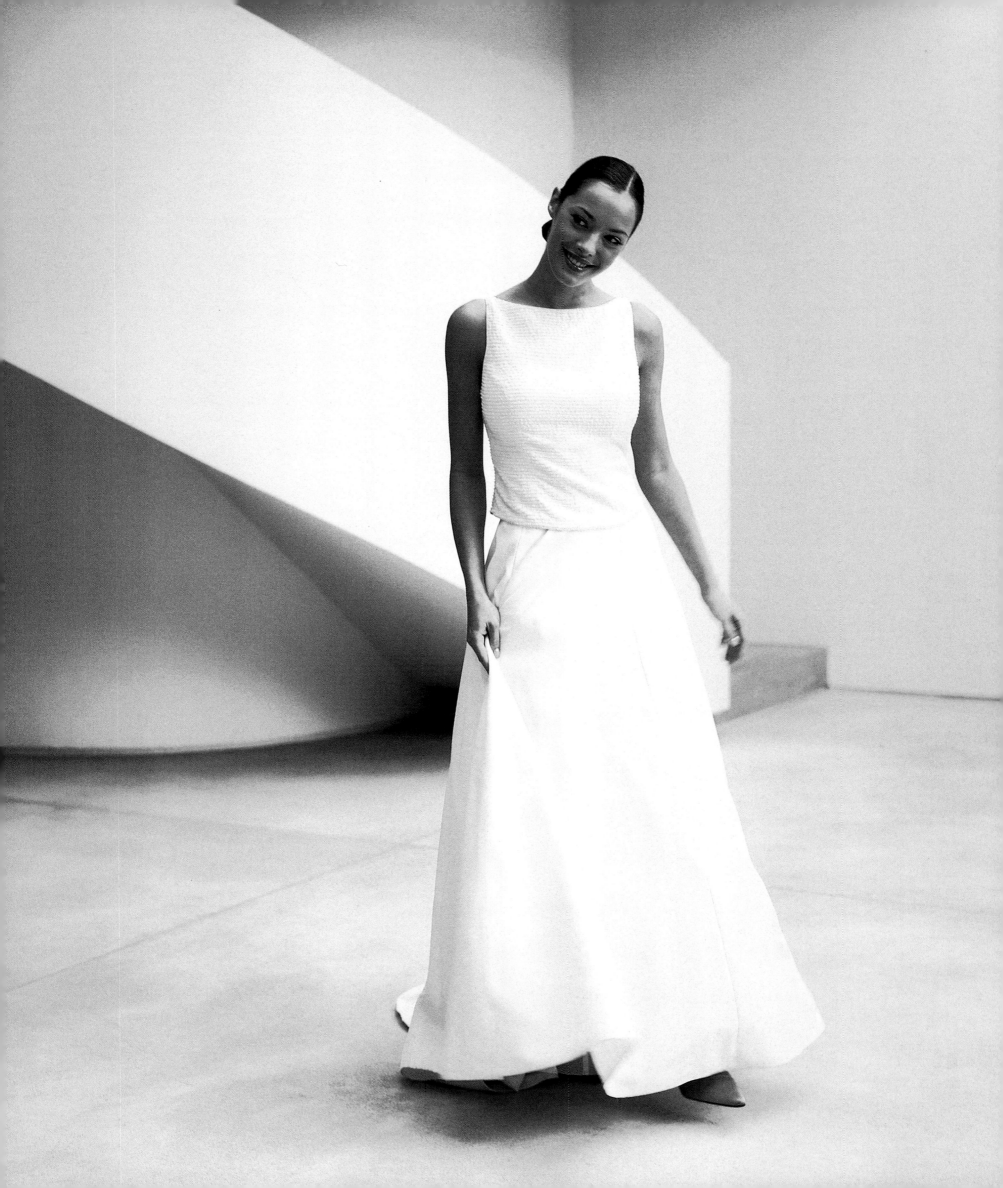

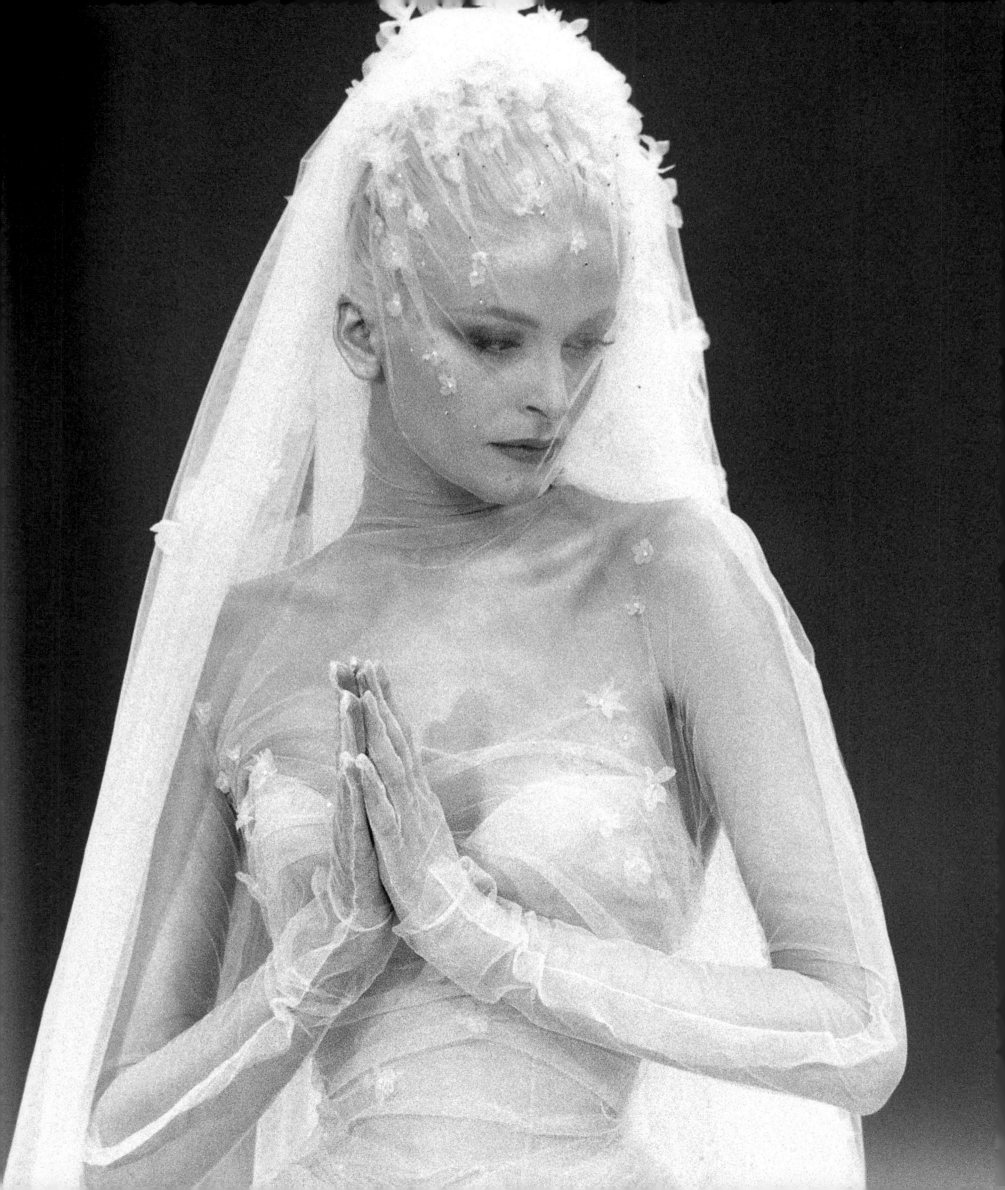

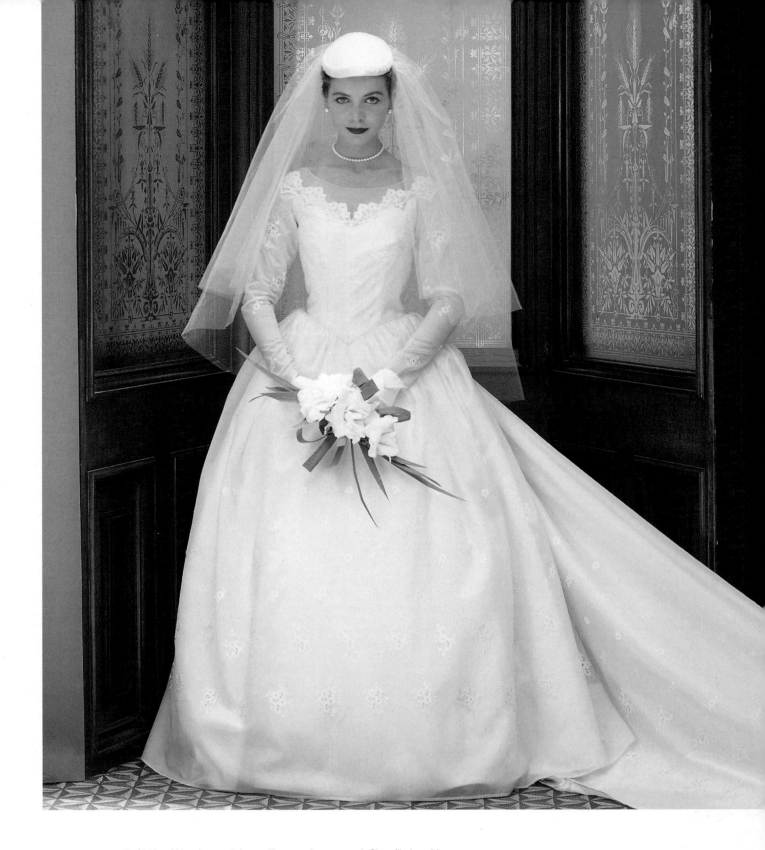

PREVIOUS PAGE... (Left) Vera Wang's pared-down silhouette in openwork Chantilly lace hints at 1950s evening dress, with its strapless molded bodice and semicircular skirt with integral train. (Right) A softly elegant wedding bodice and skirt by Debenhams, devoid of unnecessary frou frou and shown against the crisp concrete contours of modernist architecture.

OPPOSITE... Thierry Mugler subversively combines seduction and piety, with the overlaid tulle giving a glimpse of a 1950s-style strapless bodice, offset by the sleeve detailing (which emphasizes the model's hands at prayer).

ABOVE... A 1950s New Look silhouette incorporating design features such as a scalloped neckline, pillbox hat with veil, and a traditional court train.

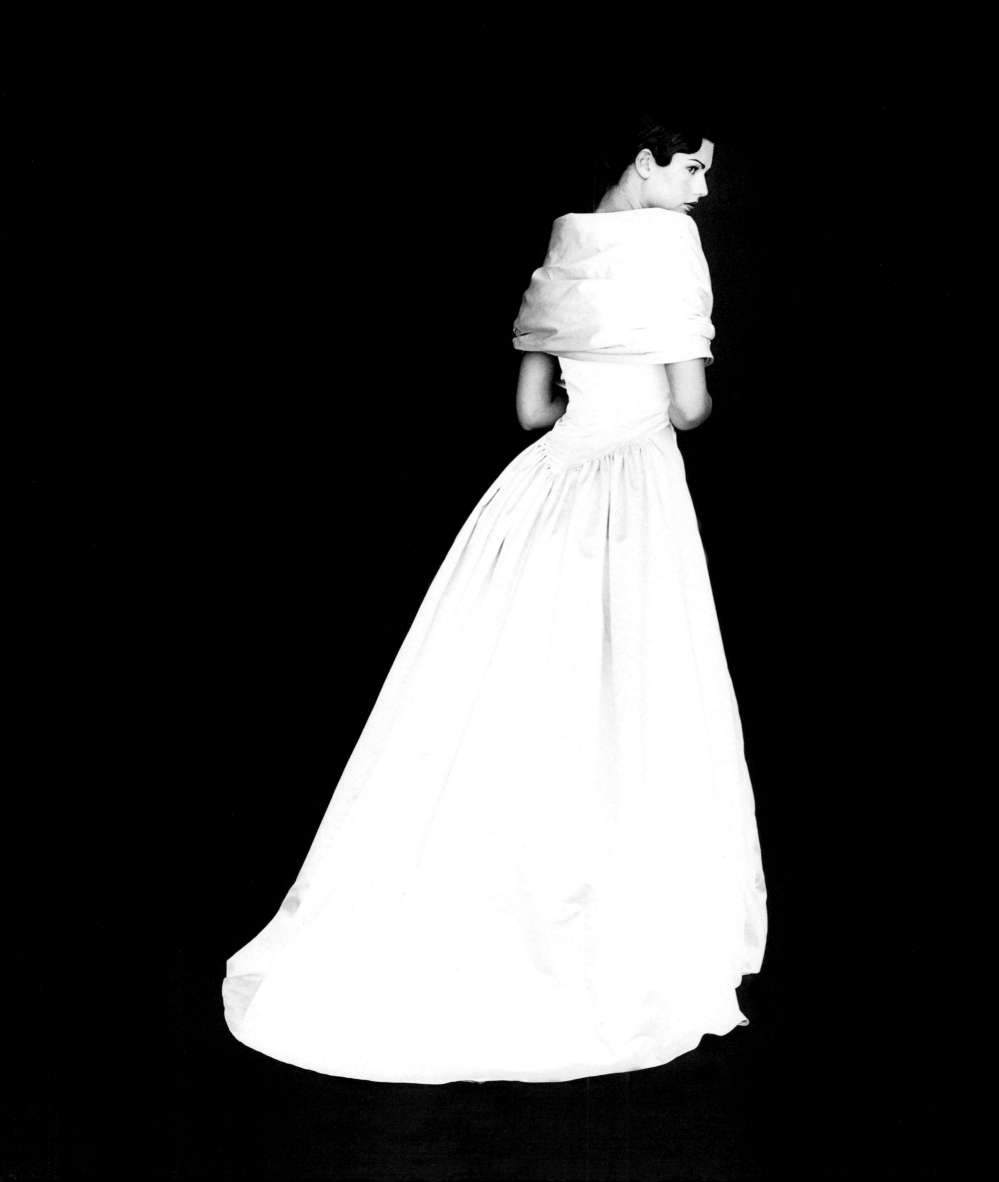

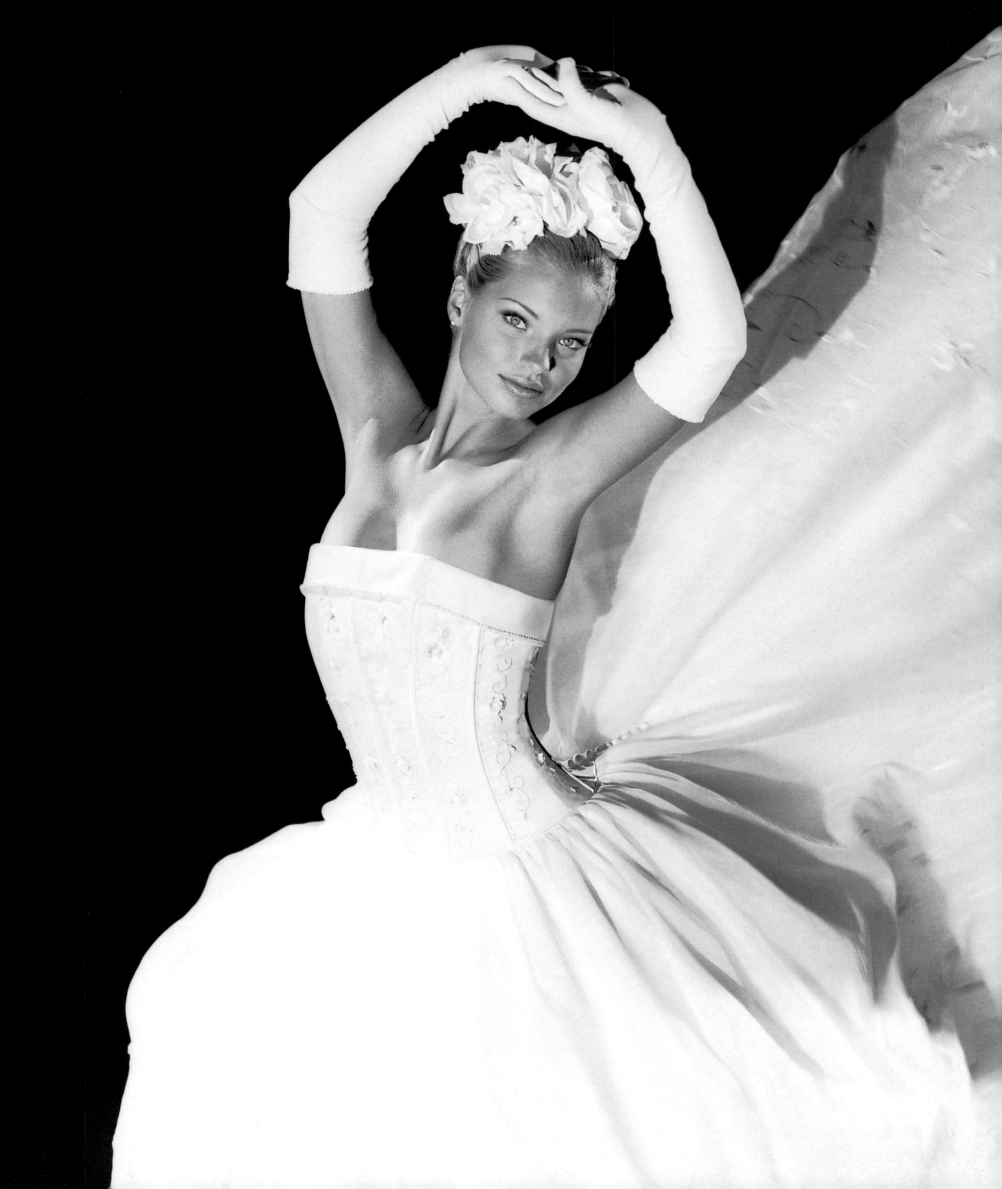

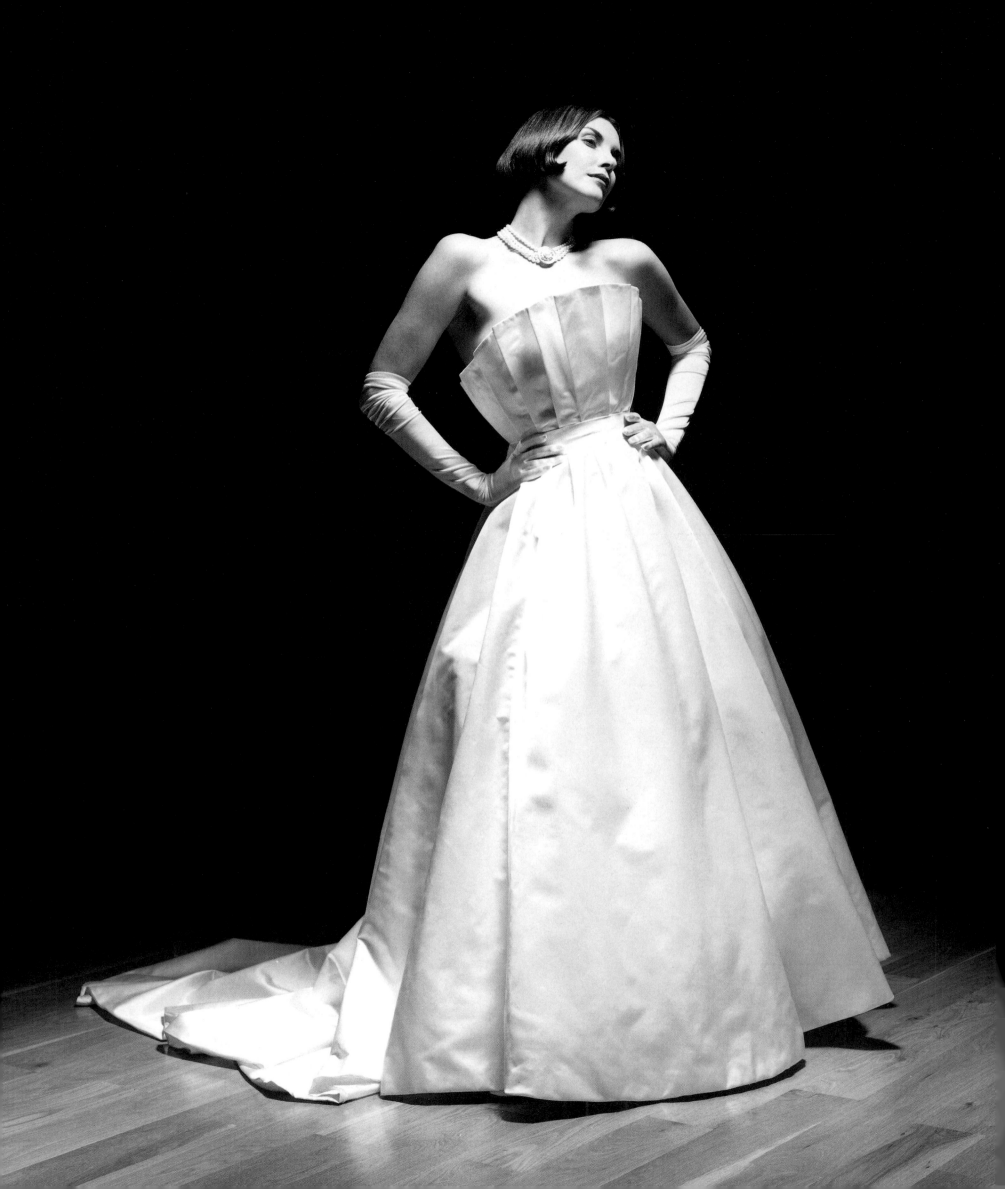

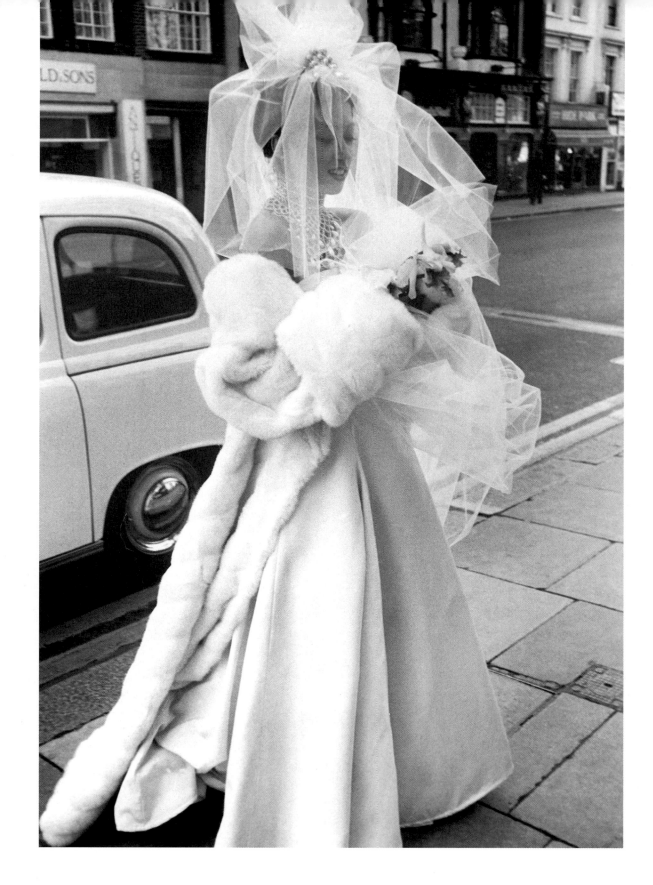

PREVIOUS PAGE... (Left) A purity of line demands attention in this demure design with exaggerated shawl collar by Sharon Cunningham. (Right) Ian Stuart reveals a fascination for the shapes and styles of 1950s evening dress in this modern bridal gown.

OPPOSITE... Caroline Holmes uses a pleated shell-shaped bodice to counteract the simplicity of the bell-shaped skirt with integral train.

ABOVE... Model Marries in Mink. In a riot of conspicuous consumption, this postwar bride wants the world to know that she has wealth, if not class. Her satin crepe gown, accessorized with a bouffant tulle veil, is there merely to showcase her extravagant white mink and lashings of costume jewelry. An excessively opulent look, which transforms the bride into a surreal apparition in such an urban setting.

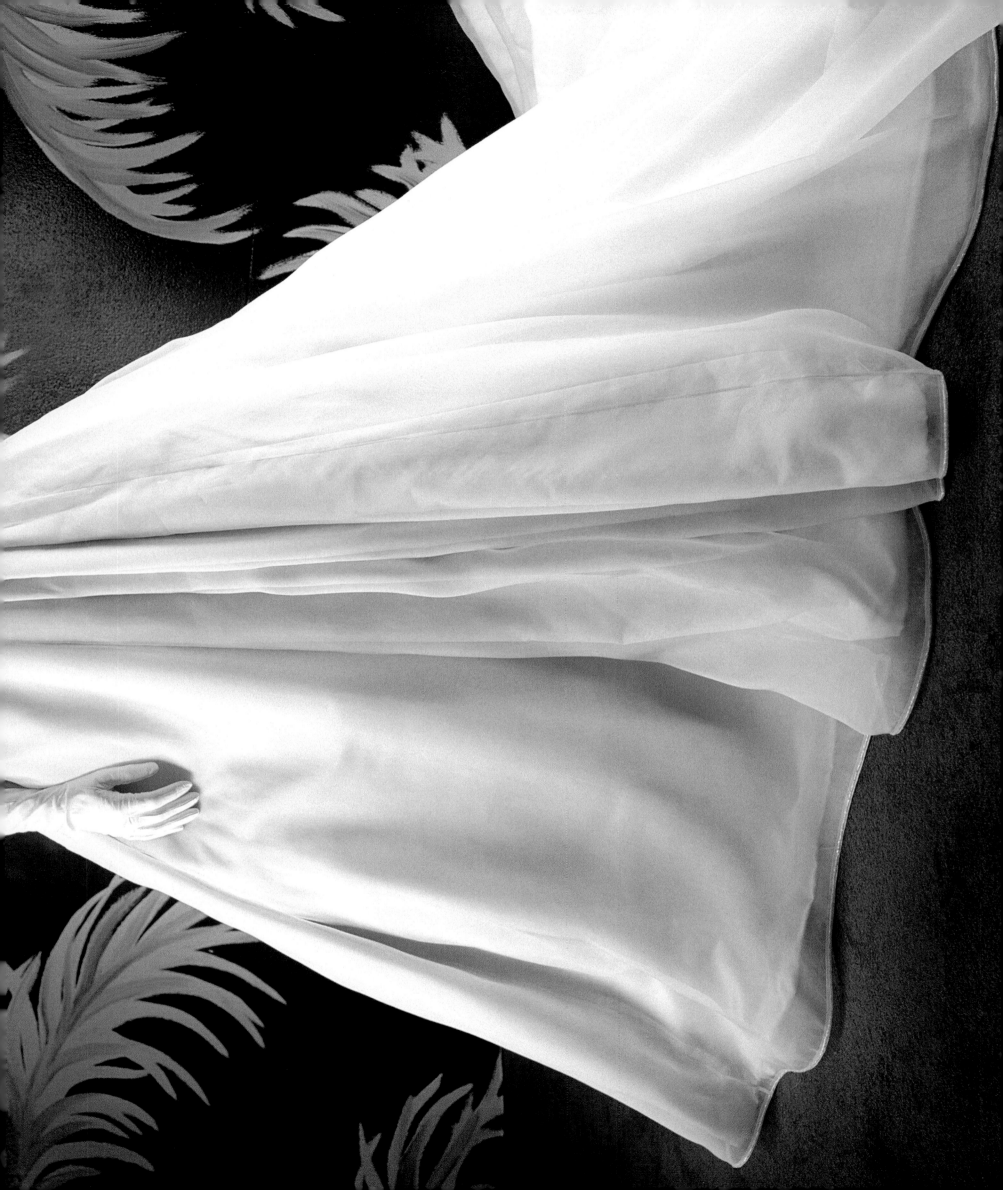

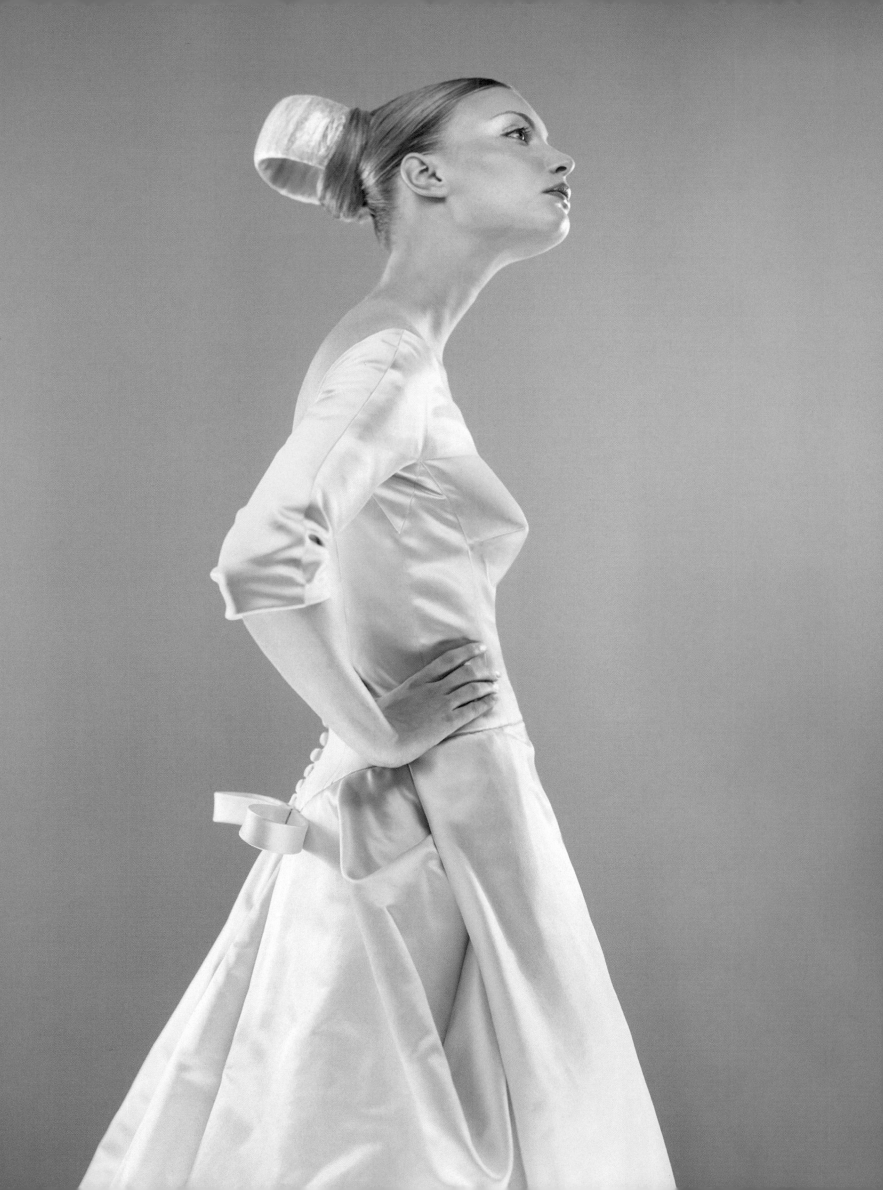

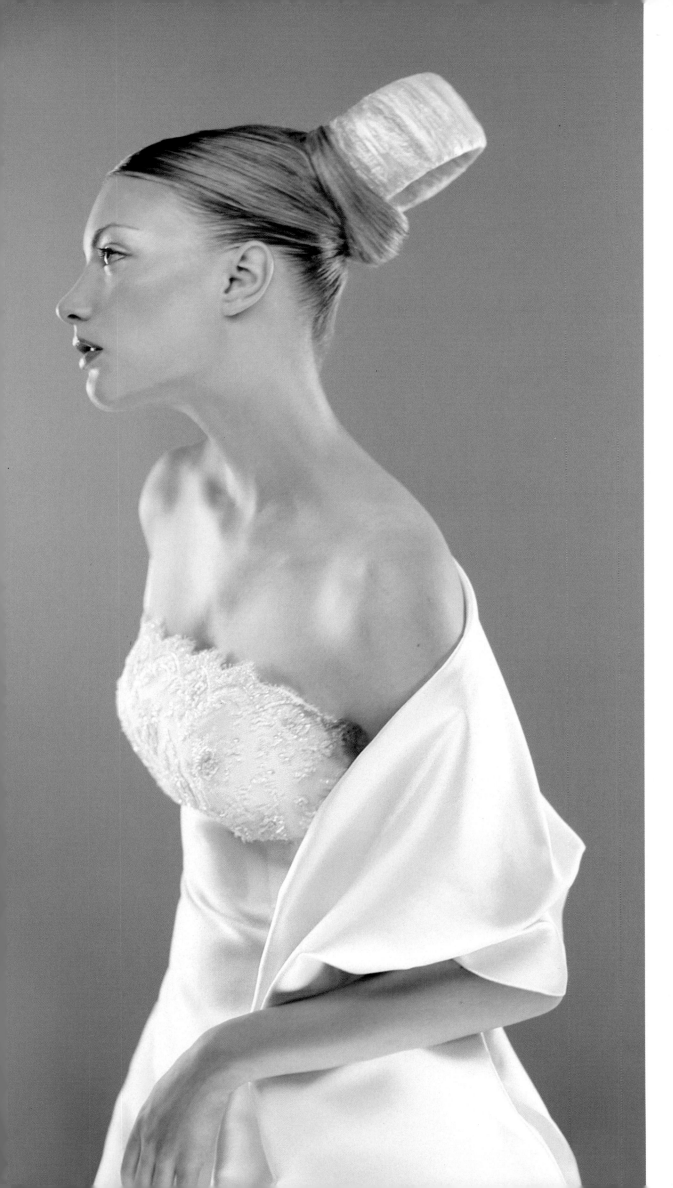

PREVIOUS PAGE... Cocoe Voci combines a strapless bodice of figured brocade with a circle skirt pleated from the waist, complete with organza overlay.

OPPOSITE & LEFT... Two designs by Peter Langner with a flavor of 1950s haute couture – an unusual choice of yellow for the bride on the left; on the right, a cleanly cut strapless gown with bodice detail and matching wrap. Both brides ignore the traditional (rather fussy) veil in favor of a sculptural headpiece.

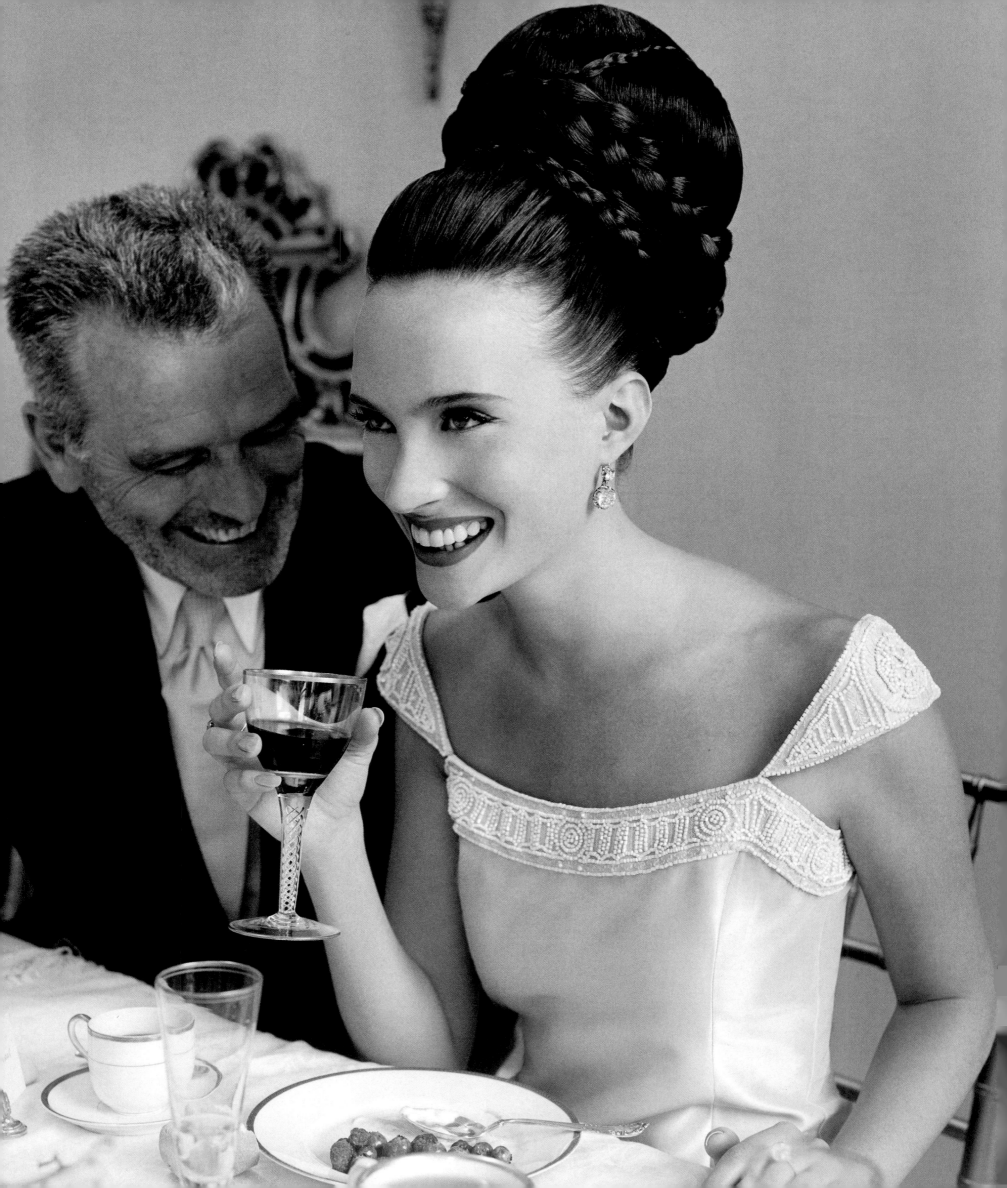

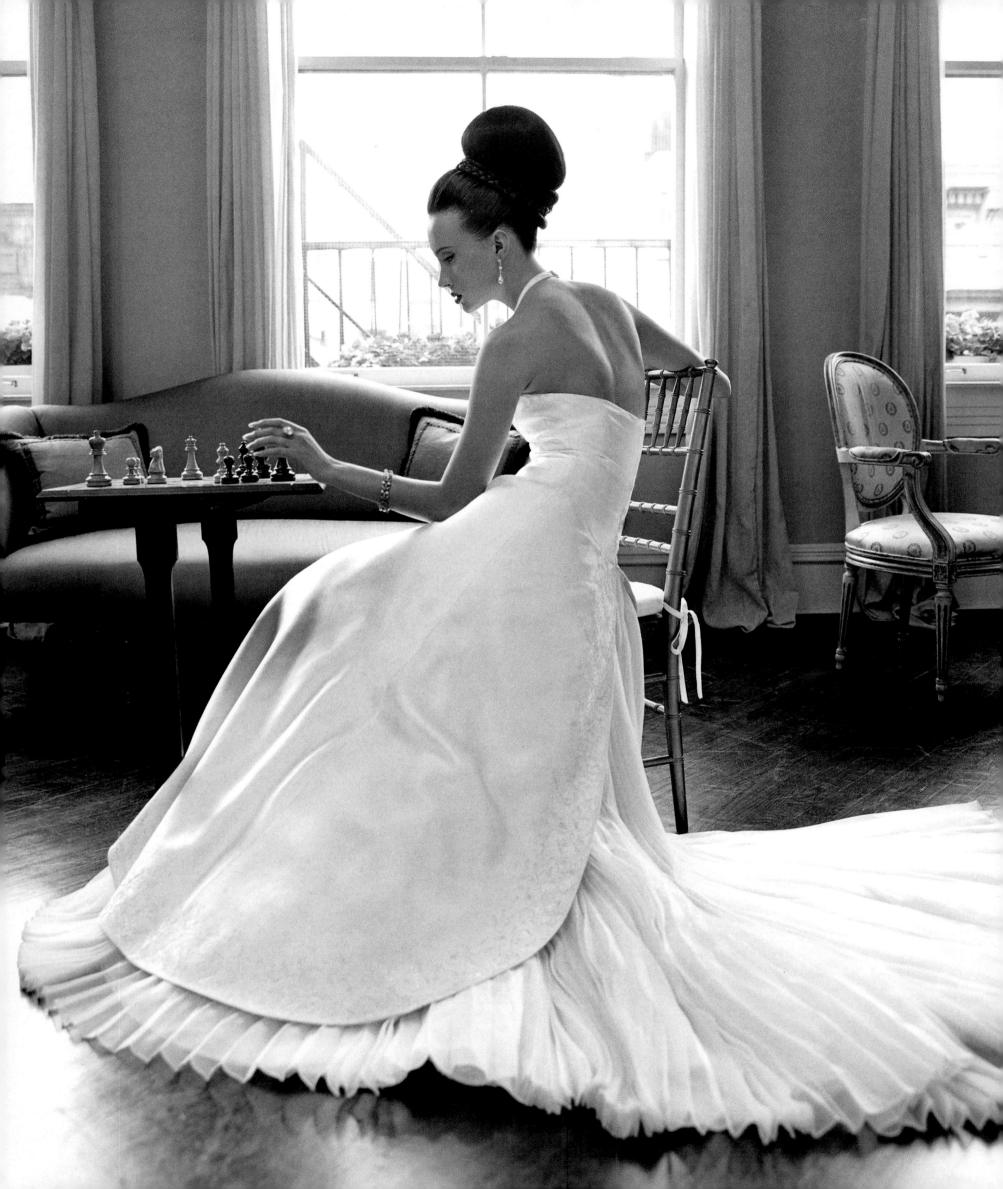

PREVIOUS PAGE… Shades of Audrey Hepburn in the styling of these gowns by Carolina Herrera. Using shapes derived from 1950s couture, the strapless gown opens at the back to reveal a cascade of pleated organza net.

RIGHT… A 1961 image by photographer Brian Duffy for *Brides* magazine shows a dramatically stylized wedding gown using the cutting techniques of couturier Balenciaga. The single-rose headpiece was a popular alternative to the bouffant veil in the 1950s and 1960s.

OPPOSITE… Irresistible (a British firm) specializes in tiaras, headwear, and veils, using semiprecious stones, pearls, feathers, and beads for a less conventional bridal look.

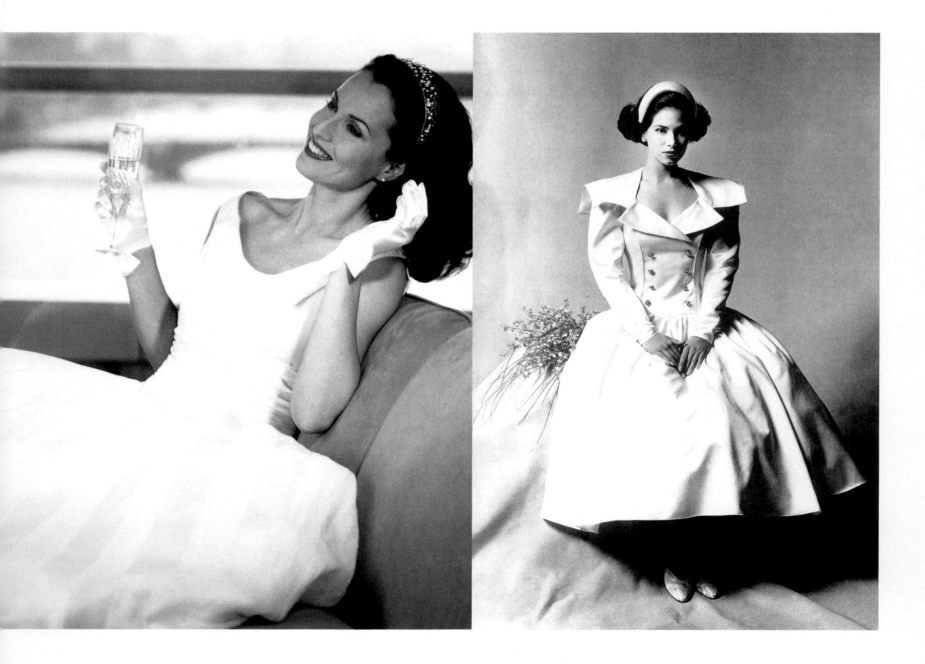

PREVIOUS PAGE... Highly acclaimed wedding photographer Giuseppe Bertolucci specializes in quirky, unconventional settings for his bridal images. Here, the bride poses against a tower of wooden pallets.

ABOVE... (Left) A fresh, young design by Caroline Holmes for a traditional bride. (Right) A 1988 image by the photographer Nick Briggs for *Brides* magazine. The huge padded shoulders of the nautical-style top echo the skirt swelling out from the hips.

OPPOSITE... French couturier Emanuel Ungaro, who trained at both Balenciaga and Courrèges, is known for his color sense. Here he shows a bold use of color for his runway bride, who wears a cerise petticoat.

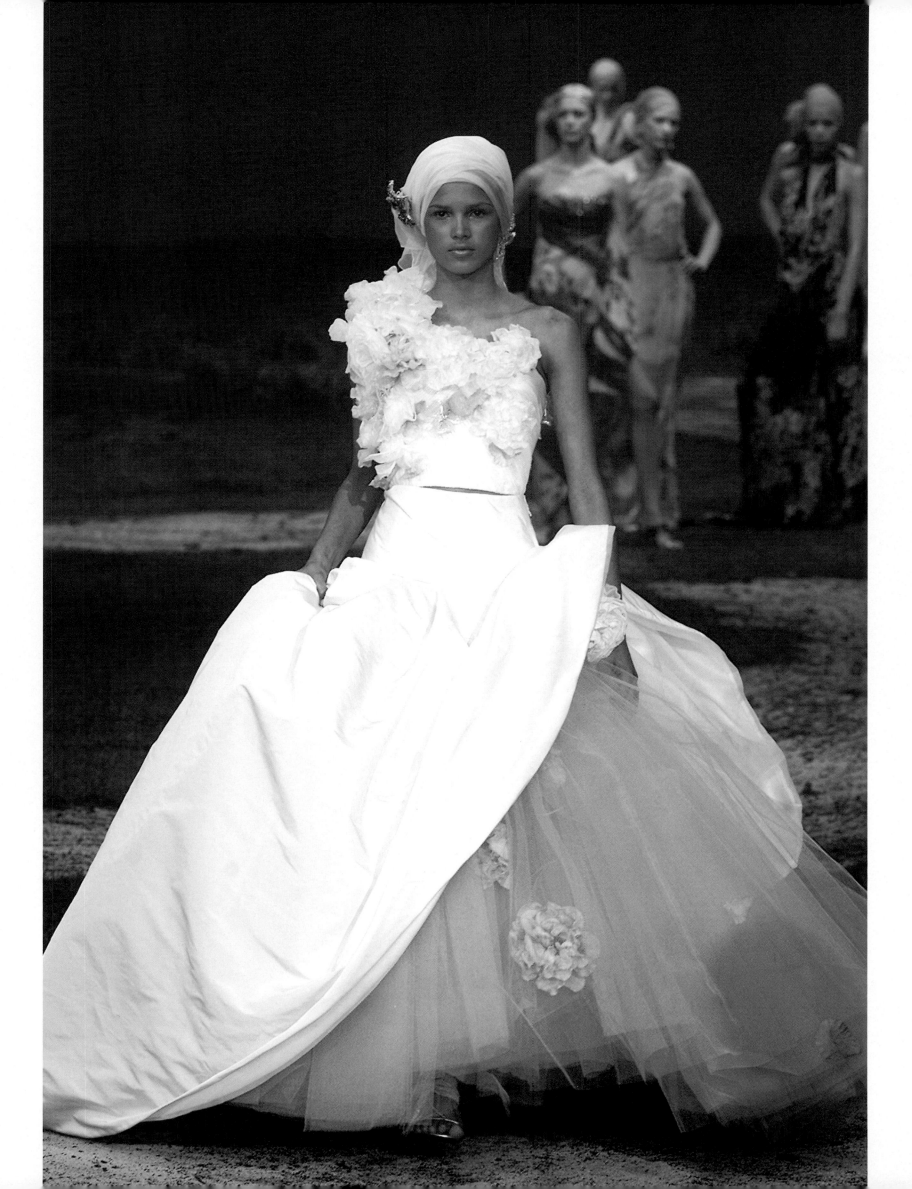

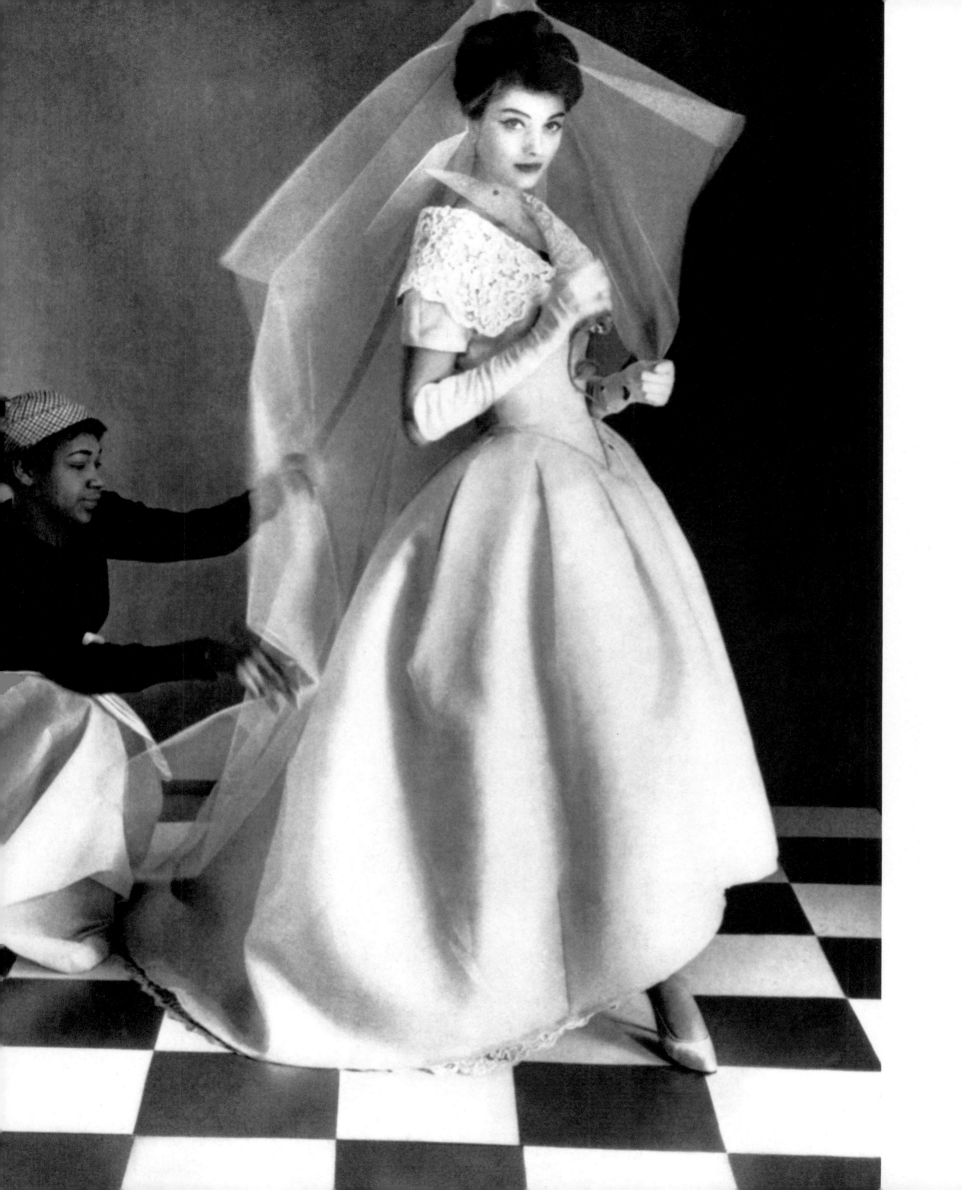

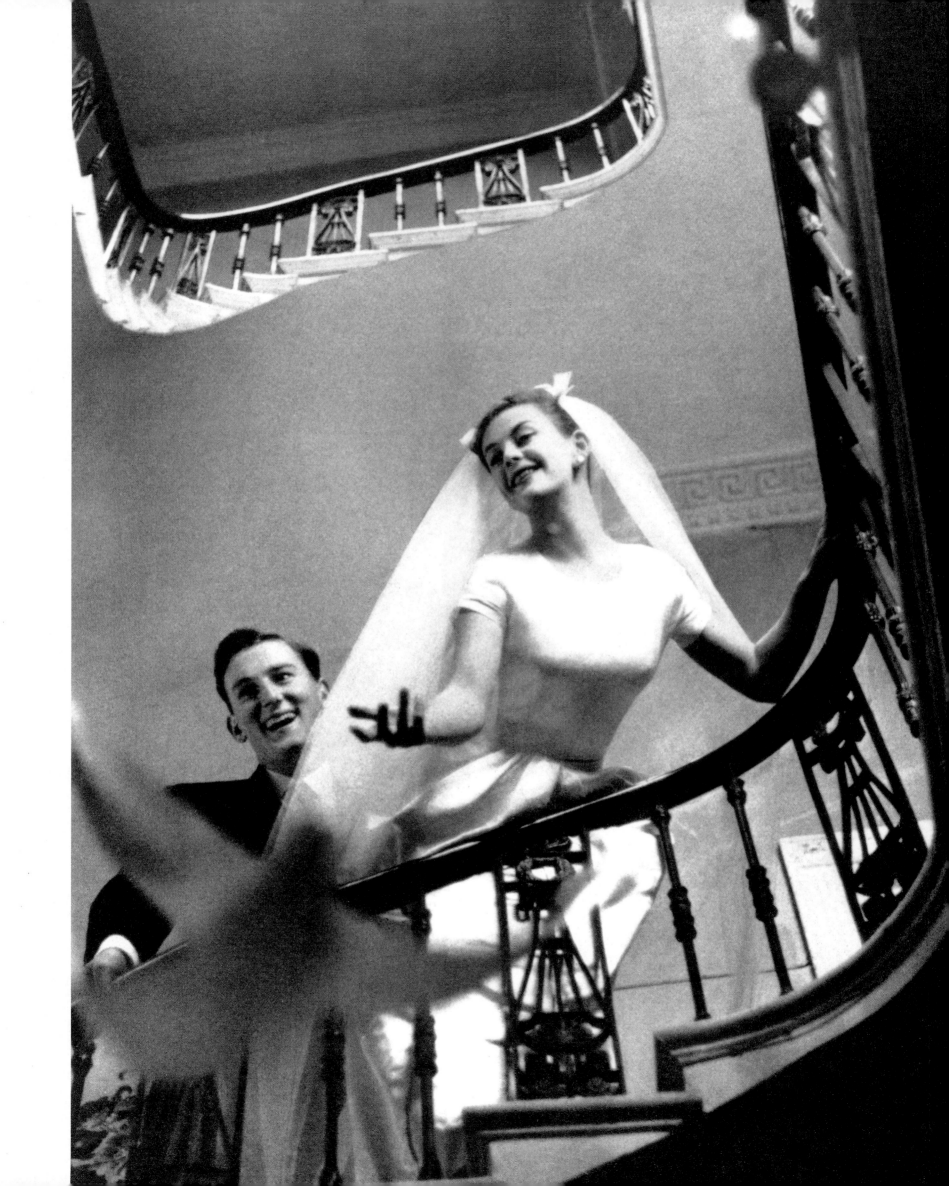

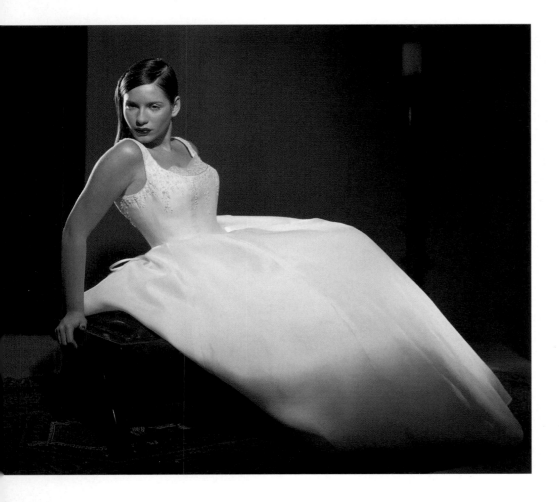

PREVIOUS PAGE... (Left) The representation of the black bride is rare in high-fashion photography in the twentieth century. In this 1958 image by Henry Clarke for *Brides Book*, the bride is set apart from her attendant, and blackness is positioned as Other. An exclusionary idealized 'whiteness' is established, which denies other races. (Right) Anthony Armstrong-Jones specialized in fashion shots that appeared uncontrolled, the models supposedly unaware of the camera's lens. The result was a stylized 'realism' that was in sharp contrast to the more staged fashion photographs of Norman Parkinson. This 1957 image was for *Brides* magazine.

ABOVE & RIGHT... These two wedding gowns by Sarmis use rich detailing to give an air of understated luxury to a sleek silhouette.

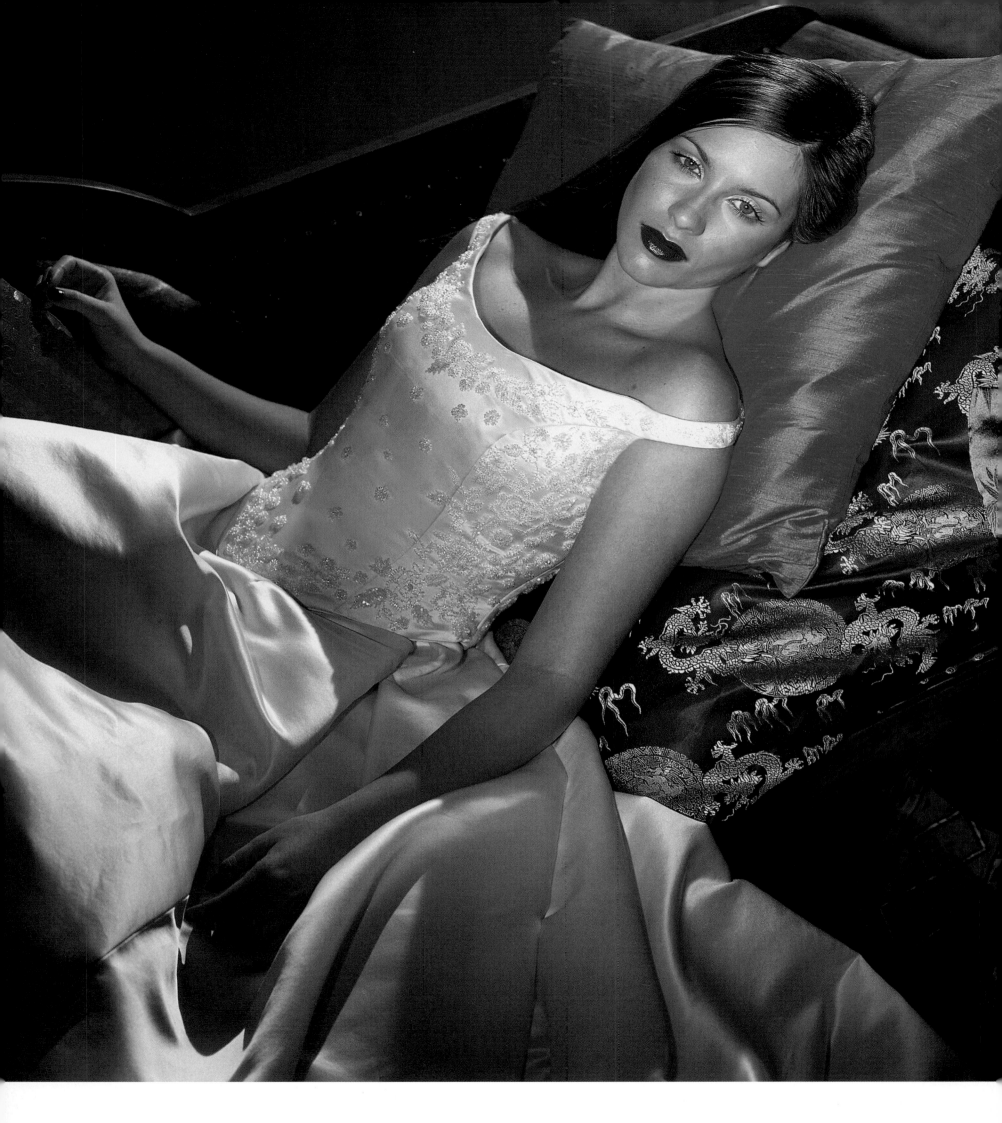

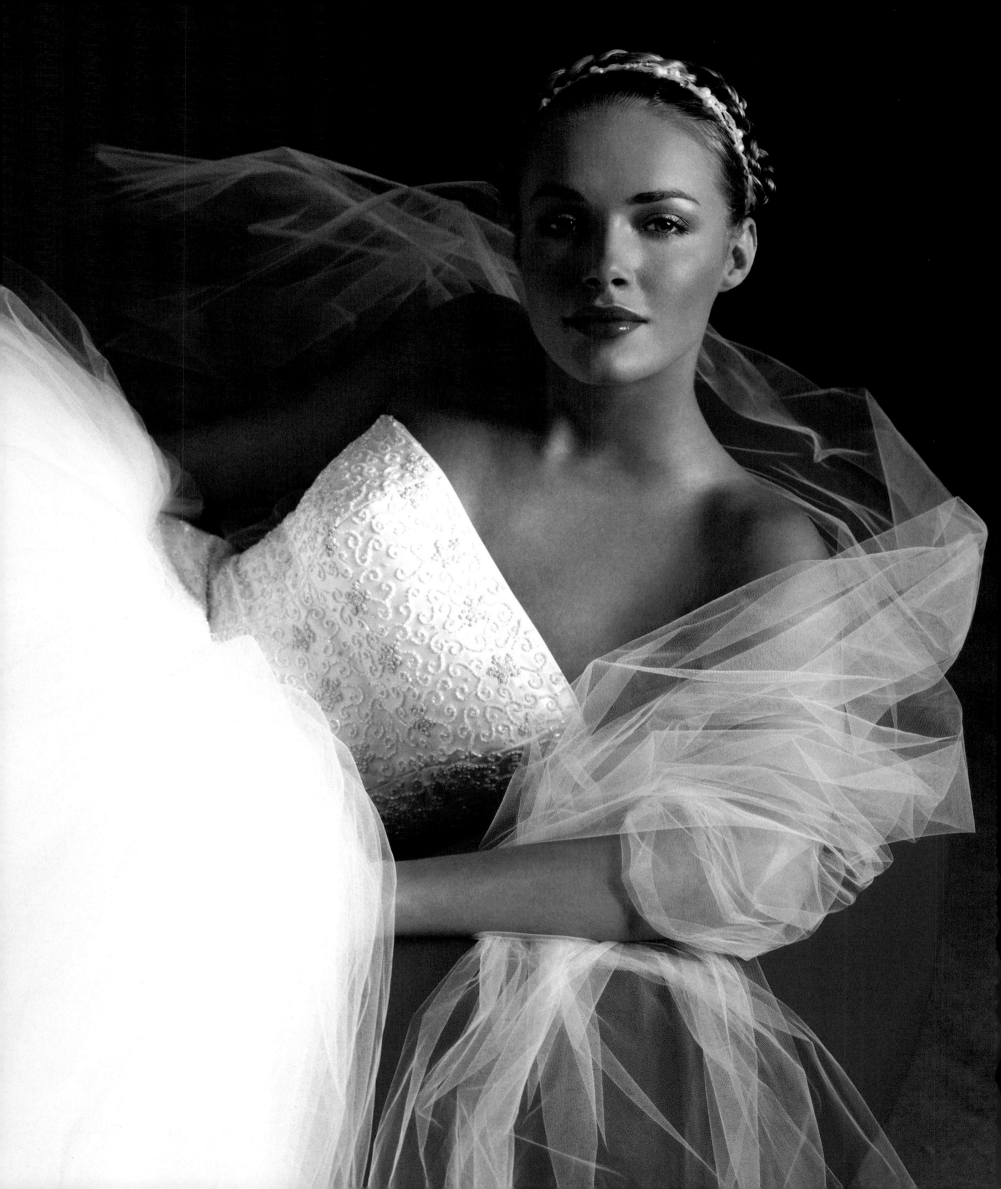

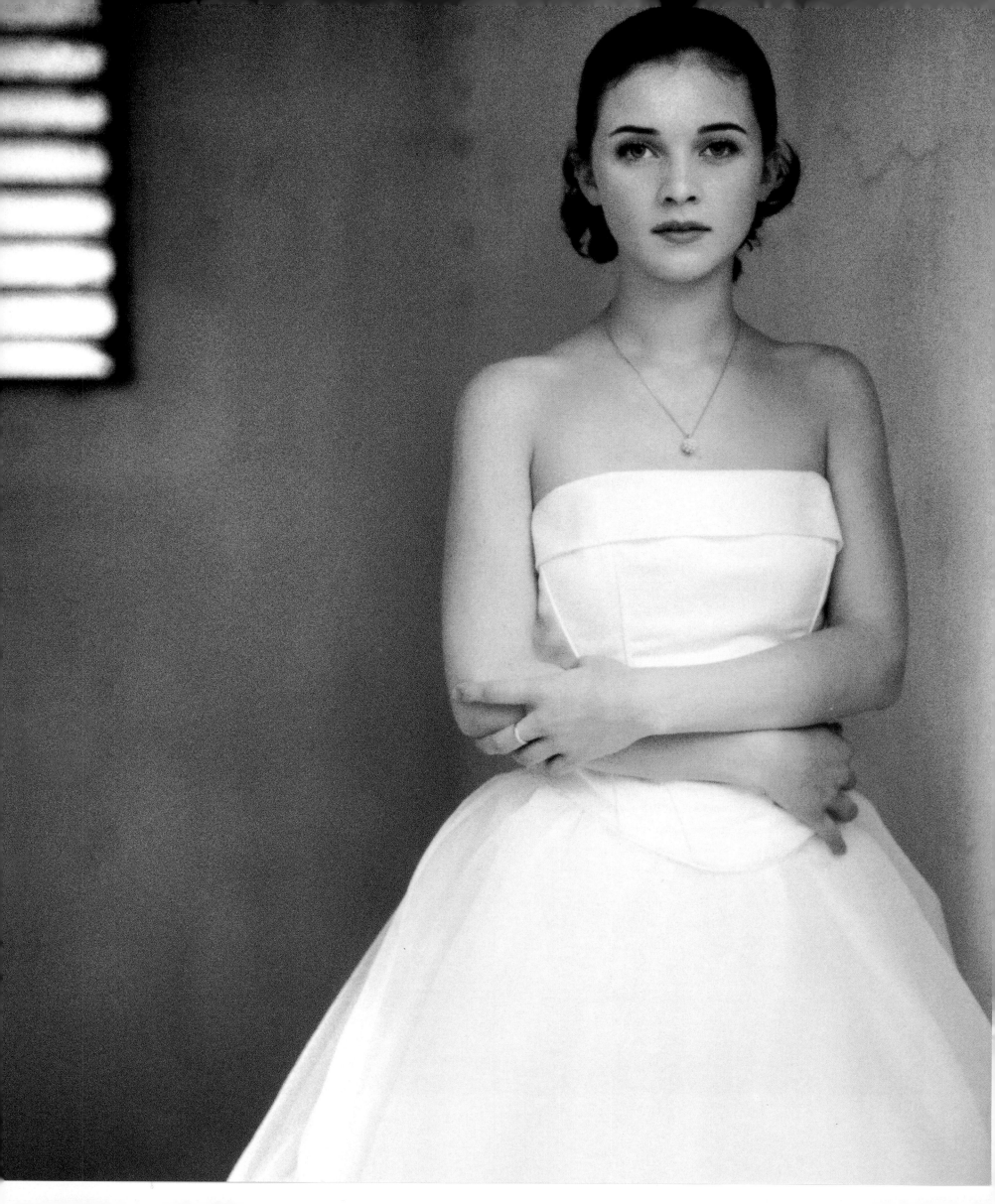

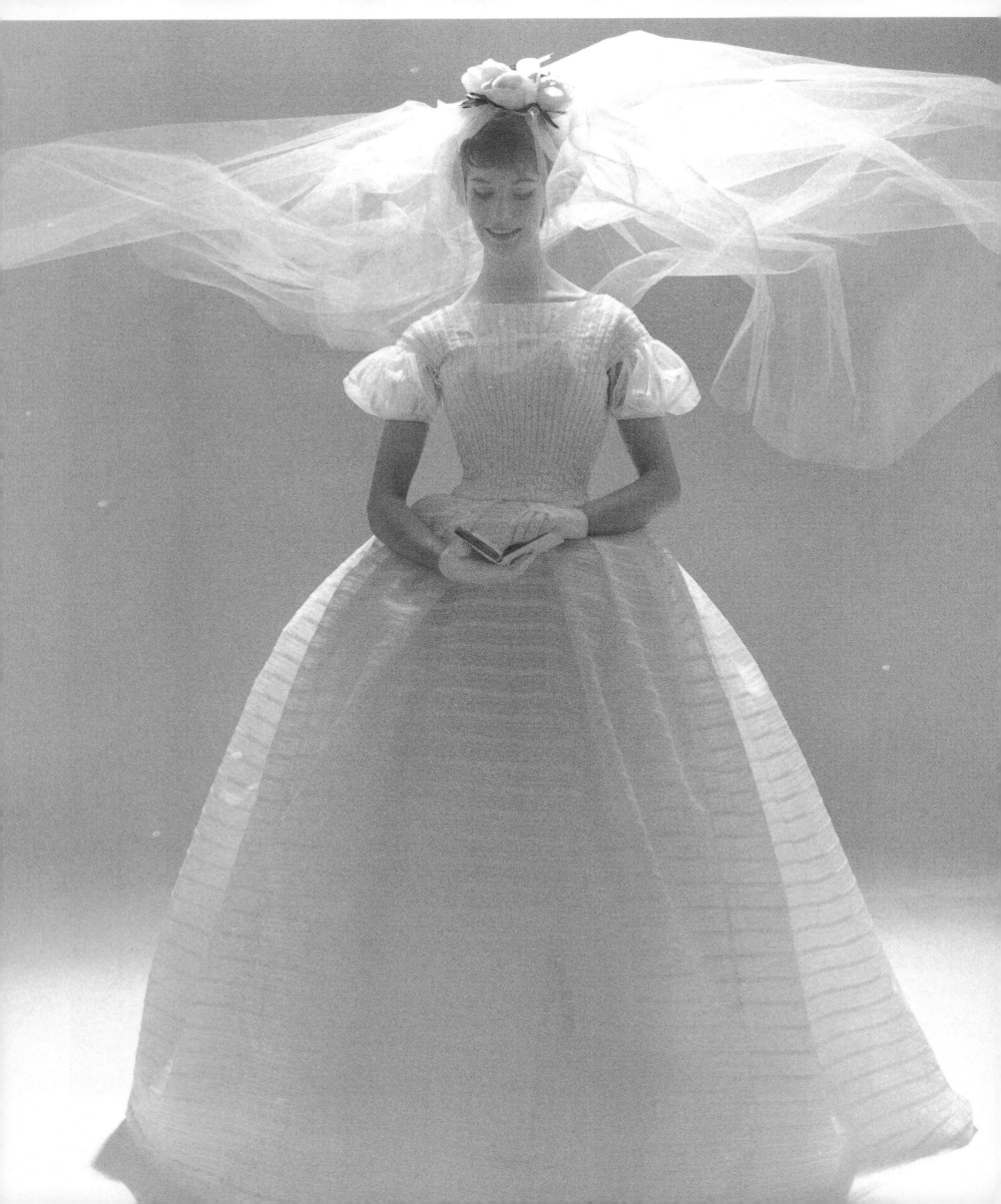

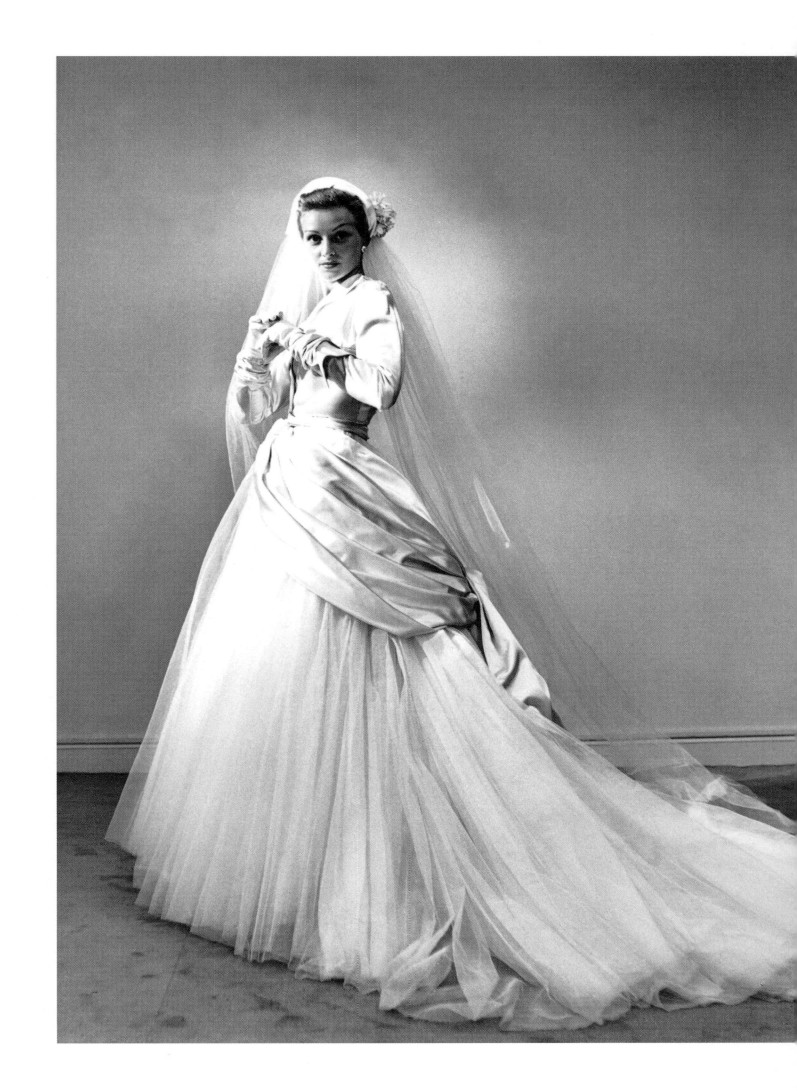

PREVIOUS PAGE... (Left) Photographer Norman Parkinson's iconic images for British
Vogue in the 1950s depicted the perfectly groomed and self-assured woman of
fashion. Here he presents a more youthful bride, her tulle veil billowing around her
silhouetted crinoline gown. (Right) A couture gown of 1949 by Christian Dior, designed
two years after his seminal Corolle line, more popularly known as the New Look.
His romantic designs based on nineteenth-century dress were in sharp contrast to
the austere wartime look and were the most influential look of the 1950s, dominating
women's clothing for more than a decade.

ABOVE & RIGHT... (Left) Romantic Rose Bride Barbie doll. (Right) Barbie Dream Wedding.
If the dreams of little girls could be encapsulated in a single figure, Barbie doll would be
it. Immaculately groomed and dressed in her tiny white wedding gown, Barbie doll
makes the perfect bride.

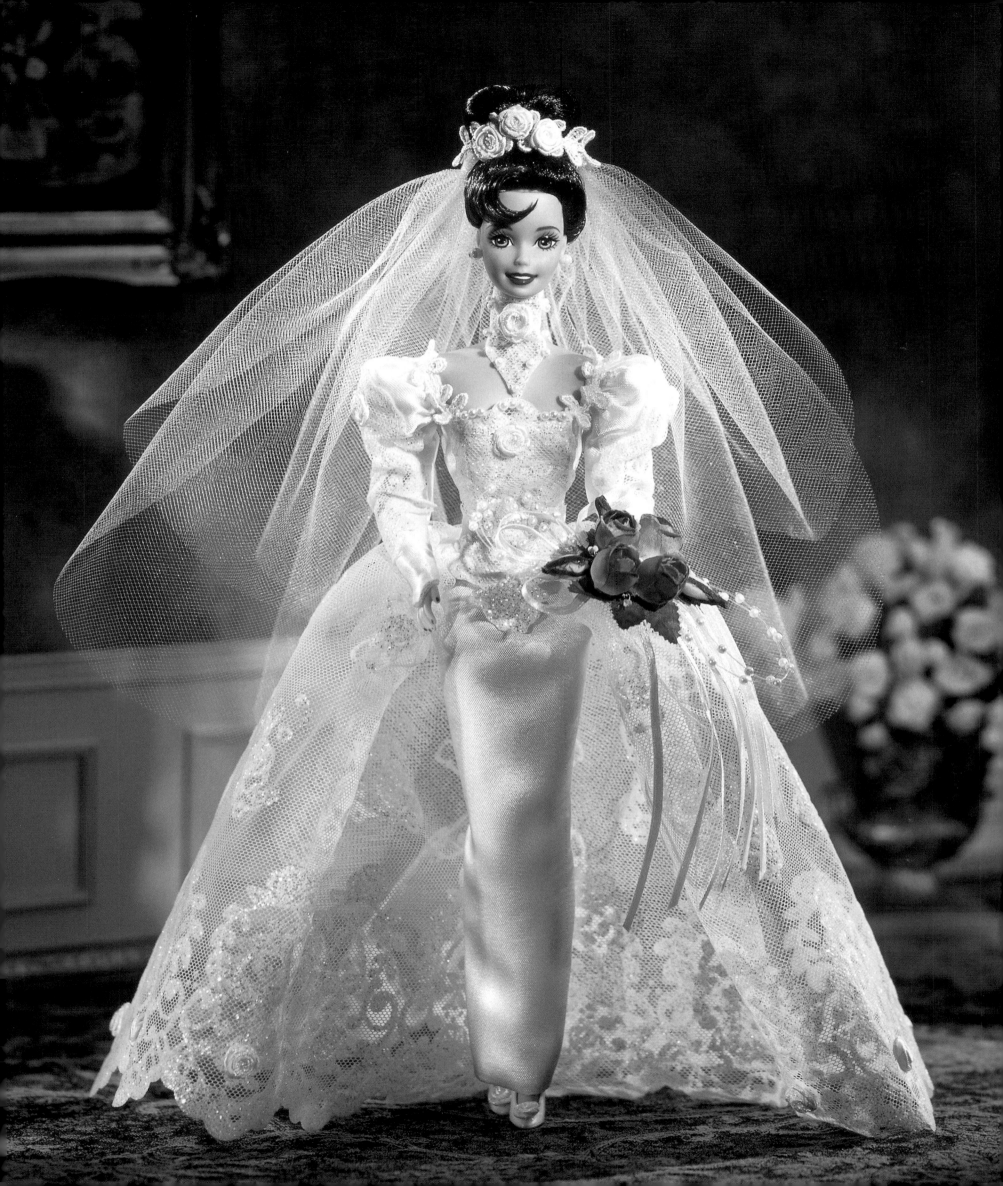

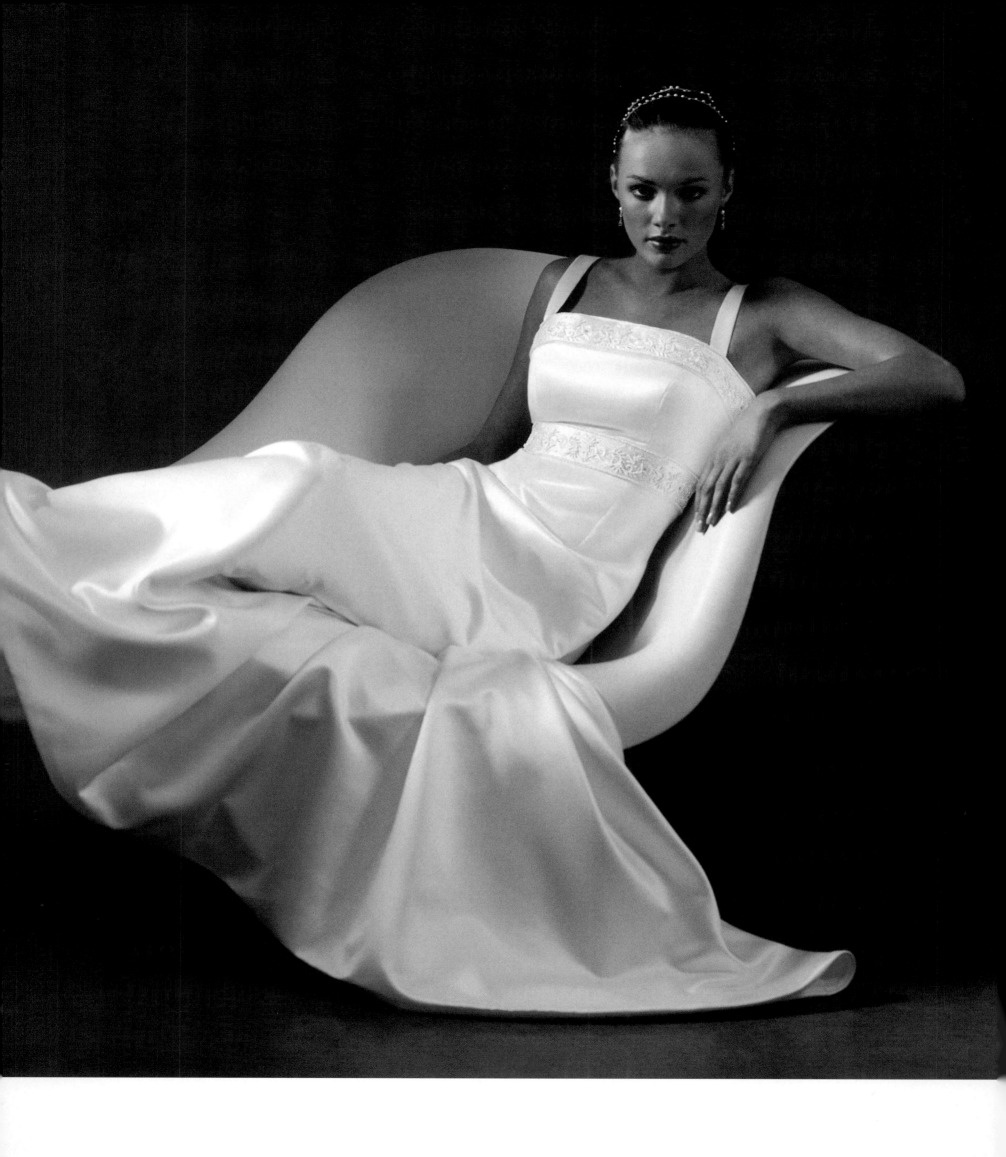

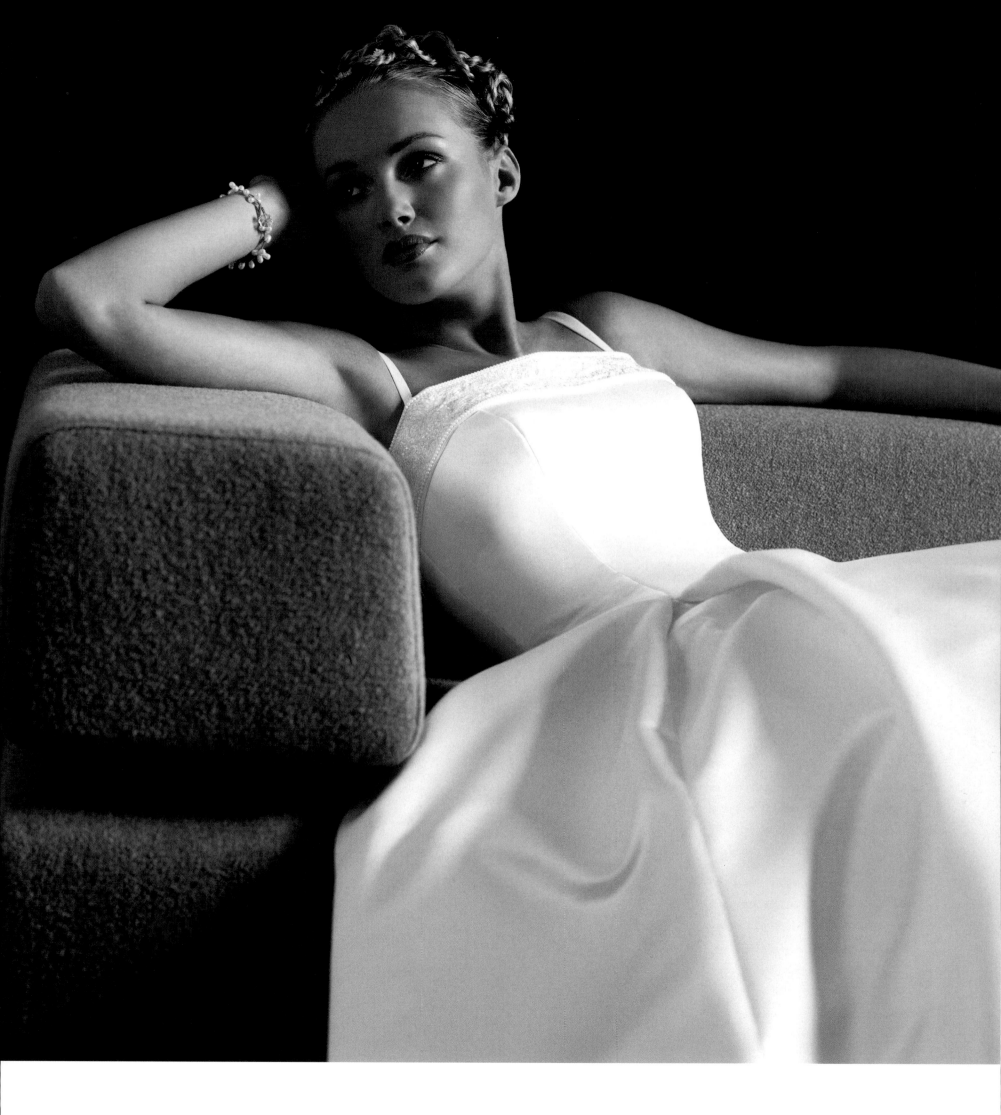

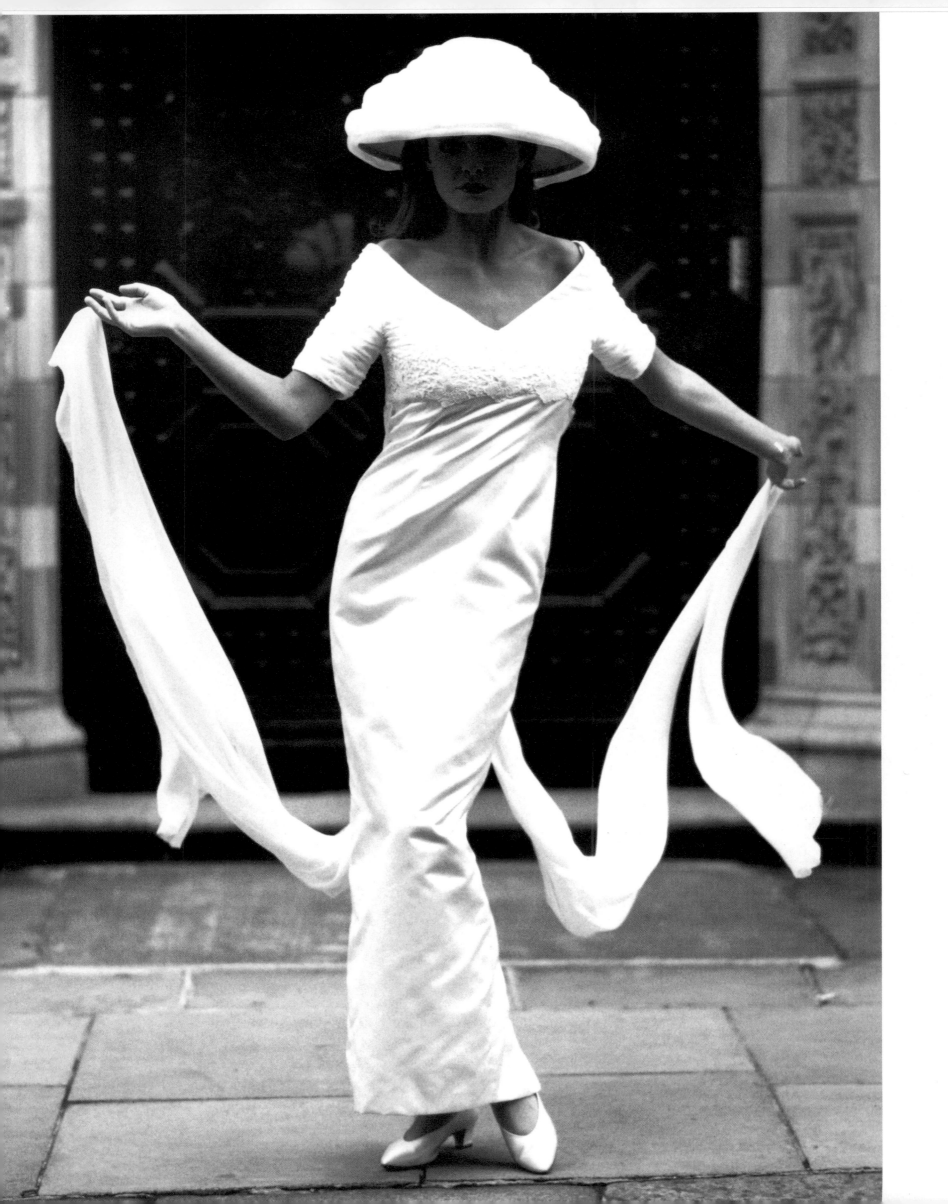

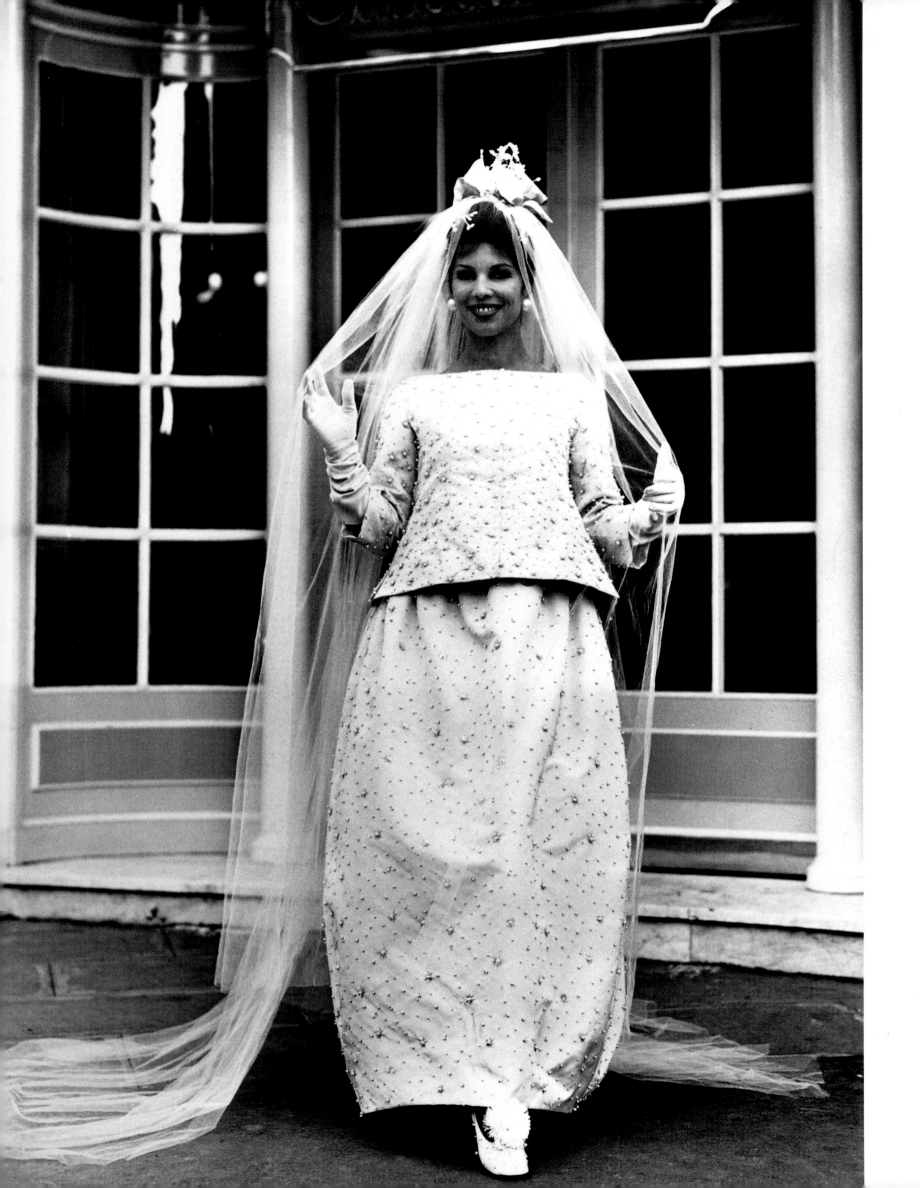

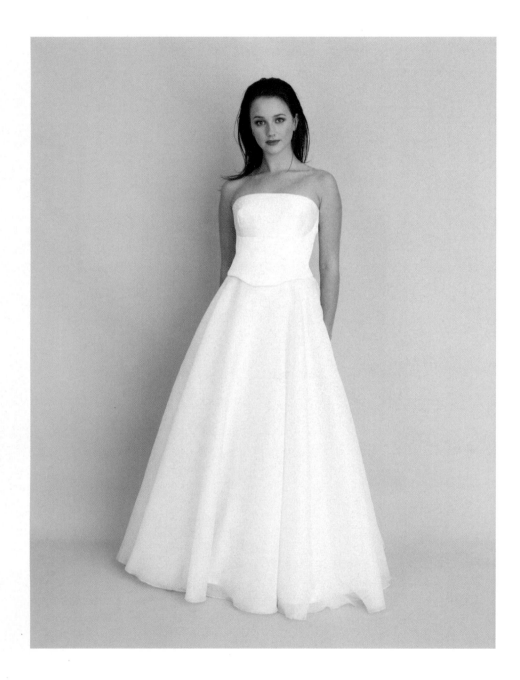

PREVIOUS PAGE... (Left) A short-sleeved closefitting sheath dress by Caroline Holmes worn with a dramatic tulle-covered coolie hat. (Right) A 1960 design by French couturier Christian Dior, who had opened his fashion house in 1947. His stylized womenswear designs, incorporating exaggerated lines and geometric shapes, are used to stunning effect in this high-fashion wedding gown.

ABOVE & RIGHT... A Beverley Lister design from the New Promise collection of 2001: a contemporary gown, featuring a feminine boned bodice and a delicately beaded full skirt.

ABOVE & OPPOSITE... Two designs by Sarmis, Katrina above and Candice opposite, reflect how wedding and evening gowns are almost indistinguishable in the twenty-first century, the boundaries of occasion dressing being blurred by the contemporary bride.

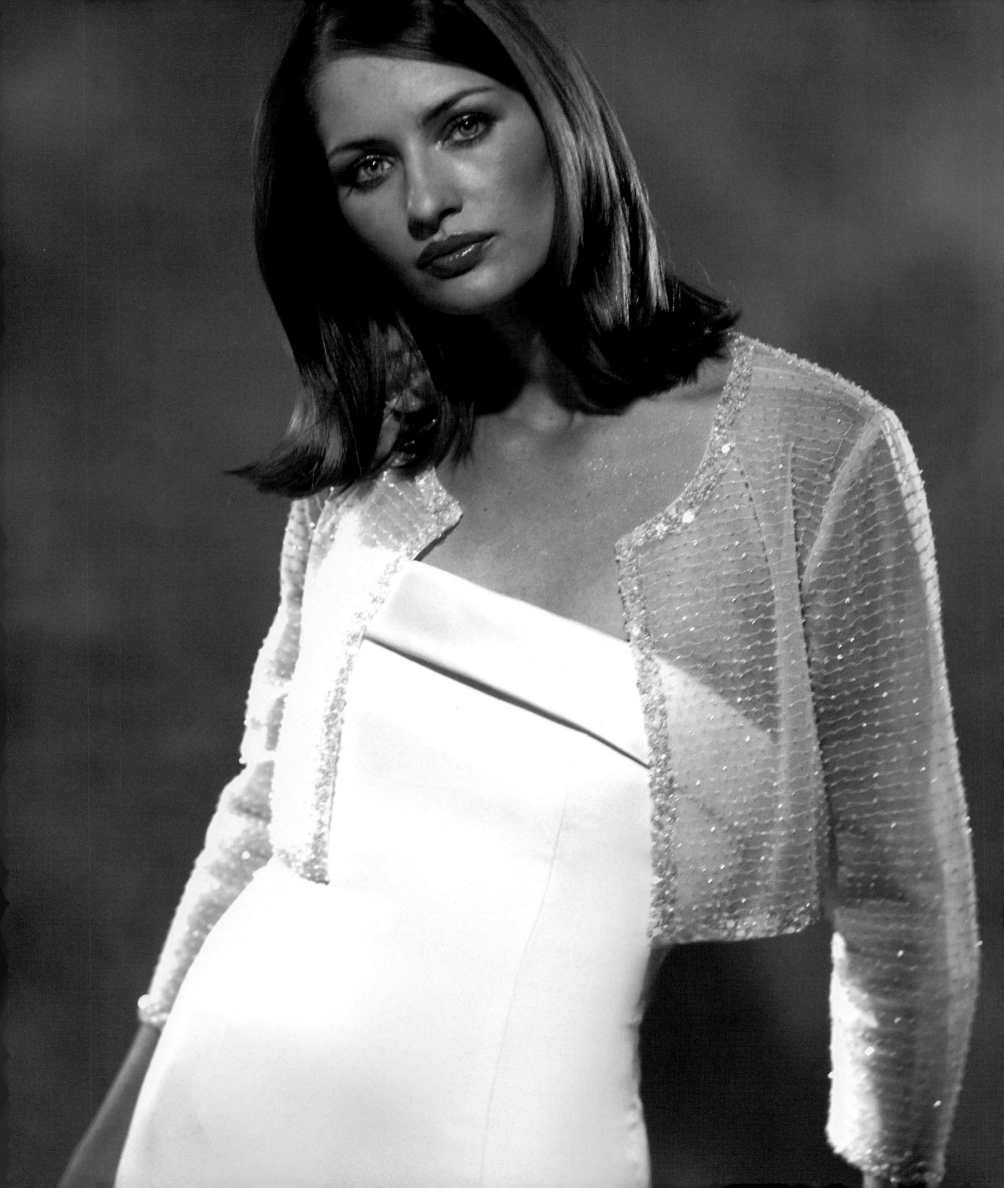

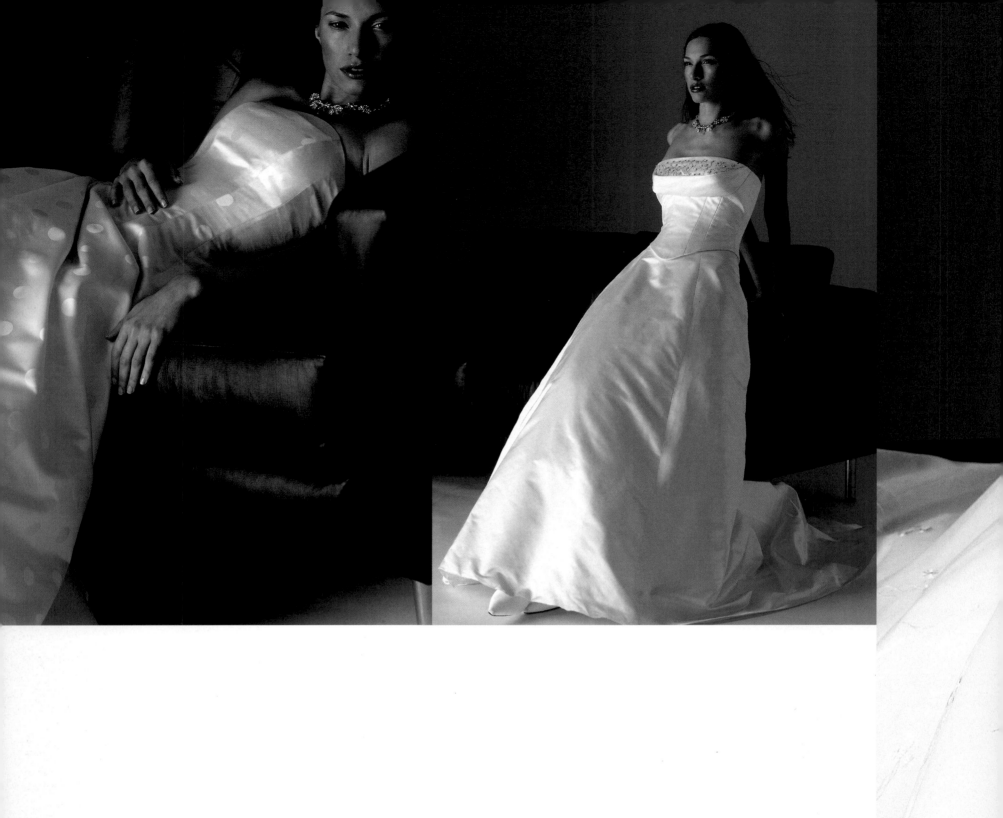

ABOVE & RIGHT... Contemporary wedding dresses by Alan Hannah with the ubiquitous strapped and boned bodice, a mainstay of modern gowns.

OVERLEAF... Pretty peach and blue pastel colors are used by Eternity Bride as an alternative to the more usual white and cream.

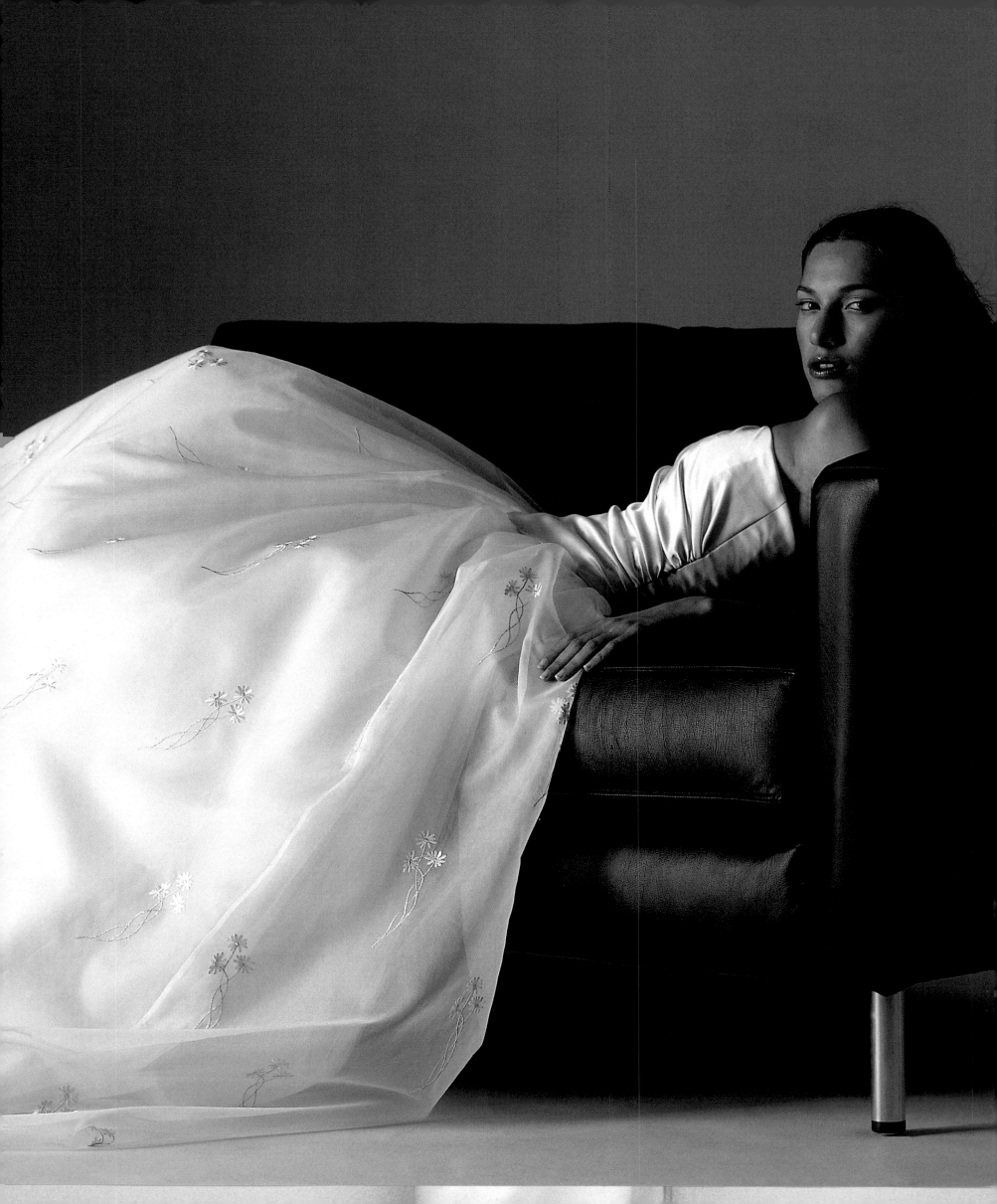

' Ann ...' he said, 'let's – I mean, do you want to get married?' 'Married?'

'Don't sound so surprised' he protested, 'Don't women always like to get married?'

'I'm quite happy to live in sin with you' she said.[1]

An American Romance (1961)

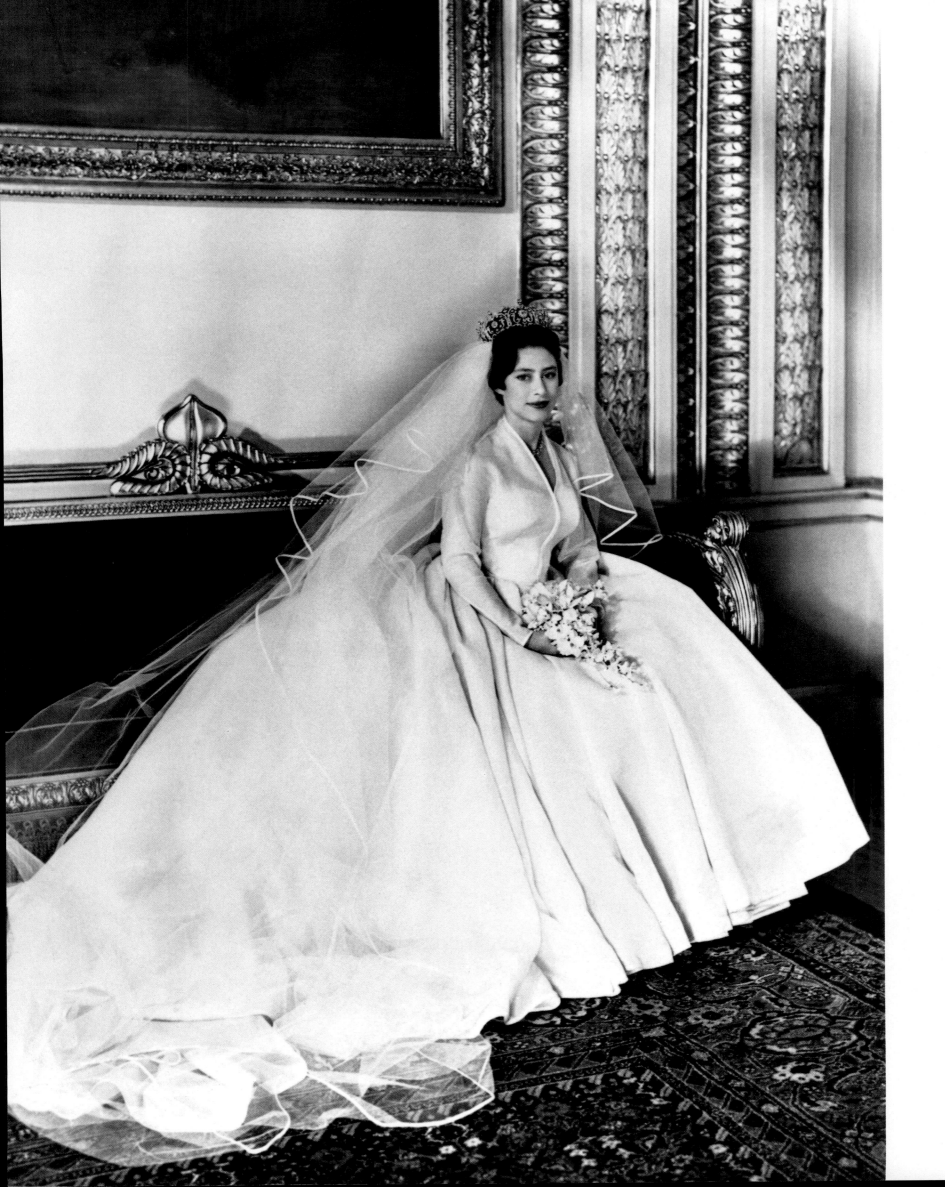

Counterculture chic

When Princess Margaret married Anthony Armstrong-Jones in 1960, her rather conservative Norman Hartnell-designed gown seemed out of kilter with the 'youthquake' that was going on around her, but it reflected a new simplicity that had entered wedding fashion. The 1950s silhouette her sister (by now Queen Elizabeth) had adopted in 1949 was honed down to one which was spare, crisp, and subtle – in part reflecting developments in haute couture, which was in a transitional period. The fussy New Look style that had been dominant for so long was being shaken off by designers in both Paris and London, in favor of a modernist mode which was minimal and – most significantly – young.

Styles were emanating from the street rather than being set by high-fashion designers or those at the apex of society, following on from the vogue for 'teenage' styles that had started in the 1950s. The boutique became the center of fashion rather than the Parisian runway, a lead taken in 1955 by Mary Quant, whose shop Bazaar on the King's Road in London helped to mythologize London as the epicenter of the so-called 'Swinging Sixties.' She wrote: 'I had always wanted young people to have a fashion of their own. To me adult appearance was very unattractive, alarming and terrifying, stilted, confined, and ugly. It was something I knew I didn't want to grow into.'[2] Instead she created simple shift dresses, easy fitting with dropped waistlines, shortened skirts, and in monochrome colors. They were almost childlike in shape and were epitomized in the looks and style of the British model Twiggy. In Paris the designers André Courrèges, Paco Rabanne, Emmanuelle Khan, and Pierre Cardin translated street styles into high fashion, with skinny, long-limbed models bounding up the runway in brilliant white Space Age-inspired mini dresses combining new stretch fabrics with plastic. For the first time in fashion, the thigh became the focus of erotic interest.

As Valerie Steele comments, 'The sixties was a period of complete upheaval in political and social, as well as purely sartorial terms. From China to Czechoslovakia, from San Francisco to Soweto, upheaval was not only ideological in character, it was generational. Youth was also the pivotal issue in the fashion capitals of the world.'[3] This did not radically affect wedding fashion at first, apart from a gradual refinement of the traditional silhouette. Integral trains (in which the train was an extension of the skirt) became popular, taking over from the long court-type train. And 'a looser waistline, either high or in its natural position, became usual. Fullness was of an increasingly stiff or padded type: the skirt front was quite flat, breadth given to the remainder with unpressed pleats or large gathers in interlined fabric. Most popular choices for this were taffeta, rayon or silk satin, organza, dotted swiss, *broderie anglaise*, linen and cottons.'[4] The synthetic bridal fabrics that had been prevalent in the 1950s had been completely redefined, now no longer modern but 'common,' particularly Crimplene, a textured machine-made material that was used in cheap

OPPOSITE On her marriage to photographer Anthony Armstrong-Jones, Princess Margaret was photographed by Cecil Beaton wearing a gown by royal favorite Norman Hartnell. Unusually for a royal bridal dress, it had a new simplicity which was to influence wedding fashion.

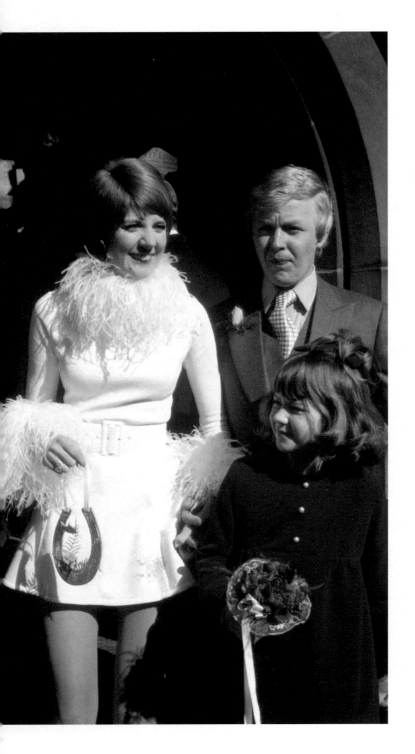

Feminists believed that women were being socialized into patriarchy and thus male domination by various strategies: fashion; makeup; the domestic; and, of course, the rituals of the white wedding. They thus rejected the limitations imposed by marriage, a form of female servitude and the resultant constraints of patriarchal power. How did this affect wedding fashion? Well, perhaps most significantly, with the acceptability of pants. This ultimate signifier of masculine power in dress began to be worn by both brides and female guests – the first time in history that this was so – helped by the appearance of trousers in French couture. Yves Saint-Laurent was the designer most responsible for this development. In 1969 he had commented: 'When I "launched" trousers, I wasn't doing anything original. Young people didn't wait for me in order to wear trousers. They had worn them for a long time already.'[19] However, Saint-Laurent made them acceptable for women who had no part in counterculture – they became chic fashion statements rather than a uniform in which to change the world. In 1971, the Nicaraguan socialite Bianca Perez Moreno de Marcias wore a stunning white Yves Saint-Laurent jacket and maxi skirt to marry rock singer Mick Jagger of the Rolling Stones.

In 1972 a shop called Barefoot Bride opened in New York, specializing in unusual gowns for groovy brides made of 'muslin, cotton lace, and eyelet dresses; hats rather than veils, Mexican wedding gowns of embroidered white cotton, and medieval-style caftans and hoods.'[20] But this offbeat look had minority appeal for women. One expert, commenting on American wedding fashion at this time, says, 'Despite the popularity of these new directions, most brides could not help but be emotionally linked to the past – these brides still coveted a measure of tradition. In 1971, 94 per cent of the wedding gowns sold were white and although minis were the rage, 87 per cent of the bridal dresses were floor length although women fought for equality, went to work, opposed the war … the

LEFT & OPPOSITE British entertainer Cilla Black had both a civil and church ceremony in 1969 when she married her partner and manager Bobby Willis. For the non-religious ceremony, she arrived in a red Rolls Royce wearing a two-year-old burgundy-colored velvet dress shortened especially for the occasion. Five weeks later, at a more formal celebration at St. Mary's Church in Liverpool, she sported a marabou-trimmed white mini dress.

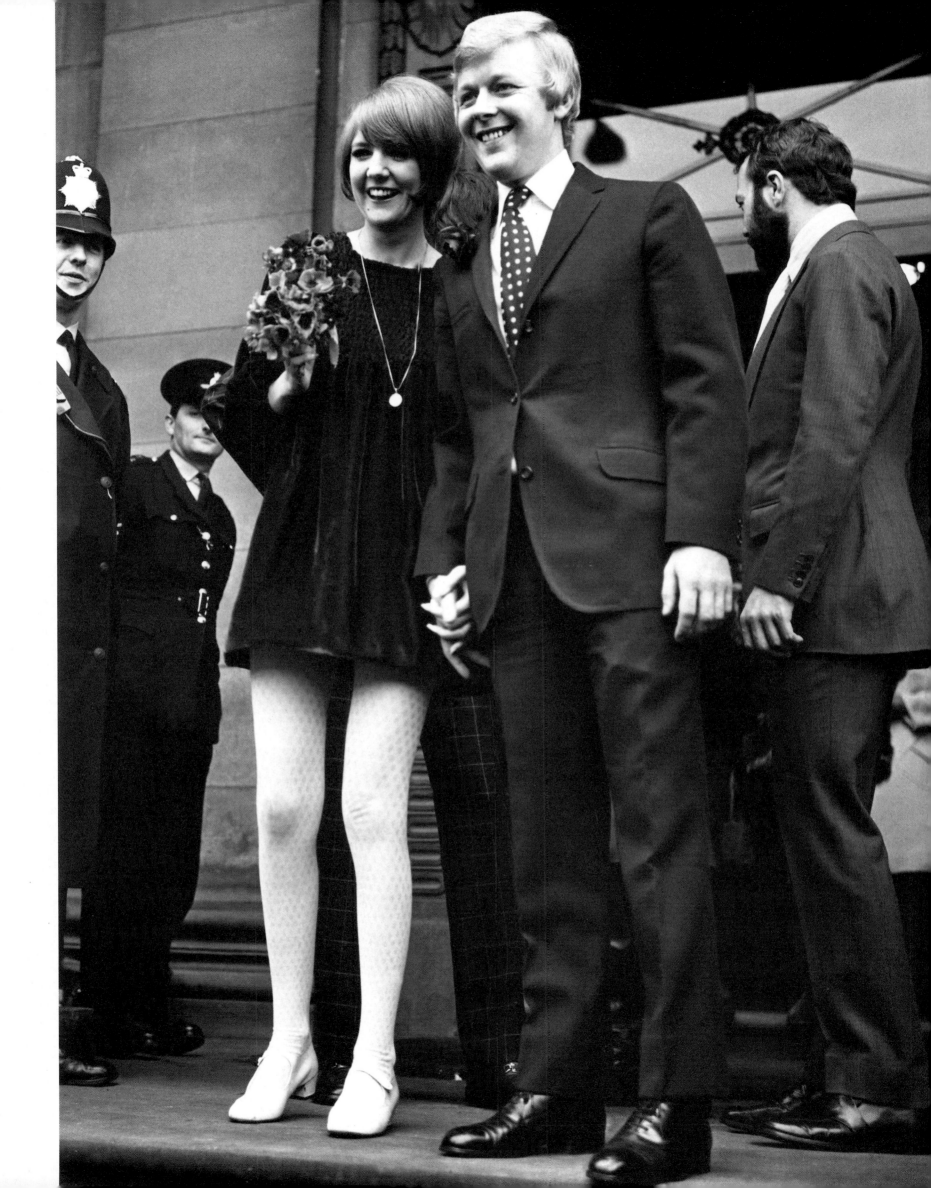

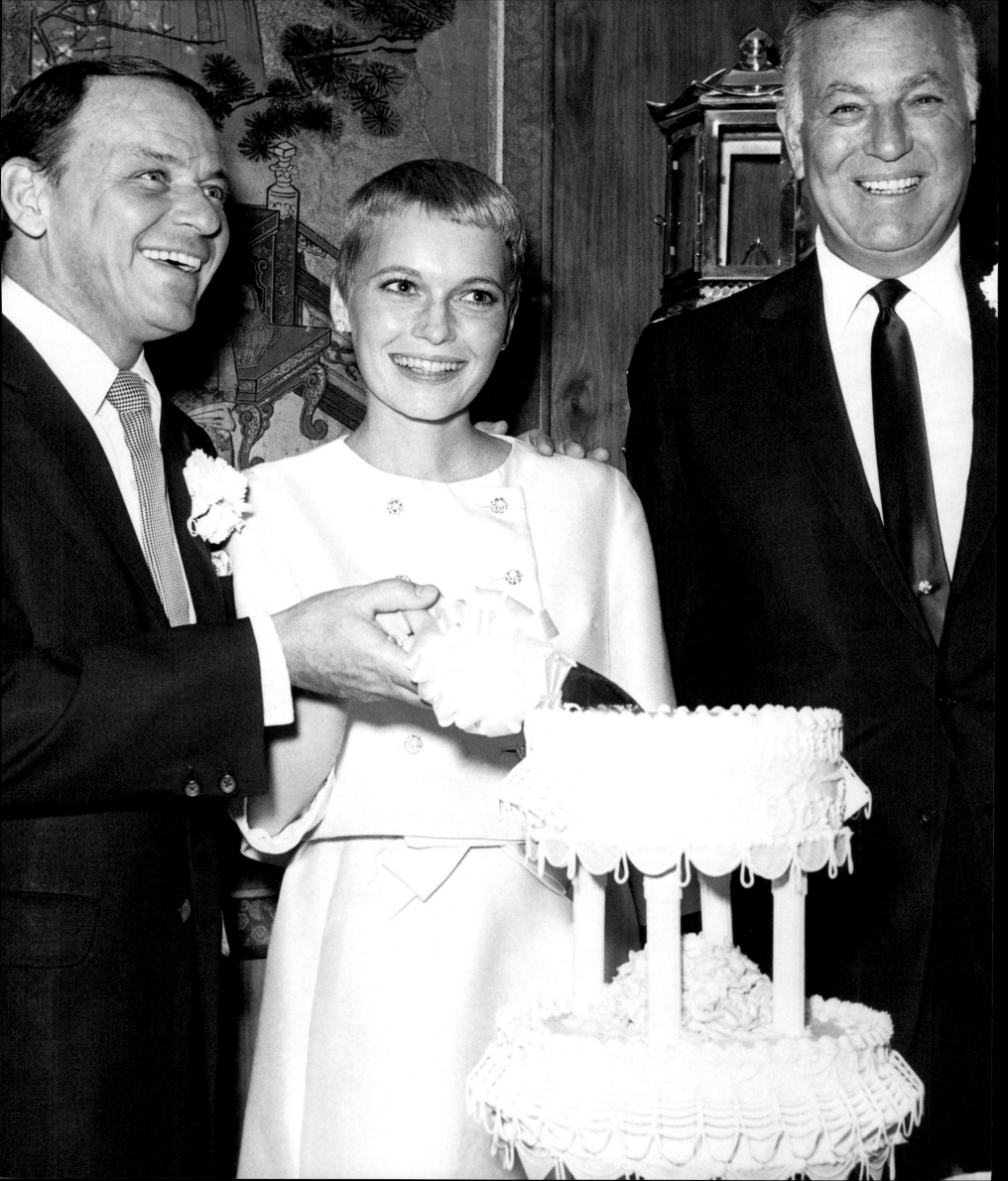

universal dream of an all white wedding never really faded.'[21] Therefore, when the model Farrah Fawcett, later to become a 1970s icon with her role in the hit television series *Charlie's Angels* (1974–9), married Lee Majors (a k a the *Six Million-Dollar Man*) in 1973, she wore a traditional white gown and veil. Another wedding of the mid-1970s with television connections had one of the biggest audiences ever, when, in 1974, forty million Americans watched Rhoda Morgenstern of *Rhoda* get married in white. Whether real or in fiction, the extremes of fashion were for most women simply not appropriate for what they felt was the most important day of their lives.

Despite the outrageous rebellion of street styles – such as punk and its American equivalent, New Wave – the dominant mood in mid- to late 1970s wedding fashion was nostalgia. Retro pastoral looks abounded, high-waisted and flounced, with lots of *broderie anglaise*, by designers such as Bill Gibb and Gina Fratini. Rural references, such as mob caps and pinafore overskirts in gingham, appeared to be suited more to a Thomas Hardy novel than the schizophrenic 1970s. Church weddings became fashionable once more, as did all the ostentation that surrounded them. One of the biggest extravagances was the cake, and enormous concoctions dwarfed the bride and groom in many photographs of the time. Cakes had continued to be showy edifices since the Edwardian era – apart from a short blip due to the restrictions of World War II – and by the 1970s, as the white wedding had become a global phenomenon, cakes appeared at almost every ceremony. By the 1970s, for instance, Westernized white weddings had become especially popular in Japan and the tradition of the elaborately tiered cake topped with plastic figures of the bride and groom had been imported, too. But, as wedding cake historian Simon Charsley comments, 'the cake is inedible and even the elaborate "icing" is hard wax, or, as a recent innovation moulded rubber. A decorative knife has to be thrust into the "cake" by the bride and groom together, and for this a slot is provided at the back. The whole thing exists for this insertion and for the standard photograph to be taken at the time. A mechanism may respond to the thrusting in of the knife with a dramatic cloud of steam.'[22]

The key element in many 1970s wedding gowns was decorative detail, attached to the simple dress shapes of the 1960s to provide a softer, more filmy appearance with an effect that 'was both dreamy, in the soft translucent fabric draping, and sensual, with the emphasis on the body beneath, which, free of any boning or bolstering with net and crinolines, shaped the dress. Hairstyles were often the bun or chignon, finished with fresh or fabric flowers, or with a tiara. Veils tended to be long, and hats were a nostalgic alternative, with dotted veiling.'[23] Vestiges of the hippie movement still remained, and for a wedding in 1978 the groom is described as wearing 'tan coloured corduroy trousers tucked into cowboy boots with a vivid green shirt embroidered by his bride with an orange and white dragon across the back. His bride wore an iridescent dark blue-green caftan and carried a matching handbag and a silver horseshoe decorated with white flowers and ribbon.'[24]

In a feature in the *Daily Telegraph* in 1978, entitled 'The Dresses to Wed In – and Wear Again,' the fashion journalist Avril Groom commented: 'It's about ten years since a few thrifty and clever girls discovered that Laura Ashley's white cotton and lace long summer frocks made very pretty (and reasonable) wedding dresses'[25] and were continuing to do so. Bouquets were made up of wildflowers, or simply picked from the garden,

OPPOSITE Singer Frank Sinatra and actress Mia Farrow married in 1966 in Las Vegas, after Sinatra had presented his bride-to-be with a $100,000 pear-shaped diamond ring. Wearing a minimalist couture suit, Farrow cut a waiflike figure with her boyish Vidal Sassoon cropped hair.

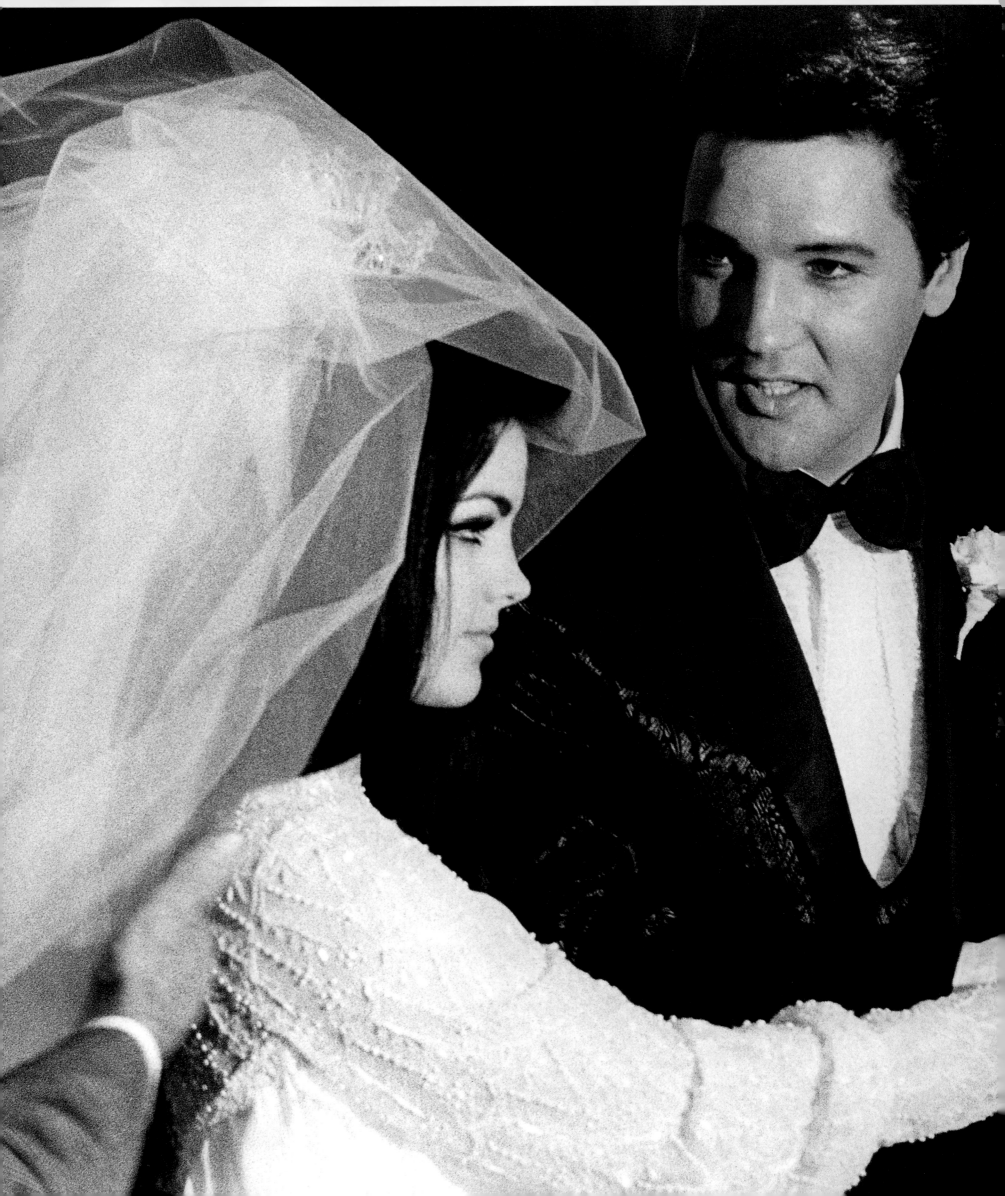

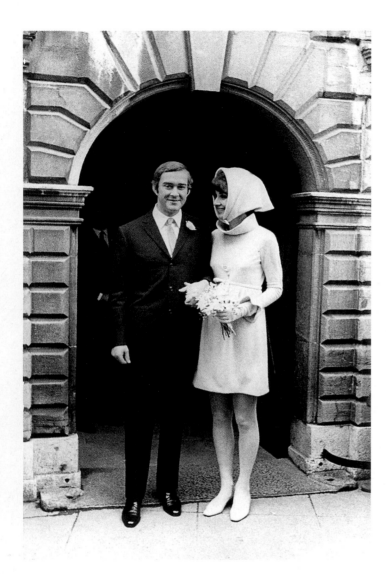

PREVIOUS PAGE... Singer Elvis Presley photographed with his bride Priscilla Beaulieu in 1967 after their Las Vegas wedding.

ABOVE & RIGHT... On her wedding to Roman psychiatrist Dr. Andrea Dotti in 1969, actress Audrey Hepburn wore a pink jersey mini-dress outfit, by her favorite French couturier Givenchy, with a matching headscarf. It was her second marriage and his first.

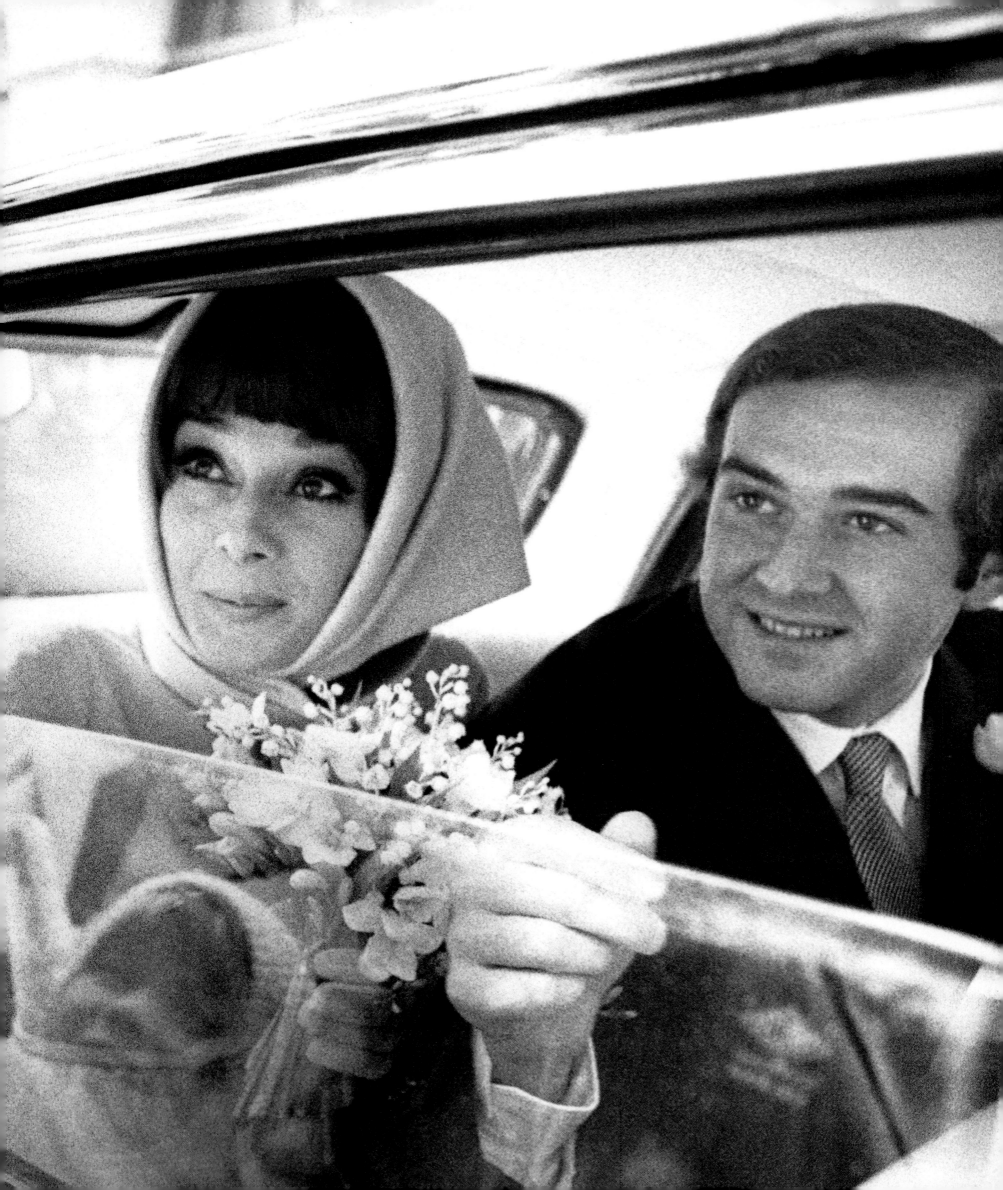

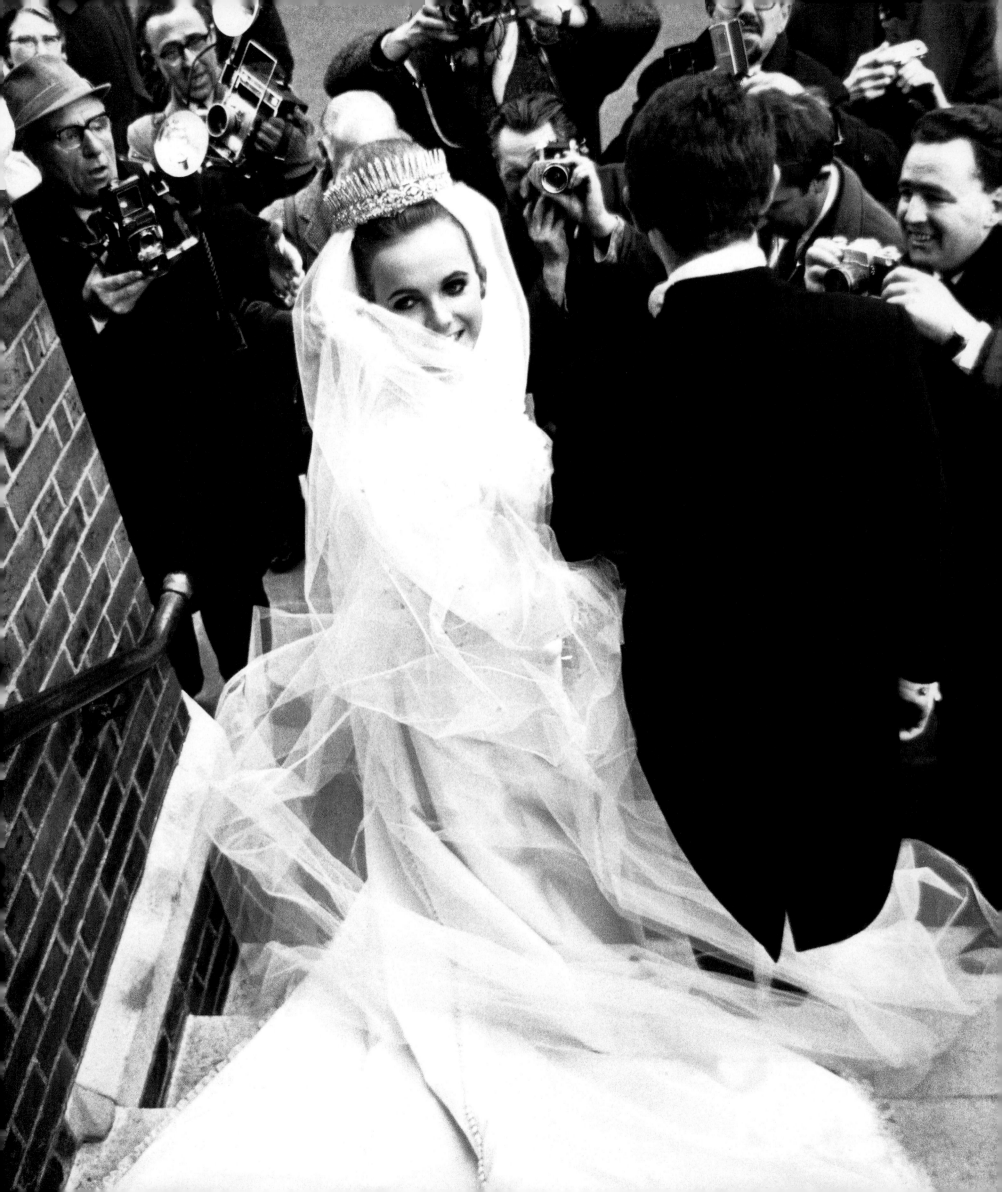

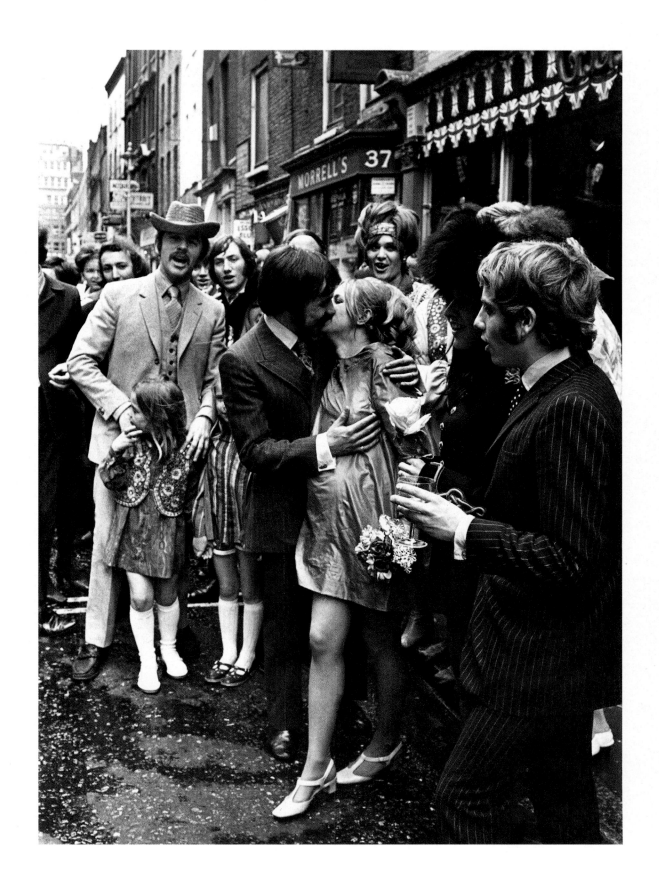

ABOVE... An obviously pregnant bride wears a mini, and the men natty suits, in a photograph entitled 'Marriage à la mod in Carnaby Street.' The bridesmaid's embroidered Indian-style waistcoat on the left shows how hippie references were being assimilated into childrenswear.

OPPOSITE... This English society bride turns back to the photographer in order to show her coronet and voluminous tulle veil and train. The groom is in traditional morning dress.

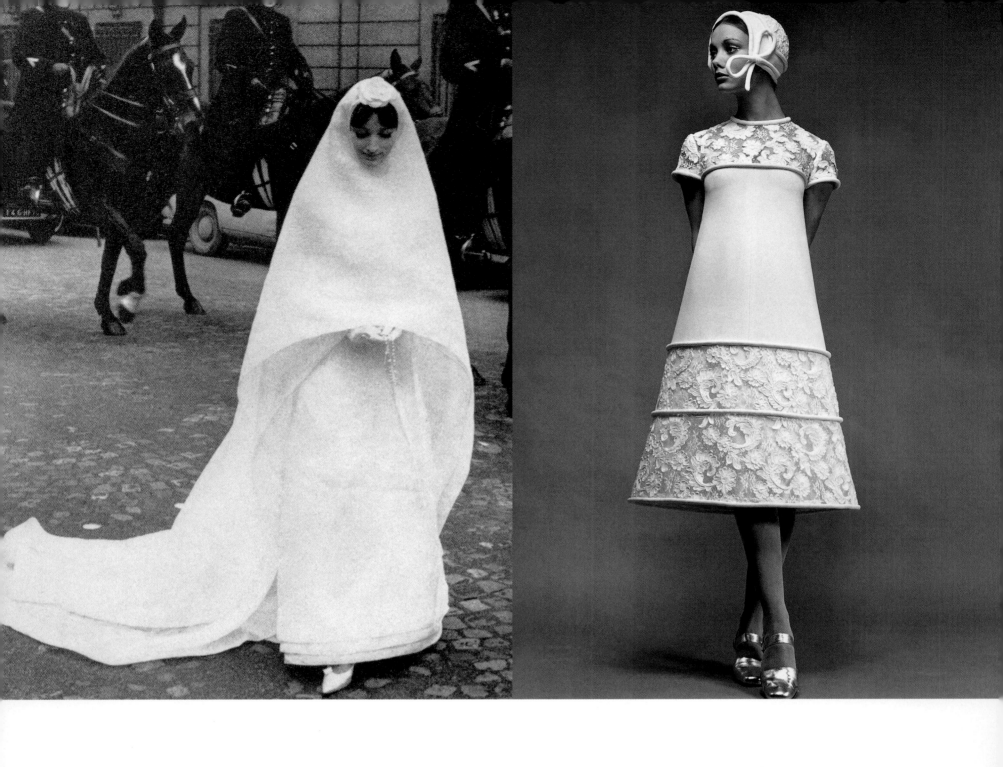

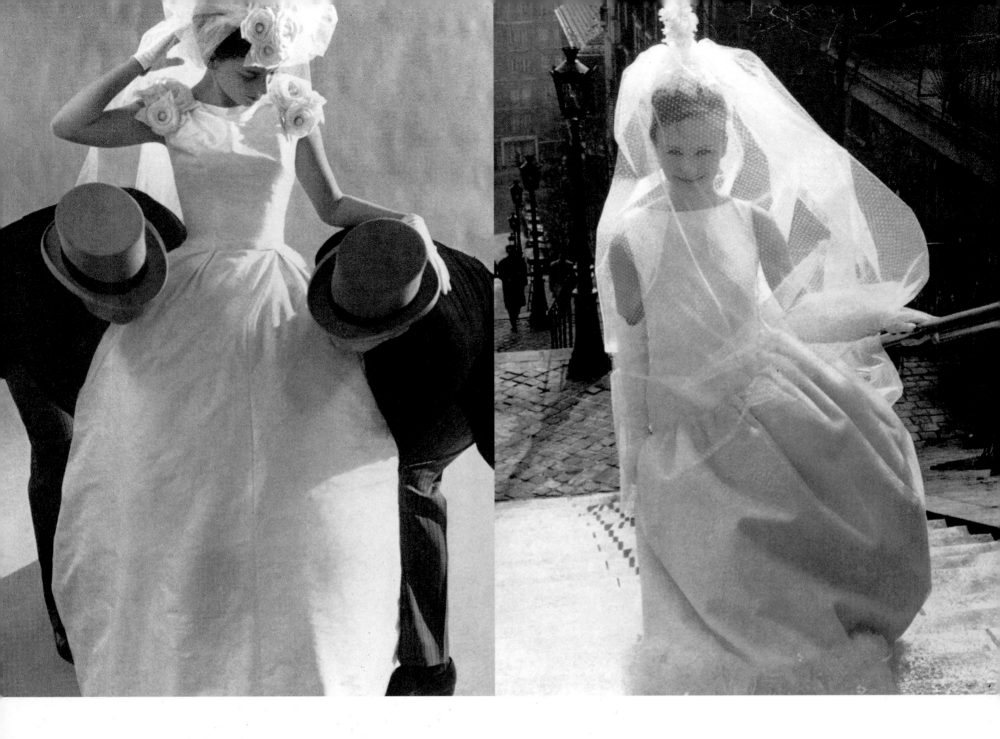

ABOVE... A pair of brides from 1961 by photographer Frank Horvat. (Left) A flower bedecked gown in a heavyweight fabric that holds its unalloyed shape. (Right) A bride ascends a staircase in a sleeveless dress with a full skirt pleated from the waist with a deep trim. A feathered headpiece looks to the showgirl for inspiration.

OPPOSITE... (Left) A modest Victorian-style bridal outfit from *Brides* magazine of 1961 – this was the more traditional approach that the majority of brides tended to take in the so-called 'Swinging Sixties.' (Right) A trapeze-line dress in short midi length where bands of lace, defined with piping, form the bodice, sleeves, and skirt. In the late 1960s and early 1970s, an array of modish headgear took over from the veil.

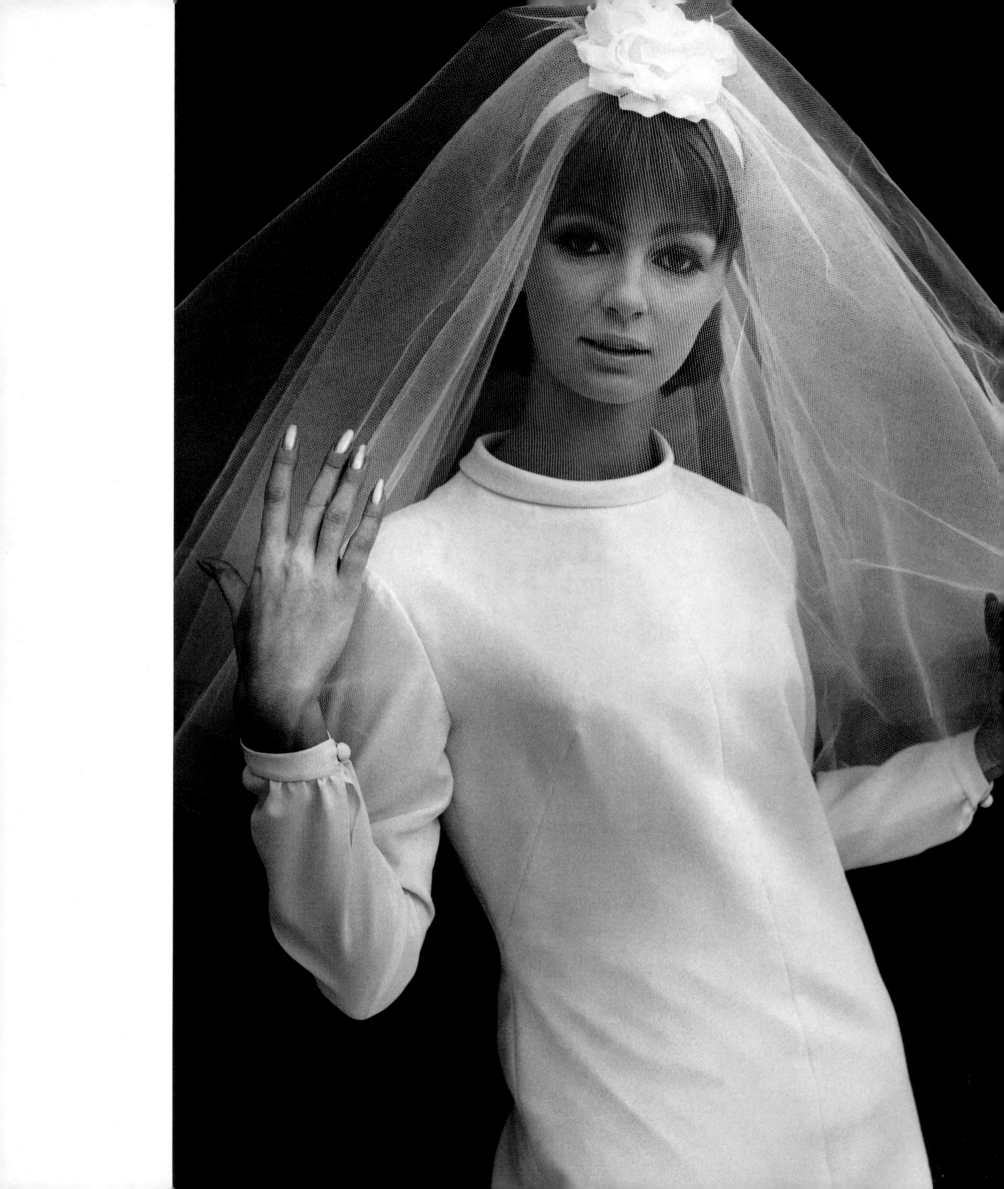

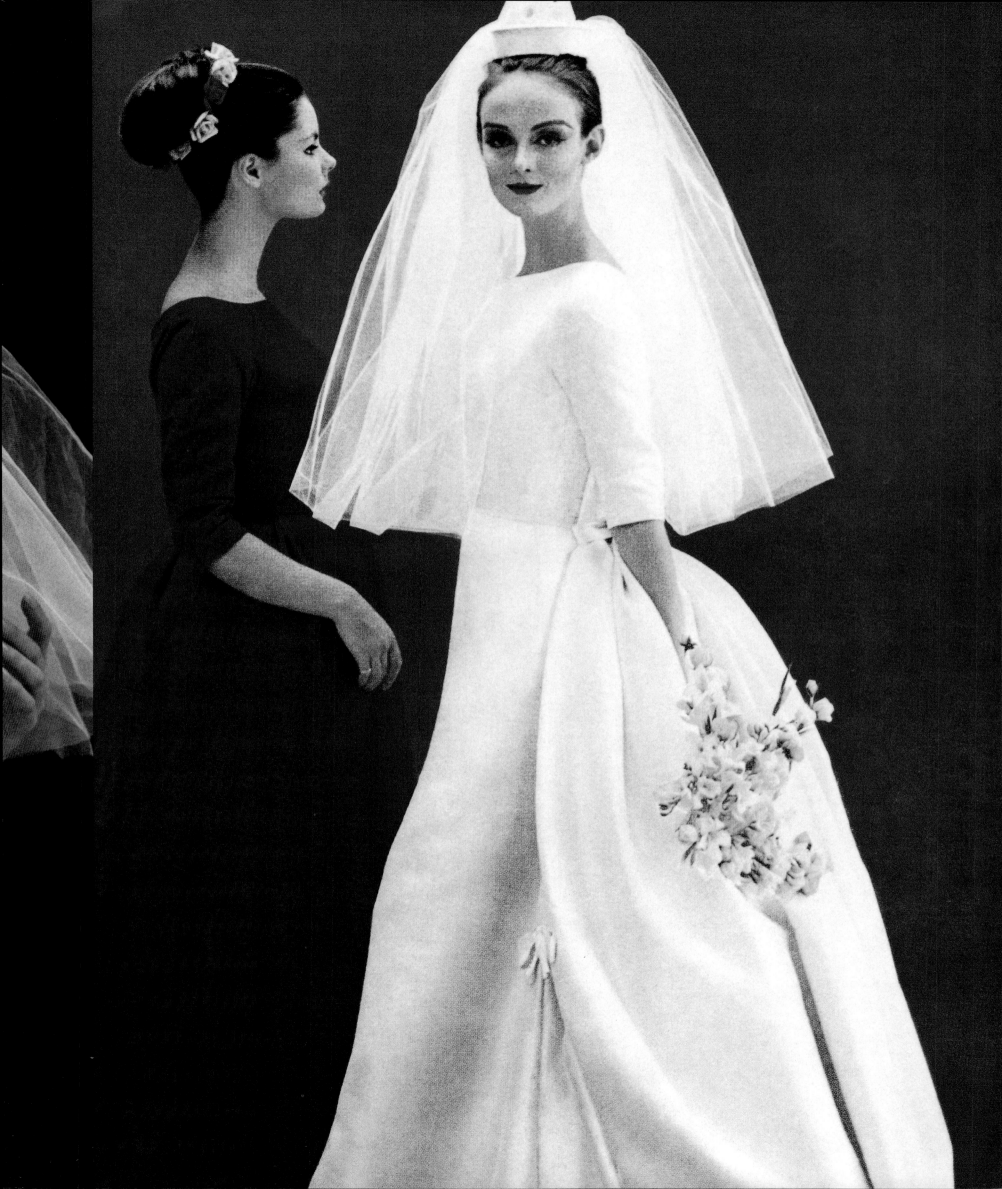

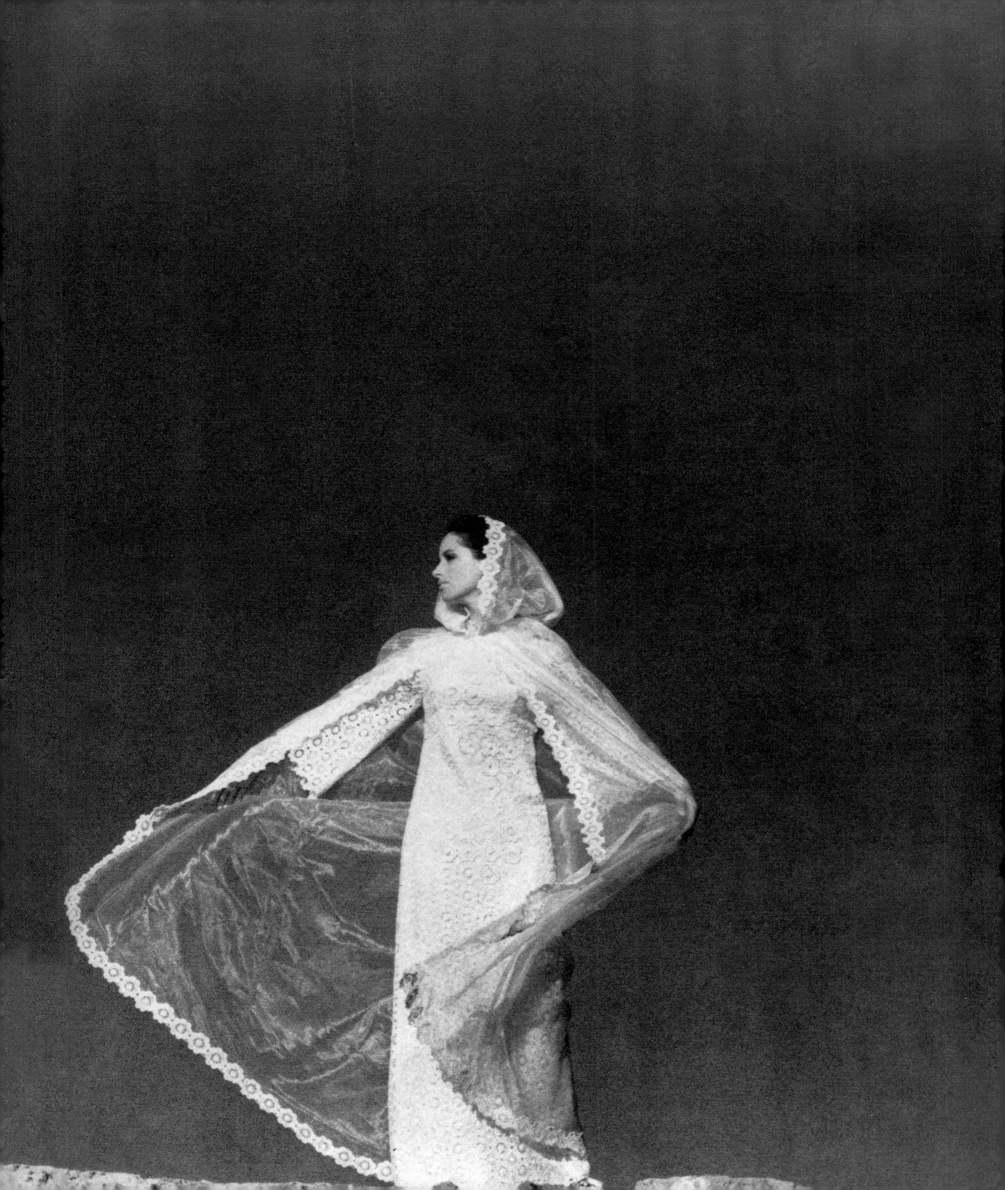

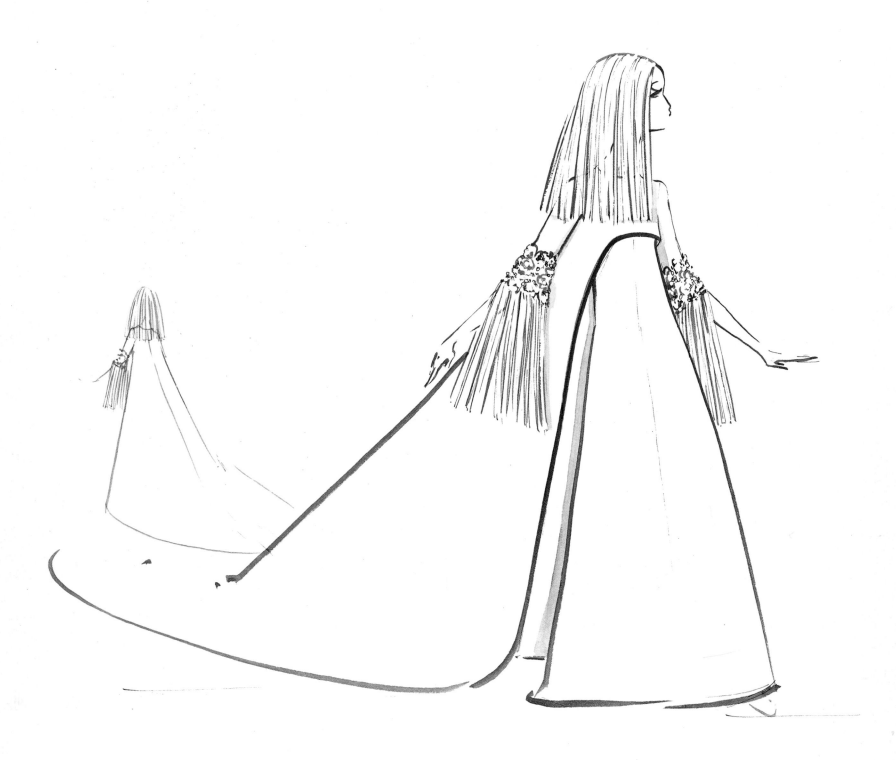

PREVIOUS PAGE... (Left) A typical 1960s look with an outsize rose on a headband holds the bouffant veil in place. The sheath dress with roll neck has used its contoured seams as the only form of decoration. (Right) A winter bride and bridesmaid of 1962 by photographer Peter Rand. A decorous sheath dress with an attached train and boat neck shows the swan-necked elegance of the bride as she is supervised by her attendant in contrasting vibrant red.

ABOVE... A fashion illustration from 1969 wittily transforms the bride's long hair into a veil, which with a surreal touch is echoed in the sleeve detail. The strong shapes of the cut add to the dramatic image.

OPPOSITE... A slender Empire-line dress in white daisy guipure with 'Camelot' sleeves and a floating organza cloak edged with lace, photographed by Patrick Lichfield in 1969.

JOSEPH E. LEVINE presents
A MIKE NICHOLS-LAWRENCE TURMAN PRODUCTION
"THE GRADUATE" AA
starring ANNE BANCROFT
and DUSTIN HOFFMAN . KATHERINE ROSS
Produced by Directed by
LAWRENCE TURMAN MIKE NICHOLS
Technicolor® Panavision® United Artists

ABOVE... In one of the most famous wedding scenes in postwar cinema, Katherine Ross flees her staid WASP

fiancée at the altar in favor of the more complicated and nonconformist Dustin Hoffman in *The Graduate*.

OPPOSITE... Arkadius creates an edgy subversive look for his runway bride in an organza, crotch-skimming mini

worn with 'urban guerrilla' headband.

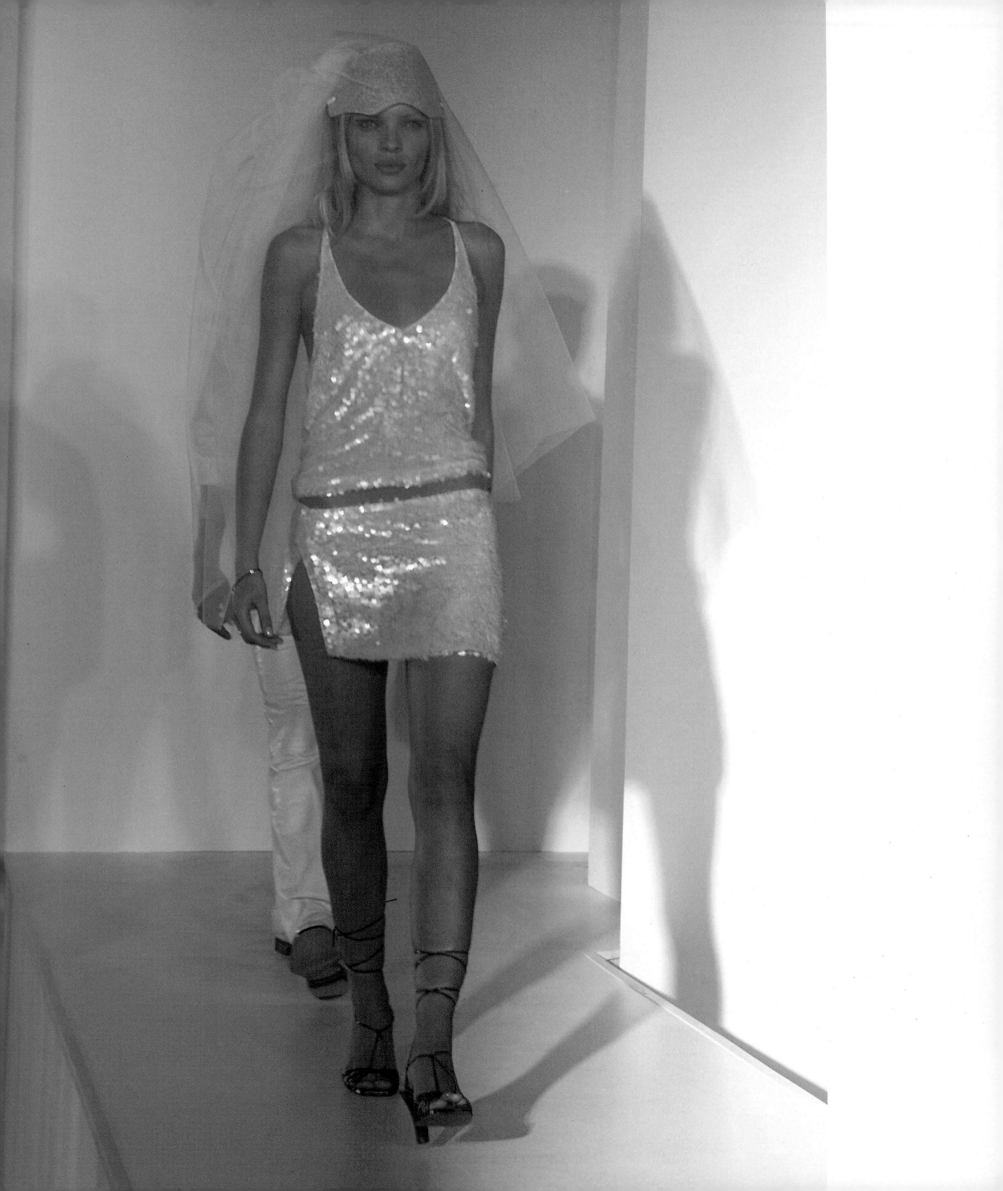

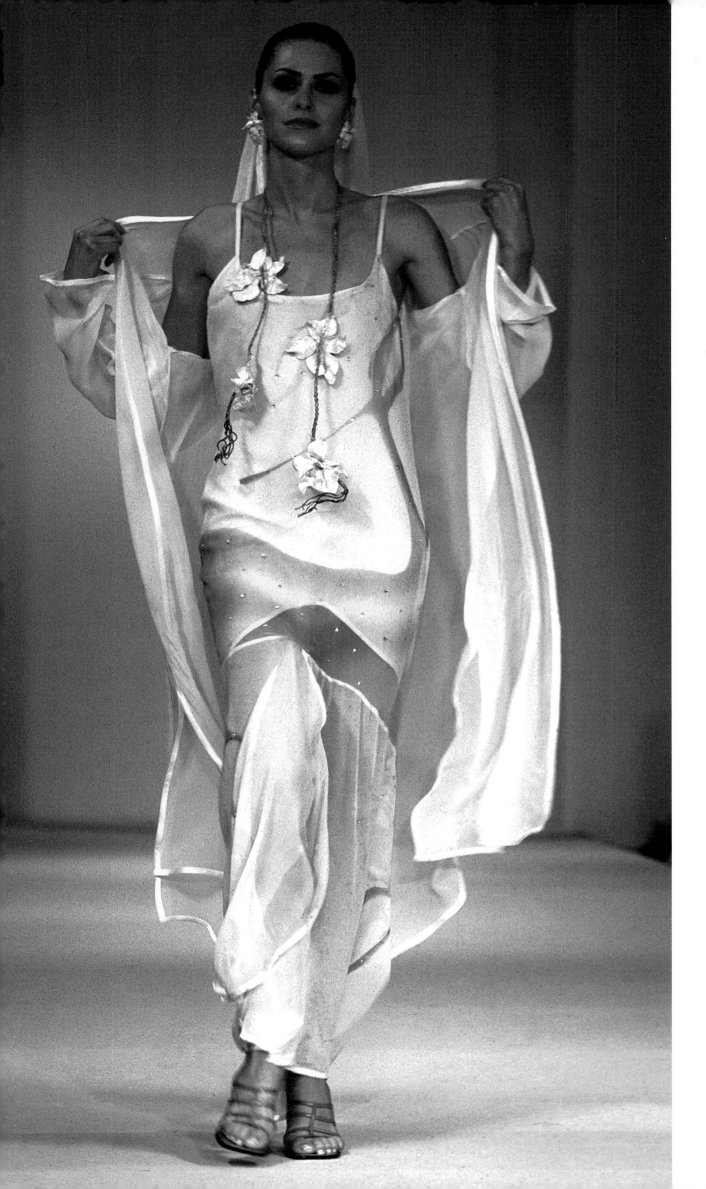

OPPOSITE... A Donna Karan sequined mini
and vest top for her spring 2001 collection,
worn with Grecian thong sandals and short
veil attached to a Juliet cap.

LEFT... The erotic aesthetic of lingerie design is
apparent in this two-piece wedding ensemble,
by Heather Jones, which features spaghetti
straps and a transparent panel at the thigh.

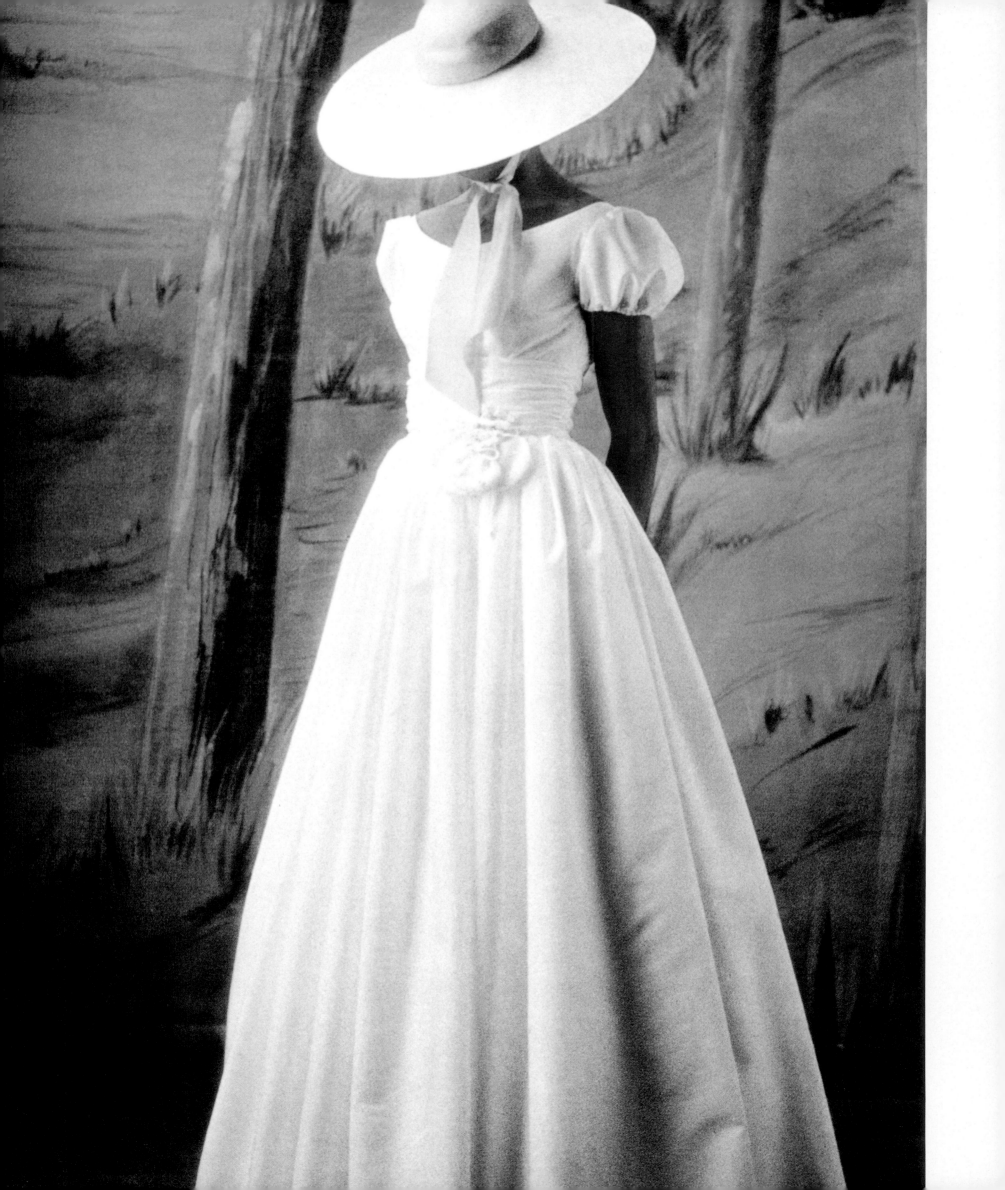

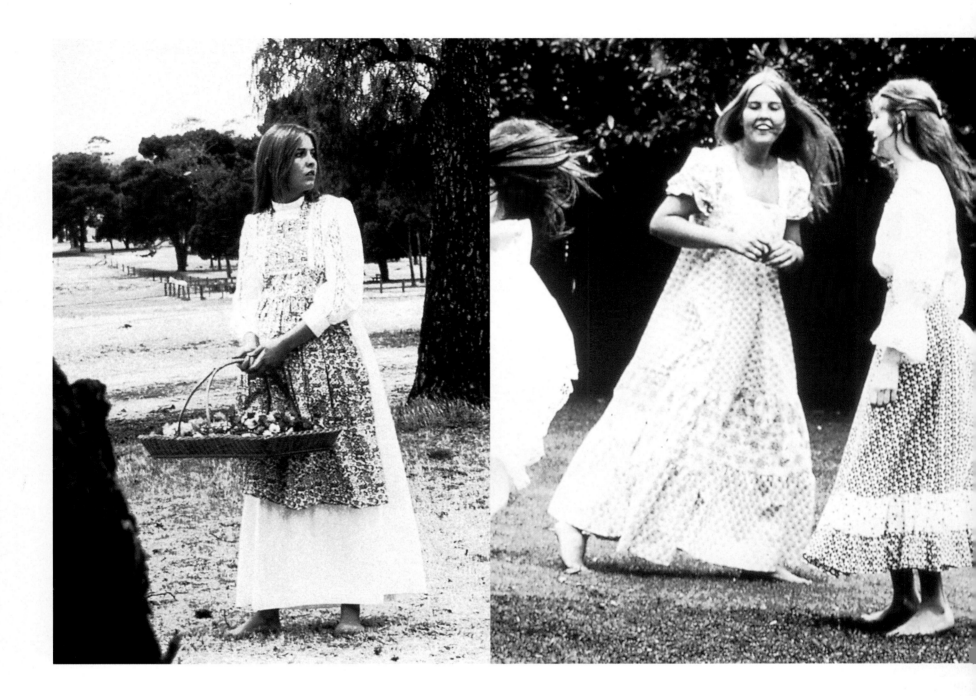

ABOVE... Laura Ashley was responsible for the unashamedly nostalgic trends in wedding-dress design in the 1970s. (Left) An Ashley design from 1970 with a flowered apron overskirt. (Right) This 1978 image shows that, despite the fashion impact of punk, many brides wore pinafore and flounced skirts that were more suited to a Thomas Hardy novel.

OPPOSITE... A romanticized rural aesthetic appeared in 1970s wedding fashion. Here, a bride photographed by John Swannell in 1977 wears a full-skirted puff-sleeved gown with a deep sash and wide-brimmed hat.

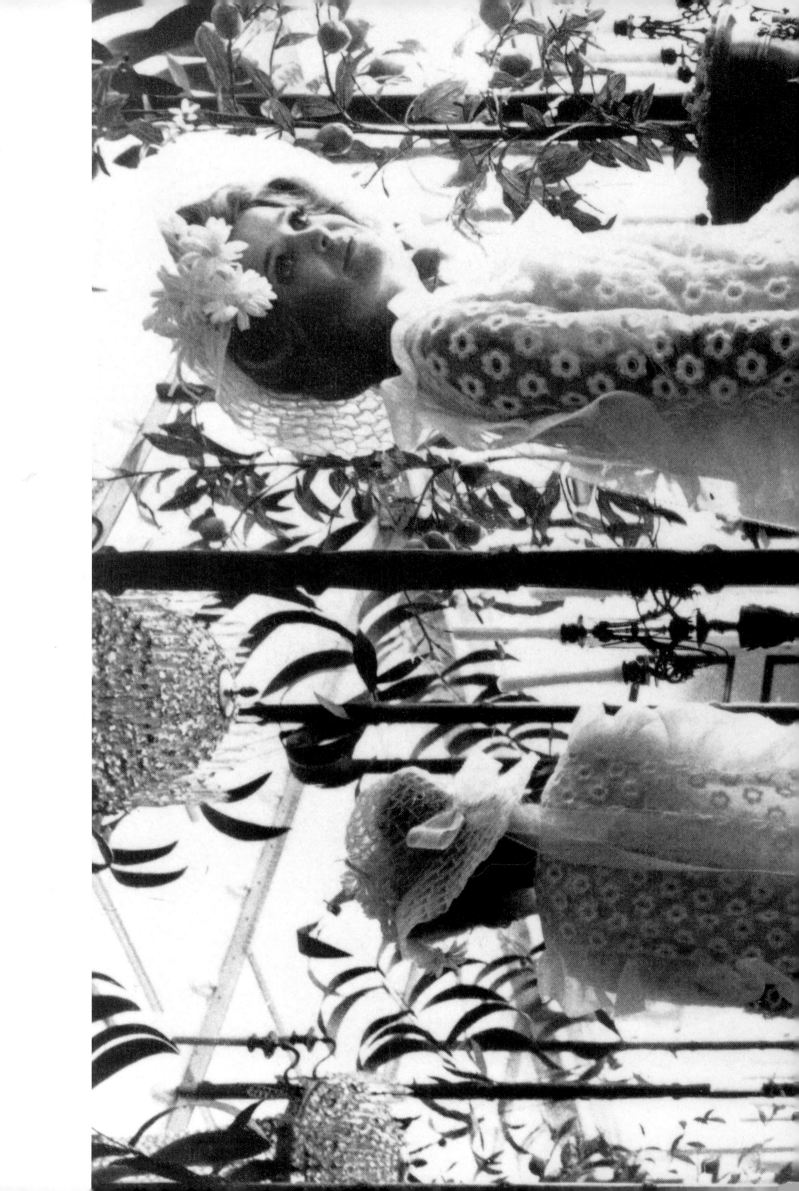

PREVIOUS PAGE... Experimental bridal fashion of 1969. Despite the Edwardian setting and traditional pose, this bride is very much of her time. Although full-length and white, this outfit looks to fashionable trends, with its floppy laced hat, daisy motif, and flounced edging.

RIGHT... A gown photographed by Patrick Lichfield in 1969 which, in its styling, shows how ideas from hippie counterculture had been diffused into high fashion by the late 1960s and early 1970s. The bride's Empire-line gown with crossover bodice also owes much to negligée design.

OPPOSITE... The bride gazes out through a diaphanous tulle veil in an unashamedly romantic 1999 design by Giorgio Armani.

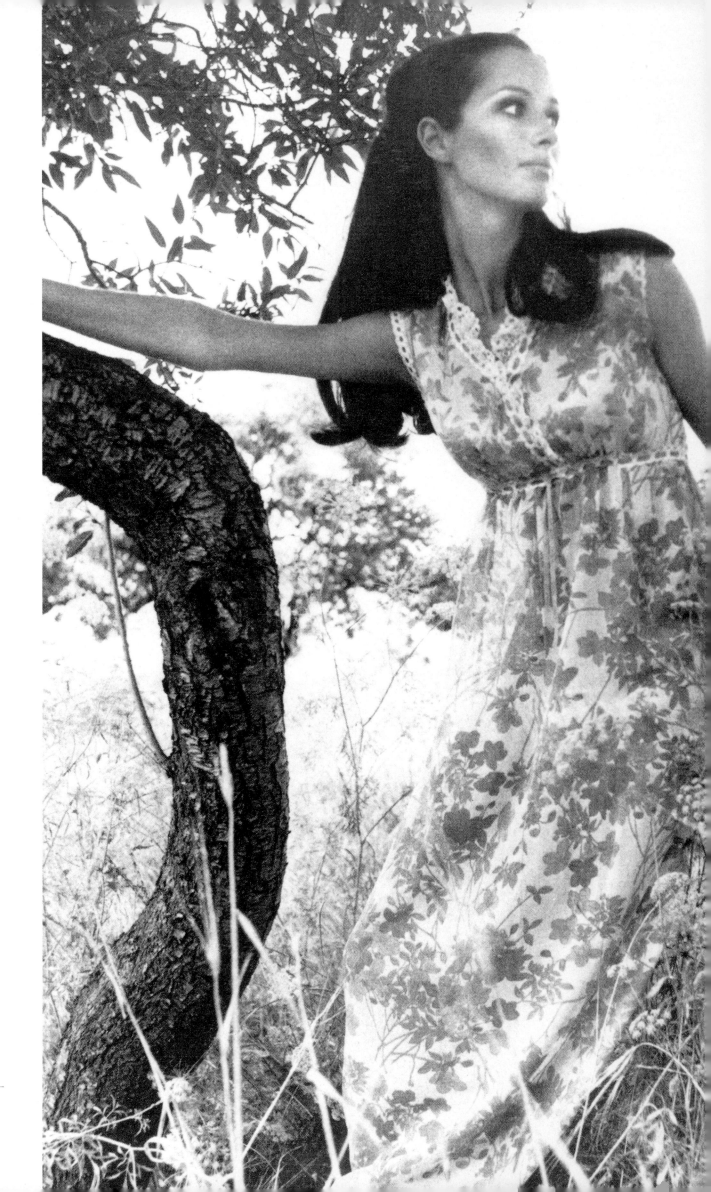

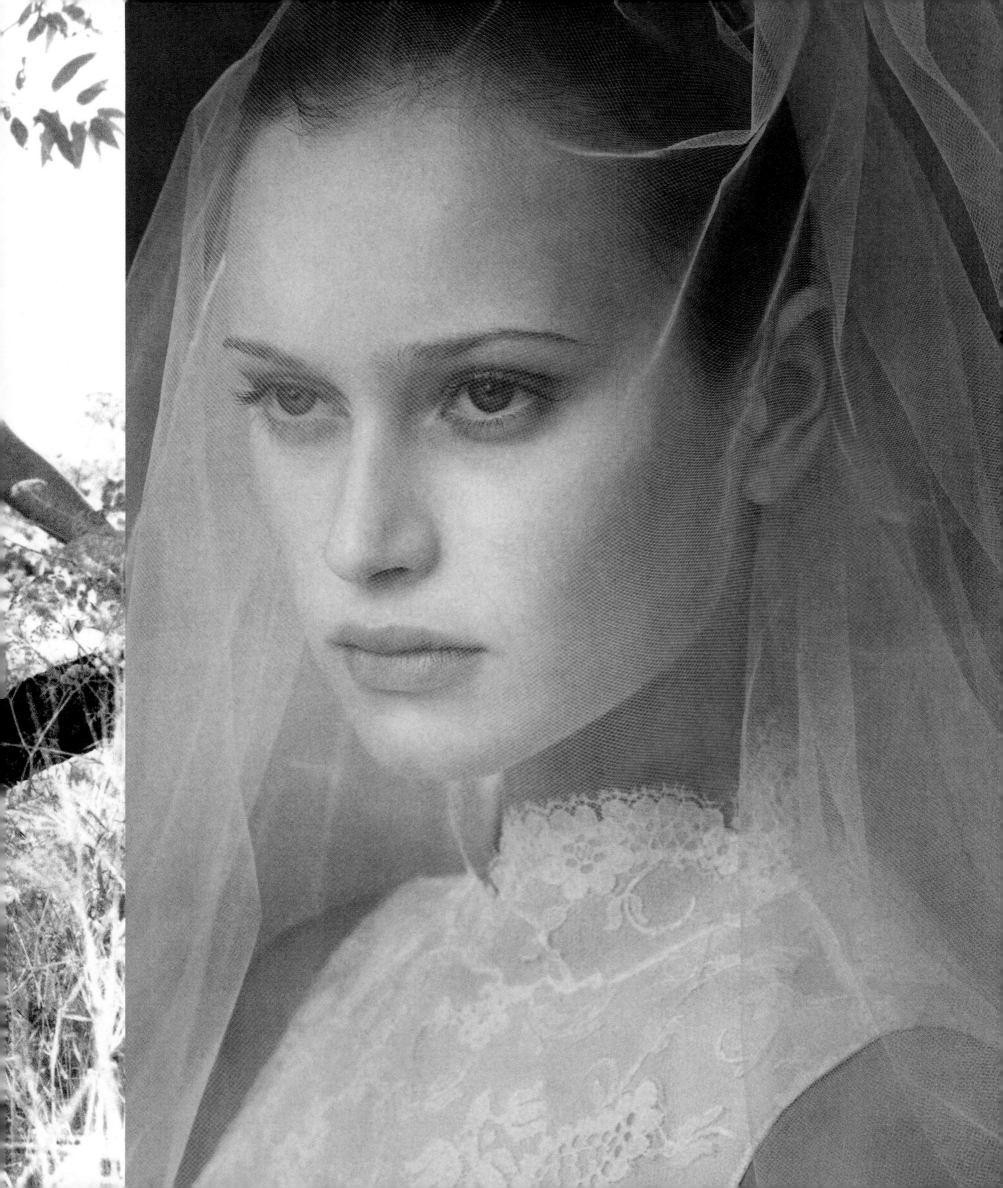

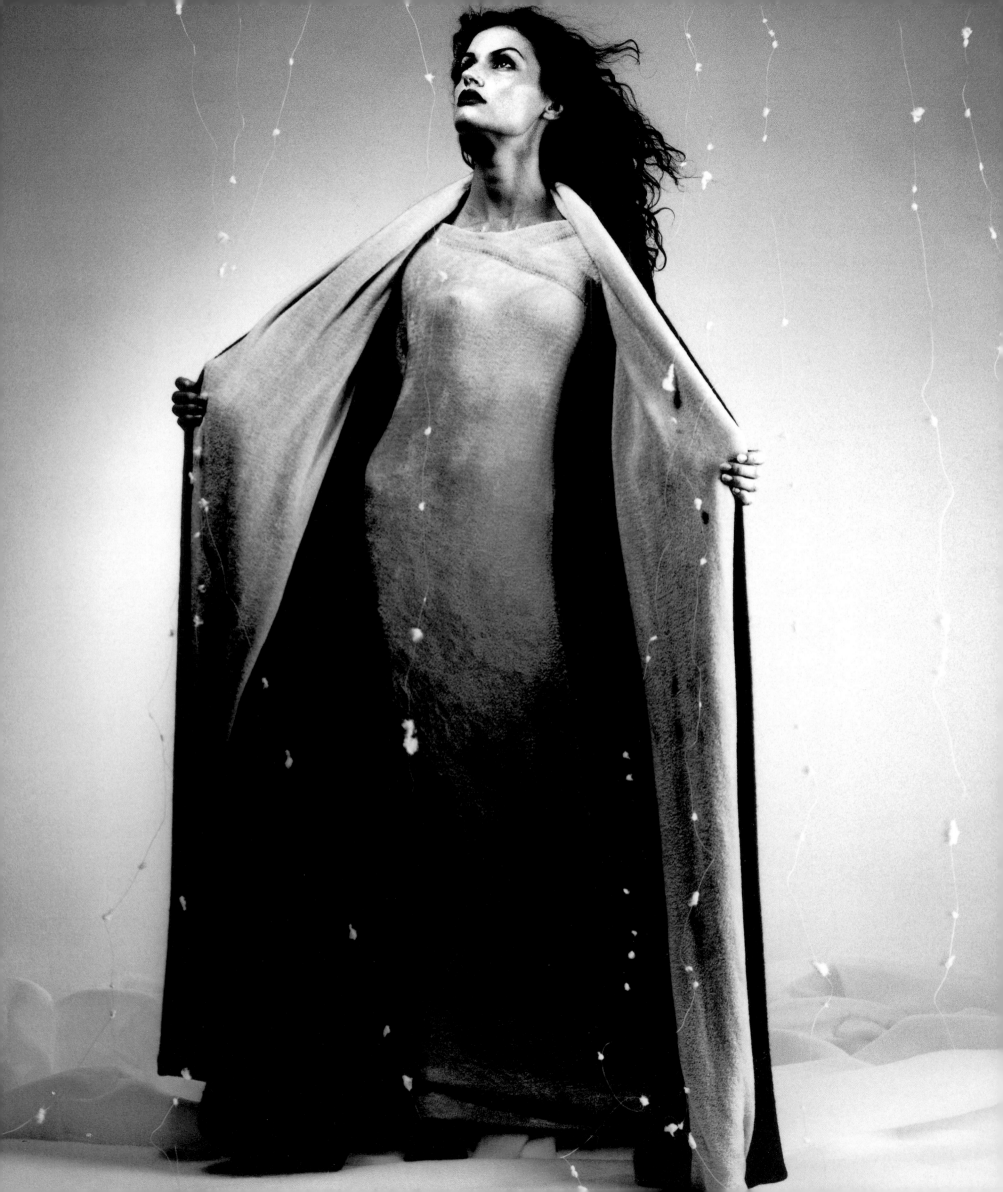

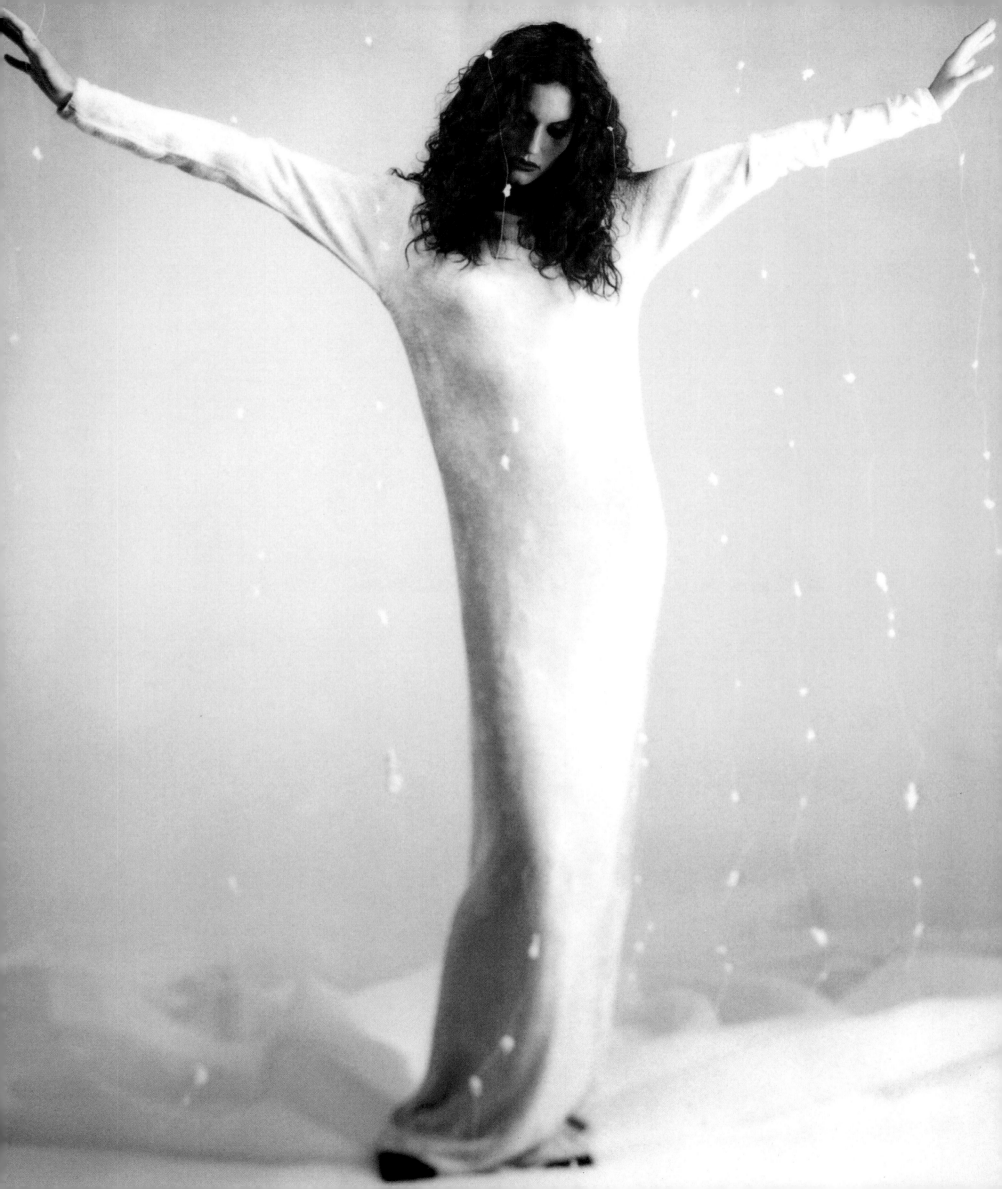

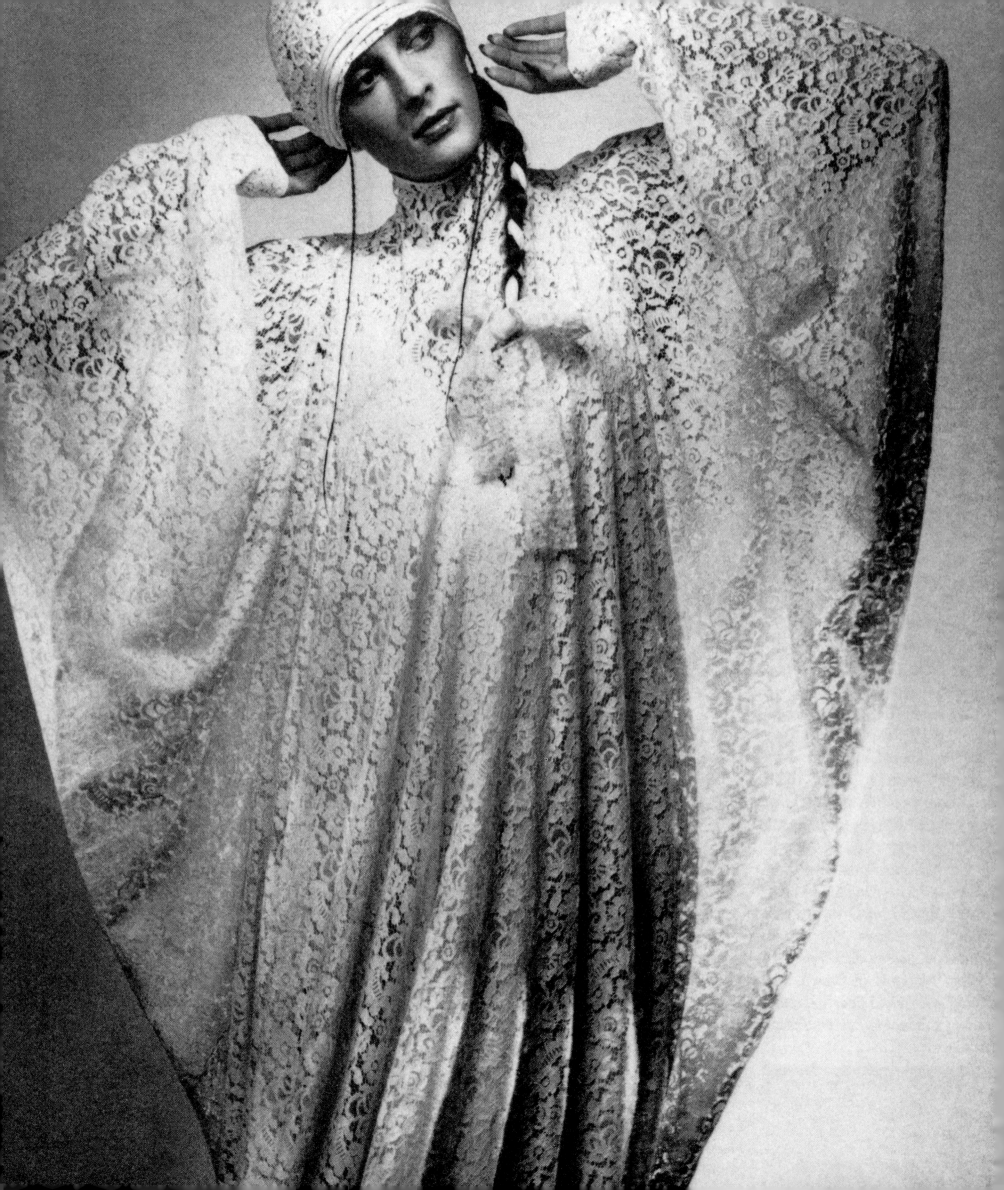

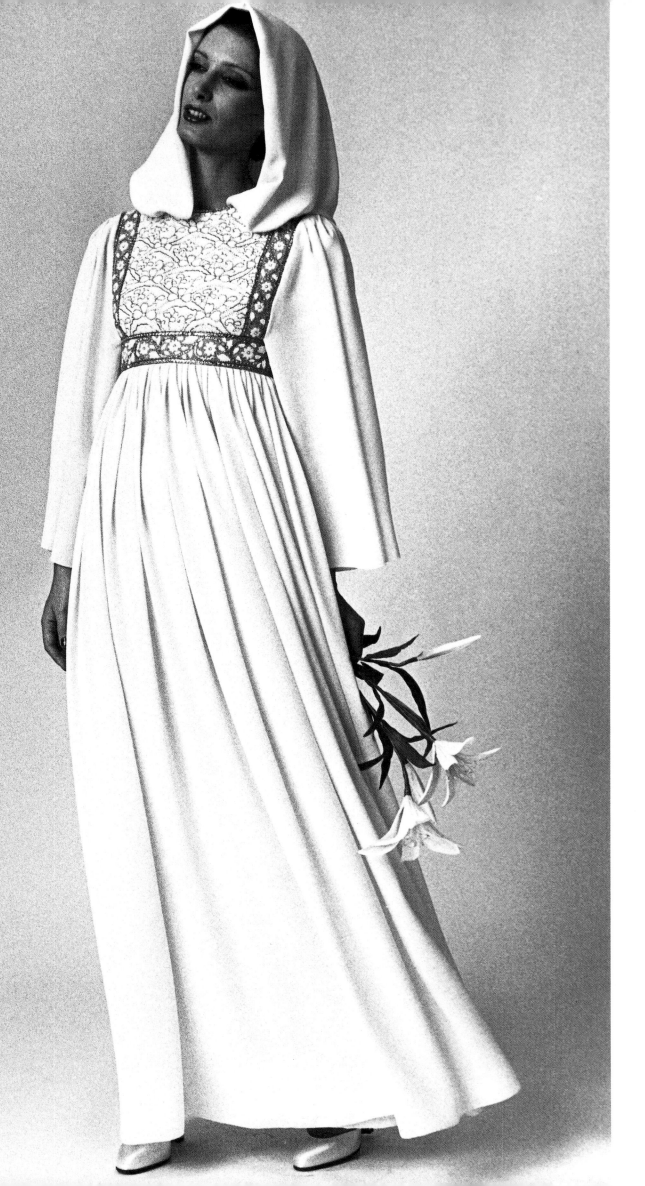

PREVIOUS PAGE... In these two statement gowns for the winter bride photographed by Giuseppe Bertolucci, the properties of stretch fabric (developed in the 1980s) are used to create simple column shapes using unusual color combinations.

OPPOSITE... Richard Dunkley photographed this bride in 1974 in a dress made of flowered lace, its flowing drapery effect reminiscent of the designs of Yuki. There is no sign of the traditional crinoline understructure.

LEFT... A hooded gown from 1975 by Christian Dior, with an embroidered faux-pinafore effect derived from Russian folk costume.

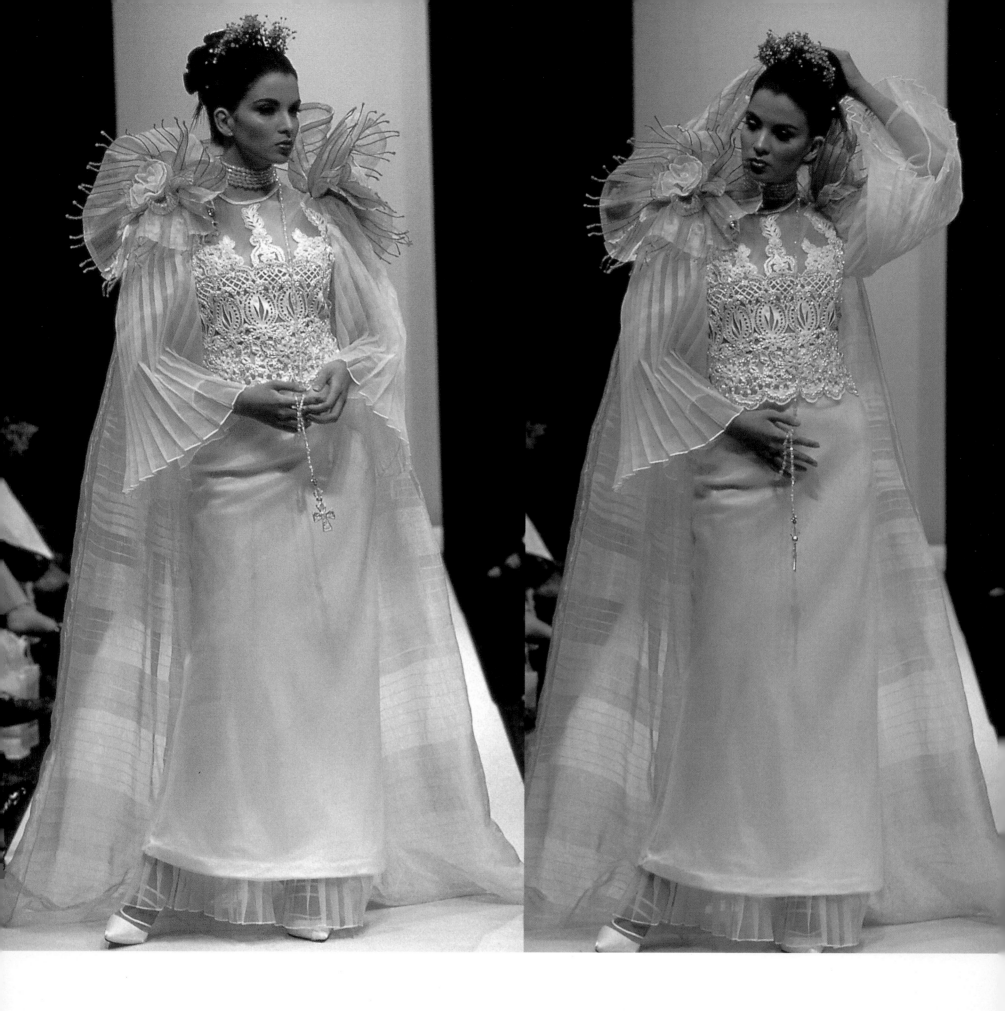

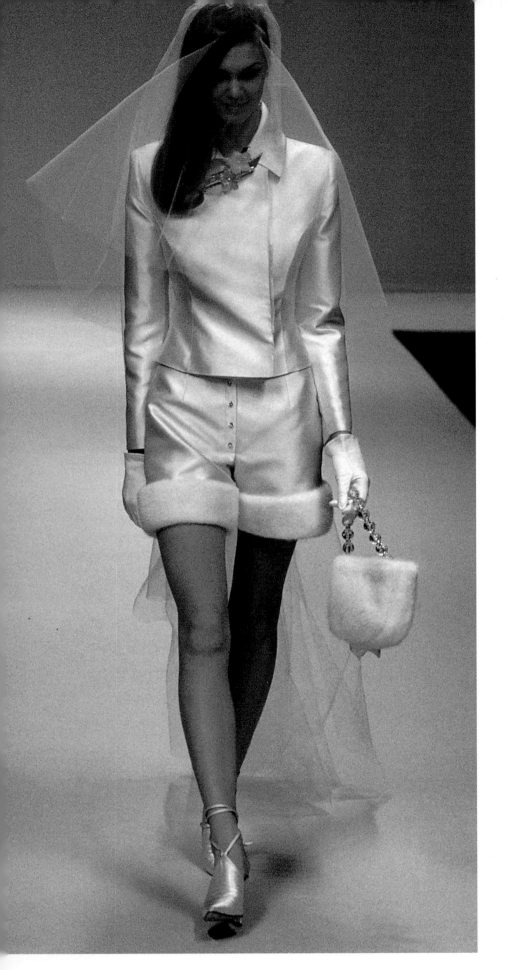

OPPOSITE... The design of this gown, by Lourdes Atencio, amalgamates Elizabethan and ecclesiastical motifs to create an uncompromisingly theatrical wedding ensemble.

LEFT... This smart hot-pants suit designed by Lorenzo Riva for the 2001–02 season looks back to that shortlived 1970s fashion statement to create an ultramodern look for today's bride.

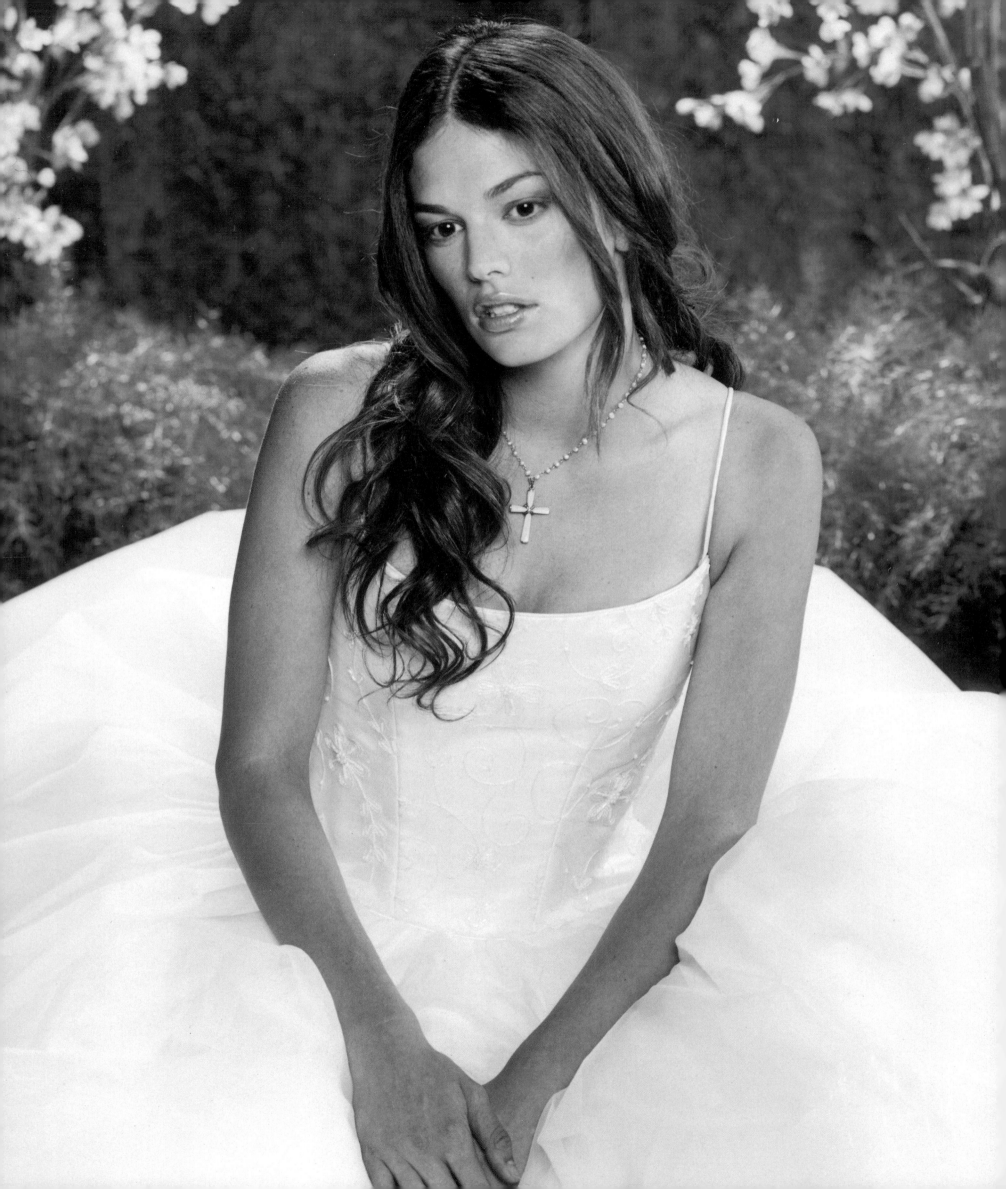

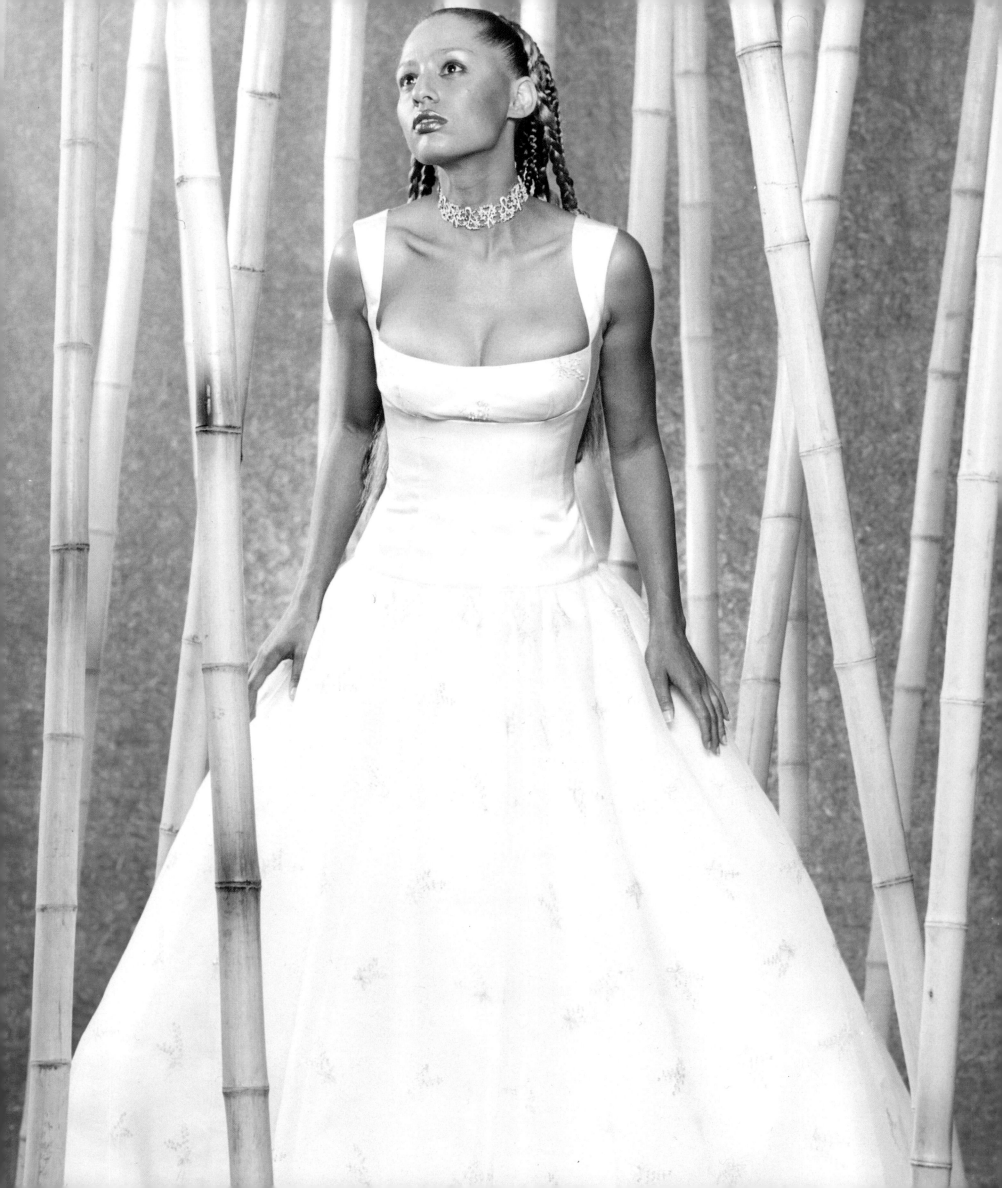

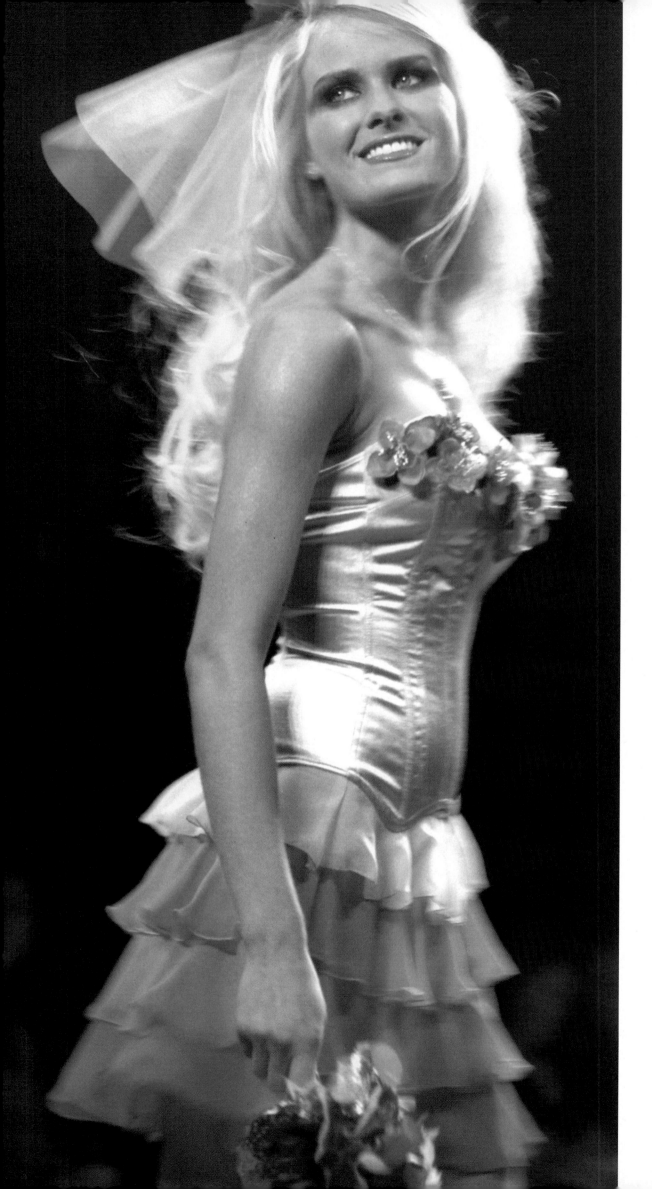

PREVIOUS PAGE… (Left) Cocoe Voci's simple bodice and full skirt in pure white positions the naturally styled bride among nature, in homage to the hippie counterculture of the late 1960s. (Right) Another Cocoe Voci design for spring 2000 with a deep décolletage and low-waisted bodice that ends in a full tulle skirt.

LEFT… This flirty, fuchsia pink cheerleader-skirted number by Betsey Johnson, incorporates a long-line boned corset with 'balconette' floral decor, accessorized with a short veil and matching posy.

OPPOSITE… A puffball-skirted gown by Arkadius, with 'Camelot' sleeves and a deep cowl neck, makes for an attention-grabbing silhouette in this impressionistic image.

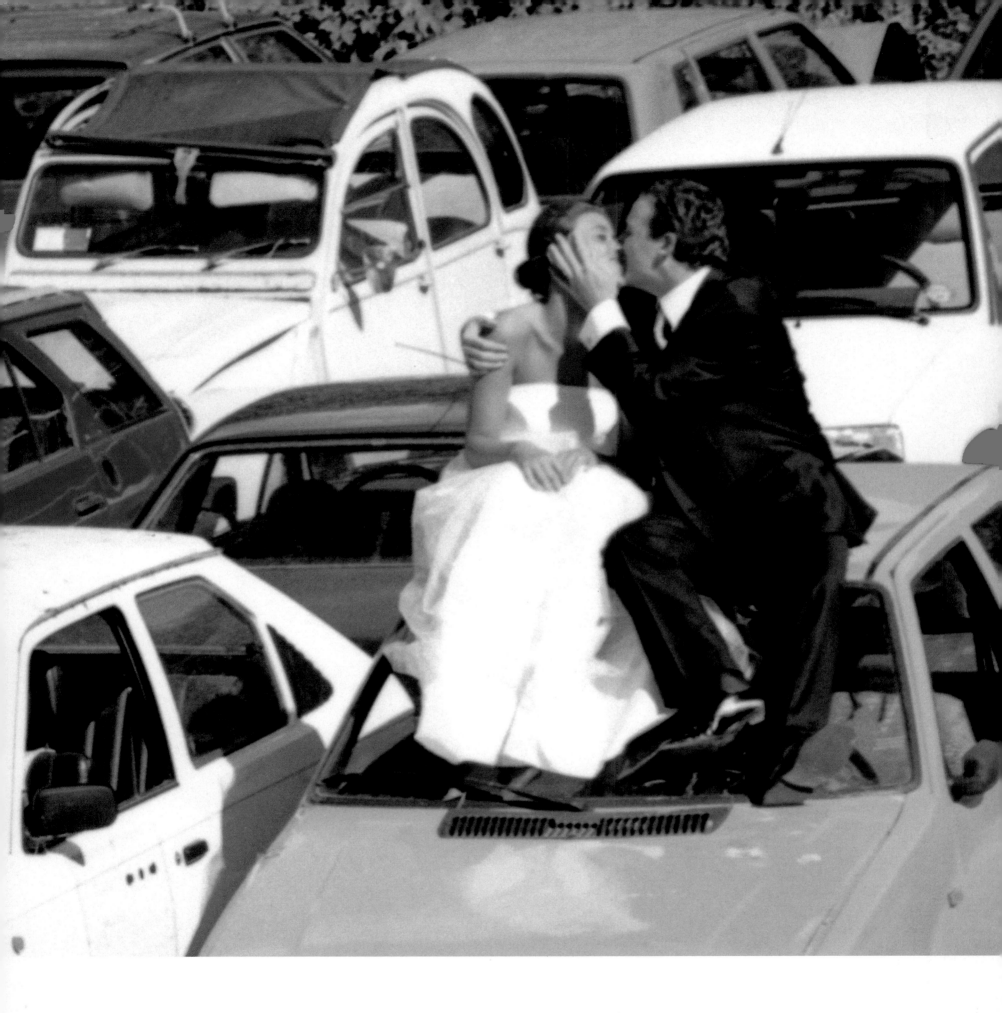

'I don't think of it as a Hollywood wedding. I think of it as a family wedding ... There's something very homespun about it.'

Catherine Zeta Jones on the eve of her $2 million wedding to actor Michael Douglas.

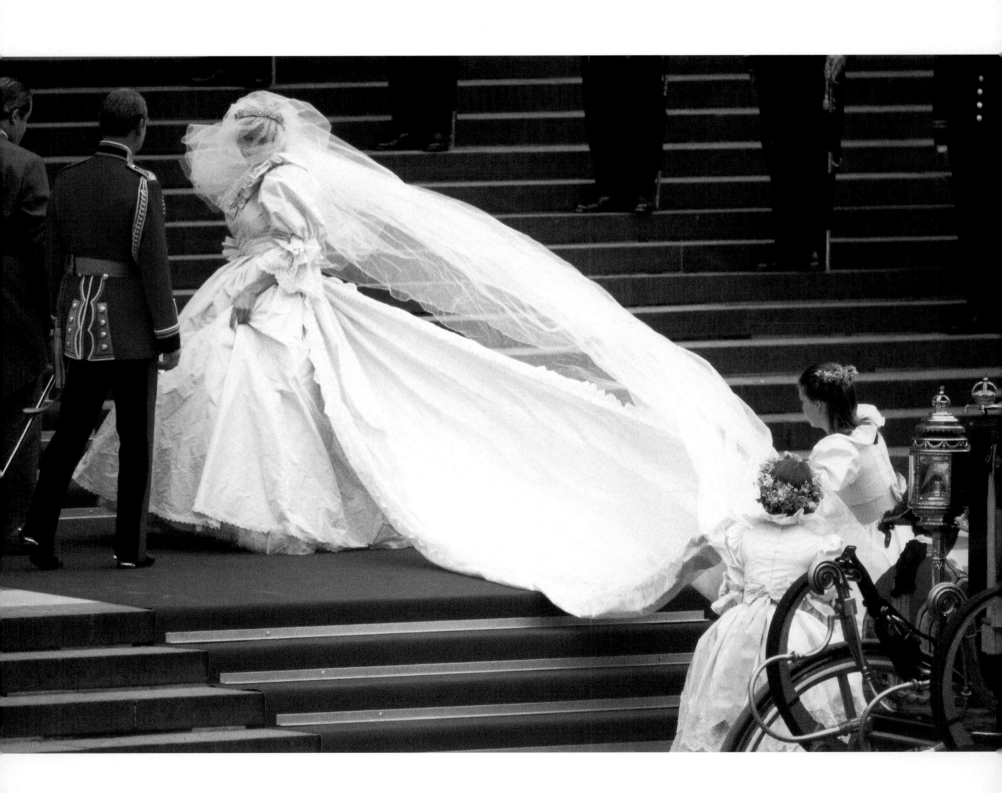

Modern fairy tales

By the 1980s the white wedding was recession-proof. Women had been thoroughly inculcated into the codes of bridal femininity through soap operas, movies, bridal magazines, and celebrity bashes, and opted for a traditional white gown even when they were power-dressing and striving for equality in the workplace. Men were no longer the main breadwinners in a household and, as more women entered the executive arena, their renegotiation of the privileges of male gender appeared in symbolic form in the power-dressing movement. Women aped their male colleagues with broad-shouldered suit jackets and short, sharp haircuts. And marriage was no longer a necessity, as the repertoire of appropriately feminine roles had now expanded to include the single, independent career woman. In a content analysis of women's magazines during 1979–80 the sociologist Marjorie Ferguson found a new figure emerging – the 'independent female,' an 'assertive, questing and questioning female … found helping herself to cope with life and love, work and play – if not on her terms, then in accordance with a negotiated, not a dictated settlement.'[2]

Despite this step toward further equality for women (or as a result of it), there appeared to be a global backlash against the effects of feminism and countercultural attitudes to love, sex, and marriage, as traditional heterosexual roles were reasserted. The moral panics surrounding AIDS caused a retreat from the liberal sexual attitudes of the last decade but concurrently a politics of cultural activism was being developed by urban gay men, leading to the first socially sanctioned marriages between people of the same sex. As the feminist historian Sheila Rowbotham points out, 'undeniably a shift in gender relations and sexual interaction was occurring. The certainties of male sexual control had been dented, leaving an ambiguity in sexual etiquette. There was a certain androgyny in style and a prevalent cool in outward behaviour among young women. The new glamour juxtaposed masculine and feminine in incongruous ways. There was a choice and the option of saying no.'[3]

Many were saying yes, though, and weddings were more popular than ever, even if increasingly likely to fail. In the midst of cultural change, the marriage ceremony returned to a Victorian and Edwardian expression of traditional values, particularly in the popularity of frock coats for grooms and crinoline gowns for brides. As weddings proliferated, they grew larger and more ambitiously upscale, reflecting the conspicuous consumption that had entered mainstream fashion trends with the cult of the designer label. The policies of free trade and tax breaks for the rich, exemplified in the politics of Reaganomics and Thatcherism, made the blatant display of wealth acceptable. Consumption was seen to define the successful self, embodied by the figure of the yuppie (or young urban professional) in popular culture. The cultural historian Deborah Silverman talks of a new cultural style in ascendancy in the U.S. at this time, 'a style aggressively dedicated to the cult of visible wealth and distinction, and to the illusion that they

OPPOSITE On July 29, 1981, Lady Diana Spencer entered St. Paul's Cathedral wearing a dress designed by Elizabeth and David Emanuel, setting the bridal silhouette for the next decade and in turn revitalizing the bridal industry.

were well earned; a style of unabashed opulence, whose mixture of hedonism, spitefulness, and social repudiation was captured in the slogan "Living well is the best revenge."'4 The U.S. journalist Holly Brubach wrote in a similar fashion that 'Conspicuous consumption … during the Reagan years was regarded as a badge of personal achievement … The heroes of the eighties, who built junk-bond empires and casinos and shopping malls as monuments to themselves, outfitted their wives in dresses by Christian Lacroix.'5

Christian Lacroix was a key designer of the 1980s who capitalized on the new money created out of the entrepreneurial spirit of the decade. From his first couture collection in 1987, wedding gowns took center stage, with the model Marie Seznek appearing in 'a meringue of ivory silk under a winged and veiled cartwheel hat.'6 Lacroix reintroduced the spectacular into couture with his trademark 'puffball,' or 'pouf,' skirts and historical referencing. The fashion writer Georgina Howell called his work 'pure theatre – a striped satin ballgown with the bustle in the front, a toreador cape of pink and yellow satin, a scarlet bustier bursting into a storm of striped petticoats.'7 One of his elaborate couture wedding gowns was eighteenth-century in inspiration, featuring 'a boned bodice in cream silk with removable sleeves, attached by ribbon bows, and decorated with heavy gilt jewels at the front. The matching silk overskirt is ruched up on one side to reveal the quilted satin overskirt. The oval-shaped bridal veil features embroidered lace edges and the headdress is a gilt tiara crown worn on top of the veil.'8

In this description we can see key elements of Lacroix's *oeuvre* – historical styles as a rich source to be plundered, elaborate detailing with an emphasis on handwork and a general deluxe style. His luxurious, expensive clothes became a global obsession amongst the magnates of Japan and Arab oil barons, who ordered some of the most mind-bogglingly expensive wedding dresses with their 1980s petrodollars. Fashion editor and author of *The Fashion Conspiracy*, Nicholas Coleridge wrote of fashion houses in the 1980s, who 'saw Arabs as cash cows and milked them mercilessly. Capitalizing on their taste for expensive beading, dresses were beaded from neck to ankle, with beads applied where beads had rarely been seen before … [including] the first $100,000 white-beaded wedding dress. "We took an order for a wedding dress yesterday – 450,000 francs," says Erik Mortensen, couturier for the house of Balmain. "But we have made more expensive ones, up to 600,000 francs. Plus the bridesmaids. They can be ten, eleven, twelve years old, and the dresses are each 125,000 francs, 150,000, 175,000, all depending on the embroidery and if they are trimmed with white mink."'9

Wedding gowns are now one of the most profitable parts of Christian Lacroix's atelier. In 2000 he created an Edwardian-inspired dress for Catherine Zeta Jones's marriage to Michael Douglas. It was of ivory duchess satin with a seven-foot train and a long 1930s fishtail skirt overlaid with eighteenth-century Chantilly lace – a cornucopia of retro influences and an example of what Lacroix called 'a balance between tradition and modernity.'10 The $160,000 dress was copied by the Hollywood clothing company ABS and was on sale for $350 a week later.

The 1980s obsession with couture, spearheaded by the wealthy wearers of Lacroix, had a trickle-down effect, with the word 'couture' entering bridal-gown vocabulary, irrespective of whether gowns were the result of painstaking fittings or cheap off-the-rack numbers. Many were

OPPOSITE The London-based bridal designer Tomasz Starzewski is renowned for his highly decorated and detailed looks, which follow in the grand traditions of haute couture. Here his gown envelops the bride in a cloud of frothy tulle.

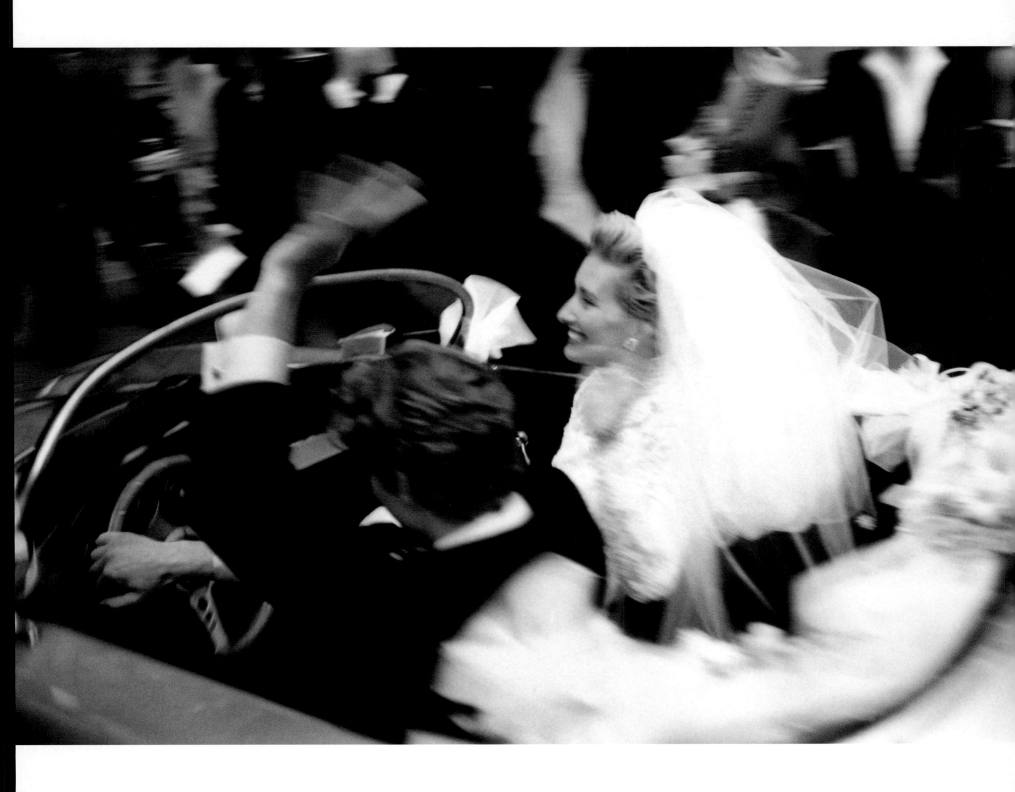

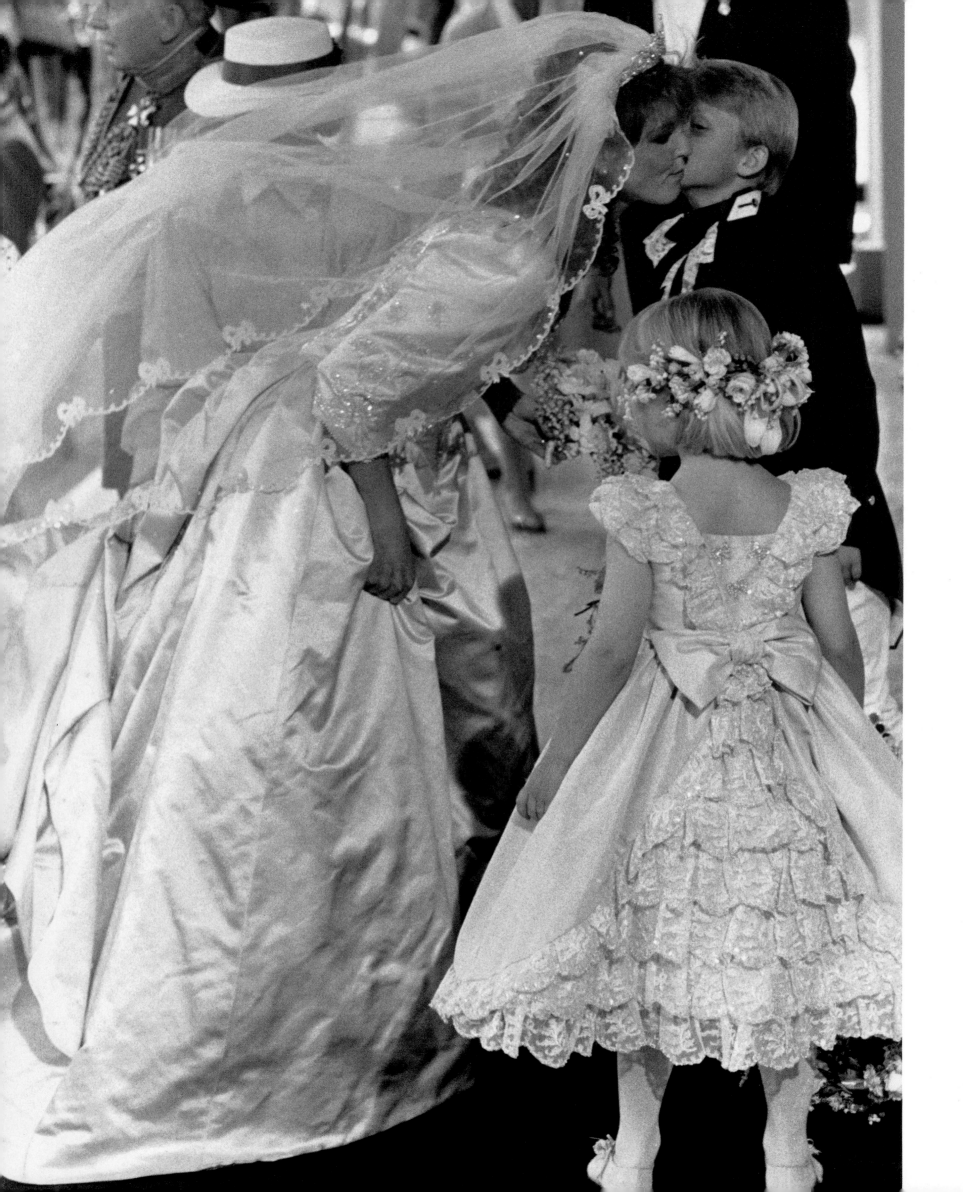

copies of the gown worn by Princess Diana for her wedding to Prince Charles in 1981. On July 29, Diana entered St. Paul's Cathedral wearing a dress by Elizabeth and David Emanuel, setting the bridal silhouette for the next decade and revitalizing the bridal industry. The design duo were known for the trademark ruffles that appeared in practically all of their designs, even swimwear, and their 'retrospectively romantic'[11] signature style.

Diana's gown was of ivory silk taffeta with a twenty-five-foot detachable court train of paper taffeta and a silhouette modeled on the nineteenth-century crinoline: 'one great creamery ivory thrill,'[12] as Jean Rook, the doyenne of British journalism put it. Her U.S. counterpart, Susan Heller Anderson of *The New York Times,* described 'a sequin-and-pearl encrusted dress ... Produced by Britain's only silk firm, the dress was hand-embroidered with old lace panels on the front and back of the tightly fitting boned bodice. A wide frill edged the scooped neckline, and the loose, full sleeves were caught at the elbow with taffeta bows. A multi-layered tulle crinoline propped up the diaphanous skirt. A diamond tiara belonging to Earl Spencer, Lady Diana's father, anchored her ivory tulle veil, aglitter with thousands of hand-sewn sequins. Also borrowed was a pair of diamond drop earrings from Lady Diana's mother ... For the final tradition-bound item something blue – a blue bow was sewn into the waistband of the dress.'[13]

In keeping with what had become a royal wedding cliché, a security firm had been employed to keep a twenty-four-hour guard over the gown to prevent any secrets slipping out to the press. Even so the first copy of the dress was in the window of a British department store within five hours of the ceremony, a cheap copy in polyester satin which retailed at $700, legitimizing aristocratic privilege by inviting a laborious imitation of a spectacle no other could hope to achieve. The whole enterprise was a commercial and cultural success, though not so much a romantic one – Diana herself described feeling like 'the lamb to the slaughter'[14] the night before the ceremony. Diana's engagement ring had also been copied, this time by the high-street jewelry firm of Ratner's, which went on to sell 40,000 of the rings in one year. There were 1600 different wedding souvenirs available for those who wanted to participate in the event in the privacy of their own homes – from a box of matches to a $11,000 set of cutlery by the prestigious jewelers, Garrard.

The blatant merchandizing of the ceremony seems somewhat unsavory in retrospect after the couple's various infidelities, divorce, and the eventual death of Diana, and effigies of Diana in her Emanuel gown in the form of mugs, teaspoons, and tea towels are a common yet poignant sight at garage sales and thrift shops. The columnist Suzanne Moore compares the fantasy fairy tale of the royal marriage with its more prosaic reality, commenting that 'even those glued to their sets on the day of the royal wedding knew that life – anyone's life – wasn't like the spectacle on their screen. All the same, the nation seemed happy to drown itself in icing sugar, needless of cynics amongst us who saw Diana as a sacrificial lamb on the altar of a monarchy in decline.'[15] Sociologist Chrys Ingraham is another commentator who deconstructs the whole sorry saga, emphasizing that this was a dynastic match rather than one predicated on love, particularly on Charles's side. In fact, Ingraham pinpoints a specific moment in the wedding ceremony when this was all made clear: '"Who gives this woman to this man?" At that point, Lady Diana's father literally

OPPOSITE The spectacle of wealth and aristocratic privilege was displayed, yet laid bare, by the 1986 wedding and subsequent divorce of Prince Andrew and Sarah Ferguson. She wore a Lindka Cierach dress of ivory duchess satin embroidered with the family crest.

gave Diana's hand to Prince Charles. Charles then placed a ring on Diana's finger and did not receive one for himself. This striking display of patriarchal tradition re-secures the upper-class role of Princess Diana as wife, future mother and future queen. This act of placing her hand into Charles's so that the ring can be placed there boldly demonstrates the transference of daughter as property of the father to husband as the new proprietor, signified by the wedding ring. Her labour will serve the interests of the British crown in providing heirs and in socializing them appropriately for their life as royalty. This display reflects a powerful relationship among romance, religious ideology, property, and wealth or accumulation. The spectacle of wealth is never called into question but is, instead, romanticized by the emcees. The conditions upon which any of these vast holdings have been amassed are rendered invisible by the heterosexual imaginary that collapses the romantic and the material world together.'[16]

Even so, this grand royal wedding had enormous influence, and the cost and size of weddings escalated accordingly. The cultural historian Simon Charsley has investigated the cultural meaning of the wedding cake and sees that 'at the beginning of the 1980s four-tier cakes were generally regarded as the ultimate. By the end of it, specialist firms at the top end of the market were making five-tiers as features for their displays, pricing them generously – in one recorded case at £500 when a three-tier could still be had locally for £100 – and finding them selling – what was needed to make an impression was escalating as the decade wore on.'[17]

The spectacle of wealth and aristocratic privilege was also displayed, yet laid bare, by the wedding (and subsequent divorce) of Prince Andrew and Sarah Ferguson in 1986. She wore a Lindka Cierach dress of ivory silk duchess satin embroidered with the family crest, and he the full dress uniform of a Royal Naval Lieutenant. There was no real relationship with mainstream fashion here. The first rumblings of ecofashion were beginning to be heard in the fashion marketplace and manufacturers were realizing that the next new trend, and trend it was, was environmentally friendly clothing. In 1990, Rifat Ozbek's 'White' collection symbolically referenced the new interest in ecology and care for the global environment. With his white sports-inspired separates, with slogans such as 'Nirvana' emblazoned across the back, Ozbek attempted to bring a new spirituality into fashion. Bridal gowns, however, could never conform to these sorts of environmental principles. They were, and still are, labor-intensive and worn for one day only. One American designer, Susan Lane, was brave enough to attempt an ecofriendly range of bridal wear that utilized recycled bottle caps, paper products, and plastic bubble wrap, but it failed to catch on – for the whole philosophy of weddings is conspicuous consumption; hang the expense; and never, ever, recycle.

Historical styling was a key characteristic of wedding dresses for most of the 1990s. The West appeared to be a culture obsessed with historical forms, perhaps as a result of moving toward the unknown territory of the new millennium. It was safer to take refuge in nostalgia, a past where marriages seemed to be more solid and long-lasting. Historical clichés were embodied in mainstream wedding fashion and particular sartorial elements became a staple of wedding-dress style, such as crinoline or bustle skirts, Empire lines, and even low-waisted 1920s flapper styles.

OPPOSITE An ethereal image of a bridesmaid dressed by London-based designer Basia Zarzycka in a full tulle skirt, pearl earrings, and gold tiara.

ABOVE... Publisher Beatrice Vincenzini and Hugh Warrender marry in Italy in 2000. The bride, a Tuscan heiress, wore a Vera Wang-designed gown with a white mink wrap, Philip Treacy headdress, and family tiara.

OPPOSITE... Some of the most traditional and extravagant weddings take place among the black diaspora. This image of an Afro-Caribbean wedding in the 1980s shows the couple in show-stopping wedding wear, with the bride in a gown with Sweetheart neckline and the groom in gray morning dress, including top hat.

By the late 1990s, there was a repertoire of bogus historical styles that had been popular for almost two decades – but the terminology was being subtly rebranded in order to appear fashionable. The 'Edwardian Era,' for instance, was relaunched as the 'Titanic' era, an entirely new term used to describe exactly the same historical moment in response to the global success of the 1997 film *Titanic*, directed by James Cameron and starring Kate Winslet and Leonardo di Caprio. Thus brides and grooms evoked their own personal fiction of an Edwardian 'golden age' that they had only seen in a Hollywood disaster movie. Cultural theorist Raymond Williams comments that tradition 'is always more than an inert historicized segment'; it is an 'intentionally selective version of shaping past and pre-shaped present.'[18] Brides posed outside country-house hotels in gowns that evoked the 'stifling daintiness'[19] of costumes from what the film director Alan Parker called the 'Laura Ashley school of film-making.'[20] Hence, the combination of particular symbols and motifs represented an invented culture, while other more troubling aspects of a time period were forgotten or ignored. As Ingraham puts it, 'Through the use of nostalgia, romance re-narrates history and naturalises tradition.'[21]

A designer who renarrated history in the 1990s, albeit with an underlying sense of subversion, was Vivienne Westwood, who showed her first bridal collection in 1993 for Liberty's of London – this was her first official move into wedding-gown design. Her range of garments included 'his and hers, gangster style trouser suits in cream wool with giant satin lapels for the bride and groom [and] matching top hats.'[22] There was a blurring of the usual distinctions between the bridal couple, except for the gendered footwear – for the bride 'teeteringly high rocking horse shoes … and carpet slippers for the groom … in shimmering white satin.' The range also included more traditional bridal shapes. 'Full blown romantic gowns … featured boned corset bodices over skirts made of literally hundreds of layers of net with ribbons, while another full-skirted strapless gown in white organza was topped by a matching organza veil.'[23]

By the end of the 1990s, celebrities had become the new royalty, as royalty was so conspicuously failing. The media was obsessed by the celebrity, and the spectacle of the celebrity bash achieved maximum coverage. For celebrities who were well-known for their 'well-known-ness,'[24] the trend was toward big weddings, and the more theatrical the better. On getting married to the pop singer Sting, Trudie Styler wore a $100,000 gown by Versace. The pairing of British micro-celebrities Victoria Adams (a k a Posh Spice, of the 1990s pop group the Spice Girls) and David Beckham (international footballer) was another example of conspicuous overkill. Having taken over in the British psyche as the textbook fairy-tale prince and princess of the plutocracy rather than the monarchy, the couple married on July 4, 1999 after the birth of their baby, Brooklyn. The wedding was described by the couple's spokesperson as a 'low key affair' comprising 300 guests flown in to Luttrelstown Castle, a 560-acre estate in the environs of Dublin, Ireland, for a £500,000 reception. In a popular marketing partnership *OK* magazine paid £1 million for exclusive coverage of the event, which was closely choreographed by the bride. Men were advised to wear traditional morning suits, and women only black or white, in order not to detract from the bride's Vera Wang gown.

OPPOSITE In the late twentieth century many brides took refuge in nostalgia, looking back to a past when marriages appeared to have been more stable and successful. Vivienne Westwood, however, used the signifiers of historical dress to provide powerful looks for women, enabling them to dominate the spaces around them. This crinoline skirt with fan-shaped bodice is one bold example.

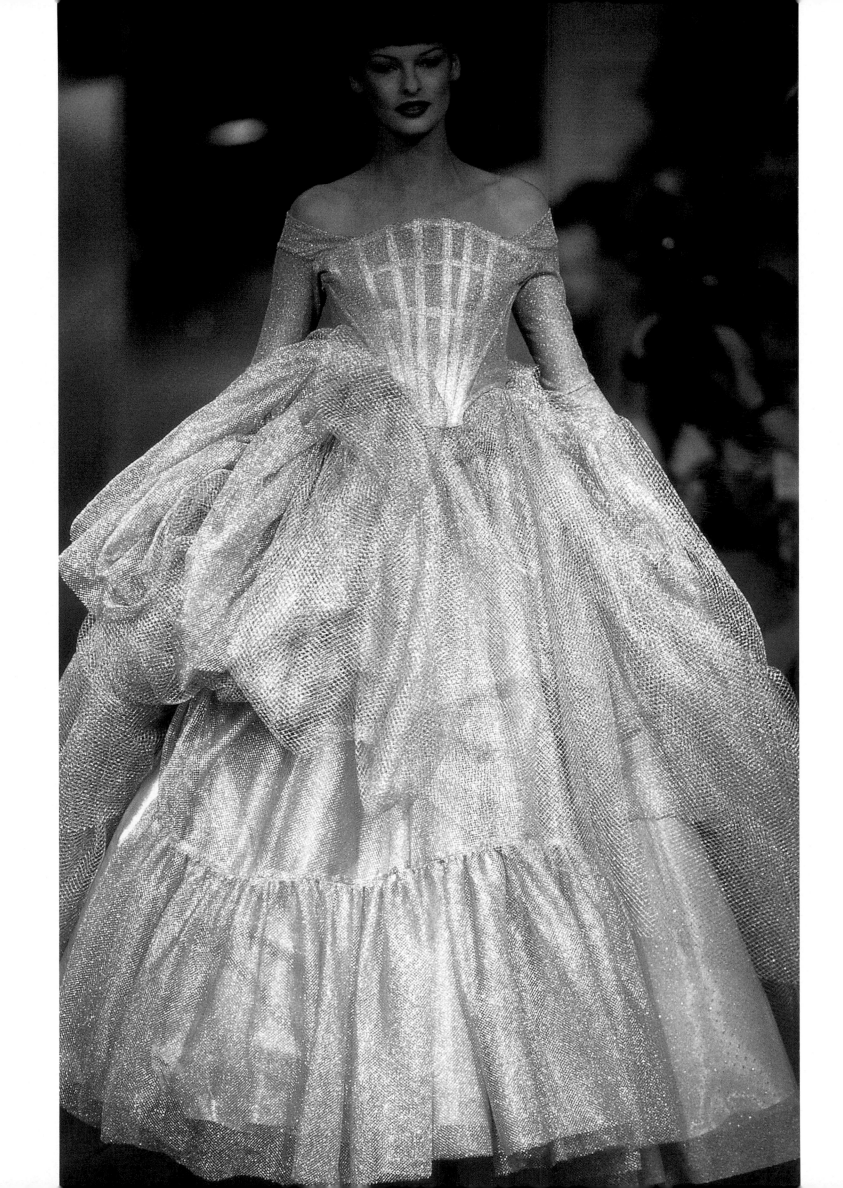

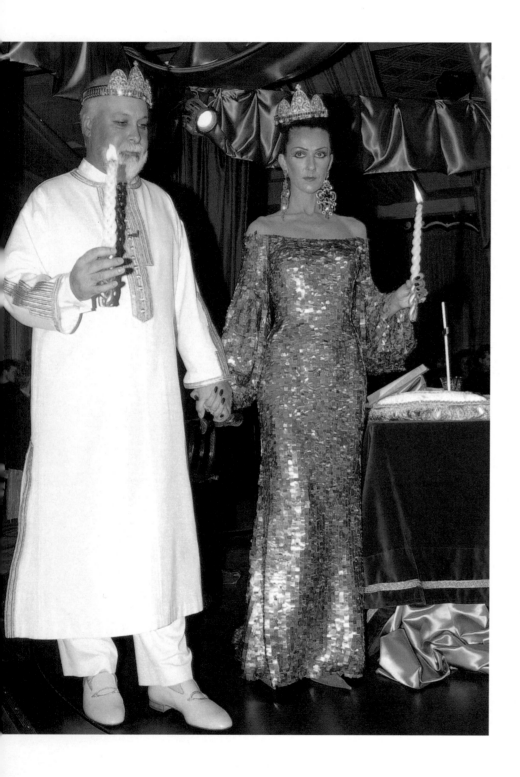

By the late 1990s, celebrities such as Victoria Adams had become models of consumption that obsessed the general public, whose own weddings became imitations on a smaller scale. An example of this is the kind of wedding that takes place within the Irish traveler community (also pejoratively referred to as tinkers), who total an estimated 19,000 in Britain. Travelers typically live on the fringes of society, in caravans, on designated sites with basic sanitation and running water. They earn money from laboring jobs such as roadwork and garbage clearance, but instead of investing it in property they spend it on cars, clothes, and (above all) weddings, an expression of their devout Catholicism and a reinforcement of their cultural identity. According to journalist Hannah Borno, 'Travellers attend dozens [of weddings] every year. There are no invitations and no directions, but some 800 people will go. Weddings are a way for families to display their wealth and status – twenty-five-tier cakes, a coach and horses and wedding dresses costing thousands are common.'[25] Gowns are big in all dimensions, brilliant white, covered in crystals and cost a minimum of $9000, worn with fifteen-inch tiaras that can cost up to $23,000 'even if it means the bride's forehead bleeds.'[26] This clearly shows that a lack of status within mainstream culture can be rectified for one day with a disproportionately lavish wedding that bears no relation to the traveler's annual wage.

Although the fantasy wedding day is as popular as ever, there does appear to be a difference in our attitude to marriage. Few of us believe in fairy-tale romance and living happily ever after, and our

LEFT In 2000, the ballroom of Caesar's Palace, Las Vegas was decorated in the style of the *Arabian Nights* for the renewal of the vows of singer Celine Dion and her manager René Angelil. The bride and groom wore Egyptian-style robes for their Eastern Orthodox ceremony.

cynicism toward the married state can be seen in varied ways. In the twenty-first century, for instance, second, third, even fourth, marriages are no longer frowned upon, although it is often not considered proper for the bride to wear white. There are other taboos over dress, too – in the Julian Barnes novel *Talking It Over*, an irate exchange takes place between the mother of the bride and her daughter, who plans to get married in the same dress as for her first wedding: 'her basic line was that I'd clearly taken leave of my senses. Only a seriously disturbed person would dream of getting married twice in the same dress. It offended against good taste, good manners, good dress sense, the church, everyone present at both ceremonies (though mainly her), fate, luck, world history, and a few other things and people.'[27]

Another post-millennium trend is that brides can wear white without blushing if sporting a new baby as the ultimate bridal accessory. In fact *People* magazine in 1997 saw pregnancy as the modern equivalent of engagement, declaring: 'These days ... pregnancy is tantamount to a diamond ... When couples have children, the child is a sign of commitment.'[28] Hence the presence of baby Dylan at the $2 million wedding of Catherine Zeta Jones and Michael Douglas at the New York Plaza Hotel, and of little Rocco Ritchie at Madonna's marriage to Guy Ritchie in 2000 at Skibo Castle in the Scottish Highlands.

More recently, there has been a backlash against the conspicuously extravagant celebrity bash as accusations of vulgarity

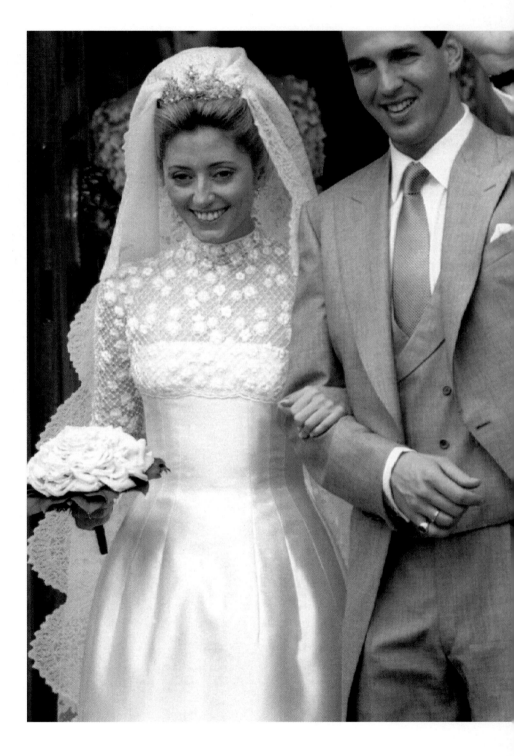

RIGHT HRH Crown Prince Pavlos of Greece marries Marie-Chantal Miller, the duty-free heiress, in the Greek Orthodox Church in London, with a reception at Hampton Court. The bride wore a Valentino dress, which in its feminine detailing embodies the dream of the traditional white wedding.

are affecting many celebrity nuptials, such as the renewing of the vows of singer Celine Dion and her manager Rene Angelil in 2000. The ballroom of Caesar's Palace in Las Vegas was decorated in the style of the *Arabian Nights,* and an estimated $1.5 million spent on various tents, circus performers, and exotic animals, formed the backdrop to Dion as she was carried in on a white *chaise longue.* At the end of the ceremony, the happy couple were crowned. Another wedding event of dubious taste was *Who Wants to Marry a Millionaire,* broadcast in the U.S. on Rupert Murdoch's Fox TV in 2000. Women contestants on the show were invited to parade in beachwear before Rick Rockwell, a self-proclaimed 'multi-millionaire' who was looking for love. After he had made his choice (a blonde called Darva Conger), the couple literally met for the first time at the television altar. An annulment followed shortly afterward and Rockwell was, in fact, revealed not to be a millionaire but a failed stand-up comedian. What has now become one of the most notorious moments on American television was also one of its most watched, with an estimated 23 million viewers.

Fear of being branded vulgar has been behind the scaling-down of extravagance or a complete ban on any media representation, as in the 2000 nuptials of Madonna and Guy Ritchie. It could also account for the trend toward simplicity in wedding fashion. There is a marked move toward simpler, straighter styles rather than the full-blown meringue that has been dominant since the 1980s. Something of an early 1960s feel is being revived through styles like the princess line and the sheath dress. The heavy materials used to create the architectural lines in that era are also enjoying something of a revival – duchess satin, corded silk, and brocade. A key twenty-first-century designer is Vera Wang of New York. Her bridal house averages fifty appointments per day for personally fitted gowns, and sells 2000 ready-to-wear dresses of between $2000 and $12,000. She favors strong, simple shapes in luxuriant fabrics such as satin-faced organza, and has a deliberate strategy of changing the traditional bridal look to one that exudes sexuality.

Even royal weddings in Britain have become more low-key. In 1999, Prince Edward arrived on foot for his wedding to Sophie Rhys-Jones. Rather than arrive in a carriage or limousine, he strode the streets of Windsor waving to the crowds. Setting a new royal precedent, he banned guests from wearing hats. Guests opted instead for a variety of tiny feathered headpieces described by one journalist as 'bits of budgie in their hair' and continued that 'It was the most TV-oriented thing the royal family have been in.'[29] The media stressed that this was a scaled-down version of a royal occasion, and it certainly seemed so in comparison with royal weddings of the past. The British comedian Linda Smith even went so far as to describe it as 'a rather dreary suburban wedding.'[30] One journalist was prepared to be more analytical, predicting that, 'in time, the wedding is likely to take on a more enduring, totally unforeseen significance. It will be remembered for providing the first signs of the Windsors' very own third way; an option which will allow them to exist into the new millennium without resorting to the pomp and ceremony of pre-Diana yore nor the Queen-riding-a-bike-to-church-in-her-curlers approach to monarchy favoured by many modernisers. For the most striking element of the whole day was that the prince and his PR executive bride had managed to pull off a royal event of disarming subtlety and lack of pretension, delicately balancing the instinctive desire for privacy with the simultaneous need for publicity.'[31]

OPPOSITE In 1992, the singer Sting married Trudie Styler, whose massive Victorian-styled white and gold crinoline caused a media sensation. The dress was designed by Gianni Versace and is rumored to have cost $100,000.

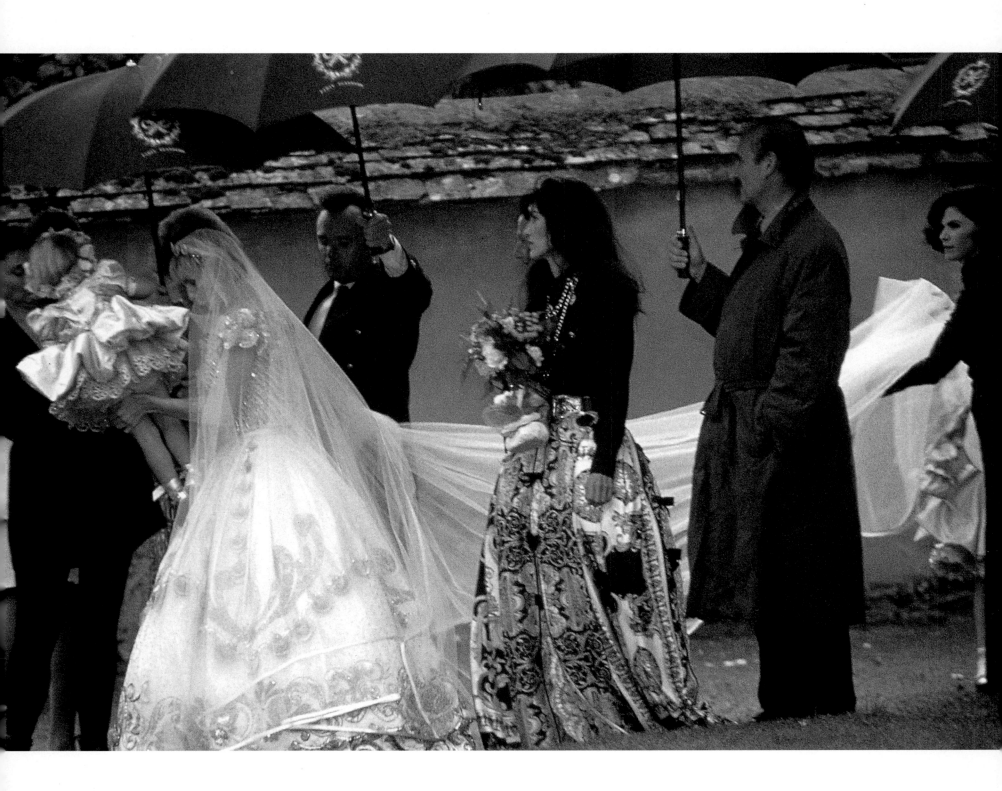

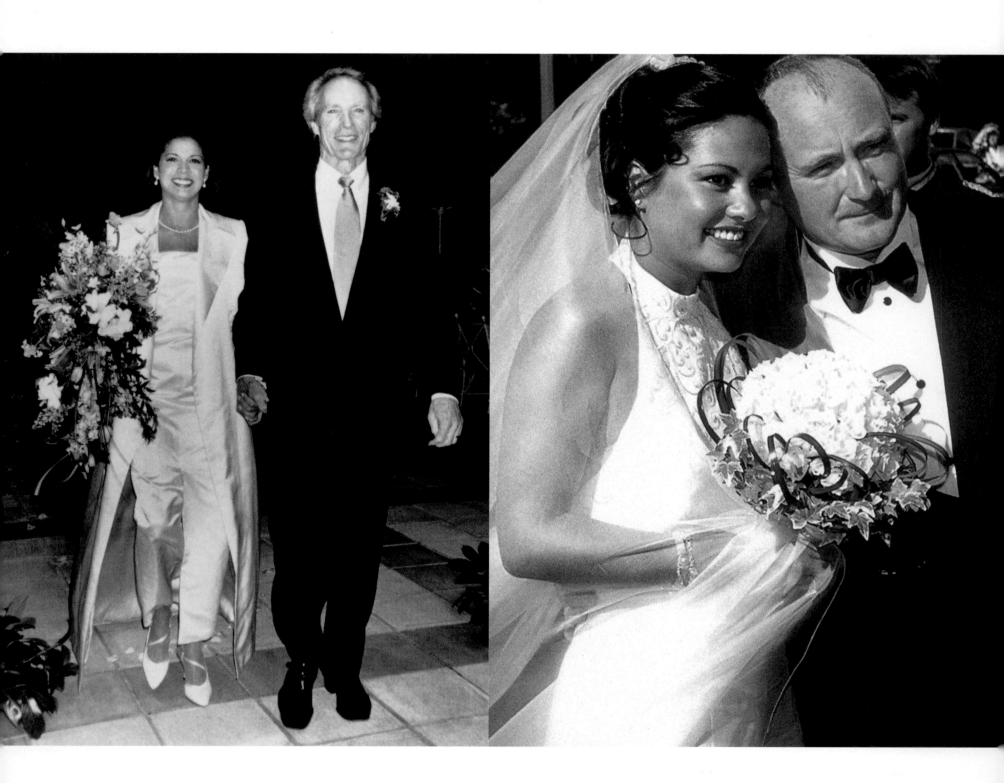

The example of Edward and Sophie's nuptials shows that simplicity in a wedding ceremony is relative. The wedding industry is still one of the biggest, most powerfully marketed forces in the world: every town has a specialized bridal store; many magazines such as *People* have their own special wedding supplements; celebrity weddings are a staple ingredient of the popular press; and the movies and soap operas remain obsessed. And all this despite the social changes that emerged in the late 1990s, in particular the rise of the single mother. The British journalist Suzanne Moore has called for a redefinition of family life, love, and marriage, taking on board new concepts such as serial monogamy: 'In the inevitable process of restructuring that the family is now going through, women can no longer rely on the old obligations which, however oppressive, have not as yet been replaced by any new ones. Consequently many men have opted out of family life altogether. This is far from ideal but surely the future depends on facing up to family life as it is lived now, with its advantages as well as disadvantages, rather than telling ourselves fairy stories about the past.'[32]

Fairy tales abound, though. Significantly, in the midst of this crisis or 'genderquake,' weddings have secured their position in popular culture with the success of films such as *The Wedding Banquet*, *Father of the Bride*, *Muriel's Wedding*, *Four Weddings and a Funeral*, *My Best Friend's Wedding*, *The Wedding Singer*, and *The Wedding Planner*. At the same time, as Chrys Ingraham observes, 'the movie industry has also managed to include a wedding in most films even when the story line seems unrelated,' e.g., *Armageddon* saves the world for two white weddings. Clearly, weddings have become the most watched, yet 'unnoticed, phenomenon in popular culture.'[33] Ingraham points out that 'as of 1997, the *primary* wedding market in the United States represented total revenues of $32 billion. To put this in perspective, consider this: If these revenues were the product of one company, it would place in the top twenty-five *Fortune* 500 corporations.'[34]

At the center of the wedding industry is the traditional meringue gown – it has achieved iconic status and is still the choice of many brides across the world. However, recent trends suggest that the cult of the body beautiful has changed the shape of many wedding dresses. Our obsession with fitness, diet, and exercise has streamlined the wedding dress into a garment that shows off a body perfected through a grueling fitness regime. The bride's body is becoming the site of conspicuous consumption rather than the dress, the internal corset of muscles displaying the attentions of a personal trainer, chef, and dietitian. This is what makes a beautiful bride – more 'get me to the gym' than 'get me to the church on time.' Thus designers like Vera Wang are at the height of their success as they create narrow, body-skimming shapes that emphasize the figure rather than piling on expensive decorative detailing. Fashionable bridal gowns are beginning to exude sexuality, an anathema in previous years when the symbolism was of virginity, purity, and decorum. Designers are reviving body-conscious techniques such as the bias cut to create gowns that mold closely to the body and use the effects of transparency with materials such as crepe or chiffon with georgette overlays.

OPPOSITE (Left) Actor and director Clint Eastwood marries for the second time, in this instance in 1995 to a television news journalist thirty-five years his junior, Dina Ruiz. He wears a black suit, she a two-piece in cream satin with wide lapels. (Right) With the bride, Orianne Cevey, dressed in a beaded halter-neck gown by Giorgio Armani, singer Phil Collins marries in Lausanne, Switzerland, on July 24, 1999.

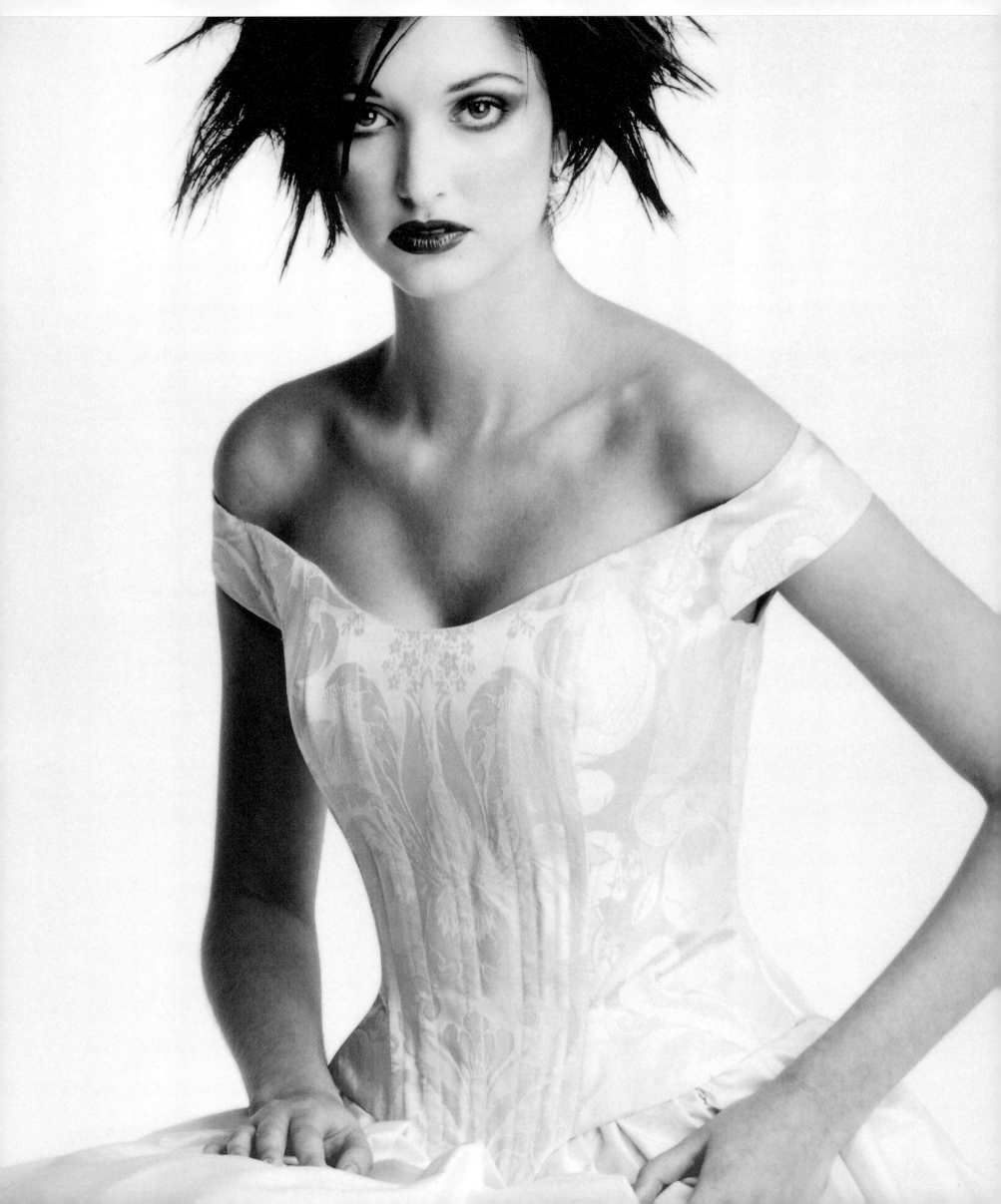

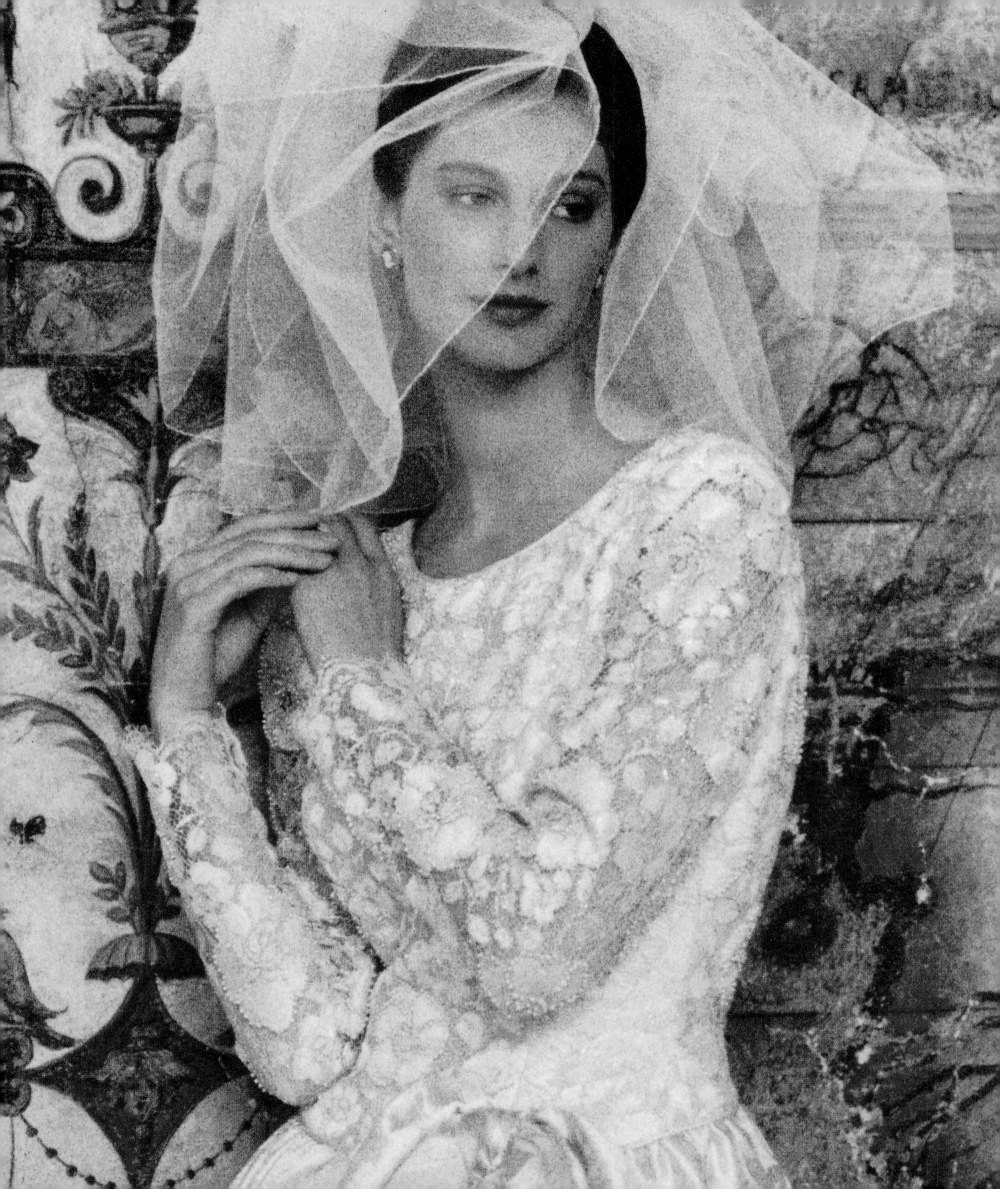

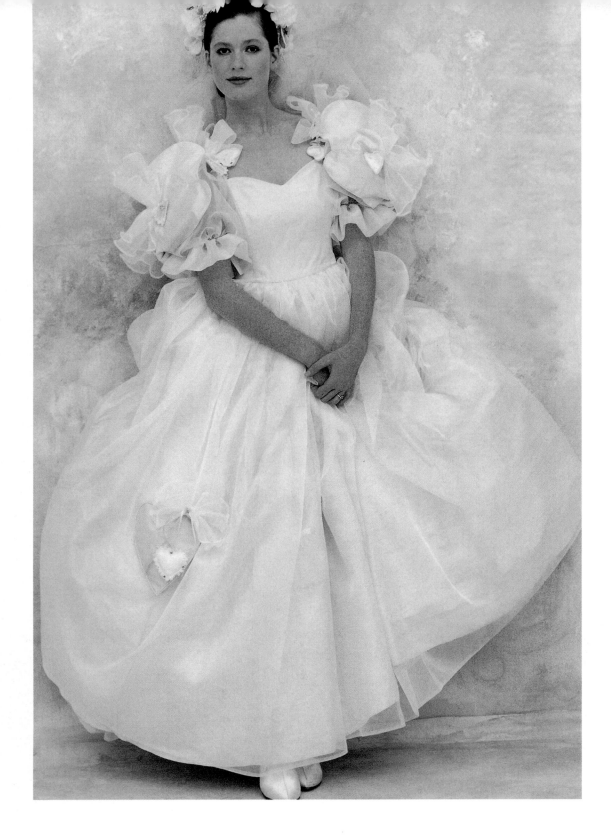

PREVIOUS PAGE... (Left) The punky hair and overt makeup in this bridal image, created by Catherine Davighi, is an overtly sexual look, emphasized by the deep décolletage of the off-the-shoulder design. (Right) Photographer Stefano Massimo poses a romantic swan-necked bride against a Meditterranean fresco for *Brides* magazine in 1989.

ABOVE... Historical clichés abounded in 1980s bridal fashion, and particular sartorial elements became staples of wedding-dress style, such as the crinoline skirt and Diana-inspired three-quarter sleeves, here photographed by Nick Briggs.

OPPOSITE... The 1980s saw much experimentation in the use of color and historical themes. This design by Joanne Crossfield is in a setting reminiscent of *Wuthering Heights*, the bride swathed in blue velvet with leg-of-mutton sleeves.

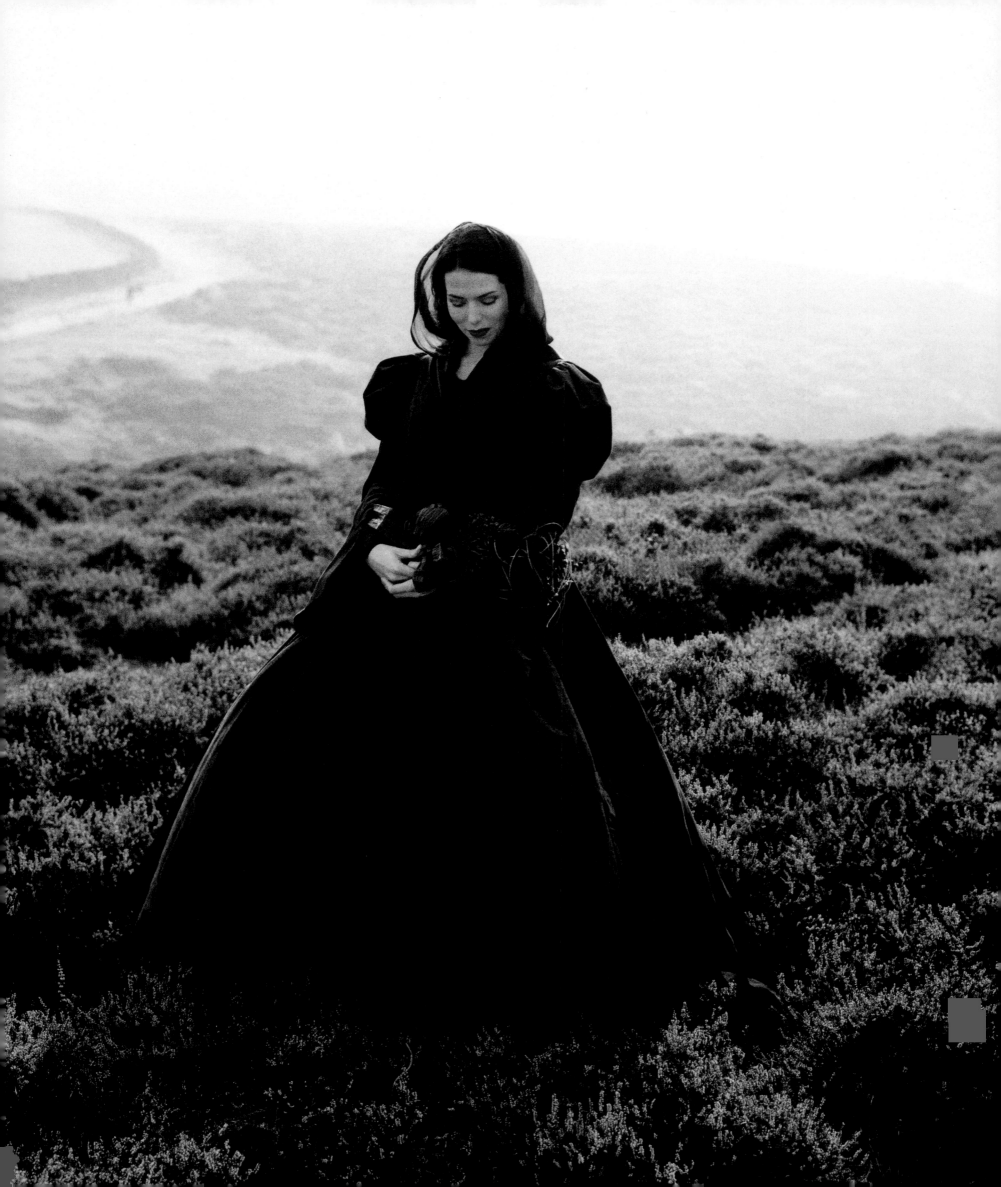

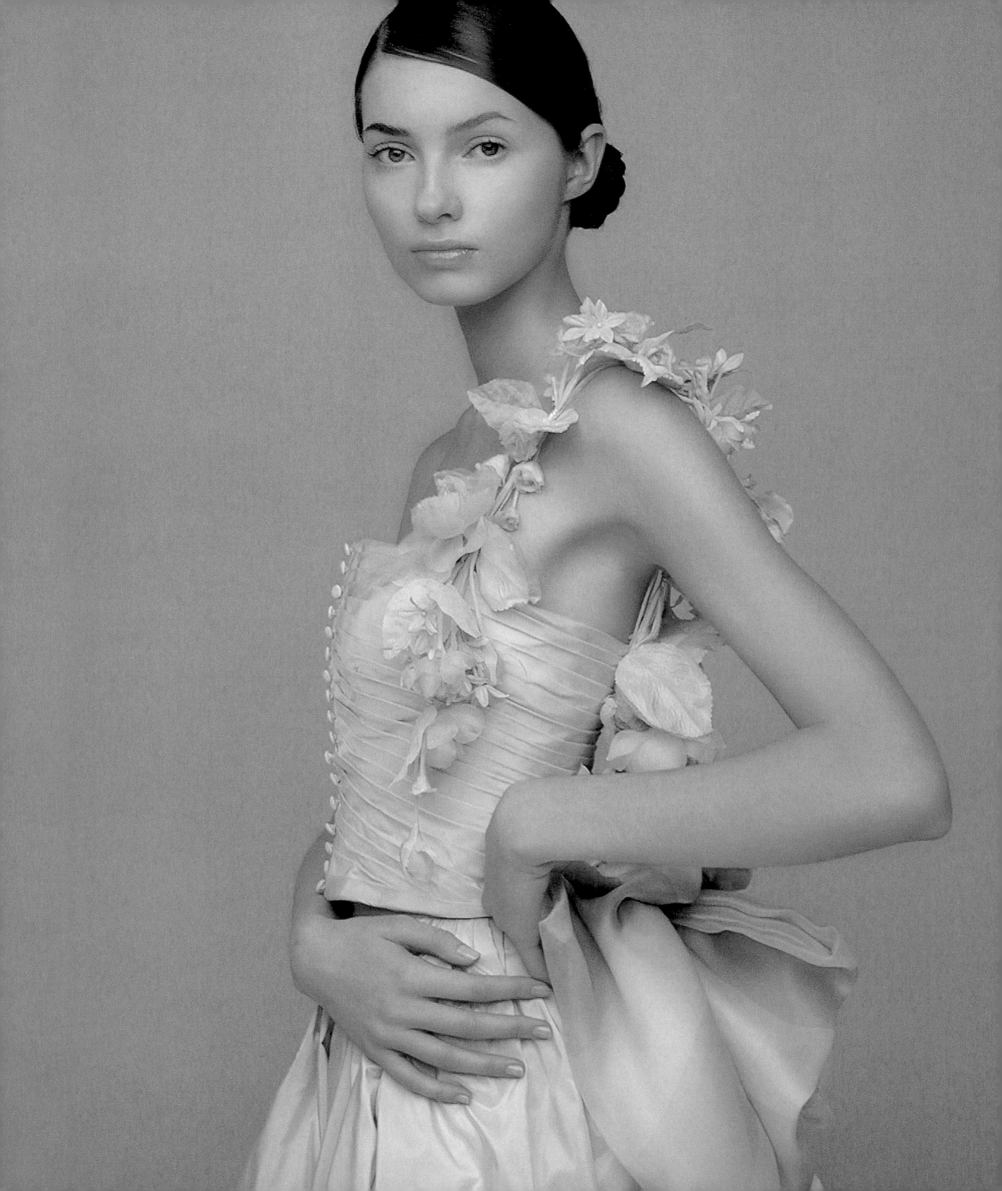

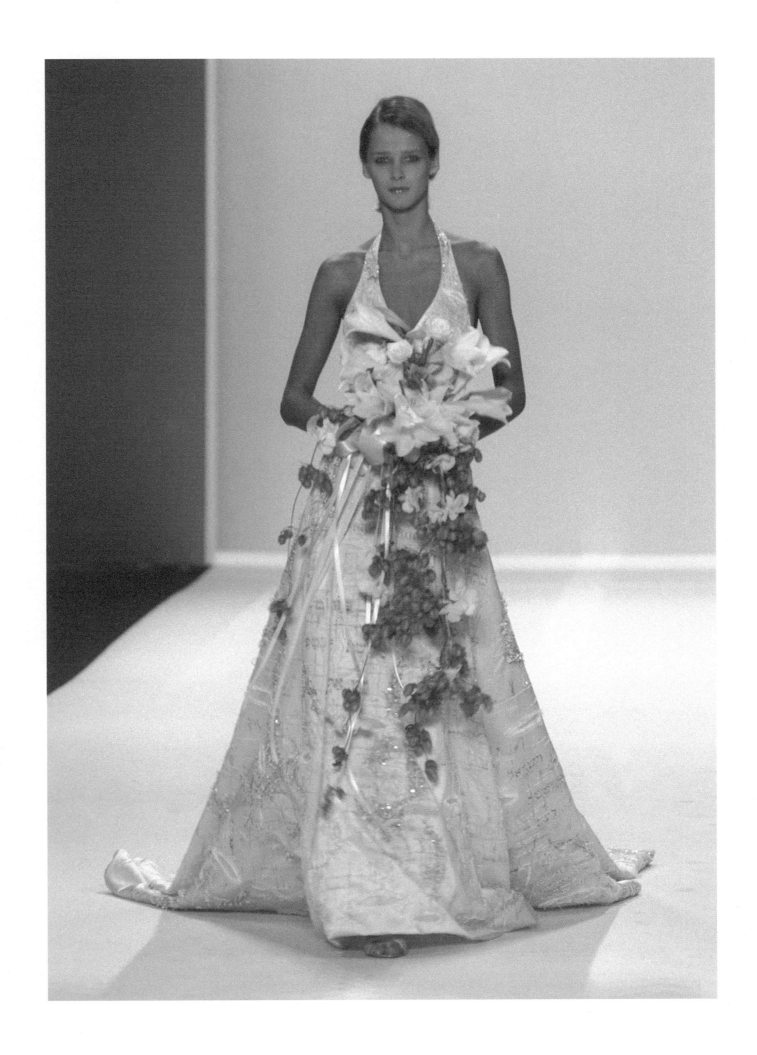

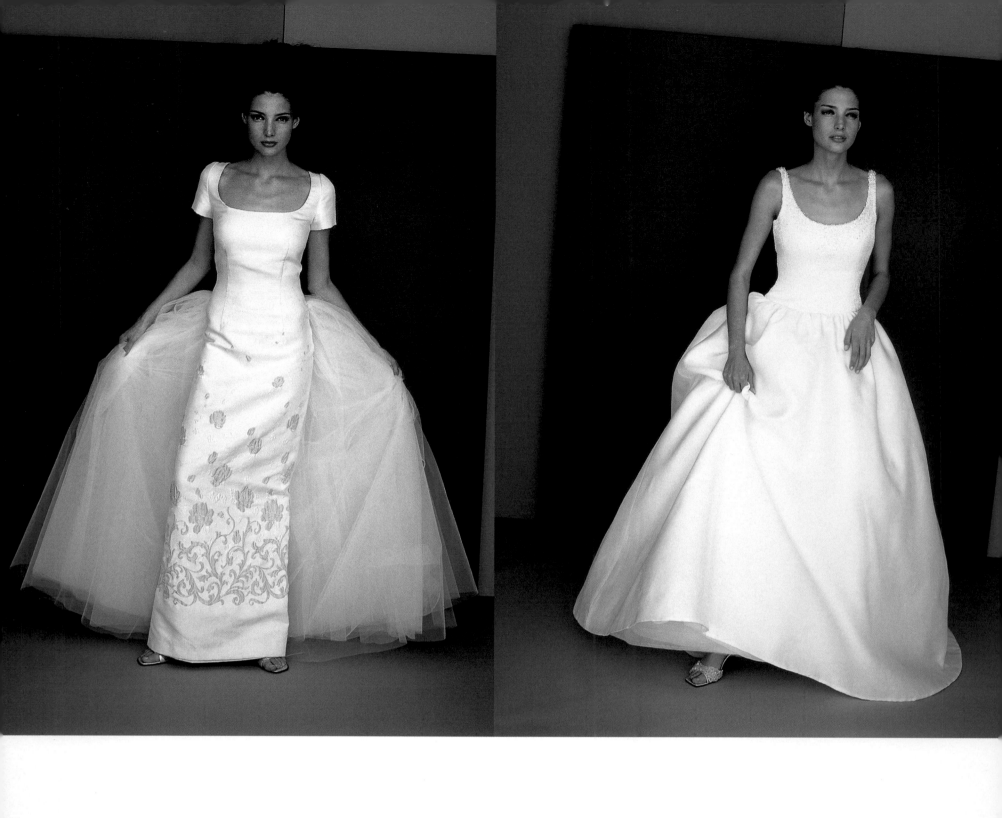

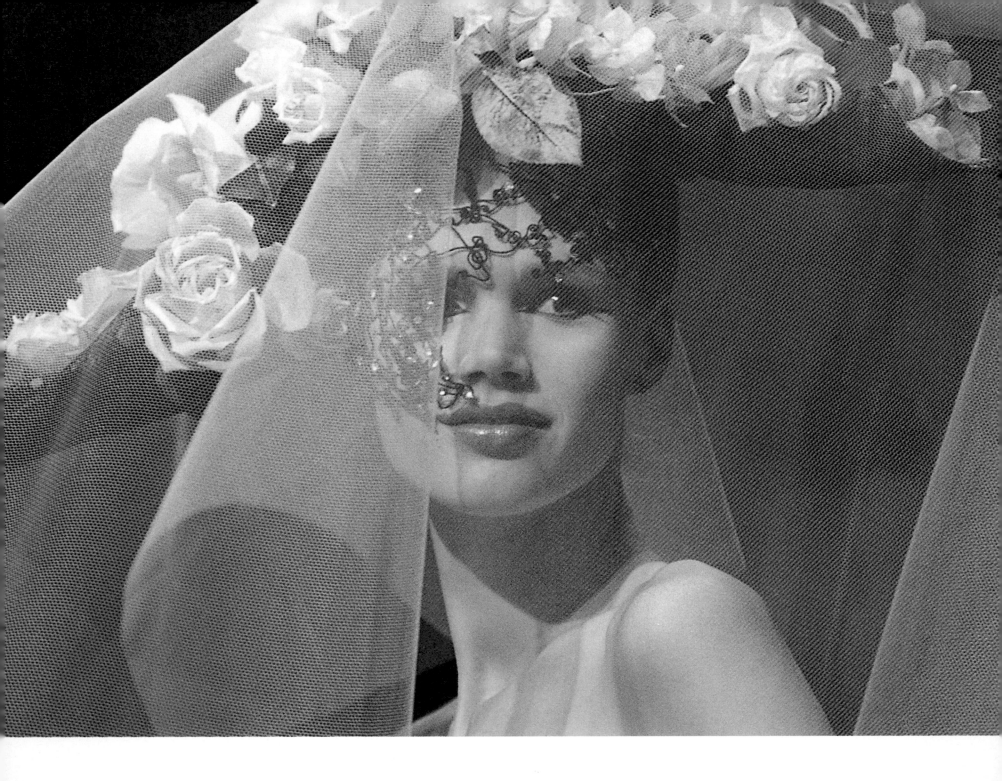

PREVIOUS PAGE... (Left) A two-piece in pale blue taffeta with a draped and garlanded bodice, the skirt with a huge bow at back by Mariage. (Right) A simple halter-neck, full-skirted gown with a large trailing bouquet, by Christina Perrin.

OPPOSITE... Two designs by Lorenzo Riva: a scoop-necked sheath dress with attached tulle train, and a sleeveless circular-skirted gown of unbridled simplicity in pure white.

ABOVE... A fanciful rose-covered headpiece by couturier Christian Lacroix for spring 1997, with an attachment of black beaded veiling. Despite the appeal of such creations, the conventional white veil remains the most popular bride's choice.

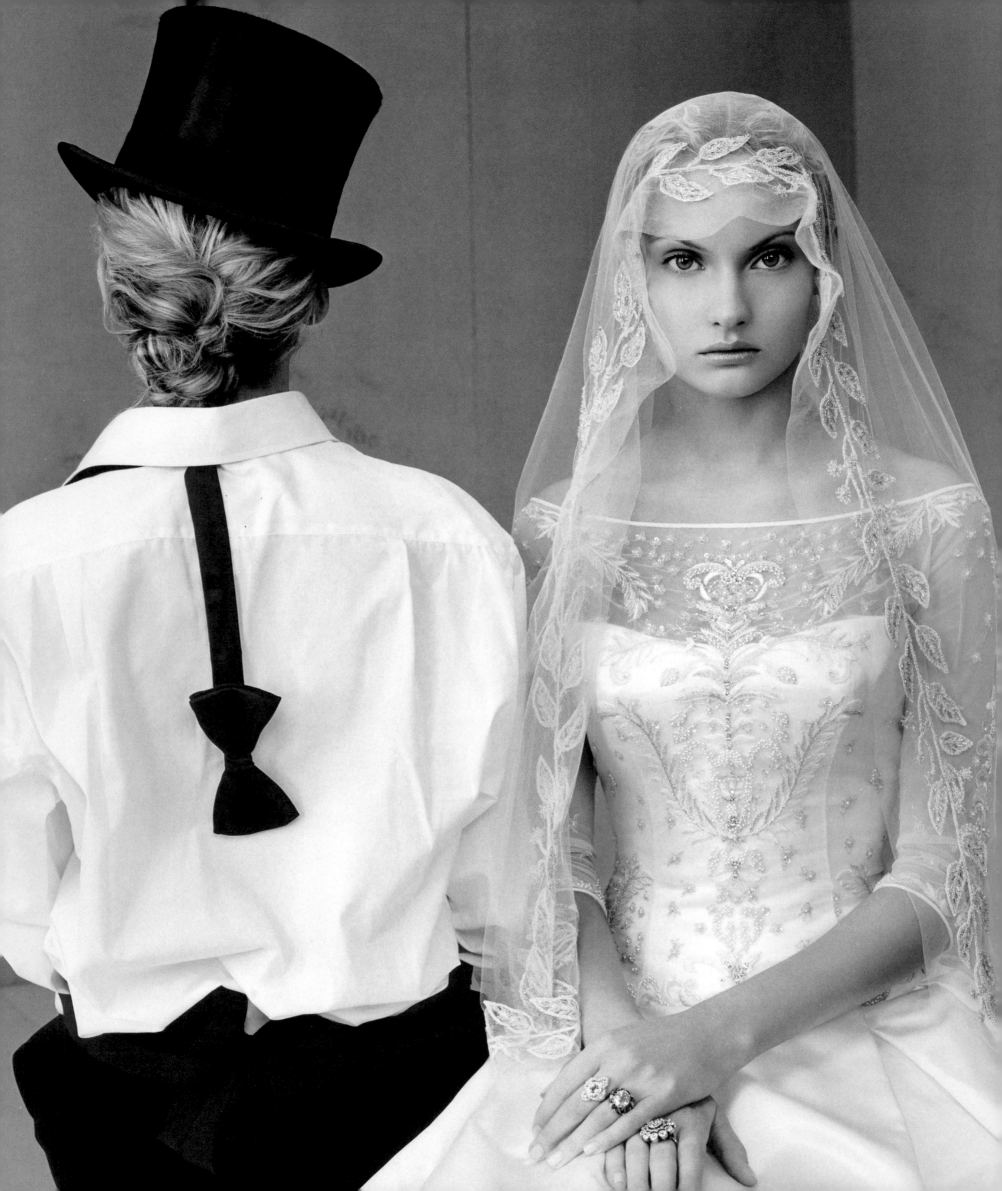

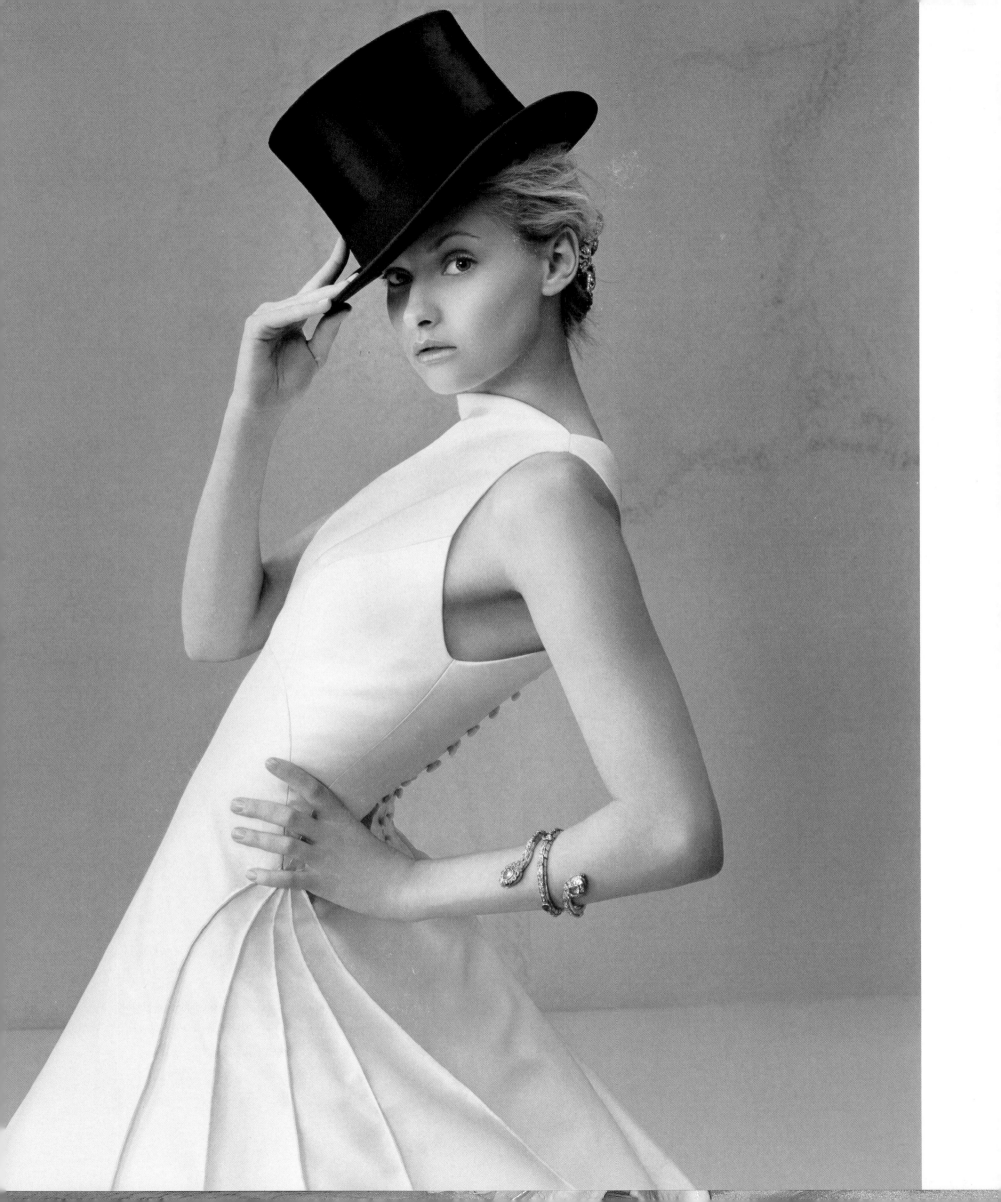

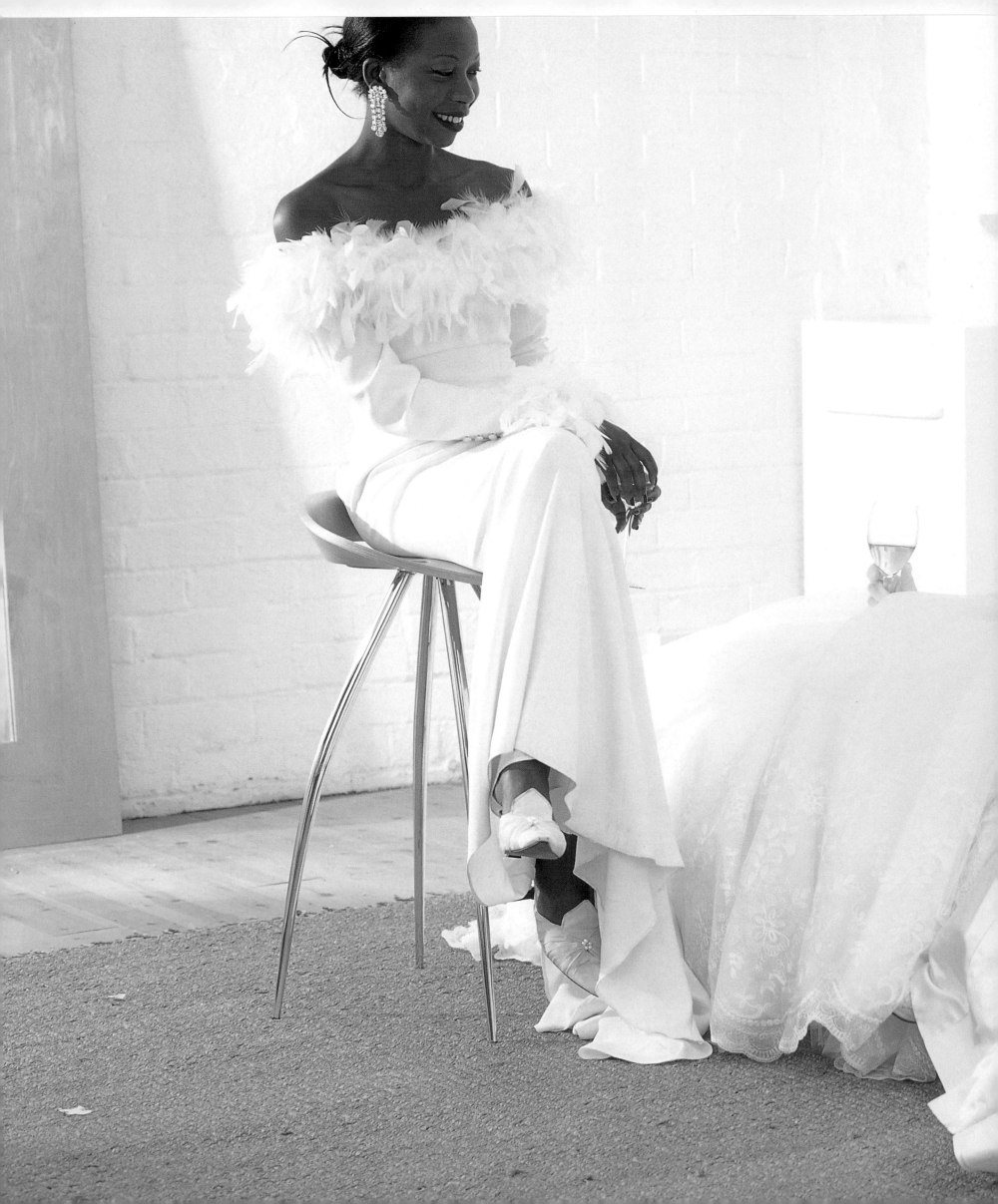

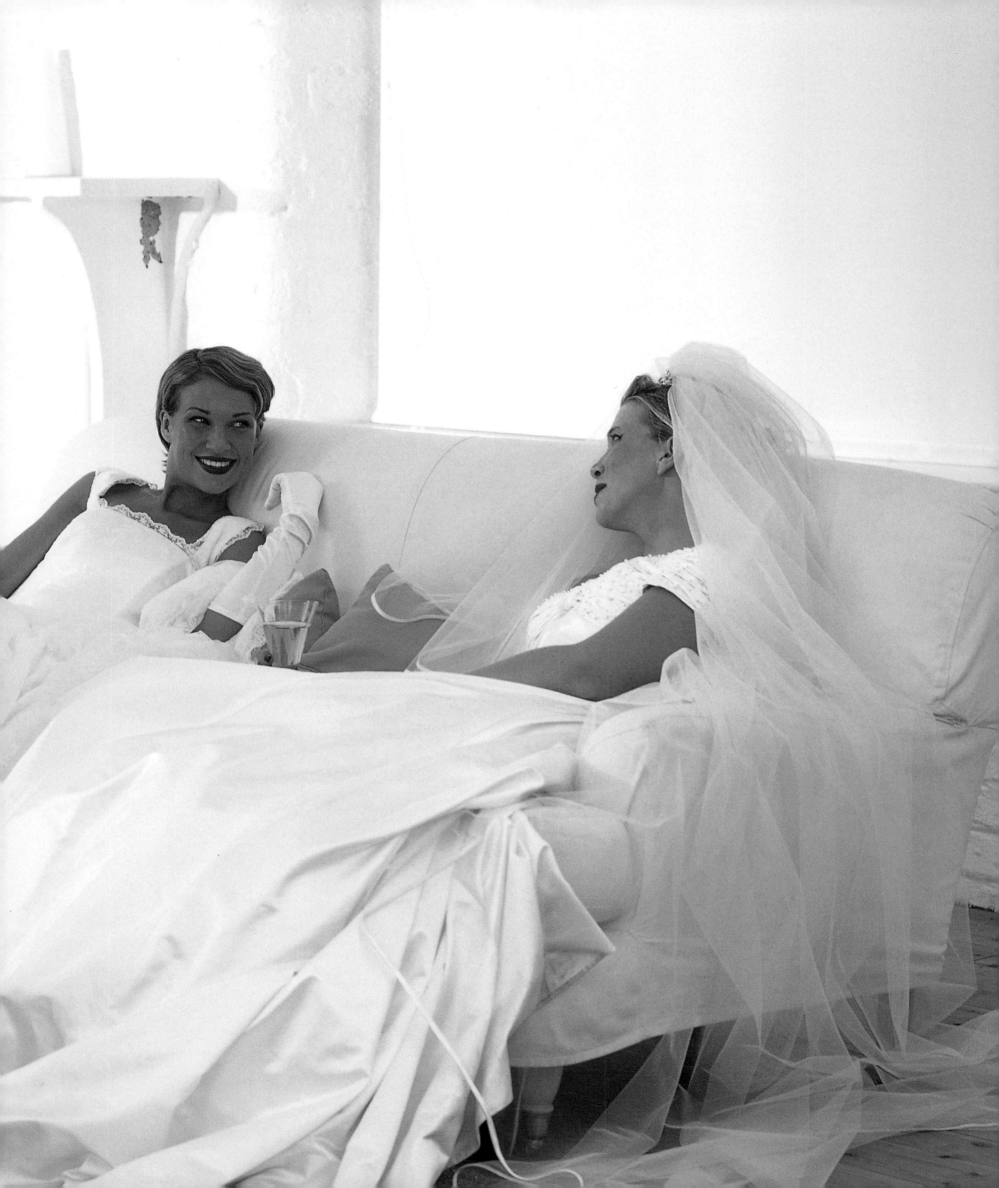

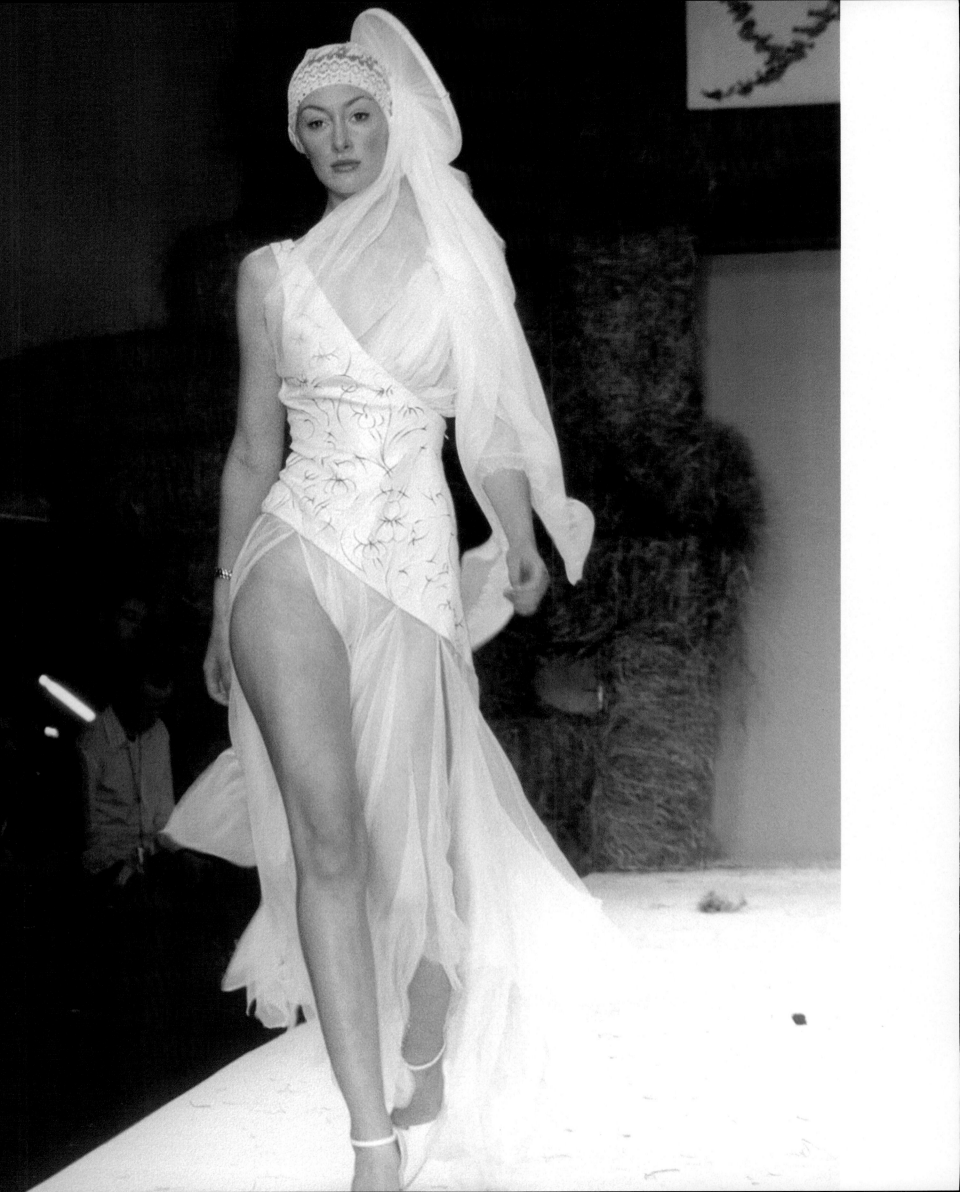

PREVIOUS PAGE... A bridal trio in quite different styles by Beverley Summers, showing the choices available to the modern-day bride. Note the marabou trimming of the off-the-shoulder 1930s style on the left, in comparison with the more traditional meringue shape on the right.

OPPOSITE... A revealing gown by Arkadius for the confident, toned woman of the twenty-first century, more runway fantasy than reality, with its asymmetrical tunic top and thigh-high split chiffon skirt.

RIGHT... A retro look by Italian firm Le Spose di Gió that harks back to the severe shapes of the 1950s, and brings to mind Audrey Hepburn.

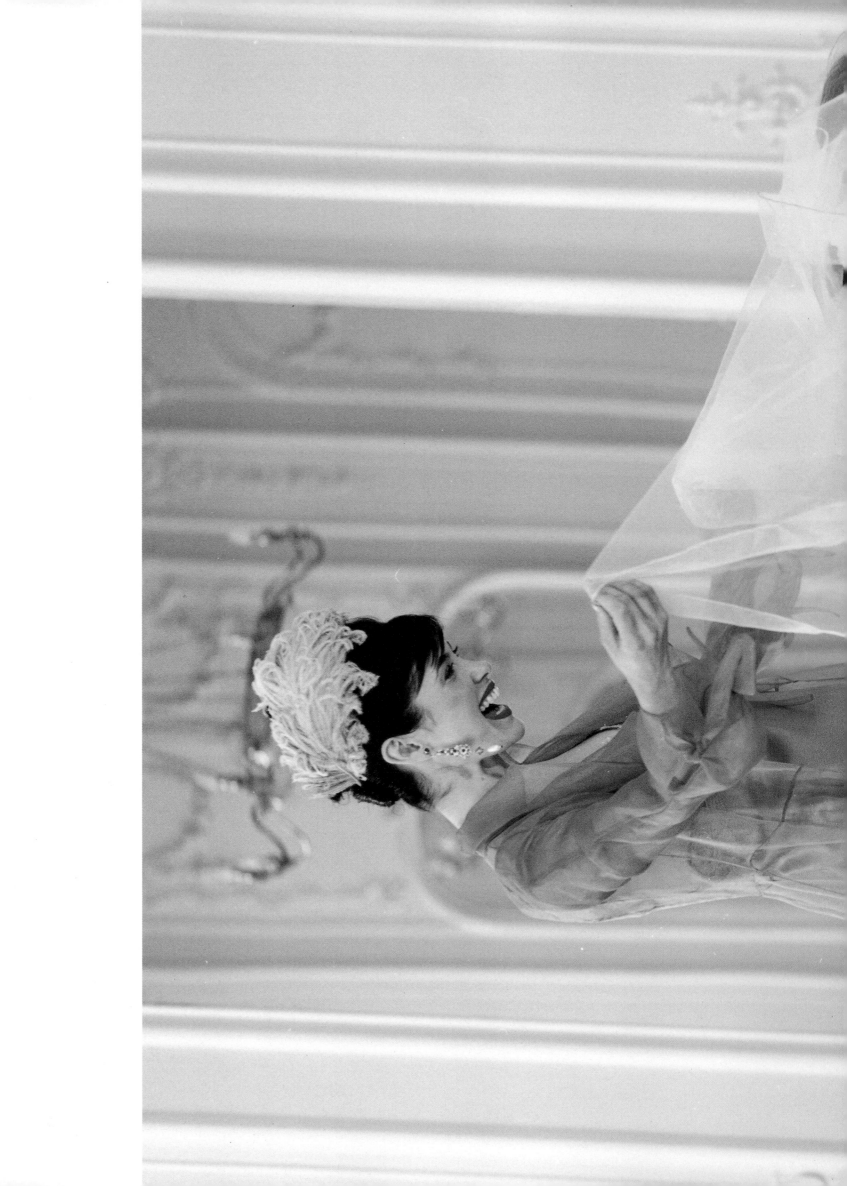

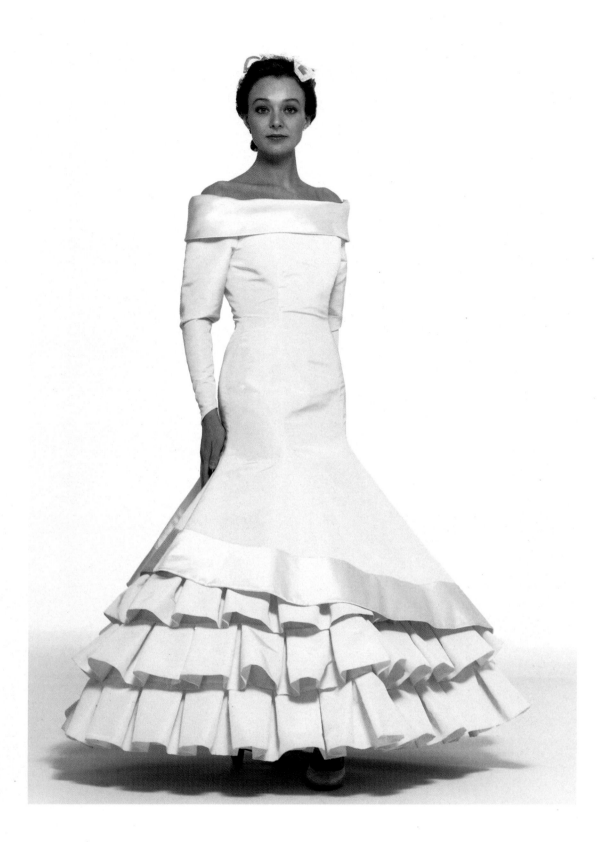

PREVIOUS PAGE... Photographed for *Wedding Day* magazine in 2001 by Costantino, this lavender dress has a skirt
caught up to reveal a richly embellished underskirt – a favored feature of the nineteenth century and 1950s.

ABOVE... Ritva Westenius's design of 1985 is of Spanish flamenco origin, with a deep off-the-shoulder cuff, understated
leg-of-mutton sleeves, and ruffled multi-layered underskirt.

OPPOSITE... From Arkadius's Queen of Sheba collection, a consummately cut and embroidered sleeveless bodice with
fluid tiered chiffon skirt, which takes on an architectural look in this image.

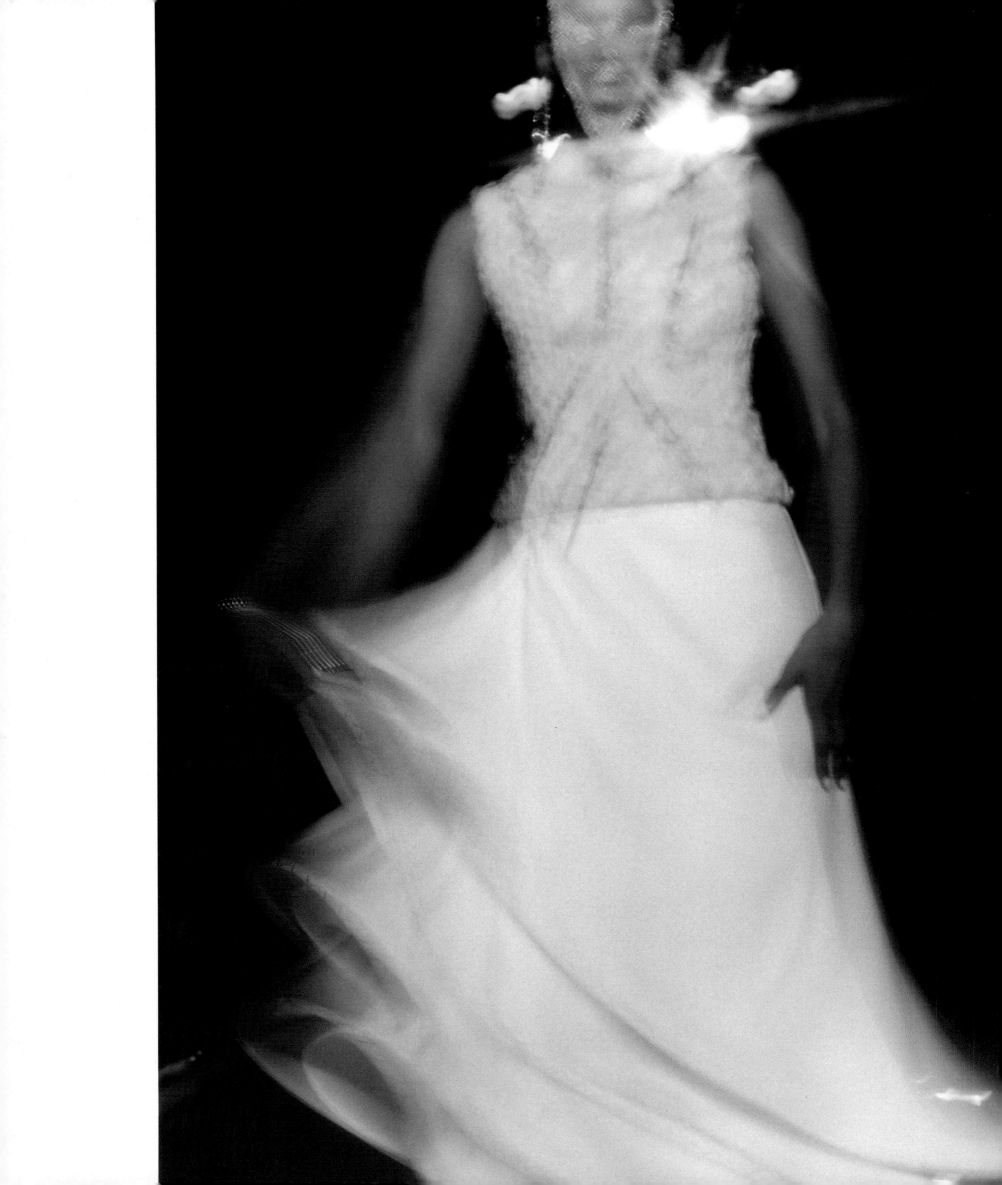

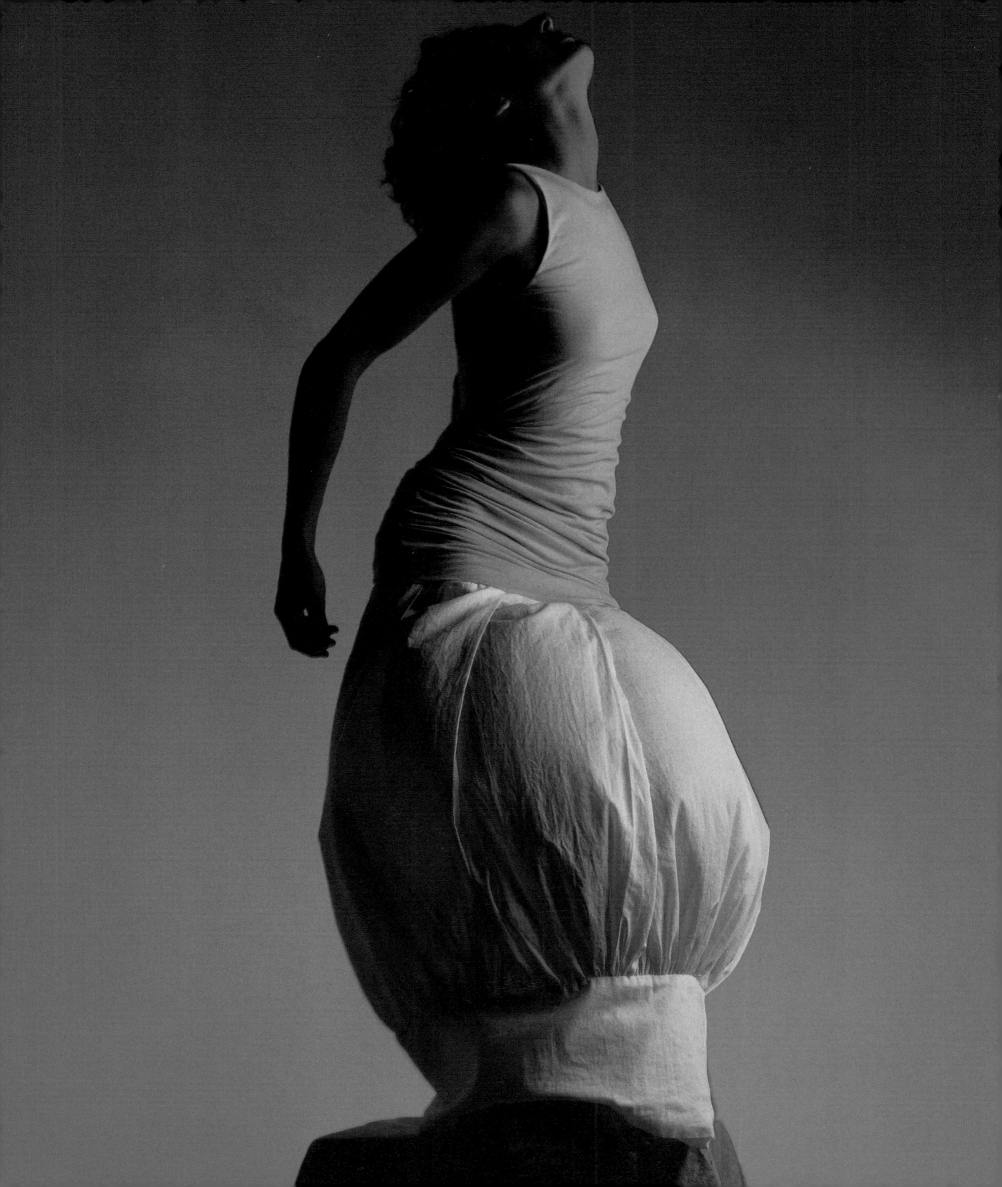

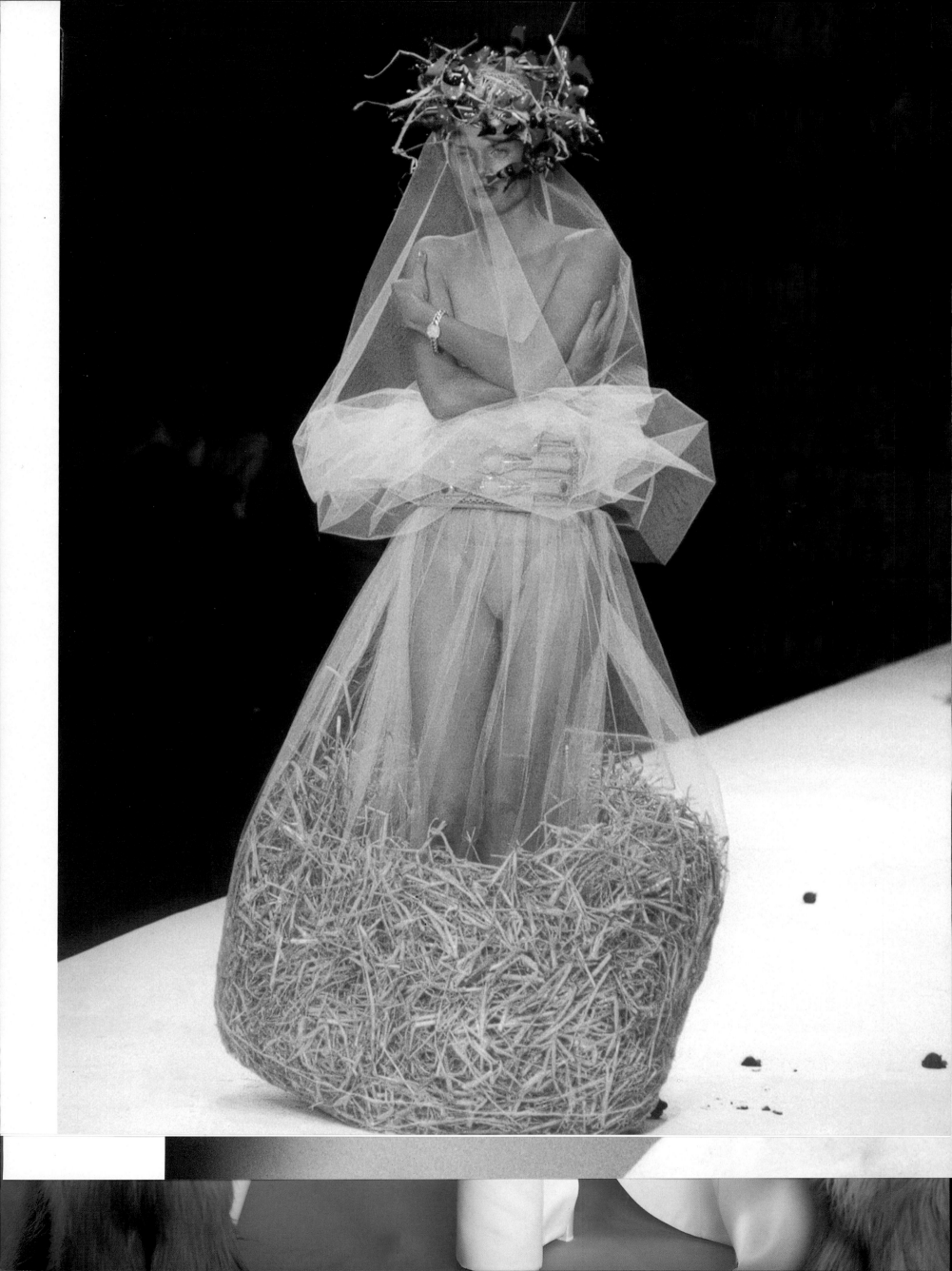

PREVIOUS PAGE... From the Sincerity collection
by Sweetheart of 2001, the intense blue of the
background enhances the icy white of the
garments. On the left the groom appears in a
sharply creased suit, and the bride in a strapless
fitted sheath with integral train. The dress on
the far right has a narrow skirt with a strappy
pointed bodice. The attached, front-opening full-
length skirt reveals the slim lines beneath.

RIGHT... Unusual design features make these
bridal gowns by Cocoe Voci truly stunning.
(Left) A strapless gown with trompe l'oeil,
three-dimensional flowers on the integral train.
(Right) A strappy bodice with crinoline skirt has a
fine overlay of tulle plus trailing flower embroidery.

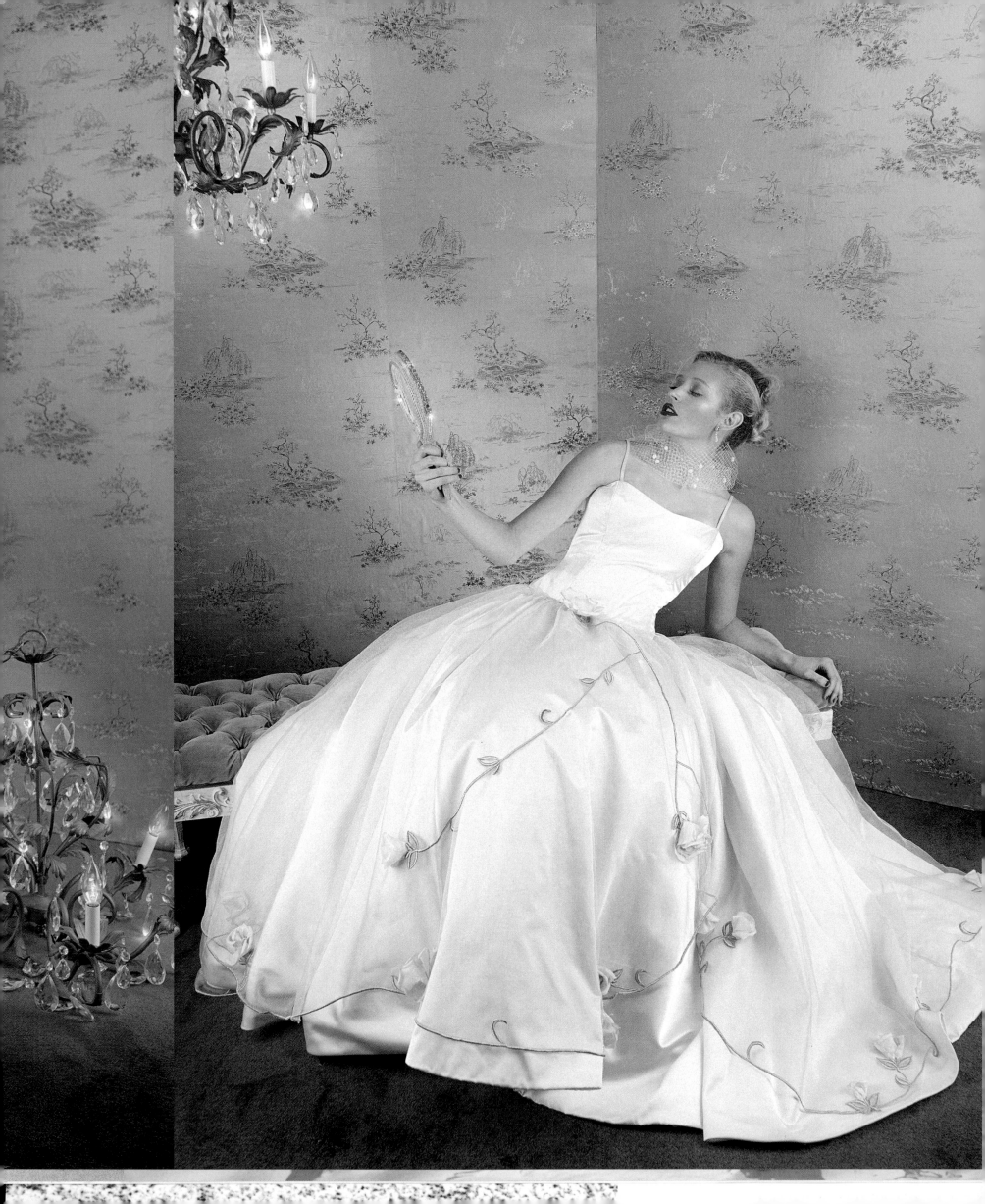

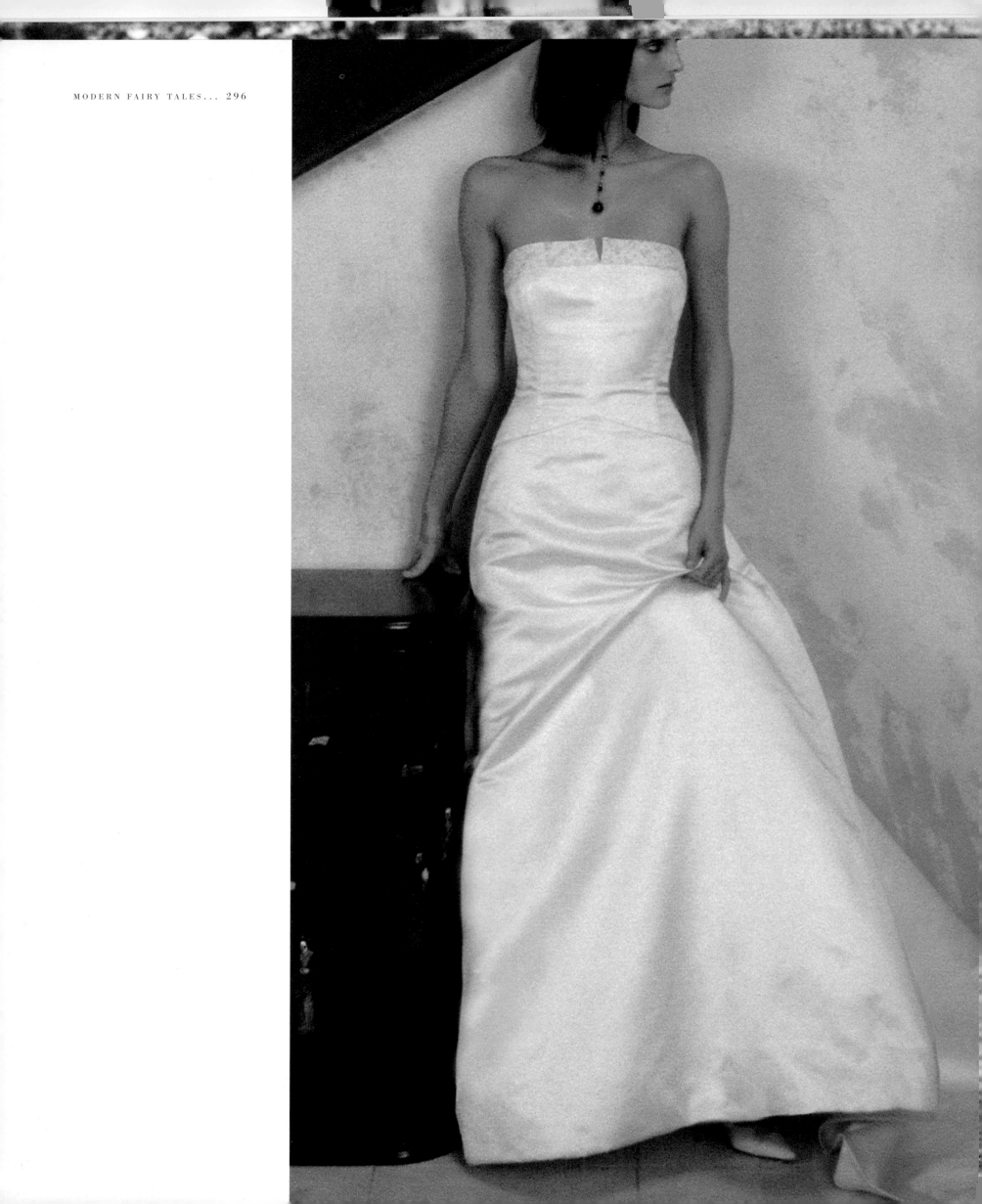

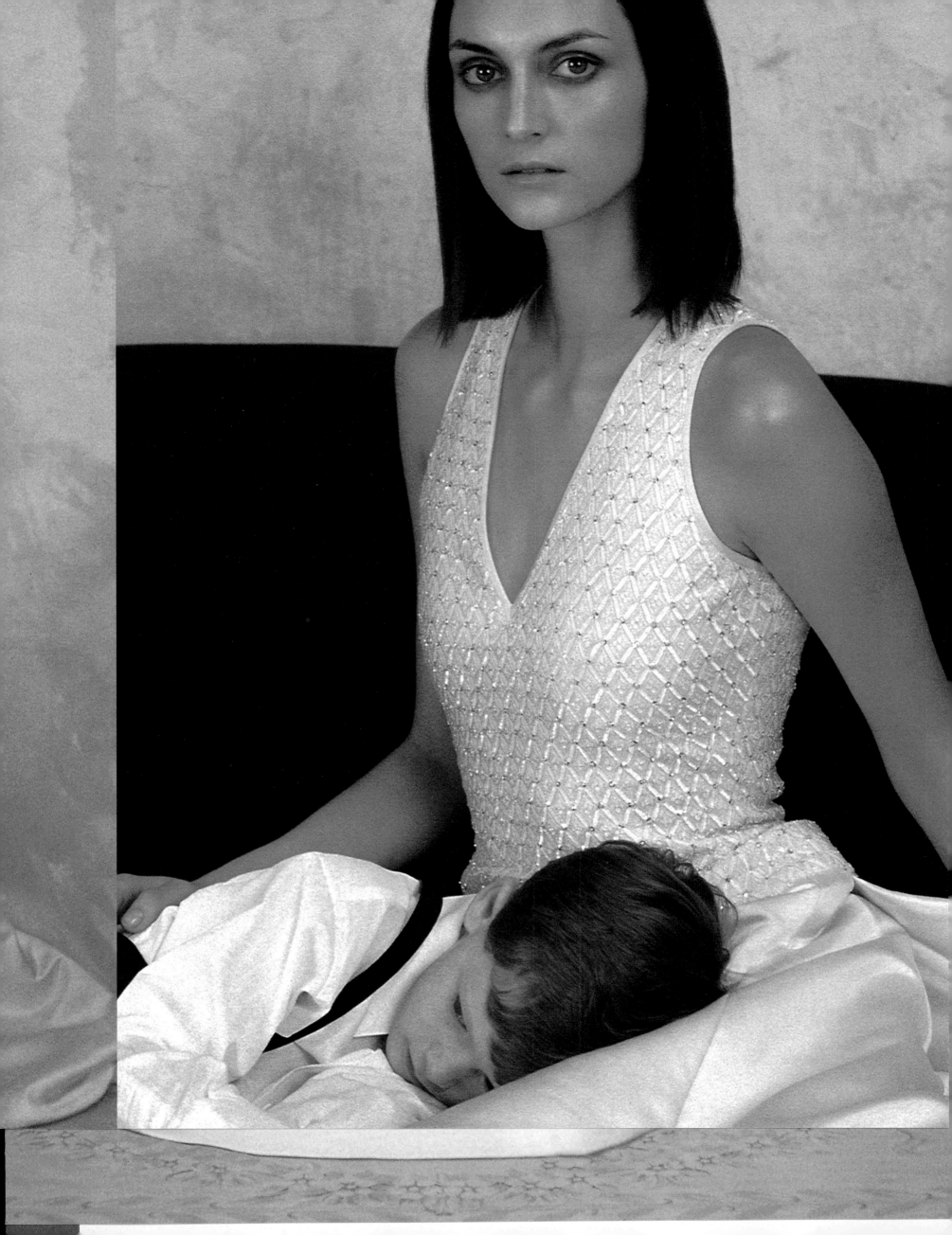

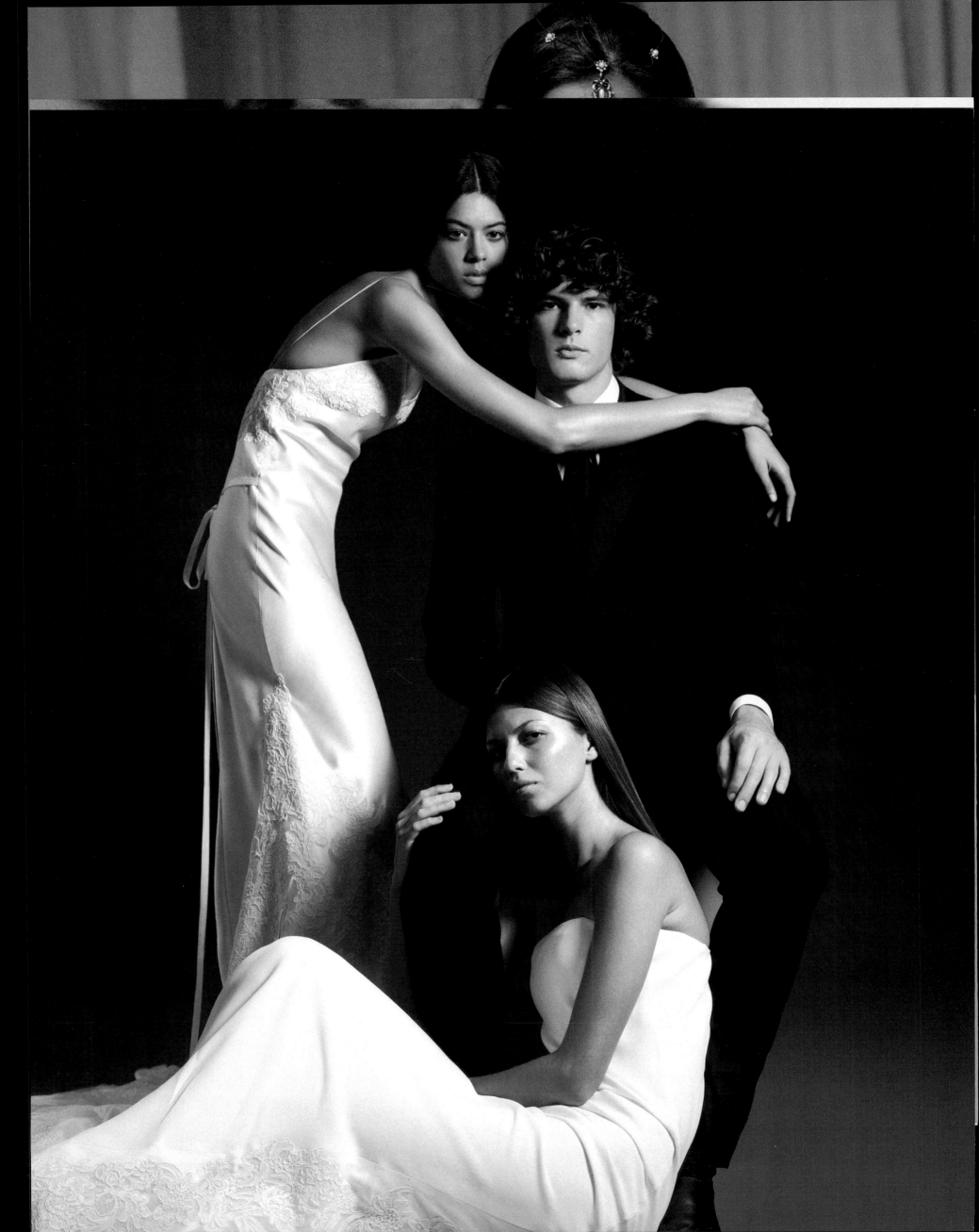

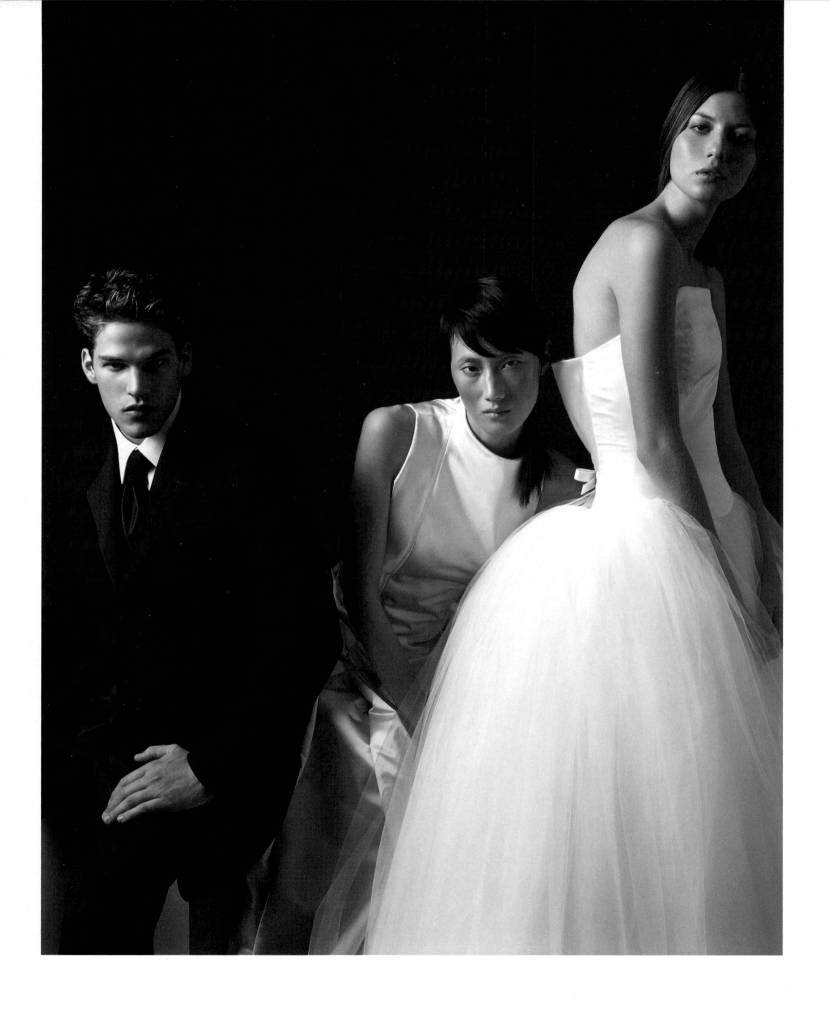

OPPOSITE & ABOVE... Wedding designs by Vera Wang showing her uncompromising approach to formal gowns – their taut silhouettes and contoured seams reveal (yet conceal) the body.

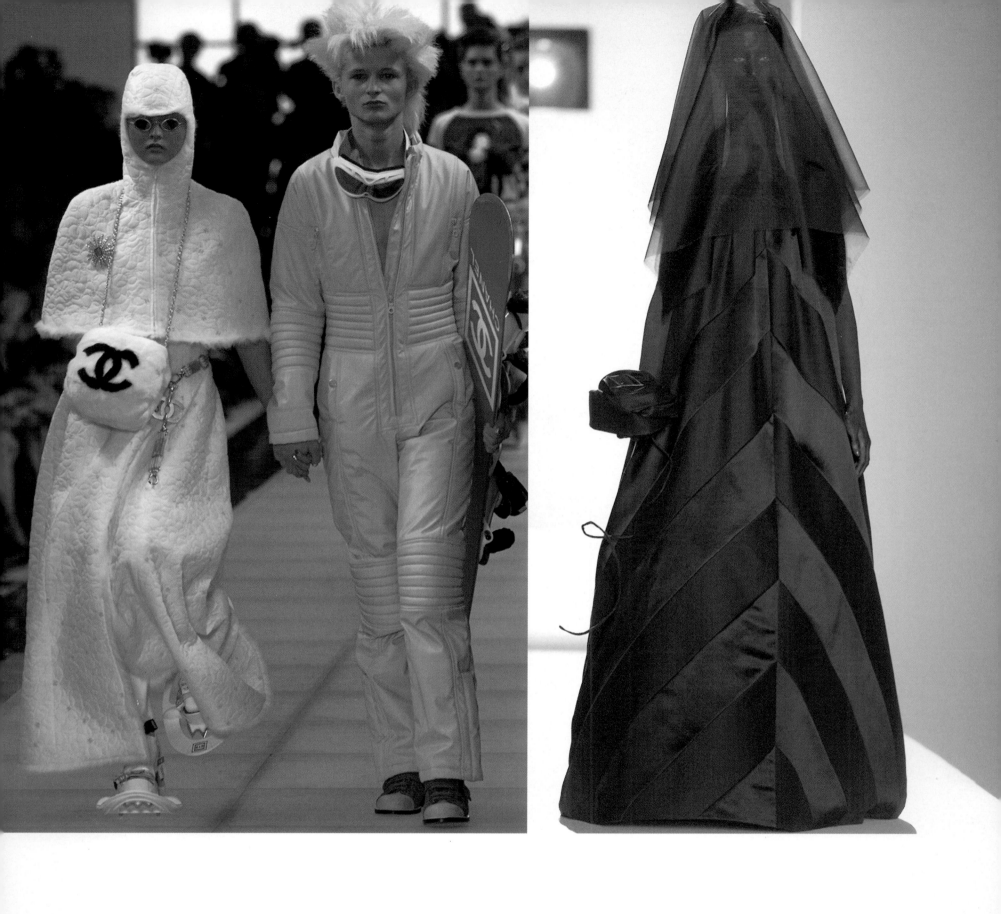

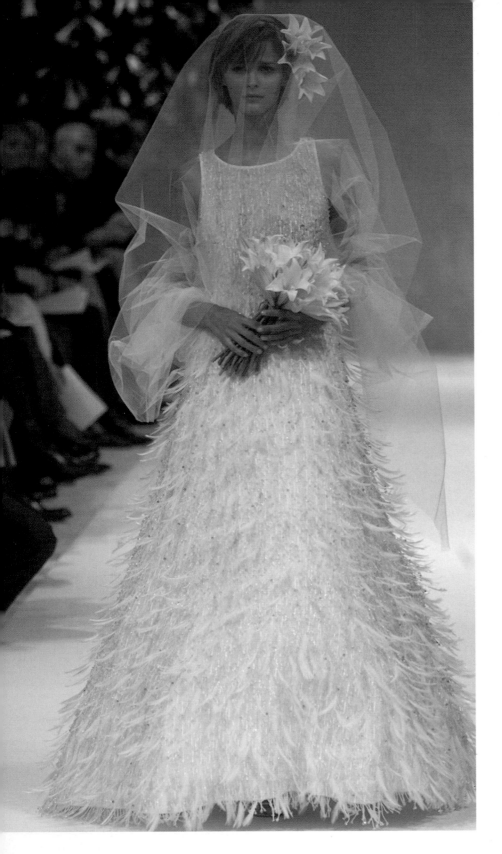

PREVIOUS PAGE... Photographer Giuseppe Bertolucci captures a bride with bowler hat in front of a bank of television screens, which contrasts with a joky shot of a bride being pushed around in a shopping cart by the groom.

LEFT... The face of avant-garde wedding fashion. (Left) A futuristic wedding couple by the House of Chanel for 2001, the bride in an A-line gown with Victorian muff incorporating the double 'C' Chanel logo, and the groom with bleached punk hair and the accoutrements of snowboarding. (Center). A bride in black by Viktor & Rolf evokes Victorian mourning wear, the diagonally patterned material providing the point of focal interest. (Right) A Pierre Balmain couture gown with voluminous tulle sleeves and beaded, fringed A-line skirt.

Picture credits

Introduction

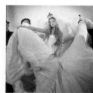

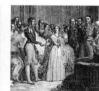

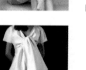

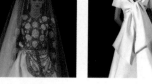

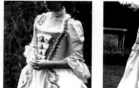
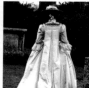

PAGE 6-7
Giuseppe Bertolucci
© Giuseppe Bertolucci
Foto Cortopassi

PAGE 8
102 Dalmatians
© Andres Aquino
Fashion Syndicate Press

PAGE 8
102 Dalmatians
© Andres Aquino
Fashion Syndicate Press

PAGE 11
Catherine Davighi
© Catherine Davighi

PAGE 12-13
Christian Dior by
John Galliano
© Christian Dior
by Rindoff
Garcia Angeli (model)

PAGE 15
Kirsty Hume
© Camera Press
by Wattie Cheung

PAGE 15
Kirsty Hume
© Camera Press
by Wattie Cheung

PAGE 16-17
© Popperfoto

PAGE 17
© Popperfoto

PAGE 18
Basia Zarzycka
© Basia Zarzycka
by Massimo Masino

PAGE 21
Christian Lacroix
© 2001 Style.com
All rights reserved.
Reprinted with permission.

PAGE 21
Peter Langner
© Peter Langner

PAGE 22
Ninya Mikhaila for
Kiss the Frog
© Kiss the Frog
by Mikhaila

PAGE 22
Ninya Mikhaila for
Kiss the Frog
© Kiss the Frog
by Mikhaila

Edwardian extravagance

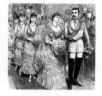

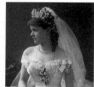
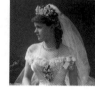
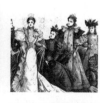

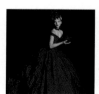

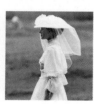

PAGE 24-25
© Giuseppe Bertolucci
Foto Cortopassi

PAGE 26
© Condé Nast

PAGE 28
© The Illustrated London
News Picture Library

PAGE 29
© The Illustrated London
News Picture Library

PAGE 30
© Corbis

PAGE 32-33
© Lace and Costume
Museum, Brussels

PAGE 35
© Camera Press
by ILN

PAGE 36
Lorraine Weselby
© Lorraine Weselby

PAGE 39
Ian Stuart
© Whole Resources
(Ian Stuart International)

PAGE 40
Silvia Tcherassi
© Andres Aquino
Fashion Syndicate Press

PAGE 44
Cocoe Voci
© Cocoe Voci

PAGE 45
Tomasz Starzewski
© Tomasz Starzewski

PAGE 46
© Condé Nast

PAGE 46
© Condé Nast

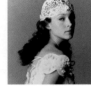

PAGE 47
© Giuseppe Bertolucci
Foto Cortopassi

PAGE 48
Lucia Zanotti
© Atelier Aimée
by Aldo Fallai

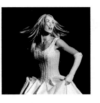

PAGE 57
Ian Stuart
© Whole Resources
(Ian Stuart International)

PAGE 58
Chantal Mallett
© Chantal Mallett

PAGE 49
Lucia Zanotti
© Atelier Aimée
by Aldo Fallai

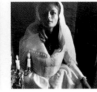

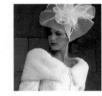

PAGE 50
Chanel
© Frédérique Dumoulin
Devon @ City, Paris (model)

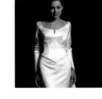

PAGE 59
Ritva Westenius
© Ritva Westenius
Couture

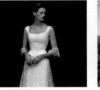

PAGE 60
Jesus Peiro
© Jesus Peiro

PAGE 50
Donna Salado
© Donna Salado
by Steve Haddocks

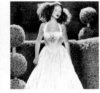

PAGE 51
© Condé Nast

PAGE 61
Jesus Peiro
© Jesus Peiro
by Outomuro

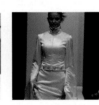

PAGE 62
Allison Blake
© Allison Blake

PAGE 51
Coleman Douglas Pearls
© Christianne Douglas
by Michelle Jorsling
Natasha Douglas (model)

PAGE 52
Cocoe Voci
© Cocoe Voci

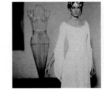

PAGE 63
Maggie Sottero
© Maggie Sottero Brical
The Bridal Co. Ltd.

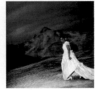

PAGE 64
Ani Alvarez Caldéron
© Andres Aquino
Fashion Syndicate Press

PAGE 53
Lorenzo Riva
© Courtesy Vogue Sposa
by Avi Meroz

PAGE 54
Reem Acra
© Ruven Afanador

PAGE 65
Jesus Peiro
© Jesus Peiro
by Artur Lleio

© Giuseppe Bertolucci
Foto Cortopassi

PAGE 66-67

PAGE 54
Vivienne Westwood
© Nick Towers

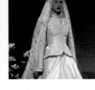

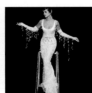

PAGE 55
Luisa Beccaria
© Luisa Beccaria

PAGE 55
Luisa Beccaria
© Luisa Beccaria

PAGE 56
Ian Stuart
© Whole Resources
(Ian Stuart International)

Flapper style

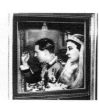

PAGE 68-69
© Giuseppe Bertolucci
Foto Cortopassi

PAGE 70
© Popperfoto

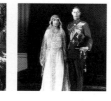

PAGE 73
© Popperfoto

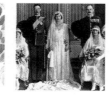

PAGE 73
© Popperfoto

PAGE 74
© Condé Nast

PAGE 77
© The Illustrated London
News Picture Library

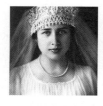

PAGE 78
© Corbis

PAGE 81
© Hulton-Deutsch
Collection/Corbis

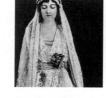

PAGE 81
© The Illustrated London
News Picture Library

PAGE 82
© Popperfoto

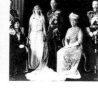

PAGE 83
© Popperfoto

PAGE 83
© Popperfoto

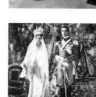

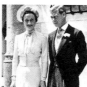

PAGE 84
© Popperfoto

PAGE 84
© Popperfoto

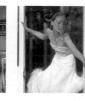

PAGE 85
© Popperfoto

PAGE 87
Arkadius
© Arkadius
by Carlos Graça

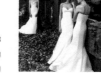

PAGE 88
Vera Wang
© Vera Wang

PAGE 89
Vera Wang
© Vera Wang

PAGE 90
Jean Paul Gaultier
© 2001.Style.com
All rights reserved
reprinted with permission

PAGE 91
Giorgio Armani
© Giorgio Armani
by Paolo Roversi

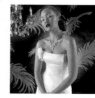

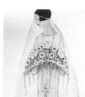

PAGE 92
Cocoe Voci
© Cocoe Voci

PAGE 93
© Condé Nast

PAGE 94-95
Luisa Beccaria
© Luisa Beccaria
by Manuela Pavesi

PAGE 96
Eternity Bride by Jim Hjelm
© JLM Europe Ltd.

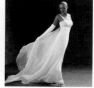

PAGE 97
Sharon Cunningham
© Sharon Cunnigham
Couture

PAGE 98
© Condé Nast

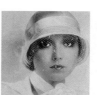

PAGE 99
© Condé Nast

PAGE 100
Stephanie Allin
© One and Only
by Ian Boddy
Camilla Ridd (model)

Forties restraint, fifties froth

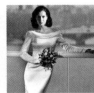

PAGE 100
Caroline Holmes
© Jean-Paul Froget

PAGE 101
Caroline Holmes
© Jean-Paul Froget

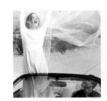

PAGE 102-103
Giorgio Armani
© Giorgio Armani
by Ellen von Unwerth

PAGE 104-105
Vera Wang
© Vera Wang
by Cleo Sullivan
Dawning Han @
Ford NY (model)

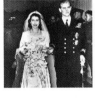

PAGE 106
Ian Stuart
© Whole Resources
(Ian Stuart International)

PAGE 107
© Giuseppe Bertolucci
Foto Cortopassi

PAGE 108-109
© Giuseppe Bertolucci
Foto Cortopassi

PAGE 110
Peter Langner
© Peter Langner

PAGE 111
Sharon Cunningham
© Sharon Cunningham
Couture

PAGE 112
Versace
© Camera Press
by B. Coster

PAGE 113
Versace
© Camera Press
by B. Coster

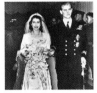

PAGE 114-115
© Giuseppe Bertolucci
Foto Cortopassi

PAGE 116
© Hulton Archive

PAGE 119
© Hulton Archive
by Fred Ramage

PAGE 120
© The Illustrated London
News Picture Library

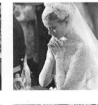
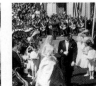

PAGE 123
© Popperfoto

PAGE 124
© Popperfoto

PAGE 127
© The Ronald Grant
Archive

PAGE 128
© Camera Press
by Rizzoli

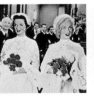
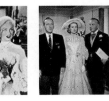

PAGE 129
© Camera Press
by Rizzoli

PAGE 130
© Bettmann/Corbis

PAGE 133
© Popperfoto

PAGE 133
© Popperfoto

PAGE 134
© MPTV.net

PAGE 134
© The Ronald Grant Archive

Forties restraint, fifties froth (continued)

PAGE 136
© Camera Press
by D/D

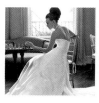

PAGE 137
© Camera Press
by C.Beaton

PAGE 151
Carolina Herrera
© Ruven Afanador

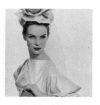

PAGE 152
© Condé Nast

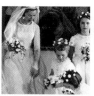

PAGE 138
Vera Wang
© Vera Wang
Dawning @ Ford NY

PAGE 139
Debenhams
© Debenhams

PAGE 153
Irresistible Headdresses
© Irresistible Headdresses
by David Thom-Wimbledon

PAGE 154-155
© Giuseppe Bertolucci
Foto Cortopassi

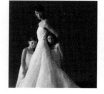

PAGE 140
Thierry Mugler
© Thierry Mugler

PAGE 141
© Camera Press
by SUS

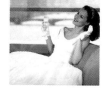

PAGE 156
Caroline Holmes
© Jean-Paul Froget

PAGE 156
© Condé Nast

PAGE 142
Sharon Cunningham
© Sharon Cunningham
Couture by Barry McCall
Alison Canavan (model)

PAGE 143
Ian Stuart
© Whole Resources
(Ian Stuart International)

PAGE 157
Emanuel Ungaro
© 2001.Style.com
All rights reserved,
reprinted with permission

PAGE 158
© Condé Nast

PAGE 144
Caroline Holmes
© Jean Paul Froget

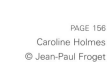

PAGE 145
© Hulton-Deutsch
Collection/Corbis

PAGE 159
© Condé Nast

PAGE 160
Sarmis
© Design Portfolio
by Mike Owen

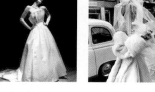

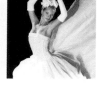

PAGE 146-147
Cocoe Voci
© Cocoe Voci

PAGE 148
Peter Langner
© Peter Langner

PAGE 161
Sarmis
© Design Portfolio
By Mike Owen

PAGE 162
Eternity Bride
© JLM Europe Ltd.

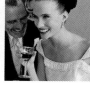

PAGE 149
Peter Langner
© Peter Langner

PAGE 150
Carolina Herrera
© Ruven Afanador

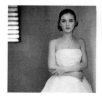

PAGE 163
Augusta Jones
© Cogrut Hong Ltd.

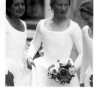

PAGE 164
© Camera Press
by M.Stewart

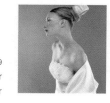

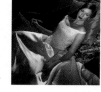
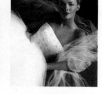

PAGE 164
© Camera Press
by M.Stewart

PAGE 165
Louis Di Carlo
© Andres Aquino
Fashion Syndicate Press

PAGE 179
Beverly Lister
© Graham Carlow

PAGE 180
Sarmis
© Design Portfolio
by Mike Owen

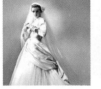

PAGE 167
Christian Dior
© Christian Dior

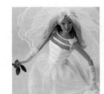

PAGE 166
Vogue 1958
© Norman Parkinson

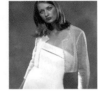

PAGE 181
Sarmis
© Design Portfolio
by Mike Owen

PAGE 182
Alan Hannah
© Alan Hannah

PAGE 168
© 2001 Mattel Inc.
All Rights Reserved. Barbie ®
and associated trademarks are
owned by and used with
permission from Mattel

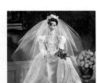

PAGE 169
© 2001 Mattel Inc.
All Rights Reserved. Barbie ®
and associated trademarks
are owned by and used with
permission from Mattel

PAGE 182
Alan Hannah
© Alan Hannah

PAGE 183
Alan Hannah
© Alan Hannah

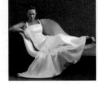

PAGE 170
Eternity Bride by Jim Hjelm
© JLM Europe Ltd.

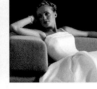

PAGE 171
Eternity Bride by Jim Hjelm
© JLM Europe Ltd.

PAGE 184
Eternity Bride by Jim Hjelm
© JLM Europe Ltd.

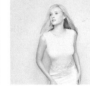

PAGE 185
Eternity Bride by Jim Hjelm
© JLM Europe Ltd.

PAGE 172
Caroline Holmes
© Jean-Paul Froget

PAGE 173
Caroline Holmes
© Jean-Paul Froget

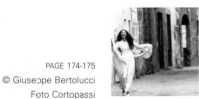

PAGE 174-175
© Giuseppe Bertolucci
Foto Cortopassi

PAGE 176
Caroline Holmes
© Jean-Paul Froget

PAGE 177
Christian Dior
© Christian Dior

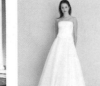

PAGE 178
Beverly Lister
© Graham Carlow

Counterculture chic

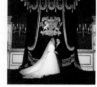

PAGE 186-187
© Giuseppe Bertolucci
Foto Cortopassi

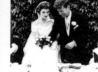

PAGE 188
© Camera Press
by Cecil Beaton

PAGE 212
© Condé Nast

PAGE 212
© Camera Press
by R.Relang

PAGE 191
© Camera Press
by B.Aris

PAGE 194
© Popperfoto

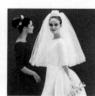
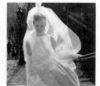

PAGE 213
© Condé Nast

PAGE 213
© Condé Nast

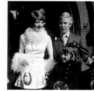

PAGE 197
© Popperfoto/Reuters
by Jim Bourg

PAGE 198 & 199
© Camera Press
by D.Nutter

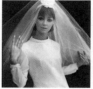

PAGE 214
© Camera Press
by Brigitte

PAGE 215
© Condé Nast

PAGE 200
© Popperfoto

PAGE 201
© Popperfoto

PAGE 216
© Condé Nast

TITLE PAGE & PAGE 217
© Lace and Costume
Museum, Brussels
by Y. Peeters for
Vive la Mariée

PAGE 202
© Popperfoto

PAGE 204
©Popperfoto

PAGE 218
© The Ronald Grant Archive

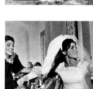

PAGE 219
Arkadius
© Arkadius
by Carlos Graça

PAGE 206-207
© Popperfoto

PAGE 208
© Popperfoto

PAGE 220
DKNY
© 2001.Style.com
All rights reserved
reprinted with permission

PAGE 221
Heather Jones
© Andres Aquino
Fashion Syndicate Press

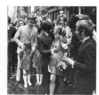

PAGE 210
© Camera Press
by The Sun

PAGE 211
© Camera Press
by T.Manley

PAGE 222
© Condé Nast

PAGE 223
Laura Ashley
© Laura Ashley Limited

Modern fairy tales

PAGE 223
Laura Ashley
© Laura Ashley Limited

PAGE 224-225
© The Condé Nast
Publications Ltd.
by Patrick Lichfield

PAGE 226
© The Condé Nast
Publications Ltd.
by Patrick Lichfield

PAGE 227
Giorgio Armani
© Giorgio Armani
by Albert Watson

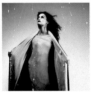

PAGE 228
© Giuseppe Bertolucci
Foto Cortopassi

PAGE 229
© Giuseppe Bertolucci
Foto Cortopassi

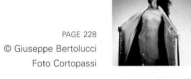

PAGE 230
© The Condé Nast
Publications Ltd.

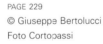

PAGE 231
© Christian Dior
Collection Haute-Cuture
Automne-Hiver 75/76

PAGE 232
Lourdes Atencio
© Andres Aquino
Fashion Syndicate Press

PAGE 233
Lorenzo Riva
© Avi Meroz
Courtesy Vogue Sposa

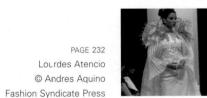

PAGE 234
Cocoe Voci
© Cocoe Voci

PAGE 235
Cocoe Voci
© Cocoe Voci

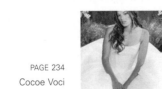

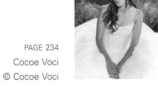

PAGE 236
Betsey Johnson
© Andres Aquino
Fashion Syndicate Press

PAGE 237
Arkadius
© Arkadius
by Carlos Graça

PAGE 238-239
© Giuseppe Bertolucci
Foto Cortopassi

PAGE 240
© Chris Lisle/Corbis

PAGE 243
Tomasz Starzewski
Courtesy Alex Montenegro

PAGE 244
Lindka Cierach
© The Sun

PAGE 246
Basia Zarzycka
© Basia Zarzycka
by Massimo Marino

PAGE 248
© Camera Press
by L. Smillie

PAGE 249
© Josh Shakerley

PAGE 251
Vivienne Westwood
© Nick Towers

PAGE 252
© Popperfoto/Reuters

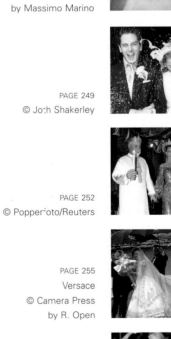

PAGE 253
Valentino
© Popperfoto/Reuters

PAGE 255
Versace
© Camera Press
by R. Open

PAGE 256
Nino & Julian Cerruti
© Cerruti

PAGE 256
Giorgio Armani
© Giorgio Armani

PAGE 259
Vera Wang
© Mills @ Astrogirl
Productions NY

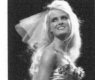

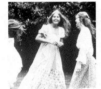

Modern fairy tales (continued)

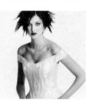
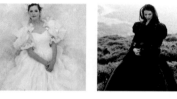

PAGE 260
Catherine Davighi
© Catherine Davighi

PAGE 261
© Condé Nast
by Stefano Massimo

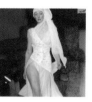
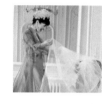

PAGE 274
Arkadius
© Arkadius
by Suresh Karadia

PAGE 275
Le Spose di Giò®
© Le Spose di Giò®

PAGE 262
© Condé Nast
by Nick Briggs

PAGE 263
Joanne Crossfield
© Joanne Crossfield
by Andrew Wilson Young

PAGE 276-277
Basia Zarzycka
© Costantino Ruspoli
Courtesy Wedding Day Magazine
Styled by Liz Savage

PAGE 278
Ritva Westenius
© Ritva Westenius

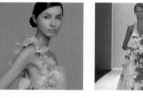

PAGE 264
Mariage Alta Moda Sposa
© Aldo Fallai
Courtesy Vogue Sposa

PAGE 265
Christina Perrin
© Andres Aquino
Fashion Syndicate Press
Carmen Kass (model)

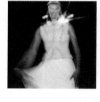

PAGE 279
Arkadius
© Arkadius
by Carlos Graça

CONTENTS & PAGE 280
© Giuseppe Bertolucci
Foto Cortopassi

PAGE 266
Lorenzo Riva
© Avi Meroz
Courtesy Vogue Sposa

PAGE 266
Lorenzo Riva
© Avi Meroz
Courtesy Vogue Sposa

PAGE 281
Arkadius
© Arkadius
by Suresh Karadia

PAGE 282
Philip Treacy
© Philip Treacy

PAGE 267
Christian Lacroix
© 2001.Style.com
All Rights Reserved
Reprinted with Permission

PAGE 268
Reem Acra
© Ruven Afanador

PAGE 283
Philip Treacy
© Philip Treacy

PAGE 284
Philip Treacy
© Philip Treacy

PAGE 269
Reem Acra
© Ruven Afanador

PAGE 270
Sharon Cunningham
© Sharon Cunningham
Couture

PAGE 285
Philip Treacy
© Philip Treacy

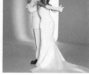

PAGE 286
Ian Stuart
© Whole Resources
(Ian Stuart International)

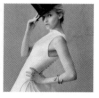

PAGE 271
Debenhams
© Debenhams

PAGE 272-273
Beverly Summers
© Beverly Summers
by Kevin Peschke

PAGE 287
Ian Stuart
© Whole Resources
(Ian Stuart International)

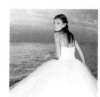
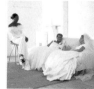

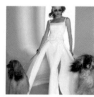
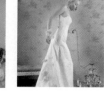

PAGE 288
Cocoe Voci
© Cocoe Voci

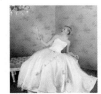

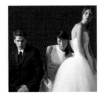
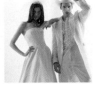

PAGE 289
Cocoe Voci
© Cocoe Voci

PAGE 290
© Giuseppe Bertolucci
Foto Cortopassi

PAGE 305
Vera Wang
© Vera Wang
Dawning @ Ford NY (model)

PAGE 306
© Iain Philpott
Courtesy *You & Your*
Wedding Magazine

PAGE 291
© Giuseppe Bertolucci
Foto Cortopassi

PAGE 292
Occasions by Jim Hjelm
© JLM Europe Ltd.

PAGE 307
© Iain Philpott
Courtesy *You & Your*
Wedding Magazine

PAGE 308
© Iain Philpott
Courtesy *You & Your*
Wedding Magazine

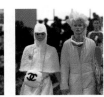

PAGE 293
Occasions by Jim Hjelm
© JLM Europe Ltd.

PAGE 294-295
Giorgio Armani
© Giorgio Armani
by Ellen von Unwerth

PAGE 309
© Iain Philpott
Courtesy *You & Your*
Wedding Magazine

PAGE 310
© Giuseppe Bertolucci
Foto Cortopassi

PAGE 296
Carolina Herrera
© Ruven Afanador

PAGE 297
Carolina Herrera
© Ruven Afanador

PAGE 311
© Giuseppe Bertolucci
Foto Cortopassi

PAGE 312
Chanel
© Shoot Digital Emiliano Grassi
Devon @ City, Paris
Przemko @ Next, Paris

PAGE 298-299
© Giuseppe Bertolucci
Foto Cortopassi

PAGE 300
Augusta Jones
© Cogrut Hong Ltd.
by Rosa Tseng

PAGE 312
Viktor & Rolf
© 2001.Style.com
All rights reserved
reprinted with permission

PAGE 313
Pierre Balmain
© 2001.Style.com
All rights reserved
reprinted with permission

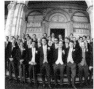
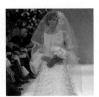

PAGE 301
Vera Wang
© Vera Wang

PAGE 302
© Giuseppe Bertolucci
Foto Cortopassi

PAGE 325-45
(picture credits)
© Joth Shakerley

PAGE 325
(contact list)
© Joth Shakerley

PAGE 303
© Giuseppe Bertolucci
Foto Cortopassi

PAGE 304
Vera Wang
© Vera Wang
Dawning @ Ford NY (model)

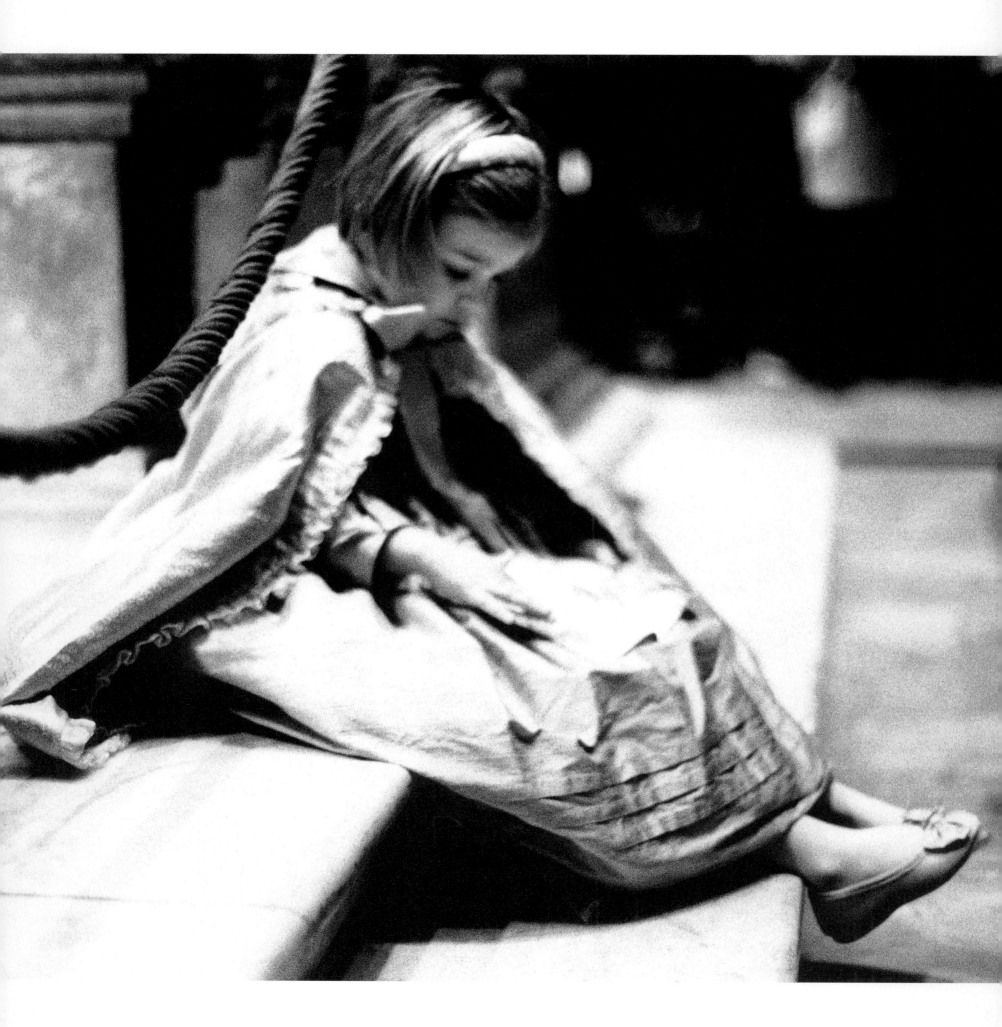

Contact list

Designers

Allison Blake Designs
116 St Mary's Road
London SE15, UK
Tel.:+44 (0)20 7732 9322

Reem Acra
245 Seventh Avenue, Suite 6B
New York, New York 10001
Tel: (212) 414 0980

Amsale
625 Madison Avenue
New York, New York 10022
Tel: 1 800 765 0170

Atelier Aimée
Via Montenapoleone 27/E
Milan, Italy
Tel:+39 02 799 300

Luisa Beccaria
Via Formentini 1
Milan 20121, Italy
Tel:+39 02 8646 0018

Manolo Blahnik (shoes)
31 West 54th Street
New York, New York
Tel: (212) 582-3007

Bolo Vasquez Boutique
237 West 35th Street, Suite#3F
New York, New York 10013
Tel: (212) 760 2450

Cerruti
789 Madison Avenue
New York, New York 10021
Tel: (212) 327 2222

Chanel
9 West 57th Street
New York, New York 10019
Tel: (212) 334 0055

Chanel
935 Michigan Avenue
Chicago, Illinois 60611
Tel: (312) 787 5500

Jimmy Choo
169, Draycott Avenue
London SW3, UK
Tel:+44 (0)20 7235 0242

Christian Dior Boutique
21 East 57th Street
New York, New York 10022
Tel: (212) 931 2954

Christian Lacroix and Masvil
650 5th Avenue
New York, New York 10019
Tel: (212) 245 4860

Christina Couture
53, Moreton Street
London SW1, UK
Tel:+44 (0)20 7976 5252
www.christianacouture.com

Lindka Cierach
The Studio, 1C Clareville Grove
London SW7 3AU, UK
Tel:+44 (0)20 7373 3131

Jo-Ann Crossfield
Archer Hall
149, Church Street
Burbage,Hinckley,
Leicester, U.K.
Tel:+44 (0)145 589 1889

Catherine Davighi
121 Adnitt Road.
Northampton, U.K.
Tel:+44 (0)160 460 4122

**Diane Von Fürstenberg
Studio**
389 West 12th Street
New York, New York 10014
Tel: (212) 753 1111

Emanuel Ungaro Boutique
792 Madison Avenue
New York, New York 10021
Tel: (212) 249 4090

Gianni Versace Boutique
647 5th Avenue
New York, New York 10022
Tel: (212) 317 0224

Gina
189, Sloane Street
London SW1, UK
Tel:+44 (0)20 7235 2932

Giorgio Armani Boutique
760 Madison Avenue
New York, New York 10021
Tel: (212) 988 9191

Alan Hannah
7A Chaseside Works
Chelmsford Road
Southgate, London N14, UK
Tel:+44 (0)20 8882 0007
www.alanhannah.co.uk

Carolina Herrera
48 West 38th Street
New York, New York 10018
Tel: (212) 575 0557
www.carolinaherrera.com

Jim Hjelm
501 7th Avenue, Suite 1014
New York, New York 10018
Tel: 1 800 686 7880
www.jimhjelm.com

Caroline Holmes
176, Walton Street
London SW3, UK
Tel:+44 (0)20 7823 7678

Emma Hope
53, Sloane Square
London SW1, UK
Tel:+44 (0)20 7259 9566

Katrina Marie Designs
11616 Eagles Wing Way
Tucson, Arizona 85735
Tel: (520) 822 1177

Yumi Katsura
907 Madison Avenue
New York, New York
Tel: (212) 772 3760
www.yumikatsura.com

Romona Keveza
450 Fashion Avenue
New York, New York 10123
Tel: (212) 273 1113
www.romonakeveza.com

Kiss The Frog
Mill Lane Studio
Mill Lane
Godalming, Surrey GU7, UK
Tel:+44 (0)1483 416 406

Kristina Marie Design
11616 Eagle's Wing Way
Tucson, Arizona 85735
Tel: (520) 822 1177

Peter Langner
Viale Parioli 63
Rome, Italy
Tel:+39 06 807 8228
www.peterlangner.com

Le Spose di Gio'
Via Italia, 40
Monza (Milan), Italy
Tel:+39 039 322 437
www.le-spose-di-gio-.com

Philippa Lepley
494 Fulham Road
London SW6, UK
Tel:+44 (0)20 7386 0927

Beverly Lister
11, Addison Road
Guilford, Surrey GU1, UK
Tel:+44 (0)1483 535 618

www.beverlylister.co.uk
Chantal Mallett
The Forge
10, Marsworth Road
Pitstone, Leighton Buzzard, UK
Tel:+44 (0)1296-661296

Badgley Mischka
525 Fashion Avenue
New York, New York 10018
Tel: (310) 248 3750

Helen Morley
226 West 34th Street
New York, New York
Tel: (212) 594 6404
www.helenmorley.com

Suzanne Neville
44, High Street
Harrow on the Hill
Middlesex HA1 3LL, U.K.
Tel:+44 (0)208 423 3161

Bruce Oldfield
27, Beauchamp Place
London SW3, UK
Tel:+44 (0)20 7584 1363

Sharon Cunningham Couture
20, Quebec Street
London W1, UK
Tel:+44 (0)20-7724 7002
www.sc-couture.co.uk

Stewart Parvin
14, Motcomb Street
London SW1, UK
Tel:+44 (0)20 7235 1125

One & Only
Designed by Stephanie Allin
81, Newton Road, Mumbles,
Swansea SA3 4BN, UK
Tel:+44 (0)1792 361477

Jesus Peiro
Roger 65-67,
08028 Barcelona, Spain
Tel:+34 3 490 87 87

Lorenzo Riva
Via Brera 7
Milan, Italy
Tel:+39 02 877 872
www.lorenzoriva.it

Michelle Roth
24 West 57th Street, Suite 203
New York, New York 10019
Tel: (212) 245 3390

SoieMême
76, Belsize Park Gardens
London NW3, UK
Tel:+44 (0)20 7483 3843

St. Pucchi
1511 Main Street
Dallas, Texas 75201
Tel: (214) 631 4039

Melissa Sweet
1816 Briarwood Industrial
Court, Suite D
Atlanta, Georgia 30329
Tel: (404) 633 4395

Philip Treacy
69, Elizabeth Street
London SW1, UK
Tel:+44 (0)20 7259 9605

Valentino Couture
11 West 42nd Street
New York, New York 10036
Tel: (212) 355 0051

Paula Varsalona
1375 Broadway, 17th fl.
New York, New York 10018
Tel: 1 800 761 1707

Cocoe Voci
185 North Robertson
Boulevard
Beverly Hills, California 90211
Tel: (310) 360 0287

Amanda Wakeley Sposa
80, Fulham Road
London SW3, UK
Tel:+44 (0)20 7590 9105

Catherine Walker
46, Fulham Road
London SW3, UK
Tel:+44 (0)20 7581 8811

Vera Wang
991 Madison Avenue
New York, New York 10021
Tel: (212) 628 3400

Arkadius Weremczuk
41 Brondesbury Road
London NW6, UK

Tel:+44 (0)20 7371 9203

Ritva Westenius
28, Connaught Street
London W1, UK
Tel:+44 (0)20 7706 0708
www.ritvawestenius.co.uk

Yves Saint Laurent Boutique
855 Madison Avenue
New York, New York 10001
Tel: (212) 988 3821

Basia Zarzycka
52, Sloane Square
London SW1, UK
Tel:+44 (0)20 7730 1660

Bridal Salons

Neiman Marcus
Tel: 888 955 9595

Saks Fifth Avenue
611, Fifth Avenue
New York, New York
Tel: (212) 940 2269

Bergdorf Goodman
754 Fifth Avenue
New York, New York
Tel: (212) 872 2777

Kleinfeld Bridal
8206 5th Avenue
Brooklyn, New York 11209
Tel: (718) 833 1100

Websites

www.coolwhite.com

www.einvite.com

www.theknot.com

www.fortunoff.com

www.perfectdetails.com

www.marthastewartwed-dings.com

www.bridalplanner.com

www.waycoolweddings.com

www.wedding411.com

www.weddings.com

www.weddings-online.com

www.weddingweb.com

Stationery

Crane & Co.
Tel: 1 800 572 0024
DB Firenze
53 East 58th Street
New York, New York 10022
Tel: (212) 688 8777

Dieu Donné Papermill
433 Broome Street
New York, New York 10013
Tel: (212) 226 0573

Gussgift Stationery
Tel: 1-850-932-1236
www.gussgift.com

Papertalk Stationery
805 Burton Trail
Adams, Tennessee 37010
Tel: 931-368-0161
www.papertalk.com

Uptown Invitations
www.uptowninvitations.com

Footnotes

INTRODUCTION

1 Charles Dickens, *Great Expectations* (London, Penguin, 1994) p.87
2 Lawrence Langner, *The Importance of Wearing Clothes* (London, Constable and Company, 1959) p.158
3 Chrys Ingraham, *White Weddings: Romancing Heterosexuality in Popular Culture* (London, Routledge, 1999) p.23
4 Guy Debord, *The Society of the Spectacle* (New York, Zone Books, 1995) p.12
5 Professor Adrian Thatcher in James Meek, 'Weddings Can Wait, Claims Theologian,' *The Guardian* (Saturday, September 4, 1999)
6 Melissa McBride-Mellinger, *The Wedding Dress* (New York, Little Brown and Co, 1993) p.18
7 Margaret Visser, *The Way We Are* (London, Penguin, 1997) p.7
8 Elizabeth Laverack, *With This Ring: 100 Years of Marriage* (London, Elm Tree Books, 1979) p.127
9 Anthea Jarvis, *Brides: Wedding Clothes and Wedding Customs 1850-1980* (Merseyside County Council Museums, 1983) p.2
10 Shane White and Graham White, *Stylin': African American Expressive Culture from Its Beginnings to the Zoot Suit* (Ithaca, Cornell University Press, 1998) p.32
11 Ibid
12 Laverack, p.44
13 Jarvis, p.3
14 *Tatler*, June 30, 1877 in Laverack, p.37
15 Nigel Arch and Joanna Marschner, *The Royal Wedding Dresses* (London, Sidgwick and Jackson, 1990) p.12
16 Ingraham, p.9
17 Simon R. Charsley, *Rites of Marrying: The Wedding Industry in Scotland* (Manchester University Press, Manchester, 1991) p.69
18 Naomi Wolf, *Promiscuities: A Secret History of Female Desire* (London, Vintage, 1998) p.231
19 Ingraham, p.162

CHAPTER ONE: EDWARDIAN EXTRAVAGANCE

1 Ambrose Bierce, *The Devil's Dictionary* (1911) in http://www.starlingtech.com /quotes/qsearch.cgi
2 *Ladies' Home Journal* (1890) in Maria McBride-Mellinger, *The Wedding Dress* (New York, Little Brown and Co, 1993) p.27
3 Anthea Jarvis, *Brides: Wedding Clothes and Customs 1850-1980*, (Merseyside County Council Museums, 1983) p.9
4 Pauline Stevenson, *Bridal Fashions* (London, Ian Allan Ltd, 1978) p.10
5 Stevenson, p.13
6 Kathy Peiss, *Hope in a Jar: The Making of America's Beauty Culture* (New York, Metropolitan Books, 1998) p.25
7 Stevenson, p.9
8 Ibid, p.13
9 Gail MacColl and Carol McD. Wallace, *To Marry an English Lord: The Victorian and Edwardian Experience* (London, Sidgwick and Jackson, 1989) p.71
10 Ibid, p.170
11 Isabel A. Mallon, 'The Art of Dressing a Bride,' *Ladies' Home Journal* (March 1894)
12 *Harper's Bazar* (sic) (December 15, 1877)
13 Lucile in Adburgham, p.246
14 Lady Violet Hardy, *As It Was* (London, Christopher Johnson, 1958) p.85
15 Elizabeth Wilson and Lou Taylor, *Through the Looking Glass: A History of Dress from 1860 to the Present Day* (London, BBC Books, 1989) p.61
16 Madeleine Ginsburg, *Wedding Dress 1740-1970* (London, Victoria and Albert Museum, 1981) p.38
17 Ibid, p.16
18 Nigel Arch and Joanna Marschner, *The Royal Wedding Dresses* (London, Sidgwick and Jackson, 1990) p.10619
19 Ginsburg, p.1
20 Princess Marie of Edinburgh in Arch and Marschner, p.90
21 Laverack, *With This Ring: 100 Years of Marriage* (London, Elm Tree Books, 1979) p.47
22 Jane Beckett and Deborah Cherry, *The Edwardian Era* (London, Phaidon Press and Barbican Art Gallery, 1987) p.78
23 Hardy, p.79
24 Beckett and Cherry, p.76
25 In Rowbotham, p.7
26 Ibid, pp.7-8
27 Steve Humphries, *A Secret World of Sex* (London, Sidgwick and Jackson, 1988) p.96
28 Ibid
29 Ibid, p.97
30 Avril Lansdell, *Wedding Fashions 1860-1980* (Shire Publications Ltd, Princes Risborough, Bucks, 1983) p.40
31 John Berger, *About Looking* (London, Writers and Readers, 1980) p.30
32 Ibid, p.33
33 Ibid
34 Winifred Foley in Colin McDowell, *The Literary Companion to Fashion* (London: Sinclair-Stevenson, 1995) p. 312
35 George Moore in Wilson and Taylor, p.50
36 Jarvis, p.11
37 *Vogue* (1917) in Christina Probert, *Brides in Vogue Since 1910* (London, Conde Nast Publications, 1984), p.8
38 JBeckett and Cherry, p.7
39 Kate Caffrey, *The Edwardian Lady* (London, Gordon and Cremonesi, 1976) p.9

CHAPTER TWO: FLAPPER STYLE

1 Dorothy Parker, 'The Satin Dress' (1928) in *The Best of Dorothy Parker* (London, The Folio Society, 1950 p.32
2 Judith Watt (ed), *The Penguin Book of Twentieth-Century Fashion Writing* (London, Penguin, 1999) p.77
3 Valerie Steele, *Paris Fashion* (New York, Oxford University Press, 1988) p.247
4 Molly Haskell, *From Reverence to Rape: The Treatment of Women in the Movies* (New York, Holt, Rinehart and Winston, 1974) p.78
5 Stuart and Elizabeth Ewen, *Channels of Desire: Mass Images and the Shaping of American Consciousness* (University of Minnesota Press, Minneapolis, 1992) p.172
6 Lucile in Watt, p.45
7 Antoine in *Antoine by Antoine* (London, W.H. Allen Co Ltd, 1946) p.46
8 Winifred Holtby, *Women* (London, John Lane, 1934) p.44
9 Steve Humphries, *A Secret World of Sex* (London, Sidgwick and Jackson, 1988) p.101
10 Ibid, p.114
11 Elizabeth Wilson and Lou Taylor, *Through the Looking Glass: A History of Dress from 1860 to the Present Day* (London, BBC Books, 1989) p.77
12 Nigel Arch and Joanna Marschner, *The Royal Wedding Dresses* (London, Sidgwick and Jackson, 1990) p.103
13 *The Queen*, March 4, 1922
14 Christina Probert, *Brides in Vogue Since 1910* (London, Thames and Hudson, 1984) p.17
15 Eric Gill in Watt, p.13
16 Pauline Stevenson, *Bridal Fashions* (London: Ian Allan Ltd, 1978) p.19
17 Lynne Joyce, 'A Message to a Bride-to-Be' in *Woman's Guide to Health and Beauty* (London, Oldhams Press Ltd), c.1930, p.236
18 Probert, p.16
19 Anthea Jarvis, *Brides: Wedding Clothes and Customs 1850-1980* (Merseyside County Council Museums, 1983) p.19
20 Probert, p.28
21 Madeleine Vionnet in Wilson and Taylor, p.86
22 Caroline Evans and Minna Thornton, *Women and Fashion: A New Look* (London, Quartet Books, 1989) p.120
23 J. B. Priestley, *English Journey* (London, Penguin, 1987) pp. 375-376
24 Wilson and Taylor, p.99
25 Arch and Marschner, p.108
26 Ibid, p.108
27 Stevenson, p.19

28 Ibid, p.19

29 Ibid, p.19

30 Judith Thurman, *Secrets of the Flesh: A Life of Colette* (London, Bloomsbury, 1999) p.60

31 Ibid, p.411

32 Mitford, p.78

33 Joyce, p.236

34 Elizabeth Laverack, *With This Ring: 100 Years of Marriage* (London, Elm Tree Books, 1979) p.40

35 Probert, p.28

36 Stevenson, p.20

37 Ibid

38 Cecil Beaton, *Self Portrait with Friends: The Selected Diaries of Cecil Beaton 1926-1974*, ed. Richard Buckle (Weidenfeld and Nicholson, London, 1979) pp.56-57

39 Barbara Tober, *The Bride: A Celebration* (New York, Harry N. Abrams, 1984) p.160

40 Laverack, p.106

**CHAPTER THREE:
FORTIES RESTRAINT, FIFTIES' FROTH**

1 Elizabeth Taylor quoted in Kitty Kelley, *Elizabth Taylor: The Last Star* (London, Michael Joseph, 1981)

2 John Costello, *Love, Sex and War: Changing Values 1939-45* (London, Collins, 1985) p.14

3 Ibid, p.17

4 Ibid, p.19

5 Ibid, p.265

6 Mellinger, p.37

7 Maureen Turim, 'Designing Women: The Emergence of the New Sweetheart Line' in Jane Gaines (ed) *Fabrications: Costume and the Female Body* (London, Routledge, 1990) p.212

8 Valerie Steele, *Fifty Years of Fashion: New Look to Now* (New Haven, Yale University Press, 1997) p.8

9 Colin and Eileen Townsend, *War Wives: A Second World War Anthology* (London, Grafton Books, 1989) p.8

10 Lansdell, p.71

11 Costello, p.21

12 Townsend, p.62

13 Ibid, p.118

14 Noel Coward, *Present Indicative* (1937) in Watt, p.205

15 Ted Hughes, 'A Pink Wool Knotted Dress' in Birthday Letters (London, Faber and Faber, 1998) pp.34-35

16 *Harper's Bazaar* October 1945

17 Turim, p.215

18 Lou Taylor, 'Paris Couture 1940-1944'
in Juliet Ash and Elizabeth Wilson (eds), *Chic Thrills: A Fashion Reader* (London, Pandora Press, 1992) p.138

19 Steele, p.1

20 Marjorie Beckett, 'Paris Forgets This is 1947' in *Picture Post* (September 27, 1947) p.9

21 Arch and Marschner, p.115

22 Ibid, p.117

23 Christina Probert, *Brides in Vogue Since 1910* (London, Thames and Hudson, 1984) p.41

24 Kitty Kelley, *The Royals* (New York, Warner Books, 1997) pp. 73-74

25 Alexander Walker quoted in Richard Dyer, *Stars* (London: B.F.I., 1979) p.43.

26 Kelley (1997) p.44

27 Ibid, p.46

28 Turim, p.220

29 Ibid, p.225

30 Sparke, p.166

31 Colin Macinnes, *Absolute Beginners* (London, E.P Dutton, 1985) p.87

32 Anne Edwards and Drusilla Beyfus, *Lady Behave! A Guide to Modern Manners* (London, Cassell and Company Ltd, 1956) p.251

33 Oleg Cassini, *In My Own Fashion: An Autobiography* (London, Simon and Schuster Ltd, 1987) p.267

34 http:people.aol.com/people/romance/kelly.html

35 Stevenson, p.22

36 Edwards and Beyfus, p.251

37 Angela Partington, 'Popular Fashion and Working-Class Affluence' in Ash and Wilson, p.151

38 Laverack, p.106

39 Penny Sparke, *As Long as it's Pink; The Sexual Politics of Taste* (London, Pandora, 1995) p.173

**CHAPTER FOUR:
COUNTERCULTURE CHIC**

1 Hans Koningsberger, *An American Romance* (London, Penguin, 1964) p.41

2 Mary Quant in Valerie Steele, *Fifty Years of Fashion: New Look to Now* (New Haven, Yale University Press, 1997), p.51

3 Steele (1997) p.49

4 Christina Probert, *Brides in Vogue Since 1910* (London, Thames and Hudson, 1984) p.62

5 Nigel Whiteley, *Pop Design: Modernism to Mod* (London, The Design Council, 1987) p.209

6 Stan Barstow, *A Kind of Loving* (London, Penguin, 1960) pp.8-9

7 Ellis Amburn, *Elizabeth Taylor: The Obsessions, Passions
and Courage of a Hollywood Legend* (New York, Harper Collins, 2000) p.155

8 Emily Post in Tober, p.53

9 Richard Neville, *Playpower* (London, Paladin, 1970) p.74

10 Goldstein in Steele, (1997) p.76

11 Louis Yablonsky, 'The Hippy Trip 1968' in Arthur Marwick *The Sixties* (Oxford, Oxford University Press, 1998) p.483

12 Probert, p.63

13 Stevenson, p.106

14 Nigel Whiteley, *Pop Design: From Modernism to Mod* (London, The Design Council, 1987) p.216

15 Probert, p.69

16 Neville, p.57-58

17 Germaine Greer, *The Female Eunuch* (London, Paladin, 1971) pp.216-217

18 Marwick, p.685

19 Yves Saint Laurent in Steele, p.61

20 Mellinger, p.41

21 Mellinger, p.41

22 Simon R. Charsley, *Wedding Cakes and Cultural History.* (London, Routledge, 1992) p.27

23 Probert, p.80

24 Lansdell, p.101

25 Avril Groom, 'The Dresses to Wed In and Wear Again' in *The Daily Telegraph* (Mon, May 29, 1978)

26 Laverack, p.62

27 Margaret Baker, *Wedding Customs and Folklore* (Newton Abbot, Devon, David and Charles Publishers Ltd, 1977) p.50

28 Chrys Ingraham, *White Weddings: Romancing Heterosexuality in Popular Culture* (London, Routledge, 1999) p.94

29 Marjorie Ferguson, *Forever Feminine: Women's Magazines and the Cult of Femininity* (London, Heinemann Educational Books Ltd, 1983) p.87

30 Ibid

**CHAPTER FIVE:
MODERN FAIRY TALES**

1 Catherine Zeta Jones in *OK* (December 2, 2000) p 26

2 Marjorie Ferguson, *Forever Feminine: Women's Magazines and the Cult of Femininity* (London, Heinemann Educational Books, 1983) p.111

3 Rowbotham, p.512

4 Deborah Silverman, *Selling Culture: Bloomingdale's, Diana
Vreeland, and the New Aristocracy of Taste in Reagan's America* (New York, Pantheon Books, 1986) p.11

5 Holly Brubach, *New Yorker* (1992) in Steele, p.111

6 Georgina Howell, *Sultans of Style: Thirty Years of Fashion and Passion 1960-1990* (London, Ebury Press, 1990) p.140

7 Ibid, p.145

8 Woram, p.97

9 Nicholas Coleridge, *The Fashion Conspiracy* (London, Heinemann, 1988) pp.198-199

10 Lacroix in *OK* (December 2, 2000) p.52

11 Jean Rook in Arch and Marschner, p.130

12 Susan Heller Anderson in Ingraham, p.38

13 Diana in Joan Smith, *Different for Girls: How Culture Creates Women* (London, Chatto and Windus, 1997) p.14

14 Suzanne Moore, *Head Over Heels* (London, Penguin Books, 1997) p.85

15 Ingraham, p.107

16 Simon R. Charsley, *Wedding Cakes and Cultural History* (London, Routledge, 1992) p.15

17 Raymond Williams in Charsley, p.5

18 Stella Bruzzi, *Undressing Cinema: Clothing and Identity in the Movies* (London, Routledge, 1997) p.35

19 Alan Parker in Bruzzi, p.35

20 Ingraham, p.88

21 Woram, p.99

22 Woram, p.99

23 Dyer, p.13

24 Hannah Borno, 'Caravan of Love' in *Marie Claire* (August 2000) p.75

25 Ibid

26 Julian Barnes in McDowell, p.218

27 Ibid, p.110

28 Nancy Banks-Smith, 'Sophie Gets Her Turkey' in *The Guardian* (Monday, June 21, 1999)

29 Linda Smith in Nancy Banks-Smith

30 Stuart Millar, 'Royals refine their own third way' in *The Guardian* (Monday June 21, 1999)

31 Moore, p.36

32 Ibid, p.12

33 Ingraham, p.8

34 Ibid, p.27

Index

Acknowledgements

The Publisher and the Author would like to thank all the designers, photographers, brides and grooms who have contributed to this publication and especially Carolyn Richardson & Marnie Angus.

All efforts have been made to contact the copyright owners of the images published in this book. If any acknowledgement has been inadvertently omitted the copyright owner is invited to contact the publisher.